Portrait Painting in America

D1376890

ANTIQUES Magazine Library

Portrait Painting in America

THE NINETEENTH CENTURY

Edited by Ellen Miles

Main Street/Universe Books

New York

Articles included in this volume are printed as they appeared originally in the following issues of *The Magazine* ANTIQUES:

Part I. Portraits in City Hall, New York, November, 1976; Paintings in the Council Chamber of Charleston's City Hall, November, 1970; Portrait Painting in Colonial and Ante-Bellum New Orleans, June, 1968; Nineteenth-Century Painting and Sculpture at the State Historical Society of Wisconsin, November, 1976.

Part II. New England Miniatures, September, 1958; Unpublished Miniatures by Benjamin Trott, August, 1931; Likeness by Audubon, June, 1955; Aaron Houghton Corwine: Cincinnati Artist, June, 1955; The Sully Portraits at West Point, November, 1955; Lithographs by Rembrandt Peale, February, 1970; Albert Gallatin Hoit (1809–1856), November, 1972; Emanuel Leutze: Portraitist, November, 1975; Three Tennessee Painters, September, 1971; Daniel Huntington, Portrait Painter Over Seven Decades, June, 1965.

Part III. American Primitive Portraiture, A Revaluation, September, 1941; Zedekiah Belknap, November, 1976; Ammi Phillips, Limner Extraordinary, December, 1961; Two American Primitives, Abijah Canfield of Connecticut, March, 1951; William M. Prior, Traveling Artist, January, 1948; Deborah Goldsmith, Itinerant Portrait Painter, November, 1943; Joseph H. Davis, New Hampshire Artist of the 1830's, October, 1943; "Drawn by I. Bradley from Great Britton," October, 1966; Asahel Powers, Painter of Vermont Faces, November, 1973.

Part IV. Nicholas Biddle in Portraiture, November, 1975; Another Coriolanus, Portraits of Keokuk, Chief of the Sac and Fox, August, 1948; Portraits of Rebecca Gratz by Thomas Sully, July, 1970; Portraits of Ante-Bellum Kentuckians, April, 1974.

First Edition

Introductory material copyright © 1977 by Ellen Miles.

Original articles copyright © 1931, 1941, 1943, 1948, 1951, 1955, 1958, 1961, 1966, 1968, 1970, 1971, 1972, 1973, 1974, 1975, 1976 by Straight Enterprises, Inc.

Library of Congress Catalog Card Number 76-55868

ISBN 0-87663-937-9, paperback edition
ISBN 0-87663-284-3, hardcover edition

Published by Universe Books, 381 Park Avenue South, New York City 10016. Produced by The Main Street Press, 42 Main Street, Clinton, New Jersey 08809.

Published by Universe Books, 381 Park Avenue South, New York City 10016.
Produced by The Main Street Press, 42 Main Street, Clinton, New Jersey 08809.

Printed in the United States of America

Contents

IV SITTERS

Introduction

This anthology of articles from *The Magazine* AN-TIQUES on American nineteenth-century portrait painting covers the period 1800–1860; ANTIQUES has published few articles on portraits painted after this period. Arranged in four categories—Collections, Trained Artists, "Folk" Artists, and Sitters—the articles have been selected to indicate the varieties of portrait styles and compositions characteristic of the period. They have also been chosen to illustrate the work of as many different artists and geographical locations as possible and to indicate some aspects of the training of a portrait painter.

No survey of American portrait painting in the period 1800–1860 has been written. In addition, surprisingly few of the major portrait painters have been studied in detail. There are no complete catalogues, for example, of the work of Thomas Sully, Rembrandt Peale, George Peter Alexander Healy, Samuel Lovett Waldo, Daniel Huntington, or Chester Harding. The paintings of many less well-known painters have also not been catalogued because of the lack of documentary evidence. Many portraits from the period are not signed or inscribed and portray sitters whose identity is no longer known. Attribution is made more difficult because the painting styles of many artists are very similar.

A major characteristic of portrait painting from 1800 to 1860 is the large number of artists involved. A quick review of the artists listed in *The New-York Historical Society's Dictionary of Artists in America, 1564–1860,* compiled by George C. Groce and David Wallace, shows that almost 3,000 artists working in the period 1800–1860 devoted some of their time to portraits. Until the 1840's, when the daguerreotype became popular, almost every painter executed at least a few portraits. Another source, the records of the Bicentennial Inventory of American Paintings Executed before 1914, compiled at the National Collection of Fine Arts, indicates that at least one-third of the paintings from this period were portraits, since fully thirty-three percent of the paintings recorded in the Inventory are portraits.

The demand for portraits characteristic of the period does not represent a change in taste from the previous century. Portraits had served as a mark of personal distinction in eighteenth-century New England, New York, the Middle Atlantic colonies, and in the South. After the Revolution, portraits also answered the need to commemorate historical events. John Jay's recommendations to Congress regarding a proposal to commission an equestrian statue of George Washington from the French sculptor Jean Antoine Houdon suggest that portraiture, and not depictions of historical events themselves, met with his approval. The statue itself was an acceptable memorial, but the proposal included commissions for reliefs on the base, reliefs which would represent "the principal events of the war, in which George Washington commanded in person." John Jay advised in 1785 that the inclusion of these reliefs was not necessary, in part because "when they are compleated none but such as may be minutely informed of the History of the Transactions alluded to will understand them, and when they do, they will find them better represented by the Historian."

Portrait painting in the United States between 1800 and 1860 can be divided into three periods, each lasting approximately two decades. The first period, dominated by the work of Gilbert Stuart, John Trumbull, and John Wesley Jarvis, can be seen to have ended with the death of Stuart in 1828. The second era began in the middle of the second decade, after the War of 1812, and lasted until the 1840's; artists who dominated this period include Henry Inman, Chester Harding, Samuel F. B. Morse, Thomas Sully, and Charles Bird King. The third period included the years from about 1840 to the Civil War and is marked by the work of George Peter Alexander Healy, Charles Loring Elliott, and Daniel Huntington.

After the Revolution and until about 1805, Philadelphia was the center of portrait painting in the United States. While it was the capital of the United States, from 1790 to 1800, Philadelphia attracted portrait painters who hoped for commissions from members of

the new government. The leading painters—Gilbert Stuart, Charles Willson Peale, Edward Savage, and John Trumbull—had all received their training in England. After the capital was moved to Washington, a number of these artists moved out of Philadelphia, to Washington, New York, or Boston. During this first decade, many of the artists who were later to dominate American portrait painting were not in the United States but in Paris or London, including Thomas Sully, Charles Bird King, Samuel F. B. Morse, Washington Allston, Edward Malbone, and John Vanderlyn.

The second decade, from 1810 to 1820, saw a great increase in the activities of portrait painters and the growth of New York as a major center of portrait painting. The defeat of the British in the War of 1812 reinforced the success of the Revolution and brought an era of national pride and prosperity conducive to portrait commissions. Many portrait painters who had studied abroad returned to the United States, establishing studios in the major cities of the East Coast. The idea of commissioning a portrait may also have been made more popular as the American engraving and publishing industry grew and engraved portraits were widely circulated. The first major American publishing venture to use portraits as illustrations for a collection of biographies, Joseph Delaplaine's *Repository of the Lives and Portraits of Distinguished American Characters*, was published in Philadelphia at this time.

The great decade of American portraiture in the first half of the nineteenth century was that of the 1820's. Some of the finest American portraits were painted during these years: John Vanderlyn's two full-length portraits of Andrew Jackson, painted in 1820 and 1824; Samuel F. B. Morse's full-length of the Marquis de Lafayette (1825) and his *Old House of Representatives* (1822); John Neagle's *Pat Lyon at the Forge* (1826); and Charles Willson Peale's self-portrait, *The Artist in His Museum* (1822). In this decade, several significant events, including the visit of Lafayette in 1824, the fiftieth anniversary of the Signing of the Declaration of Independence two years later, and the deaths of John Adams and Thomas Jefferson that same year, seem to have increased the interest in portraits of past heroes. The most famous portrait of this type was Rembrandt Peale's porthole portrait of George Washington, painted in 1823. Others include Chester Harding's life portrait of Daniel Boone and a number of portraits of Charles Carroll of Carrollton, the last living Signer of the Declaration, who died in

1832. The interest in Signers also resulted in the publication of John Sanderson's illustrated *Biographies of the Signers of the Declaration of Independence*, published in nine volumes between 1820 and 1827.

The 1830's saw considerable changes in portrait compositions. A more romantic and intimate image became popular. The younger generation turned away from England to other European centers of painting, including Rome, for training. Among the artists who began their careers in this decade were George Peter Alexander Healy, who painted in Boston until 1834, when he went to France; Thomas Hicks, who studied with his cousin Edward Hicks and went abroad in 1845; and Emanuel Leutze, who went to Dusseldorf in 1840. Publishing continued to be a source of income for some artists, including Leutze, who worked for James Barton Longacre and James Herring, two portrait painters whose first volume of their *National Portrait Gallery of Distinguished Americans* was published in Philadelphia in 1834.

Portrait artists in the 1820's and 1830's also practiced their craft outside of the large Eastern cities. The trained professionals included Nathaniel Jocelyn of New Haven, Matthew Harris Jouett and Joseph Bush of Kentucky, William Harrison Scarborough, who worked in North and South Carolina and Georgia, and George Catlin, whose portraits of Indians were painted in the Midwestern territories. Their contemporaries, the untrained professionals, including Joseph Stock, Ammi Phillips, and Joseph Davis, were popular in New England towns and cities.

The discovery of the daguerreotype process and its introduction to the United States in 1839 dramatically changed the nature of the art market. Daguerreotype studios were established in many cities, freeing some portrait painters, including Asher B. Durand and George Henry Durrie, from patronage which demanded only portraits, and permitting them instead to paint landscapes or genre. By 1850, when Francis D'Avignon and Mathew Brady published their *Gallery of Distinguished Americans*, a folio of twelve lithographs drawn after photographs by Brady, the photographic image was already in use by engravers and lithographers as the source for illustrations in books and magazines.

The photograph does not appear to have had an immediate effect on portrait composition although it was used by painters to replace the tedious portrait sittings once required or to supplement them. Most

painters continued to represent sitters in poses made popular before the invention of the camera.

Portrait painting in the United States was never the province of one school of painters. In addition to the artists born in the United States, there was throughout this period a steady immigration of European portrait painters. Therefore, portrait painting in the first half of the nineteenth century in America reflects a heterogeneity of taste more characteristic of architecture or the decorative arts than of other types of painting. For this reason, the study of styles of portraiture in this period may in the future benefit from application of the approach used by historians of furniture, who have distinguished successfully between the varying tastes of the urban, semi-urban, and rural patron. By illustrating a large number of portraits and presenting the research of both historians and art historians, it is hoped that this anthology will provide some indication of the variety characteristic of portrait painting from 1800 to 1860.

Ellen Gross Miles
National Portrait Gallery
Washington, D.C.
March, 1977

References

Coke, Van Deren. *The Painter and the Photograph from Delacroix to Warhol.* Albuquerque, 1964.

Garrett, Wendell D.; Norton, Paul F.; Gowans, Alan; and Butler, Joseph T. *The Arts in America, The Nineteenth Century.* New York, 1969.

Library of Congress. *Journals of the Continental Congress, 1774–1789,* XXIV, 1783, edited by Gaillard Hunt, 1922, p. 494–5 (the description of the proposed equestrian monument to George Washington); XXIX, 1785, edited by John C. Fitzpatrick, 1933, p. 869 (the advice of John Jay regarding the proposal).

Miller, Lillian B. *Patrons and Patriotism.* Chicago, 1966.

Newhall, Beaumont. *The Daguerreotype in America.* 2d ed., New York, 1968.

The New York Historical Society. *Dictionary of Artists in America, 1564–1860.* Edited by George C. Groce and David Wallace. New York, 1957.

Richardson, Edgar P. *Painting in America.* New York, 1965.

Stewart, Robert G. *A Nineteenth-Century Gallery of Distinguished Americans.* Washington, D.C.: National Portrait Gallery, 1969.

Suggestions for Further Reading

The Corcoran Gallery of Art. *A Catalogue of the Collection of American Paintings, I, Painters Born before 1850.* Washington, D.C., 1966.

Dickson, Harold E. *Arts of the Young Republic, The Age of William Dunlap.* Chapel Hill, 1968.

Dunlap, William. *History of the Rise and Progress of the Arts of Design in the United States.* New York, 1834.

Gardner, Albert Ten Eyck and Feld, Stuart P. *American Paintings, A Catalogue of the Collection of the Metropolitan Museum of Art.* New York, 1965.

Jaffe, Irma B. *John Trumbull, Patriot-Artist of the American Revolution.* Boston, 1975.

Larkin, Oliver. *Art and Life in America.* Rev. ed. New York, 1960.

Lipman, Jean and Winchester, Alice. *The Flowering of American Folk Art, 1776–1876.* New York, 1974.

Maryland Historical Society. *Four Generations of Commissions, The Peale Collection of the Maryland Historical Society.* Baltimore, 1975.

The Metropolitan Museum of Art. *Nineteenth Century American Paintings and Sculpture.* New York, 1970.

Museum of Fine Arts, Boston. *American Paintings in the Museum of Fine Arts.* Boston, 1969.

———. *The M. and M. Karolik Collection of American Water Colors and Drawings, 1800–1875.* Boston, 1962.

National Gallery of Art. *Gilbert Stuart, Portraitist of the Young Republic.* Washington, D.C., 1967.

National Portrait Gallery. *This New Man, A Discourse in Portraits.* Washington, D.C., 1968.

The New-York Historical Society. *Catalogue of American Portraits in the New-York Historical Society.* New Haven, 1974.

Philadelphia Museum of Art. *Philadelphia, Three Centuries of American Art.* Philadelphia, 1976.

Sellers, Charles Coleman. *Portraits and Miniatures by Charles Willson Peale.* Philadelphia, 1952.

———. *Charles Willson Peale with Patron and Populace.* Philadelphia, 1969.

The South Carolina Tricentennial Commission. *Art in South Carolina 1670–1970.* Charleston, 1970.

Wilmerding, John. *American Art.* New York, 1976.

Portrait Painting in America

I Collections

The four essays in this section have been chosen to represent collections formed in the United States between 1790 and the present and to indicate the regional boundaries of early nineteenth-century American portraiture. The first two articles, "Portraits in City Hall, New York," by Edith and Harold Holzer, and "Paintings in the Council Chamber of Charleston's City Hall," by Anna Wells Rutledge, describe collections that were formed largely by commissions for portraits as a commemorative civic gesture. The articles on "Portrait Painting in Colonial and Ante-Bellum New Orleans," (portraits from the Felix H Kuntz Collection) by Roulhac B. Toledano and W Joseph Fulton, and "Nineteenth-Century American Painting and Sculpture at the State Historical Society of Wisconsin," by James F. Jensen, indicate the use of portraits in collections which seek to document local history and have been formed after the portraits were painted.

The City Hall collections at New York and Charleston represent a fusion of two traditions in western art, that of private collections of portraits of famous individuals, and that of civic commissions for portraits in specific recognition of achievements or deeds in the public interest. Commemorative portrait collections were known in classical antiquity. The practice was revived in fourteenth-century Italy, first as an interest in portraits of *uomini famosi* or famous men of the past and present time. The idea reached its modern development in the sixteenth century with Paolo Giovio's collection of portraits at the Museo Gioviano at Lake Como, which was published with biographies of the sitters in 1546. This collection inspired others and also made popular the idea of published collections of biographies illustrated with portraits. It was the source for the modern idea of a National Portrait Gallery.

The second tradition, of commissioning portraits in recognition of contributions to the public or private corporation or town government, was in current practice by the eighteenth century when, in England at least, portraits commemorated the election of a person as an honorary citizen of a city or the contributions of a member of a private society. Early examples of civic American commissions include Boston's commission in 1742 for John Smibert's full-length portrait of Peter Faneuil, because of his gift to the city of the new market building, Faneuil Hall, and the commissions by New York and Charleston in 1766 for statues of William Pitt by the English sculptor Joseph Wilton. Jean Antoine Houdon's full-length statue of George Washington, commissioned by the State of Virginia in 1785, and the proposal in 1783 that the United States Government commission an equestrian statue of Washington from the same artist, also belong to this tradition.

Contemporaneously, private American societies and universities also commissioned portraits of their members. One of the first societies to do this was the American Philosophical Society in Philadelphia. Its first commissions in 1789 were for Charles Willson Peale's portraits of Benjamin Franklin and David Rittenhouse, the Society's first presidents.

Despite their interest in collecting portraits of members, most private societies did not collect portraits as historical documents until, at the earliest, the 1820's. Their first interest was to collect manuscripts and printed material. Instead, the largest portrait collections formed in the late eighteenth and early nineteenth centuries were private collections. The first of these was Charles Willson Peale's gallery of American portraits, begun in Philadelphia in 1783. It was unique in that it contained only portraits painted by Peale. Peale's Museum began a tradition of private portrait museums which continued into the nineteenth century. In 1814 Peale's sons Rembrandt and Raphaelle reopened their Peale Museum in Baltimore, first organized in 1796. The new museum included portraits by the Peales of many of the heroes of the War of 1812. Similar, though smaller, portrait galleries were formed by the Boston art dealer John Doggett, who, in about 1818, commissioned Gilbert Stuart to paint portraits of the first five presidents, and by Luman Reed in 1835, who commissioned Asher B. Durand to paint two sets of portraits of the first six presidents.

The intentional acquisition of portraits by historical societies seems to have begun in the 1820's. The Rhode Island Historical Society, founded in 1822, planned at its instigation to have a museum which would include paintings. Perhaps the coming of the fiftieth anniversary of the Signing of the Declaration of Independence served as a motivation for collecting portraits. Even with this early impetus, however, historical societies did not actively pursue the collecting of portraits until

later in the century. The Connecticut Historical Society, founded in 1825, did not acquire portraits for its collections until 1839. The Wisconsin State Historical Society, founded in the 1850's, began almost immediately to collect portraits. The New-York Historical Society, founded in 1804, greatly expanded its collection in 1858 with portraits from the New York Gallery of Fine Arts, itself in part the collection which Luman Reed formed in the 1830's.

The most recently established portrait collection is that of the National Portrait Gallery, a bureau of the Smithsonian Institution. The idea of a National Portrait Gallery was Charles Willson Peale's, in the sense that he planned, and hoped, to have his collection form the nucleus of a national museum. Instead it was sold at auction in 1854, and many of the portraits were purchased by the City of Philadelphia. They are now on exhibition in the Second Bank of the United States, Independence National Historic Park, Philadelphia. James Barton Longacre and James Herring used *National Portrait Gallery* in the title of their publication of American portraits and biographies in the 1830's and hoped that the collection of portraits which they formed would lead to the establishment of a National Portrait Gallery in Washington. However, the idea was frequently considered and postponed by the federal government until 1962, when the National Portrait Gallery was established.

References

American Philosophical Society. *A Catalogue of Portraits and Other Works of Art in the Possession of the American Philosophical Society.* Philadelphia, 1961.

Arnason, H. H. *The Sculptures of Houdon.* New York, 1975.

Battisti, Eugenio. "Portraiture: The Renaissance to the 20th Century," *The Encyclopedia of World Art,* XI, columns 487–491. New York, 1966.

Bell, Whitfield J., Jr. "Painted Portraits and Busts in the American Philosophical Society," *The Magazine* ANTIQUES (November, 1973): 878–894.

Craven, Wayne. *Sculpture in America.* New York, 1968.

Foote, Henry Wilder. *John Smibert, Painter.* Cambridge, Mass., 1950.

Friends of the Cabildo, Louisiana State Museum, New Orleans. *Two Hundred and Fifty Years of Life in New Orleans, The Rosamonde E. and Emile Kuntz Collection and the Felix H. Kuntz Collection.* New Orleans, 1968.

Goodyear, Frank H., Jr. *American Paintings in the Rhode Island Historical Society.* Providence, 1974.

Lawall, David B. *Asher Brown Durand, His Art and Art Theory in Relation to His Times.* Ph.D. dissertation. University Microfilms Inc., 1967.

The New-York Historical Society. *Catalogue of American Portraits,* New York, 1941.

———. *Catalogue of American Portraits.* New York, 1974.

Oliver, Andrew. "Connecticut Portraits at the Connecticut Historical Society," *The Magazine* ANTIQUES (September, 1973): 418–434.

Wainwright, Nicholas B. *Paintings and Miniatures at the Historical Society of Pennsylvania.* Philadelphia, 1974.

Portraits in City Hall, New York

BY EDITH AND HAROLD HOLZER

THE LANDMARKS PRESERVATION Commission has recently completed a thorough interior renovation of New York's City Hall, a building completed in 1811 (Fig. 1). Paint was analyzed microscopically in an effort to return to the original interior colors, which had in some cases been covered by as many as seventeen subsequent layers of paint.

One reason for the careful restoration of this small but exquisite and functioning landmark was to provide a more suitable setting for City Hall's collection of one hundred portraits, one of the finest, and least-known, collections in New York. It includes works by the best portrait painters of the nineteenth century, most of whom lived or exhibited in New York at some point in their career.

Particular care was taken to renovate the Governor's Room, a magnificent chamber containing some of the furnishings originally purchased for City Hall in 1813, as well as a desk used by Washington and sofas inherited from the old Federal Hall after the national government abandoned New York. The Governor's Room has come to be known also as the "Portrait Room," because in it

hang many of the finest paintings commissioned by the city government for its headquarters.*

A number of canvases by John Trumbull, artist, architect, and cartographer, are displayed in the Governor's Room. He executed the first portrait acquired by the city government, a life study of George Washington standing at Bowling Green (Pl. I). Trumbull also produced portraits of New York's governor George Clinton (Pl. II), Alexander Hamilton (Fig. 2), and John Jay (Fig. 3). In all, thirteen Trumbull portraits are exhibited at City Hall.

John Vanderlyn, whose panoramas were displayed in New York after 1815 in a specially built exhibition hall, painted three presidents for City Hall. His standing figure of James Monroe (Pl. III) is considered to be among the

*Documents concerning payment for some of the portraits are in the Historical Documents Collection, Queens College, City University of New York. Those relating to portraits illustrated in this article indicate that the city paid John Trumbull £186/13/4 each for his likenesses of George Washington and George Clinton; John Vanderlyn was paid $200 for his portrait of Andrew Jackson; and Henry Inman received $200 for his portrait of Martin Van Buren. We are deeply indebted to Leo Hershkowitz, professor of history, Queens College, for this information.

Fig. 1. City Hall, New York, drawn by W. C. Wall, and engraved, printed, and colored by I. Hill, 1825. The building was completed in 1811 after plans by John McComb Jr. (1763-1853) and Joseph F. Mangin.

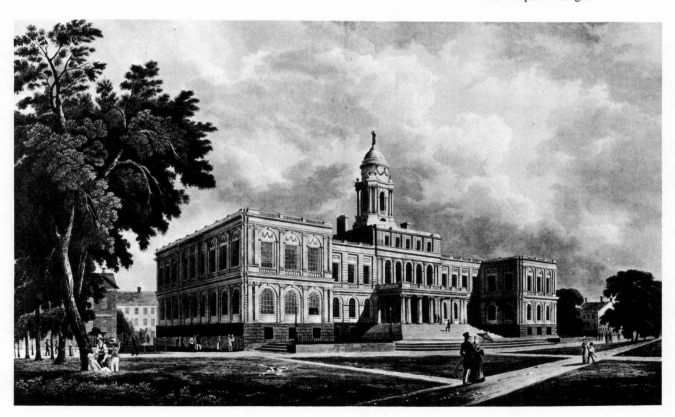

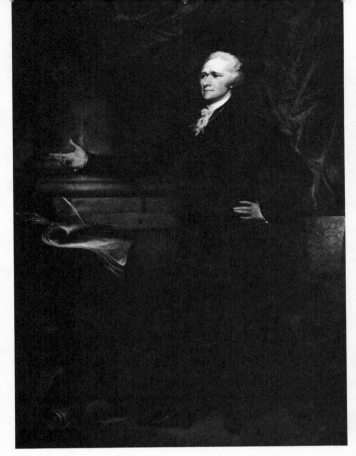

Fig. 2. *Alexander Hamilton* (1757-1804), by John Trumbull (1756-1843), c. 1805. Oil on canvas, 94 by 60 inches. This posthumous portrait is modeled on the marble bust by Giuseppe Ceracchi. Although it was not painted from life, Trumbull had painted Hamilton from life earlier. The head in the City Hall painting was later adapted for the steel engraving on the $10 bill. The city sought this painting of Hamilton after he was slain by Aaron Burr, a New Yorker whose portrait, not surprisingly, is absent from the collection. *Photograph by Taylor and Dull.*

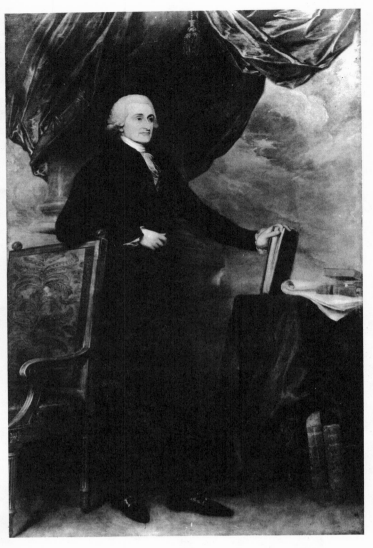

Fig. 3. *John Jay* (1745-1829), by Trumbull, c. 1805. Oil on canvas, 89 by 60½ inches. Trumbull was an aide to Jay during the latter's negotiations in London for a trade pact with England, and when the Jay Treaty was enacted, Trumbull served in London as a commissioner of one of the articles of the agreement. Jay was the first chief justice of the United States (1789-1795), and then governor of New York from 1795 to 1801. *Photograph by courtesy of the Art Commission of the City of New York.*

finest portraits in the collection. Vanderlyn also painted Andrew Jackson as a general (Pl. IV) and Zachary Taylor (Pl. V), another military hero who became president.

The English-born painter and sculptor John Wesley Jarvis was apprenticed to the engraver Edward Savage in Philadelphia from 1796 to 1801. At the end of his apprenticeship he moved to New York, where he worked in

Fig. 4. *Stephen Decatur* (1779-1820), by Thomas Sully (1783-1872), 1814. Oil on canvas, 94 by 66 inches. The city paid Sully $500 for this portrait of Decatur standing before Castle Williams, with a view of New York Bay to the Narrows in the background. *Taylor and Dull photograph.*

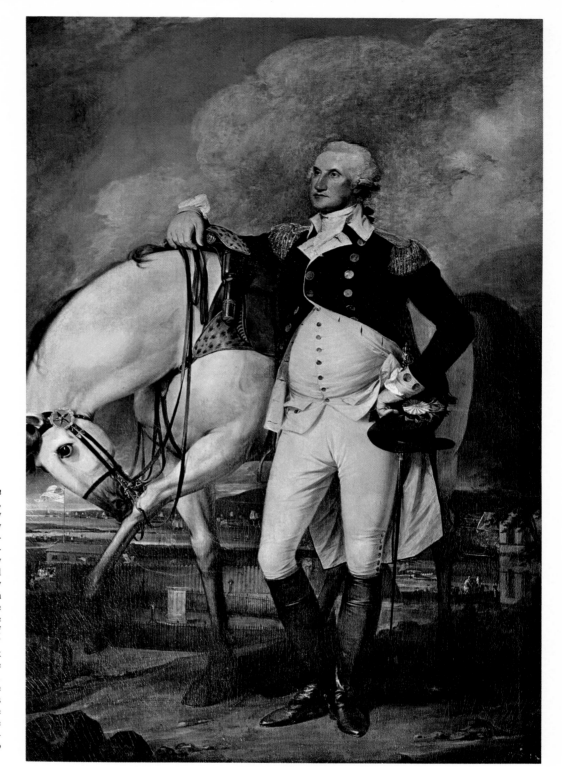

Pl. I. *George Washington* (1732-1799), by Trumbull, 1790. Oil on canvas, 108 by 72 inches. This life portrait by Washington's former aide-de-camp was the first painting acquired for New York's City Hall when it was still on Wall Street. It was commissioned by the mayor and the common council "to be placed in the City Hall as a monument of the respect which the inhabitants of the City bear towards him." Bowling Green and New York Bay as far as the Narrows are visible in the background. Since the completion of the present City Hall in 1811, this painting has hung in the place of honor over the mantel in the Governor's Room. *Color photographs are by Helga Photo Studio.*

partnership with Joseph Wood painting portraits and miniatures. In 1813 he was commissioned by City Hall to paint the heroes of the War of 1812. One of the finest of these portraits is *Oliver Hazard Perry* (Pl. VI), which hangs in the Governor's Room. Thomas Sully's canvas of Stephen Decatur (Fig. 4), also a hero of the War of 1812, hangs in the Governor's Room as well.

The prize of the City Hall portrait collection is considered to be the portrait of the Marquis de Lafayette (Fig. 5) by

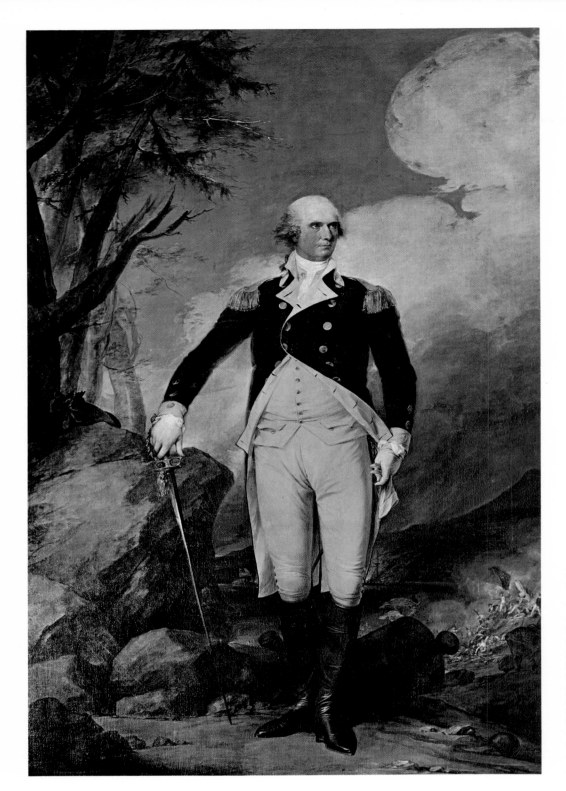

Pl. II. *George Clinton* (1739-1812), by Trumbull, 1791. Oil on canvas, 108 by 71½ inches. Clinton was governor of New York from 1777 to 1795 and again from 1801 to 1804. He was the first governor of the state to be painted for City Hall. Trumbull created the portrait as a companion piece for his Washington canvas, which it faces across the Governor's Room. More than a decade after this painting was completed, Clinton served two terms (1805-1812) as vice-president of the United States.

Samuel F. B. Morse, who settled in New York permanently in 1823. In winning the much-coveted commission to paint Lafayette, Morse triumphed over many contemporaries whose works also decorate City Hall.

The American genre painter Henry Inman moved to New York City at the age of eleven, and was apprenticed for seven years to John Wesley Jarvis. He established his own studio in New York in 1824, but left for Philadelphia in 1831 to start a lithography firm. He returned to portraiture

(Text continued on page 1036)

Fig. 5 *Marie Joseph Paul Yves Roch Gilbert du Motier, Marquis de Lafayette* (1757-1834), by Samuel Finley Breese Morse (1791-1872), 1825-1826. Oil on canvas, 96 by 64 inches. One of the best-known portraits in City Hall, it has been called the finest painting of any historical figure by an American artist. It was commissioned to commemorate Lafayette's state visit to America in 1824 and 1825. The elderly nobleman stands before busts of his American friends Washington and Franklin, much as he might have when he was the guest of honor at a city reception held in the Governor's Room, where the picture was originally displayed. (It now hangs in the City Council Chamber.) Morse spent many months on the painting after winning a competition for the coveted commission. His early labors in Washington, D.C., were interrupted by the death of his wife, and after a brief mourning period he completed the likeness from life when Lafayette came to New York. Soon afterward Morse abandoned painting almost entirely in favor of scientific research. *Art Commission photograph.*

Fig. 6. *William Henry Seward* (1801-1872), by Henry Inman (1801-1846), 1844. Oil on canvas, 98 by 66 inches. The subject was governor of New York from 1839 to 1843, later a United States senator, and then United States secretary of state (1861-1869). In 1867 Seward was instrumental in purchasing the Alaska Territory from Russia for $7,200,000—or two cents an acre—a transaction referred to during the remainder of Seward's life as his "folly." This is one of many portraits of New York State governors commissioned by the city. *Art Commission photograph.*

Fig. 7. *Thomas Jefferson* (1743-1826), by Charles Wesley Jarvis (1812-1868), 1863. Oil on canvas, 94 by 60 inches. *Art Commission photograph.*

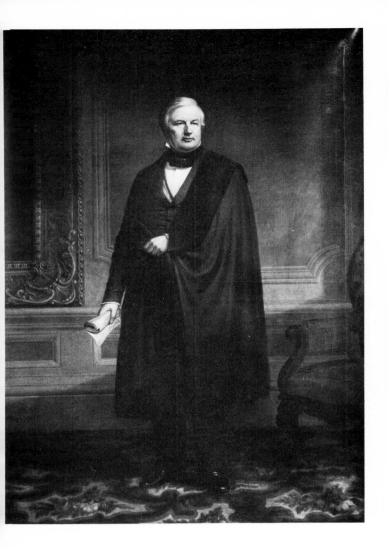

Fig. 8. *Millard Fillmore* (1800-1874), by Francis Bicknell Carpenter (1830-1900), 1853. Oil on canvas, 96 by 66 inches. Fillmore was the thirteenth president of the United States (1850-1853). In 1856 he sought to return to the White House on the "Know-Nothing" ticket, but he was defeated. The portrait hangs in the Board of Estimate Chamber. *Art Commission photograph.*

Fig. 9. *Grover Cleveland* (1837-1908), by Eastman Johnson. Oil on canvas, 60 by 42 inches. Cleveland was the first Democratic president after the Civil War, and the first and only chief executive to serve two nonconsecutive terms of office (1885-1889 and 1893-1897). He had been an assistant teacher at the New York Institution for the Blind before he rose in the political ranks from a Buffalo ward supervisor, to assistant district attorney of Erie County, to mayor of Buffalo, to governor of New York (1883—1885). *Art Commission photograph.*

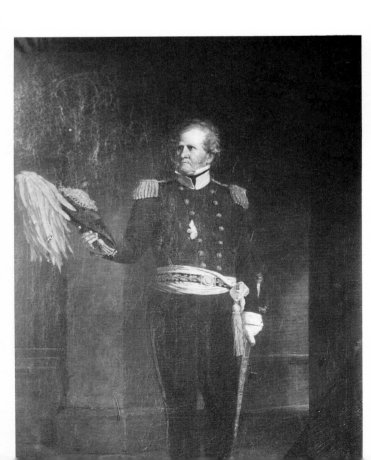

Fig. 10. *Winfield Scott* (1786-1866), by Miner Kilbourne Kellogg (1814-1889), 1858. Oil on canvas, 106 by 70 inches. General Scott, known as "Old Fuss and Feathers," was a hero of the Mexican War and, later, the unsuccessful candidate of the Whigs in the presidential election of 1852. He was commander of the United States Army at the outbreak of the Civil War, but retired soon thereafter. *Art Commission photograph.*

(Text continued from page 1033)

in 1834, and died in 1846 at the age of forty-five. A posthumous exhibition of his work in New York helped raise money for his widow. Inman painted William Henry Seward (Fig. 6) and Secretary of State Martin Van Buren (Pl. VII) for City Hall.

Inman's own apprentice was his former teacher Jarvis' son. Charles Wesley Jarvis was born in New York and worked in his native city from 1834 until his death in 1868. Among the seven portraits by him in City Hall are canvases of Henry Clay (Pl. VIII) and Thomas Jefferson (Fig. 7).

Francis Bicknell Carpenter, who lived for many years in New York City, was famous primarily for his monumental canvas of Lincoln reading the Emancipation Proclamation which is now in the Senate Chamber of the United States Capitol. His portrait of Millard Fillmore (Fig. 8) now hangs in the Board of Estimate Chamber at City Hall.

Eastman Johnson, who was known as the "American Rembrandt" during his years of study at The Hague, is represented by a portrait of President Grover Cleveland (Fig. 9). Miner Kilbourne Kellogg, who came to New York

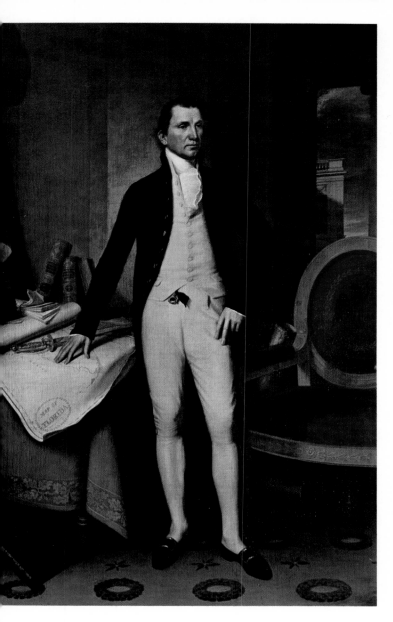

Pl. III. *James Monroe* (1758-1831), by John Vanderlyn (1775-1850), 1822. Oil on canvas, 100 by 64 inches. This canvas of the fifth president is one of eight portraits of United States presidents in the City Hall collection. It hangs in the Governor's Room. Careful scrutiny reveals that Vanderlyn originally painted Monroe with a different pair of legs.

Fig. 11. *George Brinton McClellan* (1826-1885), by William Henry Powell (1823-1879), 1868. Oil on canvas, 106 by 82 inches. A New York resident, General McClellan prevailed upon Abraham Lincoln to name him to succeed Winfield Scott as commander of the Union forces in 1861. Three years and not many successful battles later, at the age of thirty-eight, McClellan ran against Lincoln for president, but lost by four hundred thousand votes. McClellan's son George Jr. was mayor of New York from 1903 to 1909. *Art Commission photograph.*

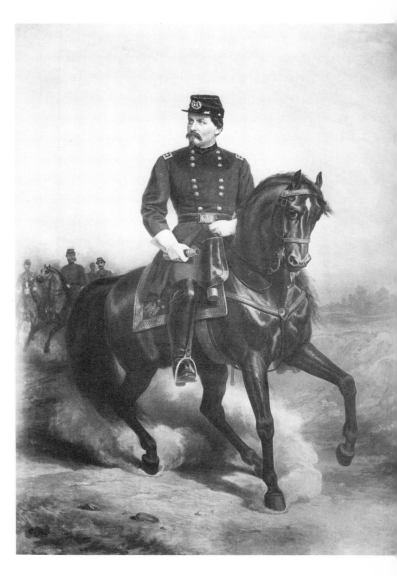

(Text continued from page 1033)

in 1851 after studies in Italy, did a portrait of the Mexican War hero Winfield Scott (Fig. 10). And William Henry Powell, born in New York City and a student of Henry Inman, produced portraits of two Civil War heroes for City Hall: General George Brinton McClellan (Fig. 11) and Robert Anderson, the commander of Fort Sumter (Fig. 12).

City Hall's entire portrait collection is currently being catalogued for publication.

We wish to thank Donald J. Gormley, executive secretary of the Art Commission of the City of New York, for providing us with background information about the portraits in City Hall, and for guiding us through the public and private rooms where they are displayed. Donald Plods of the Landmarks Preservation Commission provided information on the redecoration of City Hall, and Charles Poole, chief custodian of City Hall, helped supervise the color photography of the paintings in the Governor's Room.

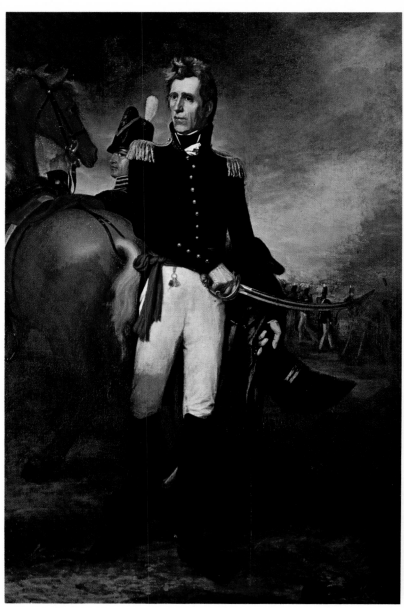

Pl. IV. *Andrew Jackson* (1767-1845), by Vanderlyn, 1820. Oil on canvas, 96 by 64 inches. The seventh president of the United States is shown as a general, with a battle raging in the background. The face was painted from life, but it has been conjectured that the body belonged to another Vanderlyn subject, probably John James Audubon.

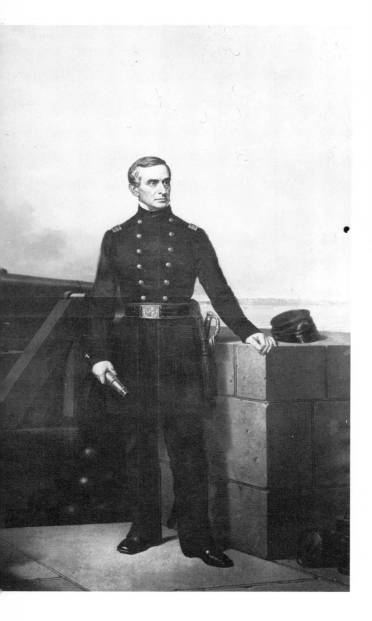

Fig. 12. *Robert Anderson* (1805-1871), by Powell, 1861. Oil on canvas, 102 by 70 inches. One of the first Union heroes of the Civil War, Anderson was commander of Fort Sumter in 1861 when it was bombarded and taken by Southern troops. The Kentucky-born commander personally raised the American flag at Sumter when it was retaken by the Union four years later. *Art Commission photograph.*

Pl. V. *Zachary Taylor* (1784-1850), by Vanderlyn, 1850. Oil on canvas, 96 by 62 inches. Taylor was the twelfth president of the United States. The picture has recently been moved to the Governor's Room after many years in the Board of Estimate Chamber.

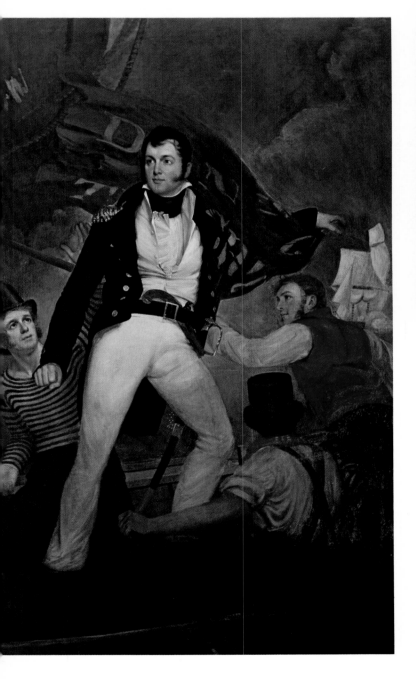

Pl. VI. *Oliver Hazard Perry* (1785-1819), by John Wesley Jarvis (1780-1840), 1816. Oil on canvas, 96 by 60 inches. Commodore Perry is shown on board his ship the *Lawrence* during the 1813 Battle of Lake Erie. His battle flag, behind him, bears the inscription *Don't Give Up the Ship*, a cry reputedly uttered by the mortally wounded Captain James Lawrence, for whom Perry's flagship was named. Jarvis painted five other heroes of the War of 1812 for City Hall: Commodore William Bainbridge, General Jacob Brown, Commodore Isaac Hull, Captain Thomas Macdonough, and Captain Isaac Chauncey.

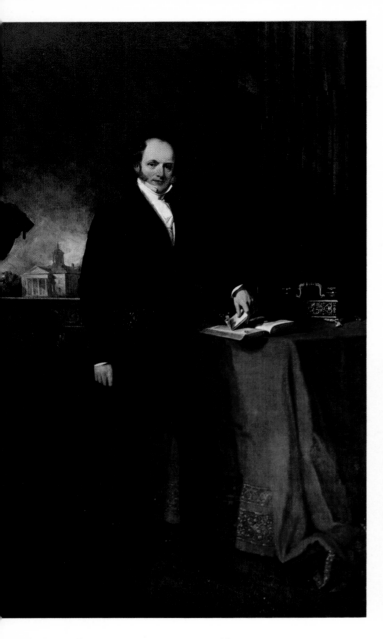

Pl. VII. *Martin Van Buren* (1782-1862), by Inman, 1829. Oil on canvas, 96 by 64 inches. In 1829 Van Buren resigned in mid-term as governor of New York to join Andrew Jackson's cabinet as secretary of state. Jackson's protégé, the so-called "Sage of Kinderhook," later became the first American president from the state of New York. New York's city council authorized this portrait, and Van Buren himself selected Inman to do the work. The fee was a princely $1,050, plus $100 for the gilded frame.

Pl. VIII. *Henry Clay* (1777-1852), by Charles Wesley Jarvis, 1854. Oil on canvas, 100 by 72 inches. The portrait is believed to have been based on a photograph. Behind the orator and statesman stands a statue of Minerva, goddess of wisdom. City Hall's collection also includes a portrait of Clay by an unknown artist and a bust by a sculptor identified only as "Pruden." The number of Clay likenesses indicates the extent of the Kentuckian's popularity, even though he failed each time he sought the presidency.

Paintings in the Council Chamber of Charleston's City Hall

Fig. 1. *George Washington* (1732-1799), by John Trumbull (1756-1843), 1792. Oil on canvas; 90½ by 63 inches. Commissioned by the Charleston City Council. *All illustrations are in the Council Chamber, City Hall, Charleston, South Carolina.*

BY ANNA WELLS RUTLEDGE

IN THE COUNCIL CHAMBER of the City Hall of Charleston, South Carolina, hangs an impressive municipal collection of paintings. Most of them are portraits which have some historical association with the city, through the subject or the artist or both. They include likenesses of men who have served as President of the United States, vice president, secretary of state, secretary of war, senator, member of the House, president of the University of South Carolina, high-ranking officers of the armies of the United States and the Confederate States of America, and secretary of the treasury of the Confederacy. A number of these portraits were commissioned by the City Council; others have been acquired by gift and bequest.

A full-length life portrait of the first President of the United States fittingly inaugurated this important collection (Fig. 1). The commissioning of the portrait of George Washington by John Trumbull was instigated by a United States senator from South Carolina, William Loughton Smith. On August 8, 1790, Smith wrote from New York to Edward Rutledge, a Signer of the Declaration of Independence, who in 1790 represented Charleston in the House of Representatives and in the state convention:

> Trumbull is painting a magnificent Picture of the President; the figure 7 foot high—a great likeness—it is for the Corporation of New York who are to give a hundred Guineas for it—I saw it yesterday & felt fired with a desire to have such a one in Charleston—can't our Corporation do the same? Would the Citizens of Charleston contribute to such a gratification with less Zeal than those of New York? I think not—suppose then you feel the pulse of the Corporation; if they are not warmed with the bare mention of it, say no more to them, but inquire whether a hundred Guineas may not be presently raised by Subscription for the purpose, & put my name after yours for the same sum you subscribe; or let the Expense be divided equally among all the Subscribers: such an opportunity may never offer again. . .

Nine months later, during the President's stay in the city in May 1791, on his southern tour, the City Council

> Resolved unanimously . . . to request of Geo. Washington, Esq., President of the United States, that he will be pleased when it is convenient to him, to permit his portrait to be taken by Col. Trumbull, in order that it may be placed in City Hall . . . to commemorate his arrival in the metropolis of this State, and to hand down to posterity the remembrance of the man to whom they are so much indebted for the blessings of peace, liberty and independence. ("The Letters of William Loughton Smith to Edward Rutledge," edited by George Rogers Jr., *South Carolina Historical Magazine*, Vol. 69, 1968, p. 133).

This portrait was painted in Philadelphia and was received at City Hall in mid-July 1792.

In the winter of 1794-1795 two of the Peales, Rembrandt and Raphaelle, brought to Charleston an exhibition of portraits of Revolutionary heroes, including a number of South Carolinians: Generals Gadsden, Greene, Moultrie, and Sumter, Colonels Washington and Morris, Doctor David Ramsay, and Henry and John Laurens. (Morris, Greene, and Washington were not born in South Carolina, but they took wives and acquired plantations there.) Attributed to Rembrandt Peale is a portrait of Gadsden (Fig. 2) which has entered the City Hall collection within the past three years.

In March 1819, when President James Monroe was in Charleston, the Council unanimously voted to request his consent to having his portrait painted. It was to be a "full length likeness" by Samuel F. B. Morse. The artist wrote from Charleston that "it is necessary I should visit Washington, as the President will stay so short a time here" and he painted the commissioned portrait in 1819 and 1820 (Fig. 3). Morse himself made four stays in Charleston between 1818 and 1821. *(Samuel F. B. Morse His Letters and Journals,* edited by Edward Lind Morse, Boston, 1914.)

More than twenty-five years elapsed between the commissions to Trumbull and to Morse, but only five years after Monroe's portrait was ordered the City Council wrote the Honorable Andrew Jackson—then a senator from Tennessee and running that year for President—in Washington that they wished a portrait ". . . transmitting to posterity the likeness of one . . . whom Carolina is proud to number among her sons." This was on January 17, 1824. On January 27 the senator answered, agreeing to sit to John Vanderlyn. The portrait was in Charleston before March 1825 (Fig. 4).

Another South Carolinian highly distinguished in public life was John C. Calhoun, who served as member of Congress, senator, secretary of state, secretary of war, and vice president of the United States and who championed the doctrine of nullification. In July 1850, some three months after Calhoun's death, George Peter Alexander Healy was commissioned by the City Council to paint a full-length standing portrait of Calhoun (Fig. 5). The artist, then resident in Paris, replied that he would be pleased to paint "a man for whom I entertained so deep an admiration, and in whose society I derived so much benefit" *(Charleston Courier,* September 2, 1850).

Healy was working in Charleston in the spring of 1861 and there completed a portrait of General Pierre Gustave Toutant Beauregard (Fig. 6), who was in command of the South Carolina forces at Fort Moultrie when the *Star of the West* was fired upon. Healy wrote that he thought this would be one of his best portraits. His Charleston host, an editor, was concerned for his guest's safety (for Healy was known as a strong Union sympathizer) and had a carriage ready for him to leave the city at an hour's notice. Healy stopped in Washington, saw President Lincoln, and sketched him and reported on Charleston.

In opposition to nullifiers and secessionists in South Carolina, there was a strong Union party, of which one member was Alfred Huger (1788-1872), a lawyer, planter, and orator. He resigned from the United States Senate in 1845 because he felt he no longer represented the people who elected him. Huger was appointed second postmaster of Charleston by President Jackson in 1835 and was offered the post again after 1865, by President Johnson, but refused

Fig. 2. *Christopher Gadsden* (1724-1805), attributed to Rembrandt Peale (1778-1860), c. 1795. Oil on canvas; 32 by 25 inches. *Bequest of Jeanne Gadsden.*

it as he was unwilling to take the "iron clad oath." A portrait of Alfred Huger attributed to George W. Flagg hangs in City Hall (Fig. 7).

Many of the artists who painted the portraits in the collection worked in Charleston but did not live there. At least one, however, was a native Charlestonian and a lifelong resident of the city. That was Charles Fraser, who practiced law and then, having "accumulated a competency," risked the chances of a painter's career (Gibbes and Bryan, *Catalogue of Miniature Portraits . . . by Charles Fraser, Esq. . . ,* Charleston, 1857; and A. R. and D. E. Huger Smith, *Charles Fraser,* New York, 1924). An industrious and able miniaturist, he produced well over four hundred likenesses between 1818 and the late 1840's. In the autumn of 1824 Fraser was in Boston and there saw a newly arrived and notable visitor, General Lafayette. He saw him again in Charleston, and in 1825 noted a portrait of the general in his account book on March 17 (Fig. 8). It was not until nine years later that he sold the miniature and entered in his account book, *July Genl. Lafayette's picture to the City Council—100.*

The portrait of the first intendant, or mayor, of Charleston, Richard Hutson (Fig. 9), has in the past been attributed to James Earl, though the attribution may be questioned since it is not certain that subject and artist were in Charleston at the same time. A native of what is now Paxton, Massachusetts, Earl resided in Charleston for most of the two years before his death there in 1796. Hutson was a delegate to the Continental Congress and a member in 1789 of the House of Representatives, later lieutenant-governor of South Carolina, chancellor, and senior judge of the chancery, or equity,

court. His death in 1795 may have occurred before Earl's arrival in Charleston.

The portrait of the city's second intendant, John Huger, painted by Edward Savage in 1787, is one of the earliest works in the City Hall collection (Fig. 10). Huger, like his predecessor, Hutson, had a long career in the service of his native state.

One man whose name is familiar to most Americans only in its Latinized derivative is Joel Roberts Poinsett, planter, diplomat, scientist, and United States minister to Mexico from 1825 to 1830, who introduced into this country from Mexico the poinsettia. His portrait in City Hall is attributed to John Wesley Jarvis (Fig. 11).

In addition to its many fine portraits, the collection at City Hall includes two views of Broad Street in Charleston. One, *The Arrival of the Mail* (Fig. 12), by the local artist John Blake White was painted in 1837 and described in the *Charleston Courier* on June 1 of that year:

The spectator is supposed to be a few steps within the north-western arch of the Exchange or Custom House, looking directly up Broad-street. This position affords a view of Ashley River, especially the beautiful spire of St. Michael's Church, tower-

Fig. 3. *James Monroe* (1758-1831), by Samuel Finley Breese Morse (1791-1872), 1819-1820. Oil on canvas; 92¼ by 59½ inches. Commissioned by the City Council.

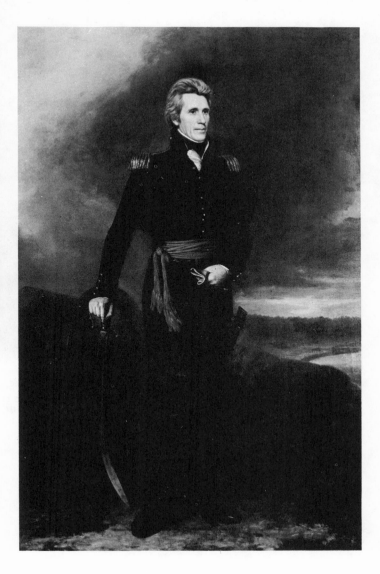

Fig. 4. *Andrew Jackson* (1767-1845), by John Vanderlyn (1775-1852), 1824. Oil on canvas; 98 by 62½ inches. Commissioned by the City Council.

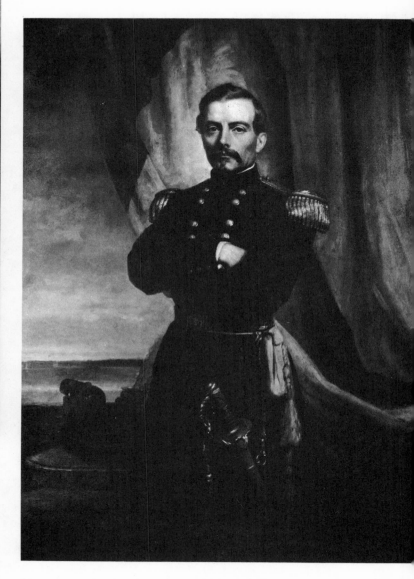

Fig. 5. *John Caldwell Calhoun* (1782-1850), by George Peter Alexander Healy (1813-1894), 1850-1851. Oil on canvas; 92¼ by 54½ inches. Commissioned by the City Council.

Fig. 6. *Pierre Gustave Toutant Beauregard* (1818-1893), by Healy, 1861. Oil on canvas; 59 by 45½ inches. *Gift of Bernard M. Baruch.*

ing majestically over all the other objects, that fill the canvass. The time is about noon, and the season of the year, that when the trees being divested of foliage, an almost uninterrupted view is afforded of the whole street, which is enlivened by military and mercantile movements.

The group portrait of thirty-three *Officers of the Volunteer Fire Department* (Fig. 13), by Christian Mayr, was called in the *Charleston Courier* on June 9, 1841, an "attractive painting—uniting the portraits of a number of our citizens with a pleasing delineation of local scenery . . ." It was sold by raffle the same year. Another notice in the *Courier* two months later said that it showed "with great beauty and effect the fine public buildings of the central part of the city. . ." These are City Hall, the city square (Washington Park), and the Fireproof Building, which formerly housed the Records Office and is now the headquarters of the South Carolina Historical Society.

Figures 12 and 13 are of special interest because they show the "man in the street" rather than the city's most distinguished citizens and visitors; and they give us, as well, a glimpse of the city these Charlestonians lived in and loved.

Fig. 7. *Alfred Huger* (1788-1872),
attributed to George Whiting Flagg (1816-1897).
Oil on canvas; 30 by 25 inches.
Bequest of Mrs. William Huger.

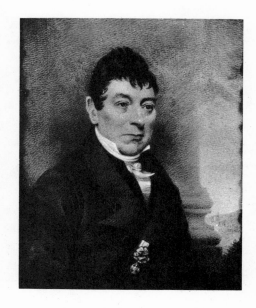

Fig. 8. *The Marquis de Lafayette* (1757-1834),
by Charles Fraser (1782-1860), 1825.
Water-color miniature on ivory;
4¾ by 3¹⁵⁄₁₆ inches.
Purchased by the City Council, 1834.

Fig. 9. *Richard Hutson* (1748-1795),
attributed to James Earl (1761-1796).
Oil on canvas; 48 by 40 inches.
Gift of Mrs. W. M. Hutson.

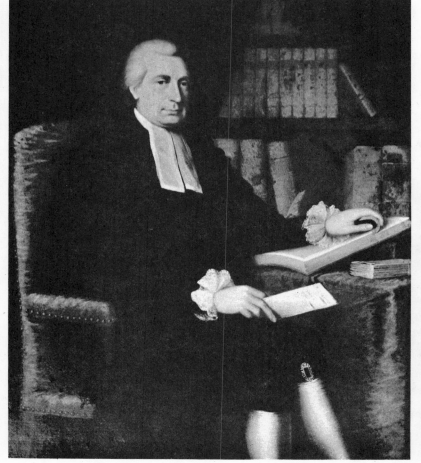

Fig. 10. *John Huger* (1744-1804),
by Edward Savage (1761-1817), 1787.
Oil on canvas; 34 by 29½ inches.
Gift of Dr. and Mrs. William H. Huger.

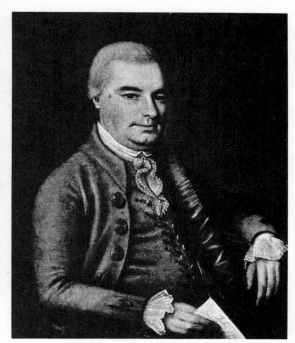

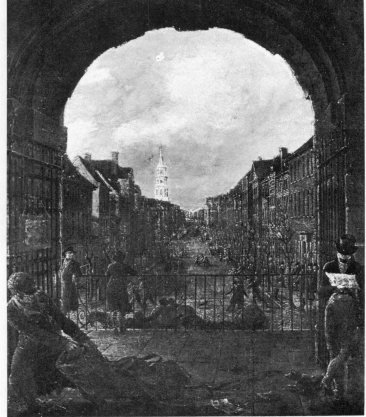

Fig. 11. *Joel Roberts Poinsett* (1779-1851),
attributed to John Wesley Jarvis (1780-1840).
Oil on canvas; 30 by 25 inches.
Gift of Mayor William A. Courtenay.

Fig. 12. *The Arrival of the Mail,* Charleston,
by John Blake White (1781-1859), 1837.
Oil on canvas; 29¾ by 24½ inches.
Gift of Octavius A. White.

Fig. 13. *Officers of the Volunteer Fire Department,*
Charleston,
by Christian Mayr (c. 1805-1851), 1841.
Oil on canvas; 45 by 65½ inches.
Gift of Mrs. Richard Wainwright Bacot.

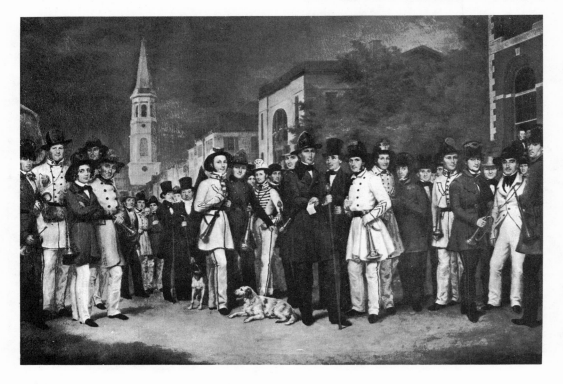

Portrait painting
in colonial and ante-bellum New Orleans

BY ROULHAC B. TOLEDANO, *Research co-ordinator, Friends of the Cabildo,*
and W. JOSEPH FULTON, *Curator of painting and sculpture, Louisiana State Museum*

FROM THE FOUNDING of New Orleans in 1718 until the outbreak of the Civil War in 1860, portraits were very much in demand. The variety of nationalities—largely French, Spanish, and Anglo-American—represented in the successive waves of immigration provided a wealthy and highly cultivated class of patrons. The position of this Gulf Coast port at the mouth of the Mississippi River, the crossroads of overland and water transportation routes, was another important factor in fostering artistic activity, for the city was easily accessible to itinerant painters, both American and foreign-born.

Among the earliest settlers were six hundred Germans and Swiss who arrived in Louisiana between 1717 and 1720 during the undertaking, since known as the "Mississippi scheme" or the "Mississippi bubble," promoted by the Scottish economist John Law who was hired by the French regent, the Duke of Orleans, after whom the city was named. In this group were people of means who brought portraits with them and had others painted in New Orleans (Fig. 1). They were followed by French and North Italian families of the *haute bourgeoisie* throughout the French colonial period, about 1720 to 1760 (Figs. 6, 10). Immigration of families of French descent was particularly heavy during and after the slave uprisings in Santo Domingo, other Caribbean islands, and Madagascar in the mid-eighteenth century. Under the Spanish domination, from 1762 to 1802, various wealthy Anglo-American and English families prospered in the colony (Figs. 2, 3). By the end of this period the city had a highly heterogeneous population of 10,000, which included descendants of the Spanish military forces and French and Spanish government officials.

At the time of the Louisiana Purchase in 1803, Americans came to New Orleans to engage in the speculative business opportunities available in the newly opened United States territory (Fig. 8). Other arrivals during the first few years of the nineteenth century included British, Dutch, and French officials representing foreign governments and individuals in the financing of the Louisiana Purchase (Fig. 3). And New Orleans continued to attract French *émigrés* (Fig. 9).

The height of activity for portraitists in New Orleans was between 1820 and 1850. By 1820 the city's total population had reached 19,000, and sugar and cotton plantations were flourishing along the river between New Orleans and Baton Rouge as well as below the city in St.

Fig. 1. *Karl Friedrich, Chevalier d'Arensbourg* (1693-1777), c. 1775. Pencil, water color, and oil on paper, 10 7/16 by 8¾ inches. D'Arensbourg, a Swede, came to Louisiana as a young man with a company of two hundred and fifty Germans. Soon afterward, the hurricanes of 1722 devastated their homes and they tried to return to Europe; but Jean Baptiste Le Moyne, Sieur de Bienville, governor of Louisiana and founder of New Orleans, in an effort to detain the settlers, ceded lands to them above the city on both sides of the river in the present parishes of St. Charles and St. John the Baptist. The village of Karlstein was named after D'Arensbourg, who had become commandant of the new German settlement. He died at eighty-four in St. Charles Parish, in 1777. Stylistically the portrait is a continuation of the Northern European graphic portrait tradition; it is one of the few early portraits found in Louisiana not relating to Spanish or French traditions.

*All portraits are from the Felix H. Kuntz Collection
on loan to the Louisiana State Museum
for an exhibition sponsored by the Friends of the Cabildo;
photographs by Betsy Swanson and Stuart Lynn.*

Fig. 2. *James Mather*, c. 1800, by Joseph Salazar de Mendoza (d. 1802); signed *Iosef de Salazar pinxit*. Oil on canvas, 32 3/16 by 29 1/16 inches. Mather, an Anglo-American merchant resident in New Orleans after 1784, was given commercial privileges by Governor Miró to trade with the Indians at Mobile and Pensacola. Appointed mayor of New Orleans by Governor Claiborne in 1807, he served until 1812. This relatively sophisticated portrait reveals Salazar's professional competence as both draftsman and painter; however, in some of his works the characterization is stiff and awkward.

Bernard and Plaquemines Parishes. A number of planters had houses in town, and for all of them New Orleans was the center of social and cultural activity. In a good many cases, portraits were painted of every member of the family. The population of the city had jumped to 100,000 by 1840 and merchants, businessmen, and even gamblers (Fig. 17) could well afford the luxury of having themselves and their families painted.

Another aspect of the development of painting in New Orleans during the 1840's was the exhibition of European masterpieces and the establishment of a museum, one of the first such attempts in the country. An artist, George Cooke, took charge of the new gallery, called the National Gallery of Paintings, where shows of pictures for sale took place. In an effort to form a permanent collection, some three hundred eighty works attributed to such masters as Raphael, Leonardo, Titian, Del Sarto, Poussin, Velázquez, Rembrandt, Rubens, and Vandyke were gathered in the ballroom of the St. Louis Hotel in 1847. These had been selected, by three Italian experts, from the homes of thirty-nine Italian noblemen, and it was hoped that the United States would purchase the entire group as a nucleus for a national gallery of art. The auction sale was a success, but only a portrait of Marie of Austria attributed to Vandyke remained in New Orleans.

A second important sale, which occurred in 1859, was that of the collection put together by James Robb, one of New Orleans' earliest art collectors. Sixty-seven important pictures were sold, and the artists' names included Rubens, Snyders, Salvatore Rosa, Horace Vernet, Natoire, and David. Some of these are now in public collections elsewhere in the United States, but Natoire's *The Toilette of Psyche* may still be seen in the Isaac Delgado Museum of Art. This canvas and fourteen others had been bought by Robb from the Jerome Bonaparte sale at Bordentown, New Jersey, in 1845. The two sales in New Orleans are significant because they occurred at

Fig. 3. *Lady at the Piano*, c. 1795, attributed to Salazar. Oil on canvas, 35 1/16 by 29 5/16 inches. There is an identical portrait in New Orleans inherited by descendants of Nicholas Michel Edmond Forstall, who moved from Martinique to Louisana where he was commandant of the Opelousas country in St. Landry Parish. In 1762 he married Pélagie de la Chaise, the granddaughter of Chevalier Friedrich d'Arensbourg. They had seven children: three daughters and four sons. This portrait may be of a daughter or daughter-in-law. The Forstall family represented the British banking firm of Baring and Company which was involved in financing the Louisiana Purchase.

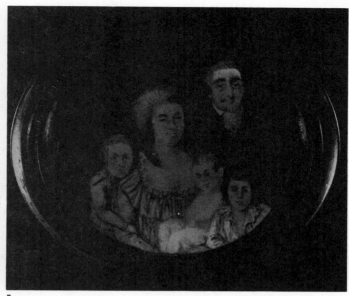

4

5

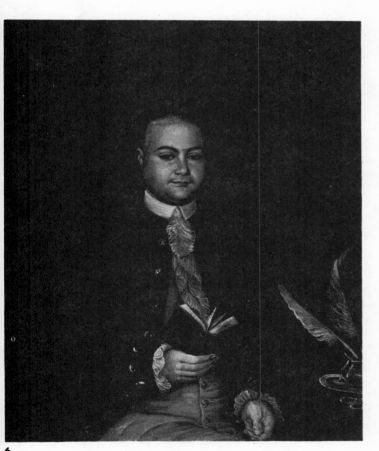

6

Fig. 4. *Portrait of an Officer,* c. 1790, New Orleans. Oval miniature on ivory, 1¾ by 1⅜ inches. A provincial version of the late eighteenth-century style.

Fig. 5. *Family Group,* c. 1795, New Orleans. Water color on paper, cut down to oval 3 1/16 by 3 3/16 inches. Family group portraits are to be found in relatively large numbers in New Orleans. This one, a real primitive, is unusual in its miniature scale.

Fig. 6. *Portrait of a Man Reading,* c. 1778, New Orleans. Oil on canvas, 38 15/16 by 31 5/16 inches. The sitter is possibly Jean Baptiste Garic who served as secretary of the Superior Council under the French from 1739 to 1769, and from then until his death in 1779 as the first notary in Louisiana under the Spanish dominion. Previously this subject was erroneously identified as Bernardo de Galvez.

a comparatively early date, and indicate a real interest in art at a time when most American communities were indifferent to such matters.

This artistic and collecting activity was interrupted by the Civil War. Many patrons of the arts returned to Europe for a number of years, and most native artists were fighting with the Confederacy. Prominent European artists and American painters of the Northeast stayed away. French artists working in New Orleans, such as Jean J. Vaudechamp, Francisco Bernard, and Jacques Amans, returned to Europe. The newspapers and directories list a few obscure foreign artists in the city during the early 1860's, but, from the scarcity of recorded portraits of the period, it appears that their production was limited.

The chief compilation of information about painting in New Orleans, until the WPA assembled further material in fourteen unpublished volumes housed at the Isaac Delgado Museum of Art, was a pioneering essay, *Art and Artists in New Orleans During the Last Century* (reprinted from the 1922 biennial report of the Louisiana

7

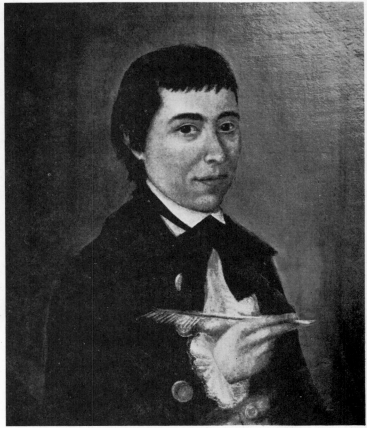

8

9

Fig. 7. *Père Antoine*, c. 1800, Louisiana. Oil on board, 13 15/16 by 11⅛ inches. The Reverend Father Antonio de Sedella, a Spanish Capuchin monk, first came to New Orleans in 1780 as an emissary of the Holy Inquisition. Governor Miró, anxious to increase the colony's population and aware that mere mention of the Inquisition would keep away immigrants, immediately had Father Antonio sent back to Spain. In 1795 he returned in another capacity and became well known in local politics, clashing often with ecclesiastical and civil authorities. When he died in 1829 the entire city paid him homage. The style of this picture suggests Spanish colonial influence. (Illustrated in ANTIQUES, February 1968, p. 182.)

Fig. 8. *William C. C. Claiborne as a Boy*, c. 1786. Oil on canvas, 23 1/16 by 19⅝ inches. Not long after this portrait was painted, probably in Baltimore, Claiborne went at the age of fifteen to New York and became a clerk of court. Encouraged by Thomas Jefferson and John Sevier, he studied law in Richmond and was admitted to the bar in three months. In 1804 Claiborne, then twenty-nine, was appointed governor of the newly acquired Louisiana Territory. His popularity led to his election as first governor of the new State of Louisiana in 1812.

Fig. 9. *Monsieur François Poupart*. Miniature on ivory, 2 3/16 by 2⅝ inches. During the French Revolution, François Poupart fled France with his family and established a coffee plantation in Madagascar. A Negro revolt there caused the family to move to New Orleans, where Poupart opened a school that he called the Collège d'Orléans. This and a companion miniature, probably of Poupart's sister, may well have been brought from France; or they may have been painted in New Orleans, where they descended in the Poupart family.

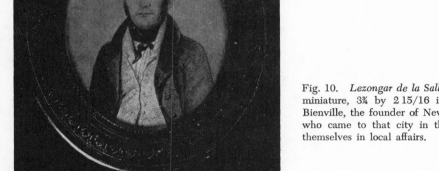

Fig. 10. *Lezongar de la Salle,* c. 1820, New Orleans. Water-color miniature, 3¾ by 2 15/16 inches. The sitter was a relative of Bienville, the founder of New Orleans, and of the De Hoa family who came to that city in the Spanish period and distinguished themselves in local affairs.

Fig. 11. *Portrait of a Gentleman,* by John Wesley Jarvis (1780-1840); stenciled on back, *J. W. Jarvis.* Oil on canvas, 30 by 25 inches. Though Jarvis claimed to have produced many portraits in New Orleans, this is the only one known that bears his name.

Fig. 12. *Françoise Aimée Boudousquie,* c. 1824, by Louis Antoine Collas (1775-?). Miniature on ivory, 2 11/16 by 3⅛ inches. The sitter was the daughter of Norbert Boudousquie and Marie Thérèse Héloïse de Chouriac, and the sister of Antoine Boudousquie, who owned Reserve Plantation and was the second printer in the Louisiana Territory; she married Martin Blanche. This miniature is typical of Collas's many portraits. His work in New Orleans in the 1820's anticipates the dominance of the French taste in portraiture of the next decade. His approach is that of the early French neoclassicism with its pleasantly straightforward realism.

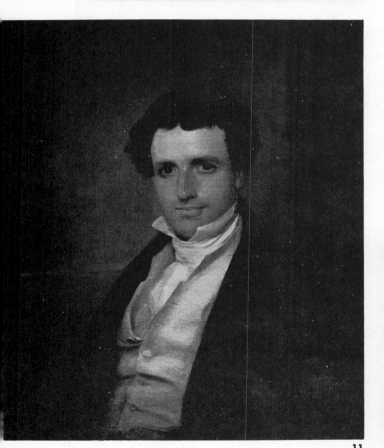

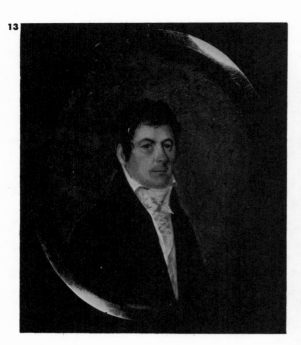

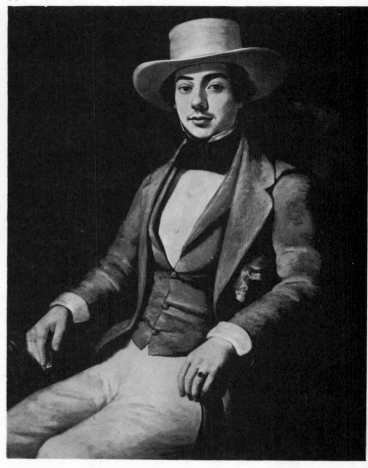

Fig. 13. *Portrait of a Man*, c. 1827, by Ambrose Duval (w. New Orleans 1823-1835); signed *Duval*. Miniature on ivory, 2⅝ by 2 3/16 inches. Although Duval's background and training remain unknown, he apparently belonged to the same French tradition as Collas, though his slightly freer technique and somewhat romantic idealization suggest a later apprenticeship.

Fig. 14. *Louisiana Planter*, c. 1840. Oil on canvas, 35⅞ by 28⅞ inches. This portrait seems to represent the heyday of the great Louisiana cotton and sugar plantations. The boldness and imposing sense of scale befit the importance of the wealthy planter.

State Museum), by Dr. Isaac Monroe Cline, honorary curator of paintings at the Louisiana State Museum. These two sources, together with the New Orleans city directories and the newspaper files, show that one hundred fifty identifiable portrait and miniature artists were active in the city before 1860. During the past four years the National Society of Colonial Dames of America in the State of Louisiana has photographed over one thousand portraits executed in Louisiana before 1860. Less than half of these were signed, and few of the unsigned paintings have as yet been carefully studied. The preponderance of portaits among the paintings done in antebellum New Orleans is indicated by the fact that of Cline's list of twenty-one artists who painted there before the Civil War, only four painted other subjects and even those four were principally portraitists.

Among the painters of Spanish descent working in New Orleans during the colonial period was Joseph Salazar de Mendoza (d. New Orleans, 1802) from Mérida, Yucatán (Figs. 2, 3). Salazar was active in New Orleans from before 1788 until his death, and Cline calls him the first positively identifiable local portraitist. The recorded names of other eighteenth-century painters such as Romegas (see ANTIQUES, April 1968, p. 504) and Prados sug-

gest Spanish or Spanish colonial backgrounds. Their artistic training probably stemmed from the academies and schools of Central and South America set up under royal auspices, as in Mexico, or by missionaries. These artists would not have studied the engravings of works by Sir Godfrey Kneller and other English artists reproduced in the North and East, but rather the religious paintings in the Catholic missions and churches, as well as portraits and engravings from Spain and France.

Many free Negroes lived in the city, some as early as 1724. About 1800, almost half of the total population of 10,000 consisted of Negroes, both slave and free. By 1850 there were 19,000, and at least one portrait painter, Julien Hudson, was among them. The Negro as a subject also proved fascinating to itinerant painters in New Orleans, as is evident in the number of portraits that survive.

Eliab Metcalf (b. Franklin, Massachusetts, 1785; d. New York City, 1834) commented that when he spent the winter of 1820 in New Orleans he had the portrait painting field to himself. He was, no doubt, referring to the absence of fellow American portraitists, but by January of 1821 the situation had changed radically. Among the American artists new to the scene were John Wesley Jarvis (b. South Shields-on-Tyne, England, 1780; d. New

15

16

Fig. 15. *Charles de Lassus de Luzière de Hault*, signed *W. Baclay 1837*. Oil on canvas, 9⅞ by 11 13/16 inches. The sitter was a native of Boneain (Artois), France, but by 1815 had served twelve years in the Royal Guards of Walloon Infantry and over twenty-one years in the Spanish Louisiana Infantry. He was named commandant of New Madrid in 1796, lieutenant governor of Upper Louisiana from 1799 to 1804, and commandant of West Florida, with headquarters at Baton Rouge, between 1807 and 1810. He had also represented France in negotiations over the Louisiana Purchase. After he turned over Upper Louisiana to Captain Amos Stoddard of the United States, he brought the Spanish Archives and other Spanish property to New Orleans in 1805. In 1826 De Lassus moved to New Orleans from St. Louis and remained there until his death in 1842 or 1843.

Fig. 16. *Andrew Jackson,* by Jacques Amans (1801-1888). Oil on canvas, 21⅝ by 17⅝ inches. Jackson arrived in New Orleans late in 1814 to protect the city from possible invasion by the British, and his defense culminated in January 1815 in the land action known as the battle of New Orleans. He remained the city's hero for many years, and his visits were cause for parades and celebrations. Traditionally Amans painted this portrait on the occasion of Jackson's last visit, though it may have been done from a print rather than from life.

York City, 1840) and Henry Inman. Though traditionally it has been held that Jarvis started spending winters in New Orleans as early as 1817, Harold Edward Dickson asserts (*John Wesley Jarvis, American Painter, 1780-1840,* New York, 1949) that it is unlikely that he came to New Orleans before 1821, when, accompanied by Inman, he had a most successful season (Fig. 11). Together they completed six portraits each week and, according to his friend William Dunlap, Jarvis made $6,000 in New Orleans that winter. He received six sitters a day for one hour each. After he finished the figure, Inman painted in the drapery and background under Jarvis' supervision. During the winter of 1821-1822 Jarvis came into contact with John James Audubon (b. Les Cayes, Haiti, 1785; d. New York City, 1851) and there are lively accounts in Audubon's diary of their meetings that year. The naturalist was then literally living on bread and cheese, having arrived on New Year's Day without one cent, and sold charcoal and pencil portraits for $25 each.

John Vanderlyn (b. Kingston, New York, 1775; d. Kingston, 1852), was painting portraits in 1821 and in the early 1830's at his "elegant" studio at Royal and St. Louis

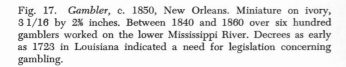

Fig. 17. *Gambler*, c. 1850, New Orleans. Miniature on ivory, 3 1/16 by 2⅝ inches. Between 1840 and 1860 over six hundred gamblers worked on the lower Mississippi River. Decrees as early as 1723 in Louisiana indicated a need for legislation concerning gambling.

Fig. 18. *Jean Pierre Kuntz*, c. 1855-1860. Oil on canvas, 10 by 18 inches. One of the most sensitive paintings in the Felix H. Kuntz Louisiana Collection is this portrait of Jean Pierre Kuntz, great-grandfather of the collector. He came to New Orleans in 1855 after the death of his wife to live with a son, Emile. Jean Pierre's other son, Nicolas, the collector's grandfather, came to New Orleans from Vera Cruz after the downfall of Maximilian.

Streets, while in New Orleans to exhibit his panorama *Versailles*. John Neagle (b. Boston, 1796; d. Philadelphia, 1865) worked briefly in the city early in his career, which began in 1818. Matthew Harris Jouett (b. Mercer County, Kentucky, 1788; d. Lexington, Kentucky, 1827) was probably in the city then. Between 1817 and 1827 he made trips down the Mississippi and painted portraits in Natchez and New Orleans. His standard fee in New Orleans was about $50, and he could finish three portraits a week—a very good livelihood at the time.

Another artist who worked in New Orleans, on and off between 1821 and 1837, was Ralph E. W. Earl (b. England, c. 1785; d. Nashville, Tennessee, 1838), the son of the well-known portraitist Ralph Earl. A relative by marriage of Andrew Jackson, he devoted himself to painting portraits of the President. Many other artists who worked in New Orleans also painted Jackson, since he was a local hero after the battle of New Orleans in 1815 (Fig. 16).

This was the nucleus of the group of American artists in New Orleans, and their numbers grew each year, although not all remained permanently. European, particularly French, painters who became quite prominent in New Orleans also began arriving in the early 1820's. Louis Antoine Collas (b. Bordeaux, France, 1775; w. New Orleans as late as 1829), one of the earliest and best-known French painters in New Orleans, arrived in 1822 (Fig. 12). A large number of signed and dated portraits attests to his competence and popularity, especially with the French Creoles. His work shows the influence of the neoclassicism favored by the French Academy, as does that of the other well-known French artists working in New Orleans in the 1820's and 1830's. Another native French portraitist, also a member of the neoclassic school, who achieved great success in New Orleans was Jean Joseph Vaudechamp (b. Rambervillers, France, 1790; d. France, 1866). He worked in the city during the winters of 1832 to 1836. Jacques Amans (b. Belgium, 1801; d. Paris, 1888) came in 1837 after academic training in the neoclassic tradition in Paris. He is believed to have been in the city earlier than that and this time stayed until 1858 (Fig. 16). After 1840 the French painters arriving in New Orleans brought the influence of the French romantic school with them.

Nineteenth-century American painting and sculpture at the State Historical Society of Wisconsin

BY JAMES F. JENSEN, *Administrative assistant, Honolulu Academy of Arts*

IN 1854, when Lyman Copeland Draper became the first corresponding secretary of the new State Historical Society of Wisconsin, he devised an ambitious plan to create a picture gallery for the Society. He had the ingenious idea of writing to a select group of American painters whose names and pictures he believed would bring prestige to the new institution, and inviting them to become honorary members of the Society. The result was as Draper had hoped, and Thomas Sully was the first to respond: "I have much pleasure in acknowledging the honour conferred on me by the Historical Society of Wisconsin, and would be farther gratified by being able to prove to the Society my willingness to deserve their kindness. Will the Society suggest the name of any person I can paint for them? Would a copy of the portrait of Washington by Stuart be acceptable?"[1] Sully's copy of Gilbert Stuart's Athenaeum-type *George Washington* (Fig. 1) arrived soon afterwards and became the first important painting in the Society's collection.

Sully's nephew Robert Matthew Sully, who was also a painter, answered the Society's invitation favorably and suggested that he wanted to visit Wisconsin to record the land and the people. Draper planned to bring Robert Sully to Madison to paint Wisconsin's native Indians, historic battlegrounds, early pioneers, and prominent public men for the Society. Unfortunately, Sully died unexpectedly in 1855 in Buffalo, New York, on his way west to Madison. However, as a result of Sully's interest, the Society possesses a number of his works, including replicas of his portraits of the Sauk (or Sac) chief Black Hawk, his son Nasheakush (Pl. I), and Wabokieshiek, "the prophet." Sully painted the original portraits in 1833 when the three Indians were imprisoned at Fort Monroe, Virginia. Sully also donated to the Society a series of watercolor sketches of the ruins of Jamestown, Virginia, done in 1828 and a portrait of Pocahontas (Pl. II).

Since these beginnings in the 1850's, the Society's collection of nineteenth-century American paintings, drawings, and sculpture has expanded to include examples by many of the major artists and schools of the period. Chronologically, the collection begins at the end of the eighteenth century with the pair of charcoal portraits of Daniel Kemper and his wife Elizabeth Marius Kemper (Figs. 2, 3) by Charles B. J. Fevret de Saint-Mémin. Dated 1797, these portraits must have been among the first Saint-Mémin made after he became a professional artist in 1796. The collection contains several other pairs of husband and wife portraits which were painted in the first half of the nineteenth century, usually by unknown itinerants or lesser-known professionals, such as the portraits by Alonzo Slafter in Plates III and IV.

Several artists passed through Wisconsin in the 1820's and 1830's, sketching Indians and wildlife as they went. The Swiss immigrant Peter Rindisbacher became the territory's first resident artist, living in southwestern Wisconsin

Fig. 1. *George Washington,* by Thomas Sully (1783-1872), 1854. Oil on canvas, 29½ by 24½ inches. This is a copy of Gilbert Stuart's Athenaeum-type portrait of Washington.

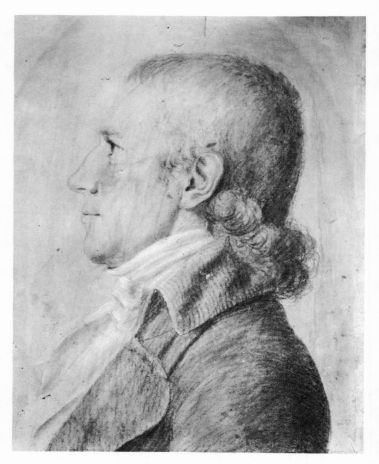

Fig. 2. *Elizabeth Marius Kemper* (1753-1830), by Charles B. J. Fevret de Saint-Mémin (1770-1852), 1797. Charcoal and chalk on pink paper, 21½ by 15 inches. The sitter was the second wife of Daniel Kemper (Fig. 3), whom she married about 1781. The drawing was subsequently engraved in 1797.

Fig. 3. *Daniel Kemper* (1749-1847), by Saint-Mémin, 1797. Charcoal and chalk on pink paper, 21⅜ by 15¼ inches. Kemper was a friend of George Washington and served as a colonel in the Revolutionary War. He was later appointed customs receiver for the city of New York. The drawing was subsequently engraved in 1797.

from 1826 to 1829. The Society owns several of his watercolors of the period, most notably a portrait of the Winnebago chief Isaac Winnesheek (Pl. V) and a drawing of a prairie wolf (Fig. 4). By the 1820's George Catlin had developed a reputation as a fine portrait painter in the East (the Society owns two of his early portraits, one of James Madison done in 1824 and one of De Witt Clinton of 1827), but he yearned to record the "living manners, customs, and character of an interesting race of people, who are rapidly passing away from the face of the earth."[2] Catlin worked toward his goal by painting among the Indians in Wisconsin in 1835 and 1836; however, except for a portrait of Eleazar Williams (Fig. 5) and a charcoal drawing of Moses Meeker, both in the Society's collection, most of the surviving drawings and paintings from his journey are in the National Collection of Fine Arts, Washington, D.C.

Fig. 4. *Prairie Wolf,* by Peter Rindisbacher (1806-1834), c. 1829. Ink and watercolor on paper, 5¼ by 7¼ inches.

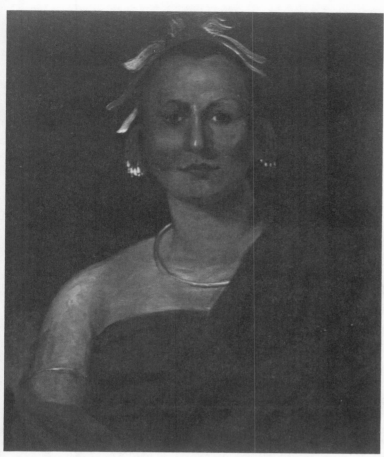

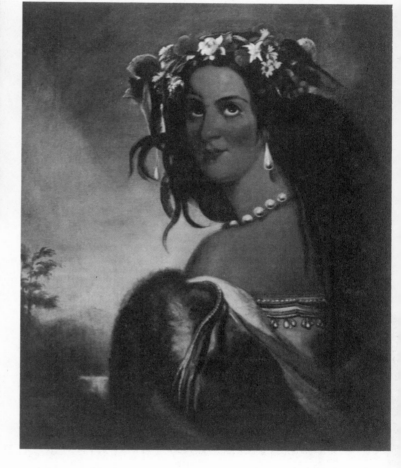

Pl. I. *Nasheakush,* by Robert Matthew Sully (1803-1855), 1854-1855. Oil on canvas, 29 by 25 inches. According to correspondence between Sully and Lyman Copeland Draper, corresponding secretary of the State Historical Society of Wisconsin, this is a replica of an original painted in 1833.

Pl. II. *Pocahontas,* by Robert M. Sully, 1854-1855. Oil on canvas, 30 by 25 inches. Sully based this portrait on a painting done in England in 1616 which was brought to Virginia in the late eighteenth century. In copying the painting, Sully not only changed the position of the figure, but substituted simple drapery for the elaborate dress of the court of James I and embellished the hair with a wreath of flowers in an attempt to restore what he considered an appropriate Indian association to the subject.

Fig. 5. *Eleazar Williams,* (c. 1789-1858), by George Catlin (1796-1872), 1836. Oil on wood panel, 24 by 18 inches. The sitter was an Episcopal missionary and Indian leader of mixed Indian-white parentage who in the 1830's declared that he was the "lost dauphin" of France, Louis XVII. Later he claimed that the prince de Joinville, son of Louis Philippe, asked him to sign an abdication at Green Bay in 1841. Williams continued to promise his friends royal favors when his wrong had been righted, but he died in poverty and obscurity in Hogansburg, New York.

Pl. III. *Joseph Parker,* by Alonzo Slafter (1801-1864), c. 1835. Oil on canvas, 28 by 24 inches. The artist worked in and around Bradford, Vermont, where the Parker family lived before moving to Wisconsin. (See p. 918.)

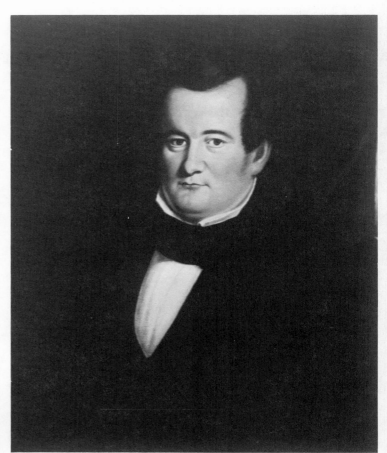

Lyman Draper's grand scheme for recording Wisconsin's Indians, battlegrounds, and early settlers, halted by the sudden death of Robert Sully, was eventually fulfilled by two artists working in loose partnership, Samuel Marsden Brookes and Thomas H. Stevenson. In 1856 the State Historical Society commissioned the two men to paint three battlegrounds of the so-called Black Hawk War, including the panoramic view of the Bad Axe battleground (Pl. VI). Brookes and Stevenson also painted a series of landscapes of the Fox River valley, as well as portraits (see Pl. VII). The majority of work surviving from this partnership is in the Society's collection. The partnership ended in 1858 with Stevenson's departure from Wisconsin; however, Brookes stayed on painting portraits until 1862 or 1863.

In addition to the Brookes-Stevenson landscapes, the Society owns a small Delaware River valley scene by the Hudson River school artist Homer Dodge Martin (Pl. VIII) and several watercolors by the naïve painter Paul Seifert (see Pl. IX).

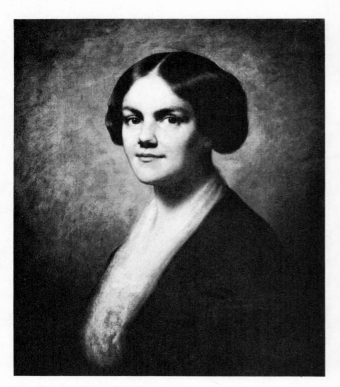

Fig. 6. *Sarah Fairchild Dean Conover,* by Eastman Johnson (1824-1906), 1856. Oil on canvas, 23½ by 19½ inches. A preliminary charcoal drawing for this portrait is in a private collection in Wisconsin.

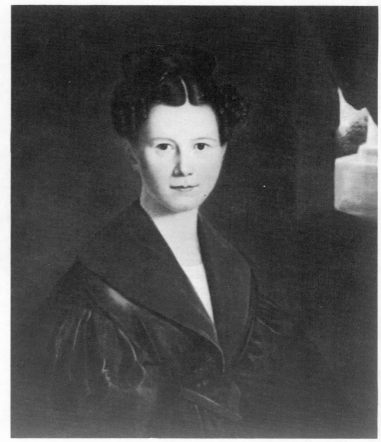

Pl. IV. *Amine Parker,* by Slafter, c. 1835. Oil on canvas, 28 by 24 inches. The sitter was the wife of Joseph Parker (Pl. III). A portrait of the Parker children by Slafter is also in the Society's collection.

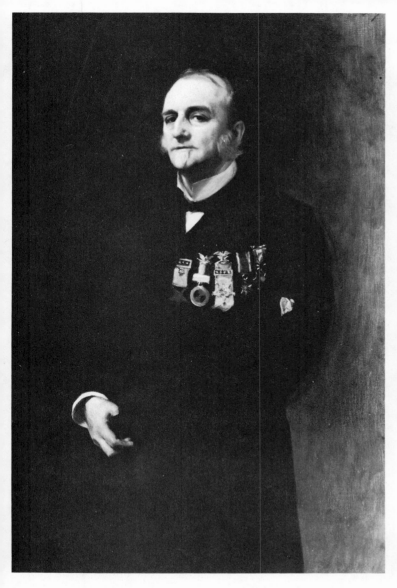

Fig. 7. *General Lucius Fairchild* (1831-1896), by John Singer Sargent (1856-1925), 1887. Oil on canvas, 30 by 25 inches. Fairchild was a Civil War hero who lost an arm at Gettysburg. He was also a politician, diplomat, and, at the time of this portrait, national commander of the Grand Army of the Republic. He disliked sitting for this portrait and appraised the nearly finished work as "a lot of badges running off with a bald-headed man."

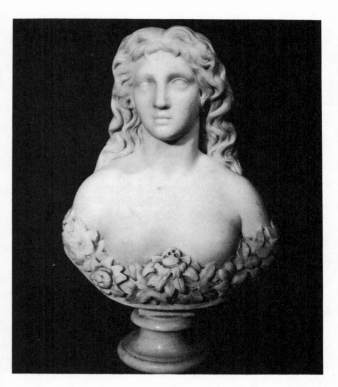

Fig. 8. *Passion Flower,* by Vinnie Ream (1847-1914), 1869-1870. Marble, height 20 inches. The artist carved a series of these idealized young women with floral titles. This one takes its title from the garland of passion flowers around the base.

Fig. 9. *Spirito del Carnevale,* by Ream, 1869-1870. Marble, height 42 inches.

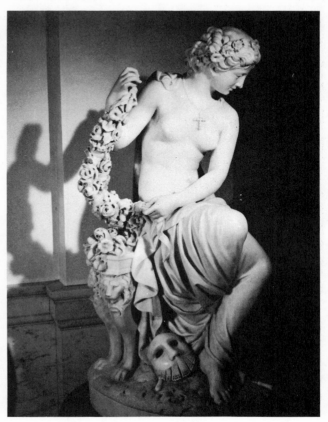

One of the most interesting and prominent families—socially, politically, and artistically—in nineteenth-century Wisconsin was the Fairchild family of Madison. In their travels and through their extensive social connections, they met many famous American and European artists. One of the happy results of just such a chance meeting is the Society's portrait of Sarah Fairchild Dean Conover by Eastman Johnson (Fig. 6). It was painted in 1856 when the sitter, vacationing on Lake Superior, was introduced to Johnson, who was on a sketching tour. The Society also owns a portrait of Sarah Conover's brother General Lucius Fairchild by John Singer Sargent (Fig. 7), painted in Boston in 1887 when Sargent and Fairchild were visiting the latter's brother Charles Fairchild.

Perhaps the best-known nineteenth-century Wisconsin native in the world of art was the sculptor Vinnie Ream

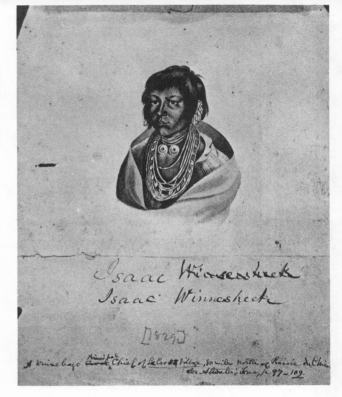

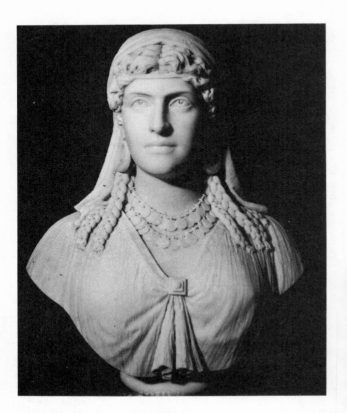

Fig. 10. *Zenobia,* by William Wetmore Story (1819-1895), 1885. Marble, height 27¼ inches. Zenobia, the so-called "Warrior Queen" of Palmyra (267-272) conquered much of Asia Minor until defeated by the Roman emperor Aurelian, who brought her captive to Rome. The English historian Edward Gibbon wrote that Zenobia was "esteemed the most lovely as well as the most heroic of her sex."

(later Mrs. Richard Hoxie), who in 1866, when she was eighteen, became the first woman to receive a Federal government commission for a work of sculpture—the statue of Abraham Lincoln which now stands in the rotunda of the Capitol in Washington, D.C. The honest realism of this early work, which was executed from models she made of the president from life, contrasts with her later work in the traditional neoclassical style (see Figs. 8, 9). The softness of form and delicately carved detail of these later sculptures provide an interesting comparison to the greater

Fig. 11. *Vinnie Ream,* by George Caleb Bingham (1811-1879), c. 1876. Oil on canvas, 40 by 30 inches. Bingham also painted the sitter in her studio, when he showed her pausing while modeling a bust of Lincoln. That portrait is in the collection of the State Historical Society of Missouri.

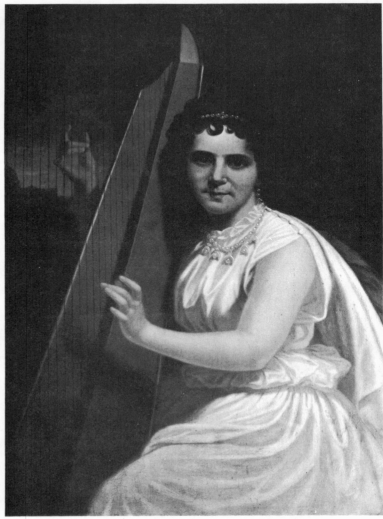

Pl. VI. *Bad Axe Battleground,* by Samuel Marsden Brookes (1816-1892) and Thomas H. Stevenson, 1856. Oil on canvas, 26½ by 36 inches. The painting depicts the site near the Bad Axe River of a battle in the so-called Black Hawk War of 1832. Brookes emigrated from England to Chicago and developed his style independently in the Midwest. Very little is known of Stevenson's life after he left Wisconsin in 1858.

Pl. VII. *Morgan L. Martin,* (1805-1887), by Brookes and Stevenson, 1856-1857. Oil on canvas, 44 by 34 inches. Martin was important in the development of the Fox-Wisconsin River valley. He commissioned the artists to paint a series of landscapes showing improvements for which he was responsible. He chose to have himself depicted in a landscape with one of his company's locks in the background.

Fig. 12. *Vinnie Ream,* by Clark Mills (1810-1883), c. 1867. Painted plaster, height 14¾ inches. The Society owns an old photograph of the classical bust for which this plaster was a preparatory study.

Pl. VIII. *Delaware Valley*, by Homer Dodge Martin (1836-1897), 1860-1870. Oil on canvas, 11½ by 17½ inches.

robustness and deeper carving evident in *Zenobia*, by Vinnie Ream's contemporary William Wetmore Story (Fig. 10). Vinnie Ream's success as a sculptor was based on her talent, but certainly her captivating personality did much to make her the popular woman that she was. She knew many of her fellow artists as friends and was several times the subject of their work. George Caleb Bingham painted her twice; the version in the Society (Fig. 11) is an intimate portrayal, emphasizing that music was her greatest interest next to sculpture. Clark Mills, who is remembered almost exclusively for his equestrian bronze of Andrew Jackson in Washington, D.C., used Vinnie Ream as a model for a now-lost classical bust. The preliminary plaster life study he made of her is a superb example of this artist's rare work (Fig. 12).

In building its collection of nineteenth-century American paintings and sculpture, the State Historical Society of Wisconsin has benefited from the foresight and talent of many people, from the dreams of Lyman Draper to the tokens of esteem bestowed on Vinnie Ream by her artist admirers. Wisconsin is extremely fortunate to have had many first-rate artists interpret and record its history and people in the last century. It is both the artistic quality and the regional historical relevance of the collection which are its outstanding features.

[1] Sully to Draper, April 1854, archives, State Historical Society of Wisconsin.
[2] George Catlin, *The North American Indians* (Edinburgh, 1926), vol. 1, p. 3.

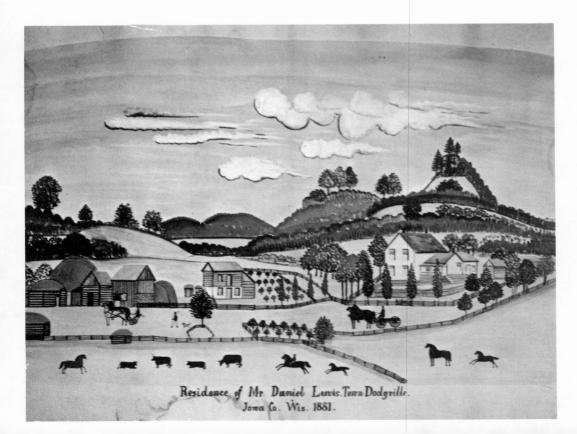

Pl. IX. *Residence of Mr. Daniel Lewis*, by Paul Seifert (1840-1921), 1881. Watercolor, tempera, and oil on cardboard, 16 by 20 inches. Seifert was a German immigrant who worked as an itinerant artist, painting large watercolor views of Wisconsin farms from the 1860's to about 1915. He sometimes received as much as $2.50 per painting.

II Trained Artists

Until recently, *The Magazine* ANTIQUES rarely published articles on nineteenth-century American portrait painters with academic training, with the exception of several articles on miniaturists. Perhaps this was because of the magazine's predominant interest in the decorative arts. (One of these early articles, Jean Lambert Brockway's "Unpublished Miniatures by Benjamin Trott," is included here.) Then, in the 1940's, the magazine began to publish the work of lesser known portrait painters, those with local rather than national reputations, and those whose work was less academic in style (*see* Section III: Folk Artists). It was not until 1955 that the magazine began to publish extensive articles on individual academic portrait painters.

The articles selected for this section are organized in chronological order of the artists' earliest works. They have been chosen to represent the wide geographical and visual variety characteristic of American academic portrait painting in the first half of the nineteenth century. As such, they demonstrate the variety of training and patronage available to artists, the various compositions chosen by different painters, and the circumstances which led patrons to have their portraits painted.

These artists are distinguishable from the folk artists discussed in the next section because they were trained to organize their portraits to emphasize the face of the sitter and subjugate the visual role of secondary objects. For some, like John James Audubon, Thomas Sully, and Rembrandt Peale, this education came from study with painters in London and Paris. For others, like Aaron Corwine, the training came from American artists who had in turn received their training in a European portrait painter's studio. Still others, like Albert Gallatin Hoit, were self-taught, learning by their observation of other portraits.

We can ascertain something of their approach to portraiture by reading the advice of the two leading American painters and teachers of the early nineteenth century, Thomas Sully and Gilbert Stuart. Sully's *Hints to Young Painters,* written in 1851, revised in 1871, and published in 1873 after Sully's death, summarizes his experience and his training in England. Gilbert Stuart's advice comes to us through the notes made by his pupil Matthew Harris Jouett when he studied with Stuart in Boston in 1816.

According to the English school of portraiture, the sitter's clothing, and decorative details such as curtains, furniture, or landscape backgrounds, were painted with less detail and less highlighting than the sitter's face, head, and hands. Jouett quoted Stuart on this subject, as saying: "Cry of the English school, Sink your drapery Stuart and bring out the flesh," which meant that highlights were to appear most strongly on the face and hands, not on the drapery or other secondary objects. Jouett also noted Stuart's advice about backgrounds:

> Backgrounds should contain whatever is necessary to illustrate the character of the person. The eye should see the application of the parts to the illustrate [sic] of the whole, but without separating or attracting the attention from the main point. . . Too

much parade in the background. . .very apt to fatigue by the constant shifting of the attention. . . .

The methods of artists in Paris, Dusseldorf, and Rome had similar aims, although the techniques were different. For some artists, like Rembrandt Peale and Emanuel Leutze, a more dramatic lighting effect gave their portraits a greater impact than that seen in the English style.

The articles included here represent some of the best research on nineteenth-century American portraiture. John Francis McDermott's "Likenesses by Audubon" (1955) and Jean Lambert Brockway's "Unpublished Miniatures by Benjamin Trott" (1931) reflect initial research on these artists' works. Trott's miniatures have since been catalogued by Theodore Bolton and Ruel P. Tolman in *The Art Quarterly,* VII (1944): 257–290. The subject of Audubon's portraits was more completely covered in 1965 in the exhibition *Audubon Watercolors and Drawings* at the Munson-Williams-Proctor Institute, Utica.

The articles on Albert Gallatin Hoit by Patricia L. Heard, Daniel Huntington by Agnes Gilchrist, Aaron Houghton Corwine by Edward H. Dwight, and three Tennessee painters by Budd H. Bishop are the major sources of information about these artists. John Mahey's "Lithographs by Rembrandt Peale" and Barbara S. Groseclose's "Emanuel Leutze: Portraitist" are both the results of extensive research on these artists. (The former article's cover illustration of Peale's lithograph of George Washington, made in 1825, has not been republished here.) Dr. Groseclose's work on Leutze has been published in her exhibition catalogue compiled for the National Collection of Fine Arts, *Emanuel Leutze, 1816–1868: Freedom Is Only King* (1976). John Mahey has published additional research on Rembrandt Peale in his article on "The Studio of Rembrandt Peale," in the *American Art Journal,* I, no. 2 (1969).

With Thomas Sully, as with other major American nineteenth-century portrait painters, we discover that William E. Steadman's "The Sully Portraits at West Point" is one of few articles to treat a group of Sully's portraits. Sully's work, although always included in surveys of nineteenth-century American painting, has not been accorded a major exhibition or catalogue since the 1920's. Edward Biddle and Mantle Fielding published *The Life and Works of Thomas Sully* in 1921, and Sully's work was exhibited at the Pennsylvania Academy of the Fine Arts the following year. In fact, since the publication of Lawrence Park's *Gilbert Stuart* in 1926, few major American nineteenth-century portrait painters have had their work properly catalogued. Notable exceptions are Harold E. Dickson's *John Wesley Jarvis, American Painter, 1780–1840* (New York, 1949), Barbara Groseclose's catalogue already mentioned, Rebecca J. Beal's *Jacob Eichholtz, 1776–1842; Portrait Painter of Pennsylvania* (Philadelphia, 1969), and Theodore Bolton and Irwin F. Cortelyou's *Ezra Ames of Albany* (New York, 1955).

New England miniatures

BY BARBARA N. PARKER

This article is based on an exhibition and catalogue, *New England Miniatures,* sponsored by the National Society of the Colonial Dames of America in the Commonwealth of Massachusetts and held at the Museum of Fine Arts, Boston, in the spring of 1957. Mrs. Parker organized the exhibition and prepared the catalogue.

COLLECTING OBJECTS FROM THE PAST, things worthy of being preserved, is a rewarding experience in itself. Portrait miniatures—tiny likenesses done in a variety of media on ivory, card, wood, or metal—are particularly rewarding to collect; it is a pleasure to hold one in the hand and marvel at the technical skill which went into its making.

These little pictures were produced in considerable numbers, mostly in water color on ivory, before the invention of the photograph; the art was at its peak in America from about 1765 to 1840. The painter of miniatures took great pains and an incredible number of brush strokes to catch the likeness of a person in little; in the recent exhibition at the Museum of Fine Arts in Boston arrangements were made to show several of the miniatures through magnifying glasses, and the glasses had to be of fairly high power to allow the individual brush strokes to be seen. Often the artist required many sittings. John Singleton Copley (1738-1815) wrote to his half-brother, Henry Pelham (1749-1806), in 1771: "I saw a miniature the other Day of Governor Martin by Miers [Jeremiah Meyer] which cost 30 Guineas and I think it worth the Money. The Gover'r says he sat at least 50 times for it." (*Copley-Pelham Letters,* p. 128.)

The two techniques chiefly used by painters of miniatures were stippling and crosshatching, which were often dextrously combined to build up the paint surface. A flat wash of color would have obscured the ivory itself, and its translucence—retained by these methods—was an important factor in achieving natural flesh tones and

Self-portrait, by John Singleton Copley (1738-1815), enlarged to show technique; signed with the monogram *J.S.C.* and dated [176-]. *Collection of Mrs. Henry Copley Greene.*

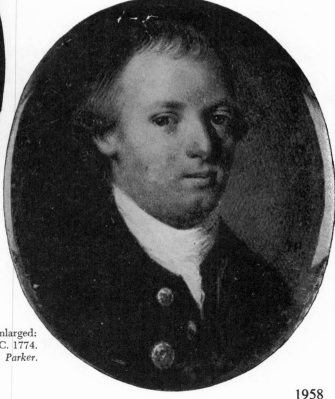

Adam Babcock, by Henry Pelham (1749-1806), enlarged: initialed *H.P. C.* 1774.
Collection of Mrs. Jefferson D. Parker.

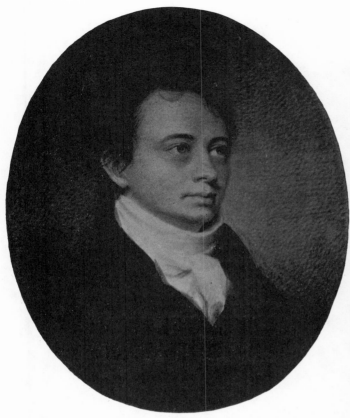

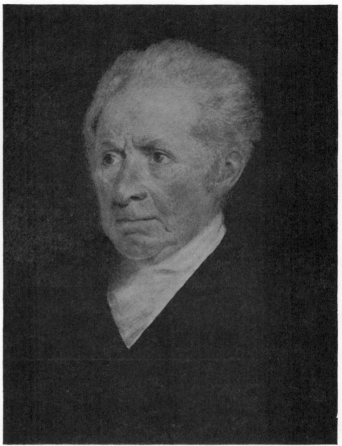

Washington Allston, by Edward Greene Malbone (1777-1807),
enlarged; signed *Malbone.* C. 1800. *Museum of Fine Arts, Boston.*

Gilbert Stuart, by Sarah Goodridge (1788-1853); enlarged. C. 1825.
Museum of Fine Arts.

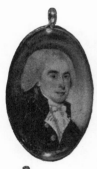

Charles Bulfinch,
by Joseph Dunkerley
(w. 1784-1787); c. 1787.
Museum of Fine Arts;
except as noted,
miniatures are shown actual size.

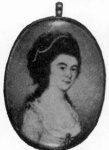

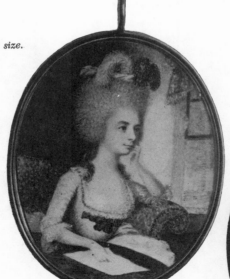

Mrs. Charles Bulfinch,
by Dunkerley; c. 1787.
Museum of Fine Arts.

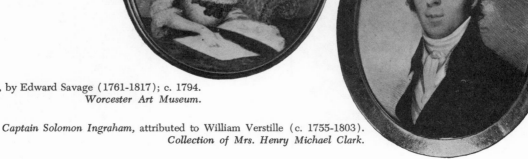

Mrs. Edward Savage, by Edward Savage (1761-1817); c. 1794.
Worcester Art Museum.

Captain Solomon Ingraham, attributed to William Verstille (c. 1755-1803).
Collection of Mrs. Henry Michael Clark.

49

effective highlights. Four miniatures are illustrated here in enlargement to demonstrate these techniques: Copley's *Self-portrait*, dating from the 1760's; Pelham's *Adam Babcock*, painted in the 1770's; *Washington Allston*, by Edward G. Malbone (1777-1807), about 1800; and *Gilbert Stuart*, by Stuart's pupil Sarah Goodridge (1788-1853), done about 1825.

The earliest dated and documented miniature portrait painted in New England is the Copley self-portrait, which bears his signature in monogram and the date 176- (the last figure has become obscured). The actual size of Copley's miniatures is illustrated by that of Samuel Cary, painted in Boston shortly before the Revolution, which also demonstrates Copley's extraordinary ability to give a three-dimensional quality to these little portraits. The gold case for this miniature has small loops at the top and bottom so that a ribbon can be attached to fasten it around the wrist.

In the eighteenth century goldsmiths collaborated with the painters by making such exquisite locket cases for the little likenesses, and these, too, are collectors' items. Kathryn C. Buhler of the decorative arts department of the Museum of Fine Arts has found direct evidence in the daybooks of Paul Revere that the silversmith made locket cases for Copley, though no specific case has been identified. The daybooks also show that Revere rented a house to Joseph Dunkerley (w.1784-1787), a Boston miniaturist of the late eighteenth century whose work has much charm. Dunkerley, represented here by his portraits of the famous Boston architect Charles Bulfinch and his wife, painted a small portrait of his landlord's wife, and in all probability the exquisite little gold locket case which frames it (miniature and frame are now

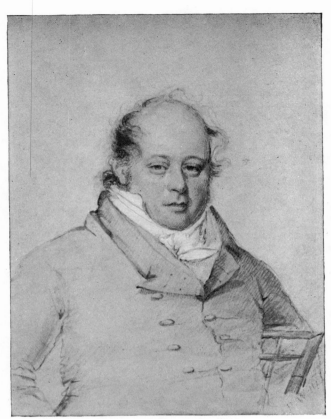

Unknown man, by Henry Williams (1787-1830);
signed *H. Williams.* C. 1816.
Museum of Fine Arts.

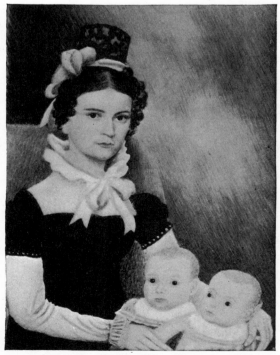

Mrs. Henry Somes Low, by unknown artist; c. 1823;
Collection of Mrs. William Potter Lage.

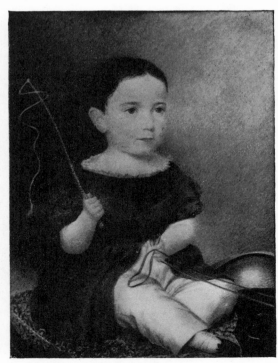

Stephen Salisbury III,
by Eliza Goodridge (1798-1882).

50

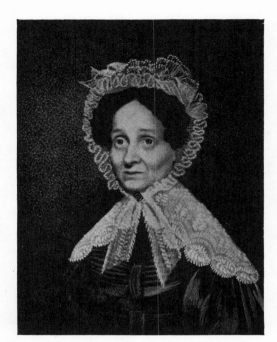

Mrs. James Page, by Caroline Negus (1814-1867); 1837. *Museum of Fine Arts.*

owned by the Museum of Fine Arts) was made by Revere. In the nineteenth century, perhaps because it was realized that miniatures fade if they are not protected from the sun, a new kind of case was made for them. It was of leather, with a cover, and miniatures were painted on a rectangle of ivory rather than an oval to fit these new cases.

The career of our most noted painter of miniatures, Edward Greene Malbone, was short, falling in the years between about 1795 and his early death in 1807. Malbone confined himself to portraits on oval pieces of ivory about three inches high by about two and a half inches wide; within that area and in that medium he understood his art superbly. His ability to use the luminosity of the ivory to enhance the flesh tones of his sitters is well illustrated by his portrait of a young girl reproduced here. The late Ruel P. Tolman, director of the National Collection of the Fine Arts in the Smithsonian Institution and an authority on Malbone, spent much time and effort in an attempt to identify the sitter of this miniature, who had been called "Annette" in the past; but she remains unknown. One of Malbone's most telling portraits is that of his close friend Washington Allston, with whom he traveled to England in 1800.

Another fellow-artist friend of Malbone was Charles Fraser (1782-1860) of Charleston, South Carolina. It was he who wrote Malbone's epitaph: "Cut off in the Meridian of his Life and Reputation while travelling for the benefit of his health. Seldom do the records of Mortality boast the name of a victim more preeminently excellent. His death has deprived his country of an ornament which ages may not replace, and left a blank in the catalogue of American Genius which nobody has a tendency to supply . . ." Fraser traveled north occasionally and took likenesses of New Englanders, but it was in Charleston that he painted the delightfully romantic and sensitive portrait of Alvan Fisher shown here; Fisher, a

New England painter, was visiting in that city in 1819. Samuel F. B. Morse (1791-1872) records the occasion in a letter dated February 4, 1819: "I am exerting my utmost to improve . . . Mr. Frazer, Mr. Cogdell, Mr. Fisher, of Boston, and myself meet here of an evening to improve ourselves."

It is odd but true that several of our best portrait painters became famous not because of their portraits but for their mechanical inventions. Morse is, of course, one, and Robert Fulton (1765-1815) is another. Fulton's miniature of Mrs. Oliver Hazard Perry, painted about 1811, indicates that he had a sensitivity perhaps surprising in one who is remembered chiefly as an engineer.

By far the most prolific and one of the most charming painters of miniatures in the Boston area during the period from about 1820 to 1845 was Sarah Goodridge (the name is also spelled Goodrich). Her portrait of Mrs. Abel Lawrence Peirson shows her work at its best. Miss Goodridge was introduced to Gilbert Stuart early in her career and made many fine miniatures copied from his larger portraits. Her likeness of Stuart himself is one of her best. Stuart's biographer George Mason remarks on it thus: "Stuart had two faces; one full of fire and energy, and the other dull and heavy, 'looking' as he said when he saw the miniature he had permitted a New York artist to paint—'like a fool.' He was unwilling to be handed down to posterity thus represented, and so he asked Miss Goodridge to paint him. When she had developed the head, she wished to do more to it, but he would not allow her, lest she injure the likeness."

Sarah's younger sister Eliza (1798-1882) also painted miniatures, though only a few have been identified as from her hand. These, however, have great charm, as is shown by the portrait of Stephen Salisbury III as a child (he was later to found the Worcester Art Museum).

It does not seem too rash to say that the art of miniature painting, as it was practiced before the advent of the photograph, is a lost one; no painter of today uses the infinite number of small brush strokes necessary to build up a likeness in little. It is in many instances impossible to identify the painters who did practice the difficult art, for they were as modest as they were skillful and seldom signed their work. All we can do in such a case is to be grateful to the unknown artist who worked with such patience to create the lovely object we admire today.

Color plate, facing page. Clockwise from upper left:

Samuel Cary, by Copley; c. 1772. *Collection of Edward Cunningham.*

Portrait by Malbone, c. 1800. Known as "Annette," the subject may be Mrs. Alexander Bleecker (see Ruel P. Tolman, *The Life and Works of Edward Greene Malbone,* p. 133). *Museum of Fine Arts, Boston.*

Alvan Fisher, by Charles Fraser (1782-1860); initialed *C. F.;* c. 1819. *Museum of Fine Arts.*

Mrs. Oliver Hazard Perry, by Robert Fulton (1765-1815); c. 1811. *Collection of James Jackson Storrow, Jr.*

Mrs. Abel Lawrence Peirson, by Sarah Goodridge; c. 1825. *Collection of Mrs. Harriet Ropes Cabot.*

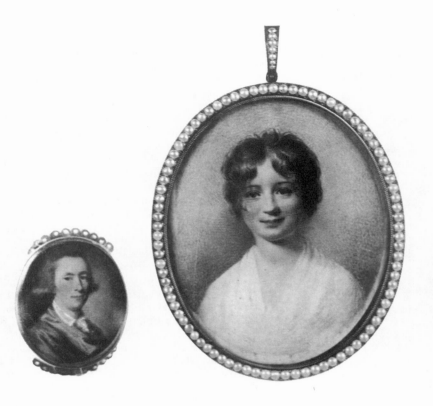

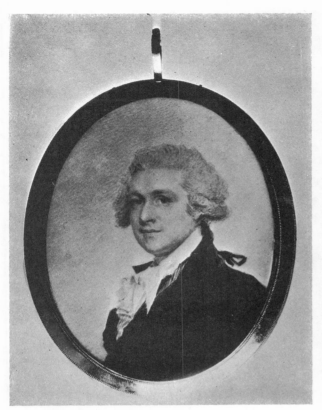

Fig. 1 — ALEXANDER JAMES DALLAS (*c. 1800*)
From the collection of Mrs. Campbell Madeira

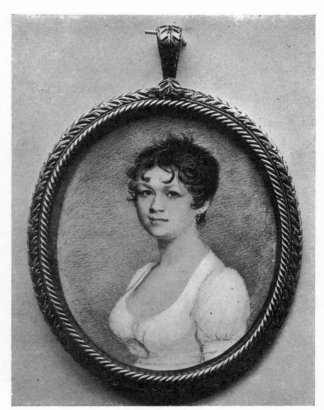

Fig. 2 — MRS. FOX OF SWEDESBORO, NEW JERSEY (*1805–1815*)
From the Metropolitan Museum of Art

Unpublished Miniatures by Benjamin Trott

By JEAN LAMBERT BROCKWAY

BENJAMIN TROTT was an American miniature painter of the early Republic. Born probably in Boston, about 1770, he was apparently self-taught. It was in New York that he began the professional practice of his art, though he subsequently lived in at least seven other cities, from Albany to Charleston. During a long career, lasting from about 1791 until 1841, Trott was highly praised for his likenesses, and enjoyed a reputation that not only brought him many desirable commissions, but won him the confidence of critics and fellow artists alike. Twice he shared a studio with Thomas Sully in Philadelphia; he was favored by Gilbert Stuart, and became a close friend of Elkanah Tisdale, with whom he was established in Albany.

But Trott's reputation from his own day to ours has dwindled, so that, at present, he is less known than he deserves to be. In 1927, the Metropolitan Museum's exhibition of American miniatures contained but eighteen of his portraits, very nearly all that were then known. This seems a small number in view of Trott's long career, and from the standpoint of quantity offers an inadequate foundation for reëstablishing the artist's early fame.

One reason for the scarcity of known Trott miniatures is discoverable in the artist's technique. He was indecisive in his style, tending now in one direction, now in another, so that his works are not easily identified by their individuality of treatment. As Dunlap gently points out, there were psychological and temperamental difficulties in the painter's personality, a lack of self-confidence, which prevented the development of an artistic consistency. His miniatures vary widely, both in conception and

in technique. Hence some of them have been attributed to other artists, particularly to Malbone. Three of the miniatures here considered had been thought to be Malbone's work previous to the 1929 Malbone exhibition held at the National Gallery of Art in Washington. This event permitted the careful study and comparison of many of Malbone's miniatures, with the result that several hitherto wrongly ascribed examples of Trott's work were restored to their rightful author.

In 1793 Trott followed, or accompanied, Gilbert Stuart to Philadelphia, where he was to make miniature copies of the master's larger portraits. The arrangement must have been agreeable to one who found it difficult to develop his own manner; furthermore, Trott was a skilled copyist. Dunlap notes that "his copies on ivory, with water colors, from Stuart's oil portraits, were good — one from the 'Washington,' extremely beautiful and true." The charming portrait of Alexander James Dallas, from the collection of Mrs. Campbell Madeira, is one of these copies (*Fig. 1*). It was probably painted in 1800; for that was the year in which Dallas sat to Stuart, and, at the time, Trott was Stuart's neighbor at the Falls of Schuylkill. The miniature is very fine, painted with great subtlety in the line technique, and displaying the characteristic economy of means which is one of the virtues of Trott's best work. The color is skilfully handled, a harmony of soft gray, black, and rose. Whereas Stuart's background is uniformly dark, Trott has employed his typical light background, the bare ivory showing through the easy strokes. Alexander Dallas, later Secretary of the Treasury

under Madison, was forty-one years old when his portrait was painted by Stuart, and repeated by Trott.

It is interesting to note that Trott was extremely envious of the coloring of Walter Robertson, who also painted in miniature after Stuart. The fact that Stuart preferred Trott's more natural coloring was not sufficient to sustain the latter's self-confidence or to keep him from attempting to imitate the brilliancy of Robertson. "I have seen," says Dunlap, "in his [Trott's] possession one of the Irishman's miniatures, half obliterated by the Yankee's experiments, who, to dive into the secret, made his way beneath the surface like a mole, and in equal darkness."

So much for Trott's copies of Stuart, of which at present but five are known: those of Mr. Dallas, Joseph Anthony, Joseph Anthony, Jr., Mrs. Greenleaf, and Washington. The last of these is known only through contemporary references.

A very fine portrait of George Simson (not illustrated), owned by J. S. Bradford and Miss F. M. Bradford, furnishes an excellent

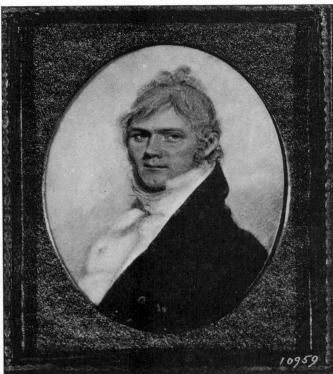

Fig. 3 — ABNER LEGRAND (c. 1819)
From the collection of Frank LeGrand Gilliss

example of Trott's style in the first few years of the century. The costume and technique suggest that the work was done between 1805 and 1810. The fine lines of color are applied with a free swing; few strokes are used; and the effect is so simple that the miniature looks unfinished as compared to one, say, by Robertson. But this is the sophisticated simplicity of mature art. The portrait is skilfully composed, possesses unity, and is decorative in design.

The charming miniature of Mrs. Fox of Swedesboro, New Jersey (Fig. 2), is an addition to the small group of portraits of women known to have been painted by Trott. It should probably be ascribed to some year between 1805 and 1815. The drawing is true, facile, and sympathetic, and the whole study masterly both in conception and in technique.

About 1819 Trott painted the attractive likeness of Abner LeGrand, now owned by the latter's grandson, Frank Le-Grand Gilliss (Fig. 3). The lifelikeness of the pose and expression, the subordination of details in painting hair and costume

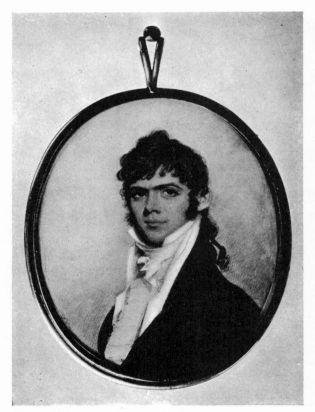

Fig. 4 — UNIDENTIFIED PORTRAIT (c. 1819)
From the collection of Mrs. Thomas B. Gannett

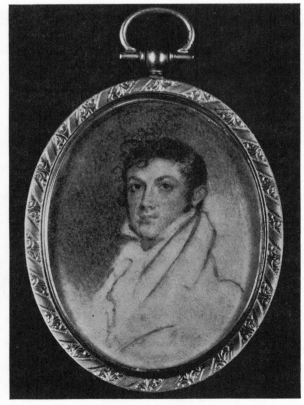

Fig. 5 — YOUNG MAN OF THE BEIDERMANN FAMILY
From the collection of Albert Rosenthal

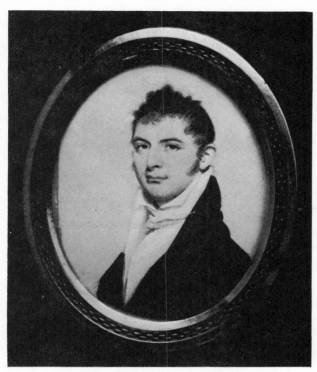

Fig. 6 — UNIDENTIFIED YOUNG MAN (*c. 1820–1825*)
From the collection of Albert Rosenthal

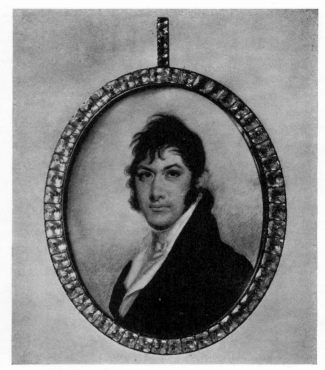

Fig. 7 — UNIDENTIFIED MAN
From the collection of Mrs. T. E. Jansen

make this an eminently satisfactory portrait. The technique and lighting are similar to those of the George Simson miniature, and the freedom is typical of Trott's strongest work. The firm, expressive drawing, the almost bare ivory background, the simplicity and directness of conception are all in the very best style of the American school and bear witness to Trott's skill and taste.

The handsome portrait of an unidentified young man, owned by Mrs. Thomas B. Gannett, painted about the same time as the Abner LeGrand, also has freedom of style but of a different sort (*Fig. 4*). The face is executed in stipple instead of line, in a somewhat slapdash manner peculiar to Trott. The hair is indicated with easy strokes finished with fine, diagonal, right-and-left lines. The fresh, rather vivid color in face and hair is set off by a light, transparent background. The result is an intensely vivid and vital portrait, a brilliant illustration of the skill of an artist who could gain his effects by simple means. Trott's tendency to elongate the line of the neck, exaggerating stiff high collar and stock — a peculiarity in drawing found elsewhere in his studies of men — is observable in this miniature. That the subject is Washington Allston, the American artist, as has been surmised, seems unlikely; for Allston would have been forty-one years old in 1820, and this subject appears to be a young man of between twenty-five and thirty. Comparison with other portraits of Allston of the time fails to reveal points of resemblance.

A Young Man of the Beidermann Family, belonging to Albert Rosenthal, is to be credited to the same period of Trott's career (*Fig. 5*). The few strokes used in the costume suggest rather than describe, and give the portrait the appearance of an unfinished sketch. A similar treatment occurs in the artist's miniature of Edward Johnson Coale and also in that of Nicholas Biddle.

The *Portrait of a Young Man*, another Trott owned by Mr. Rosenthal (*Fig. 6*), perhaps lacks the dash and freedom of the miniature just described, but it is more subtly painted and exquisitely detailed and finished. The smart contrast between white vest and black coat, an attractive color scheme, a conscious use of design, render this miniature brilliant and somewhat more decorative than the other examples here shown. It was, no doubt, painted between 1820 and 1825.

The monogram P.M.C.L. appears on the back of the Trott miniature owned by Mrs. T. E. Jansen (*Fig. 7*), painted probably almost contemporaneously with the *Portrait of a Young Man*. Yet the two are by no means similar. In the face painting of the older man a light wash is overlaid with stipple, which, however, is badly managed and does not suggest the texture of skin. Both because of the weak drawing — note the curious position of the ear — and the lack of subtlety in the stroke, this portrait suffers by comparison with stronger paintings such as that of Abner LeGrand. Perhaps, in this instance, Trott's loss of technical reserve and nicety was due to his absorption in the personality of his subject. With all its faults, this handsome yet malign countenance, at once romantic and cynical, idealistic yet sensual, is an amazing piece of characterization — and it has the virtue of fine color.

It is apparent from these newly discovered miniatures that Trott used a variety of methods in his brushwork and was erratic in the character of his drawing. He did, however, cling more or less consistently to his own style of background, lighting, and color. His work usually possesses dash and freedom, a pleasing directness of approach. He was an artist who could paint in miniature without becoming finicky. He could make a few strokes do the work of many, and could, with a limited medium, create an art combining fine quality with masculine vigor.

As a group, these works, while they add to our knowledge of Trott's *œuvre*, suggest that much more is yet to be learned both as to the man's personal biography and as to his artistic achievements. A loan exhibition would doubtless bring forth hitherto hidden miniatures, and might thus do much to reëstablish an able and delightful painter to a place among his peers.

Likeness by Audubon

BY JOHN FRANCIS McDERMOTT

OF EARLY NINETEENTH-CENTURY itinerant portraitists John James Audubon, though one of the most skillful and prolific, has remained one of the least known. He began in desperation and he abandoned portraiture at the first opportunity to devote himself to the *Birds of America,* but for half a dozen years or more his chalk sketches bought his bread and butter.

Audubon has said that his first portrait was the rather primitive profile of his friend James Berthoud shown here; doubtless Mme. Berthoud sat at the same time as her husband. Berthoud died in August 1819, so this first attempt was made before that date. Flat and literal as these profiles are, they did suggest to the artist a way in which he might earn his living at this time when his enterprises had failed and his capital was exhausted.

In Louisville Audubon drew some portraits gratis to introduce himself in his new capacity, and in the course of a few weeks he had, at five dollars a head, as much work as he "could possibly wish." The improvement which came with practice is evident in the more skillfully modeled sketch of Nicholas Berthoud, son of James, almost certainly done in Louisville in 1819, and in a portrait of Benjamin Page done in that year and now in the collection of a descendant in Morristown, New Jersey. The best of the Louisville work is the charming and effec-

tively lighted black chalk profile of old Henri de Gallon made in November of that year.

When he had taken "all the likenesses Louisville could afford" Audubon moved on to Cincinnati. There he did not have to depend on his portraits: "Through Talents in stuffing Fishes" he entered the service of the Western Museum at a hundred and twenty-five dollars a month. Part of his time was now spent as drawing master to a class of twenty-five, but he still had time for portraiture. He seems to have done a number of pencil sketches of local notables for the museum. Two of these have survived. One is believed to be of Aaron Corwine, the Cincinnati portraitist who is the subject of Edward H. Dwight's article in this issue; the other depicts the once famous (or notorious) John Cleves Symmes. Symmes is portrayed with a faraway look in his eyes as he thinks, doubtless, about his fascinating theory that the earth is a set of concentric spheres open at the poles. On the back Audubon wrote: *John Cleeves Simms, the Man with the hole at the Pole, drawn and a good likeness it is by John J. Audubon, Cincinnati, August, 1820.*

Other extant work for the stay in Cincinnati includes the dignified chalk portraits of General and Mrs. William Lytle, which show Audubon in full command of his chosen medium; and the pencil sketches of Robert Best

Mr. and Mrs. James Berthoud, by John James Audubon (1785-1851); c. 1818. *Speed Art Museum, Louisville.*

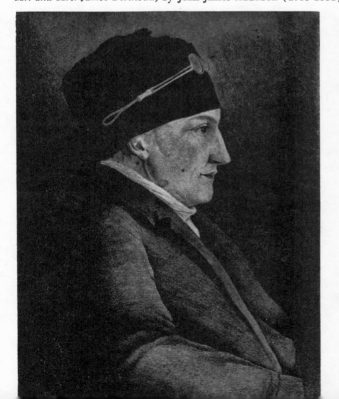 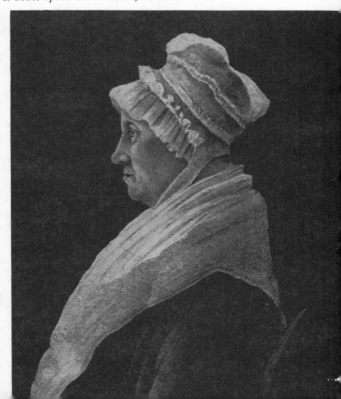

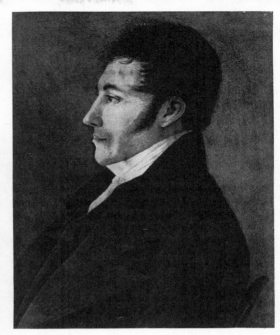

Nicholas Berthoud, son of Mr. and Mrs. James Berthoud, by Audubon; signed on the back *John James Audubon/fecit September 1819 Shippingport Ky. Speed Art Museum.*

Henri de Gallon, by Audubon; November 1819. *New-York Historical Society.*

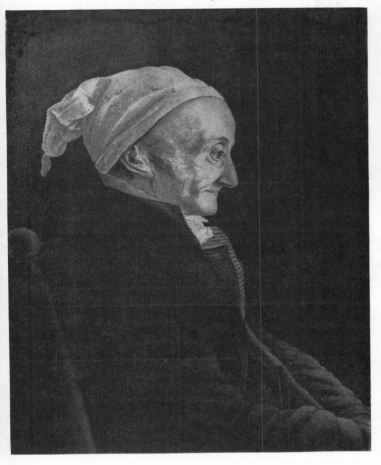

(fellow worker and later curator of the Western Museum) and his wife Sarah, now in the Karolik collection of American drawings at the Museum of Fine Arts in Boston.

His work as a taxidermist finished, the flow of commissions dropping off, Audubon became restless once more. He determined to explore the South for specimens for his collection of American bird portraits, and on October 12, 1820, he left Cincinnati in a flatboat. On the way to Natchez he sketched birds, but "having Not one Cent when I Landed here I imediatly Looked for something to do in the Likeness Way for our Support (unfortunately Naturalists are Obliged to eat and have some sort of Garb)." Two commissions at five dollars each were "fine sauce to our stomacks." One was immediately paid for; the other, "a very excellent resemblance of Mr *Mathewson* probably never will be, for that Gentleman absented himself the same Evening and never Left orders to any body to pay."

He must now do heads to keep from starving, and his journal is filled with details of typical itinerant experiences. He sketched a shoemaker and his wife in return for two new pairs of boots. Dickerson, master of the flatboat on which he continued his journey, paid him in gold for a portrait. At New Orleans one day he made a likeness "for a Lady's Sadle, a thing I had not the Leass use for, but the Man I had Made a portrait for, Wanted his Wife's Very Much and Could not Spare Money, and Not to disapoint him I sufered Myself to be Sadled." On another occasion he met with "one of those slight discouraging Incidents connected with the life of the artist": he had a likeness "Spoken of in very rude terms by the fair Lady it was made for." Late one night he was called out to a "Dying Neighbour's house . . . but arrived rather late for Mr James O'Connor was dead. . . . I had the displeasure of Keeping his body's Company the remainder of the Night . . . peace to his Soul I made a very good sketch of his head."

More normal was his meeting with Mr. Pamar, who, on hearing that the artist wanted twenty-five dollars for drawing a face, said he had three daughters and "you may put them all on one piece." Audubon boldly replied that he must then have a hundred dollars; eventually he had the satisfaction of portraying the three girls separately, and Mrs. Pamar as well.

He was now well established in New Orleans: between January 19 and 27 he did eight portraits at twenty-five and one at twenty dollars. He was weary of body these days but "in good Spirits having plenty to do at good Prices and my Work much admired." Much of his time was spent sketching birds and giving drawing lessons, but Audubon nevertheless completed fifty portraits "of all sorts" by October 25 of that year. Three special subjects may be mentioned to show his versatility. One was a sketch of the head of Vanderlyn's *Ariadne*, made from an engraving, for which he was paid fifty dollars. Another was a water-color portrait (full length?) of Father Antonio Sedalla, a well-known priest of New Orleans. The third was a full-length reclining nude. Accosted one day on the street by a heavily veiled woman, Audubon agreed to do her likeness at her house. On arriving there he was received by a beautiful young lady who asked him to draw "the whole of her form naked." When she had dressed again she asked him "a thousand questions about his family, residence, Birds, way of traveling, of living, &c." He did not rush this picture to completion: for ten days he had "the pleasure of this beautiful

woman's company one hour naked and two talking on different subjects."

In October 1923 Audubon returned to Louisville, and the following spring, in an attempt to find a publisher for his ornithological work, he went to Philadelphia. There, and later in New York, he did at least occasional portrait sketches. He visited Niagara ("a view satisfied me that Niagara never had been and never will be painted"), traveled overland from Erie through Meadville to Pittsburgh. Whenever money was low he managed to find sitters. Soon he rejoined his family in the South, and presently his wife's savings and his own success in a "dancing speculation" made possible a trip to England in 1826 to hunt for subscribers to the *Birds of America*. There he did some portrait sketching to please friends, and as late as 1843 he drew Alexander Culbertson and his Indian wife at Fort Union on the Missouri. But his days as an itinerant closed with his departure for England.

No mention has been made here of Audubon's work in oils. The scarcity of authenticated canvases makes that a study requiring separate treatment. But of portrait sketches in black chalk, pencil, ink, or water color he must have drawn several hundred between 1819 and 1826. Louisville, Cincinnati, Meadville, Natchez, the parishes of Louisiana, and New Orleans ought to yield many a specimen—and Audubon's work is so strongly characteristic in these mediums that it is easily authenticated even when not signed. Enough have already been found to show that in the development of the ornithological artist a genuine talent for human portraiture was lost. The deft assurance of his crayon in portraying the Lytles, the charming delicacy of his Henri de Gallon, make us glad that for a few years this sensitive artist gave much of his time to sketching his fellow man.

Note. The author would welcome information about other portraits known or suspected to be by Audubon.

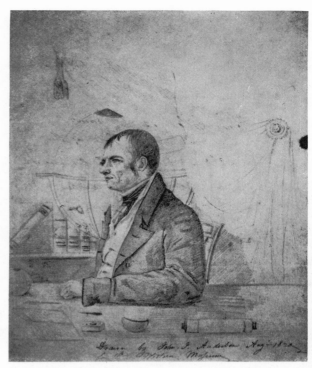

John Cleves Symmes, by Audubon; August 1820. This portrait drawn for the Western Museum is particularly interesting for its background detail; almost all of Audubon's known portraits show half-length figures against a dark ground. *New-York Historical Society.*

General and Mrs. William Lytle, by Audubon; 1820. *Photograph by courtesy of Virginius C. Hall.*

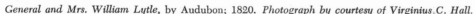

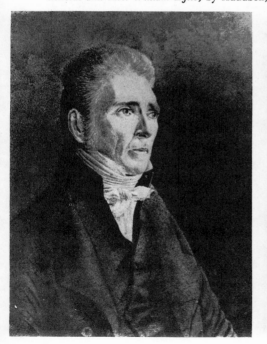

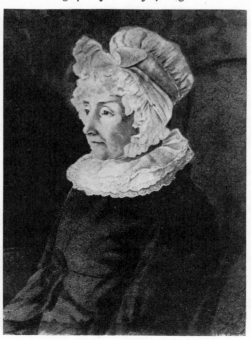

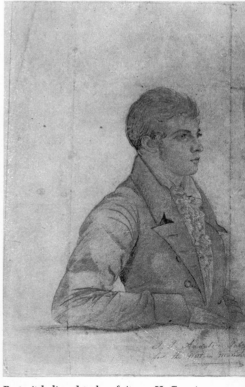

Portrait believed to be of Aaron H. Corwine, drawn by Audubon for the Western Museum; July 1820.
Collection of Mrs. Samuel B. McPheeters.

Aaron Houghton Corwine:

BY EDWARD H. DWIGHT

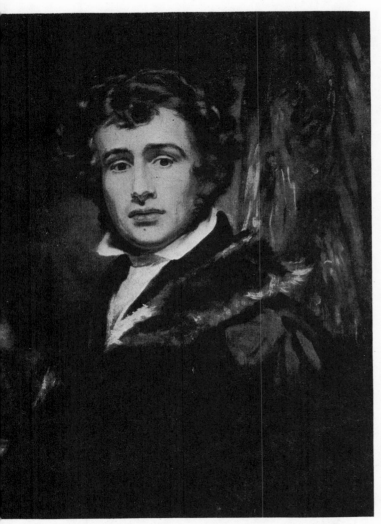

Self-portrait by Aaron Houghton Corwine (1802-1830); oil on canvas, 30 by 25 inches. Painted in London the year before the artist's death, this pensive, somewhat quizzical self-portrait shows the influence of Lawrence and other English portraitists. *Maysville and Mason County Public Library, Maysville, Kentucky.*

• When I began research on the artist whose work is illustrated here I did not know the location of one of his paintings; aside from a brief reference in Dunlap, I found no mention of him in any book on American art; the last article about him was published in Cincinnati exactly one hundred years ago. Yet in his day he was known as a genius, and I think consideration of his surviving portraits justifies the judgment of his contemporaries.

IT WAS JULY 1818 when Aaron Houghton Corwine took leave of his parents and traveled downstream from Maysville, Kentucky, near his birthplace, to Cincinnati, where for a decade he was to be considered the finest portrait painter. His parents, Amos and Sarah Corwine, had migrated from New Jersey to Mason County, Kentucky, in 1788. Amos was a farmer and of the six children Sarah bore him, Aaron was the youngest. Aaron helped with the farm work and amused his brothers with grotesque drawings of men and animals scratched on the barn and fences. Pleased to learn that the cartoons were the work of his youngest child, Amos encouraged him, educated him as much as he was able, and placed him with J. W. Turner, a self-taught itinerant. After Aaron had learned all he could from Turner, his teacher advised that he go to Cincinnati.

When Corwine arrived in Cincinnati that summer in 1818 he was not yet sixteen. He knew no one in this town of ten thousand, he had never been away from home, his means were modest, he had seen no more than six paintings and had painted only a few portraits. He brought with him a letter of introduction to Dr. Daniel Drake, an energetic man of many interests whose book *Diseases of the Interior Valley of North America* is a medical classic. A few weeks after his arrival in the largest city in the West, the *Cincinnati Inquisitor* urged support of this "literally self-taught, ingenious and promising youth." Dr. Drake and his friends were so struck by the talent of the young Kentuckian that they paid in advance for their portraits so he might go on to study with Thomas Sully in Philadelphia.

Sully's account of the young aspirant appears in William Dunlap's *History of the Arts of Design in the United States.* Corwine began his studies late in 1818 and showed great talent, but he was indolent—perhaps because his health was not good. He had a "painting room" in the frame shop of one Mr. Earl, and he spent a good deal of time studying the pictures that were brought there for framing. "He was gentle," Sully wrote, "and full of kind sympathy and delicate taste—he was candid and guileless." When Corwine returned to Cincinnati he discharged his obligations and began a career as Cincinnati's first resident portrait painter. The authors of *Cincinnati in 1826* boasted that he had but one rival in the entire western country (probably Matthew Harris Jouett).

During his ten years in Cincinnati, Corwine painted its leading citizens: Daniel Drake, Nicholas Longworth, Nathan Guilford, William Greene, Levi James, John H. James, and many others. In 1825 Captain John Cleves Symmes, whose portrait by Audubon illustrates John F. McDermott's article on that artist in this issue, told a

Cincinnati artist

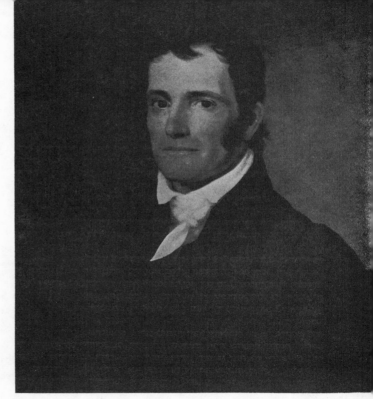

Dr. Samuel P. Hildreth, by Corwine;
oil on canvas, 27 by 22 inches; 1823.
Collection of B. H. Putnam.

friend: "Mr. Corwine is taking my likeness . . ." This portrait has recently been located and is recorded, with several other Corwines (or Corwaines), by Anna Wells Rutledge in her recently published exhibition record of the Pennsylvania Academy. When Andrew Jackson visited the city in 1825, Corwine took his likeness; and later that year he made a portrait of the famous visitor Lafayette. In 1828 many of his paintings were included in an exhibition assembled by Frederick Eckstein, who was attempting to raise funds for the first art academy in Cincinnati. (This venture is described by the redoubtable Mrs. Trollope, as is the Western Museum—"that of Mr. Dorfeuille.")

In 1829 Corwine wrote Sully for advice on where he should study art in Europe, and Sully replied that if he wished to advance as a portraitist he should go to England—advice Corwine followed, though he wanted to visit Italy as well to fit himself for other kinds of painting.

There was another, more immediate, reason for this trip. Corwine had tuberculosis, and it was hoped that the voyage might be beneficial. He left for England early in 1829, but from the time of his arrival tragedy seemed inevitable. The funds he entrusted to a London merchant were lost by "mismanagement." During the summer his condition improved, but overwork brought on fainting spells; and the next winter he became so much worse that he was forced to return—to Philadelphia, where he stayed with cousins. Oddly foreshadowing better-known art patrons of the twentieth century, these good Samaritans were two maiden ladies named Cone. Corwine died at their home on Independence Day, 1830. He was twenty-seven. In Cincinnati many mourned his passing, and a long obituary paid tribute to this genius who had died so full of promise.

Corwine's success as a portraitist is due to several factors. He arrived in Cincinnati when the town was just beginning to develop in wealth and in intellectual and cultural institutions, and leading citizens warmly accepted the young man and praised his ability to get a perfect likeness and to capture an expression of vitality. His work, like his character, is candid and guileless, modest and unobtrusive. It has none of the cleverness of Sully's portraits—is closer, in fact, to the more direct work of Charles Willson Peale. But these influences are of minor importance. Actually, like Chester Harding, Jouett, and many others of his contemporaries, Corwine was virtually self-taught. Americans were proud that these artists were self-reliant; they were proud, too, of their own individuality, and they wanted straightforward, unflinching likenesses. In giving them what they wanted Corwine produced some of the most vigorous and forthright portraits of the period.

Mrs. Nicholas Longworth, attributed to Corwine;
oil on paper mounted on canvas, 27¾ by 22¼ inches.
Collection of Mrs. Nelson E. Perin.

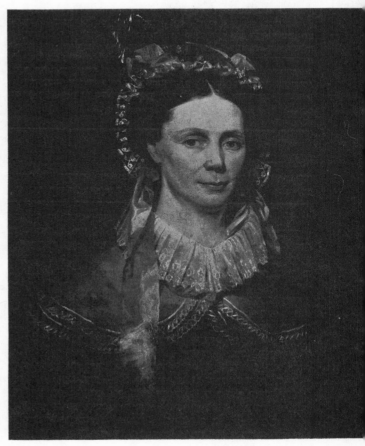

60

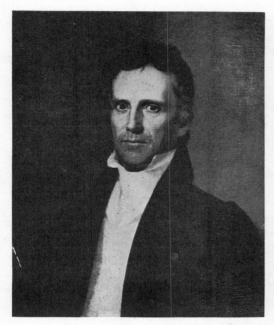
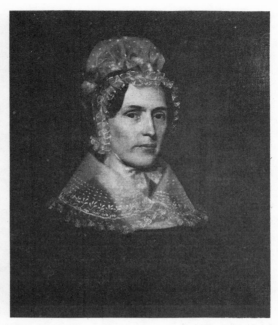

Mr. and Mrs. Levi James, by Corwine; oil on canvas, each 26 by 22 inches;
c. 1825. *Collection of Hamilton D. James.*

John Hough James, son of Mr. and Mrs. Levi James, by Corwine;
water color on paper, 3¼ by 2¼ inches; c. 1823.
Collection of Margaret L. James.

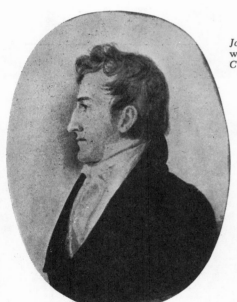

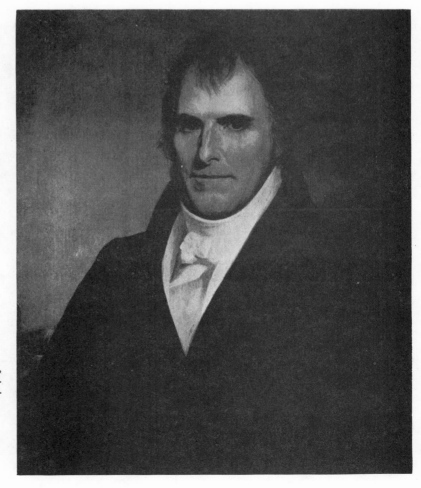

Zaccheus Biggs, by Corwine; oil on canvas,
27½ by 24 inches; 1826.
Collection of Frances F. Biggs.

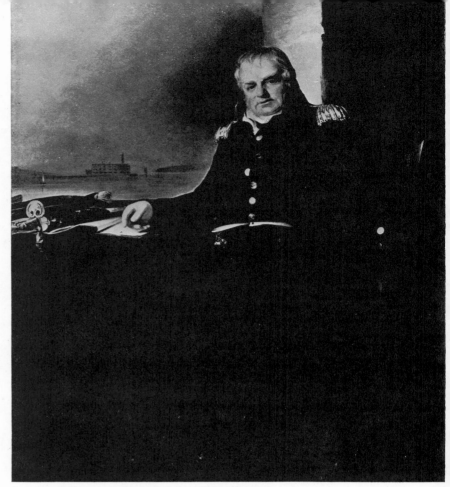

The Sully portraits at West Point

Jonathan Williams, by Thomas Sully (1783-1872).

Thomas Jefferson.

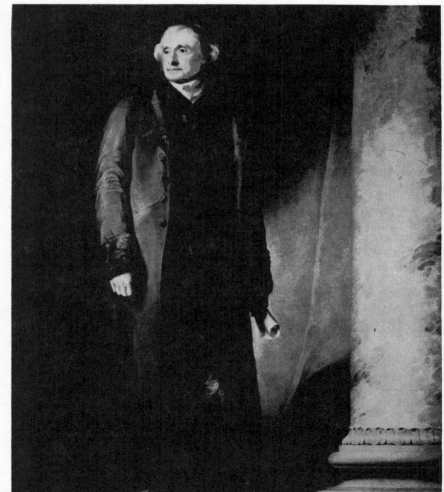

1955

WITH THE ESTABLISHMENT of the Military Academy at West Point in 1802 as the principal post and school for the United States Corps of Engineers, its officers and professors began to collect portraits of distinguished persons connected with the school. Today the West Point collection is significant not only because of the people depicted, but for its artistic quality as well. It includes works by such artists as Gilbert Stuart, John Wesley Jarvis, and J. P. Healy, as well as the eleven little-known portraits by Thomas Sully illustrated here.

Ten of these Sully portraits were done on order for the Military Academy and have remained there, except for a few occasions; the eleventh was given to West Point some time after the subject's death and has only recently been identified. All are documented by original letters and other papers in the manuscript collection of the West Point library.

It has been said that Sully's portraits of men lack virility. Certainly the first painting he did for the Academy, which also portrayed its first superintendent, does not bear out this criticism. The portrait of Jonathan Williams, majestic in concept as well as in size (54 inches by 94), has dominated the Academy library since its erection; here Sully has portrayed a man of great physical, as well as moral, strength. Williams was the grandnephew of Benjamin Franklin and an officer well qualified to head the newly established Academy—a likely man for President Jefferson to choose for the post. The painting was begun in February 1815 and finished in May of that year. Governor's Island in New York harbor appears in the background, and the circular fort, Castle William, built under Williams' supervision, is clearly visible.

One of the outstanding portraits at the Academy is the full length of Thomas Jefferson, painted in 1822, four years before the President's death. It shows the statesman in complete command of his many years. This is the largest Sully canvas, measuring 103 by 67 inches. The pillar and drapery in the background reflect the influence of the theater on the artist. In *The Life and Works of Thomas Sully* Edward Biddle and Mantle Fielding record that a small full-length study of Jefferson in identical pose and costume was done in 1822, and that the large canvas for the Military Academy was finished on May 7 of that year. The latter was painted from studies done at Monticello in 1821. The American Philosophical Society in Philadelphia has a head-and-shoulders portrait in the same pose and costume, also by Sully.

A letter to Jefferson from Jared Mansfield of the Academy indicates how arrangements were made to add important portraits to the West Point collection:

West Point, N. Y.
January 26, 1821

SIR:

The Superintendent, Officers, Professors, Instructors, and Cadets of the U.S. Military Academy impressed with a high sense of the great services you have rendered the nation, and this institution, with which they are connected, originated under your patronage, and presidence, are anxious for some special, and appropriate memorial of your person which may descend to posterity. They have already in the Academic Library the portraits of the great Washington, The Founder of the Republic and Col. Williams the first chief of the Mil. Academy, and they wish to add yours to the number, as being alike, of the Founders, and Patrons of both.

Presuming on your goodness, they have already engaged one of the best portrait painters of our Country (Mr. Sully of Philadelphia to wait on you for that purpose,) whenever it may suit your convenience.

May I request, Sir, that you would gratify us by sitting to him for your picture, and that you would signify to me, as acting in behalf of my Colleagues the time when Mr. Sully may be permitted to attend you for that purpose.

I am with most profound respect,
Your obedt & devoted Humble Serv't
JARED MANSFIELD
Professor at Mil. Academy.

From an artistic and psychological point of view the most interesting portrait in the series is that of this same Jared Mansfield, Yale graduate of the Class of 1777, who entered the army as a captain of the engineers in 1802, advanced to lieutenant colonel in 1808, and from 1812 to 1828 was professor of natural and experimental philosophy at the Academy. With a few strokes of the brush Sully captured the beloved professor and revealed him as a great human being.

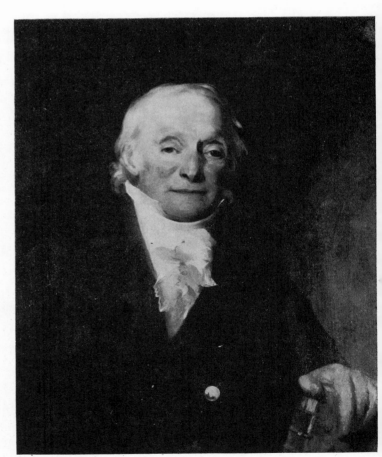

Jared Mansfield, by Sully.

Walter Keith Armistead.

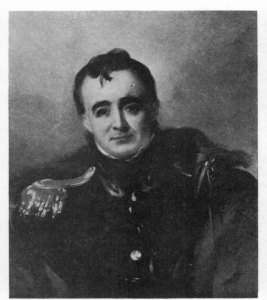

Joseph Gardner Swift.

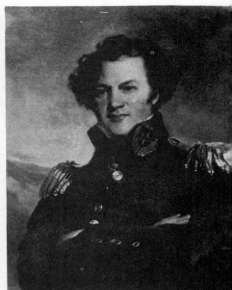

Alexander Macomb.

In 1829 Sully painted four notable portraits for the Academy, those of General Walter Keith Armistead, chief of engineers during the War of 1812 and inspector at the Academy, 1818-1821; Colonel Joseph Gardner Swift, the first graduate of the Academy and inspector in 1818; General Alexander Macomb, who was in command of land operations at the Battle of Plattsburg; and Captain Thomas Jefferson Leslie, paymaster of the Corps of Engineers and treasurer of the Academy.

Correspondence between Sully and Lieutenant-Colonel Sylvanus Thayer, superintendent of the Academy, reveals that the artist was commissioned in 1830 to do a portrait of General Charles Gratiot, inspector from 1829 to 1838. Gratiot had graduated from West Point in 1806 and had served with distinction in the War of 1812. He became chief engineer of Harrison's army in 1813-1814, when he was brevetted colonel. He was engaged in the defense of Fort Meigs in 1813, and in the attack on Fort Mackinac in 1814. In 1815 he was appointed major of engineers, and in 1828 he was brevetted brigadier general.

Sully's portrait of James Monroe shows the President in dark coat, knee breeches, and white silk stockings—his inaugural attire of 1832. This painting provides one of the earliest depictions of the Phi Beta Kappa key: Monroe's is clearly visible, hanging from his vest.

A three-quarter-length portrait of Colonel John James Abert, chief of the Corps of Topographical Engineers, is the last Sully painting commissioned by West Point. In this one painting the artist seems to fail in composition and in technical dexterity.

Last year West Point's Sully collection was increased from ten to eleven with the identification and attribution to this artist of a portrait of Major George Blaney, adjutant at West Point during 1820-1821 and 1822-1824. In a storeroom filled with paintings the brilliant draftsmanship and high color of this portrait fought its way through layers of dust and cracked varnish. Years of handling had left noticeable marks, but Sully's technique was still apparent. A check of old records revealed that he Blaney portrait had been given to the Academy by

Miss Frances Vaughn Elliott, a daughter of Major-General Washington Lafayette Elliott, because of Major Blaney's connection with the Academy. Miss Elliott had owned two Sully portraits; besides the Blaney, she had had one of Lydia Sheurer Biddle, whose daughter Major Blaney had married. The portrait of Lydia Biddle had been sold to Edward Biddle, Mrs. Biddle's great-great-grandchild and a collector of and authority on Sully's paintings. Recent correspondence with Miss Elliott's

Charles Gratiot.

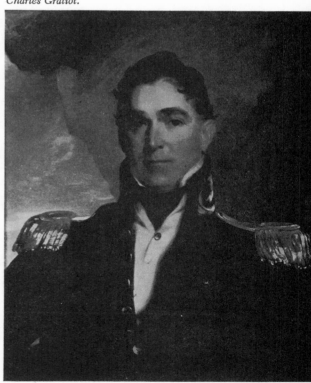

64

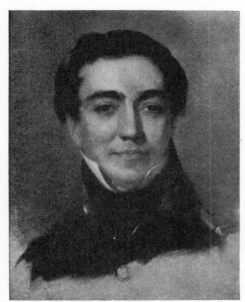

Thomas Jefferson Leslie.

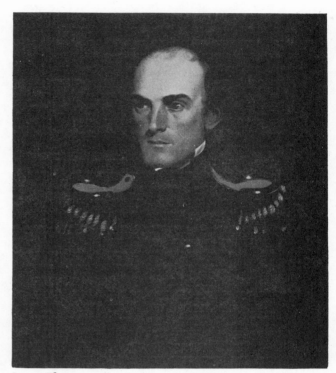

relatives has confirmed the identification and attribution.

Sully was a great painter and a prolific one—more than twenty-six hundred canvases bear his signature. The West Point collection of his works is particularly valuable because of his power of characterization, his immense sympathy with people, and his understanding of human types. His portraits of these distinguished men provide a lesson in history and a continual inspiration to the potential defenders of our country.

George Blaney.

James Monroe.

John James Albert.

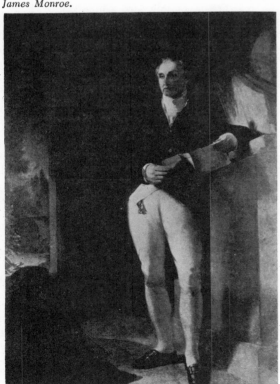

Lithographs by Rembrandt Peale

BY JOHN A. MAHEY, *Director, E. B. Crocker Art Gallery, Sacramento*

AMONG AMERICA'S pioneer lithographers, William and John Pendleton occupy a position of prime importance. And among American artists who supplied designs for the Pendletons, Rembrandt Peale (1778-1860) was responsible for a body of work which, in quality if not in magnitude, set a level of excellence rarely equaled throughout the remainder of the nineteenth century.

Alois Senefelder (1771-1834), the German inventor of lithography, wrote an account of his life and his invention in 1817. For a number of years before his book appeared in English, European lithographs had been available in America, but the technique was not well enough understood to allow the development of the art here. Then, in 1819, there occurred a series of events which led quickly to the establishment of an American school of lithographers. First came the English translation of Senefelder's book, published in London by R. Ackermann as *A Complete Course of Lithography* and made available in America almost at once. Next there was the production by the American artist Bass Otis (1784-1861) of what is generally conceded to be the first American lithograph, a small landscape. This was followed later in the same year by a long article in the *Analectic Magazine* describing the lithographic process in detail and reproducing the Otis lithograph. For the first time technical data on lithography was readily available to American printers.

It is difficult to estimate the influence of Senefelder's book and of the *Analectic Magazine* article, but shortly after their publication a number of professional lithographers began appearing in cities along the eastern seaboard: in 1821-1822 the firm of Barnet & Doolittle is listed in New York; in 1823, Henry Stone in Washington; in 1824, Chañou & Desobry in New York; in 1824-1825, Peter Maverick in New York; and in 1825, William and John Pendleton in Boston.

Of these first-generation American lithographers, William and John Pendleton established and maintained a particularly high standard of excellence. In addition, their various establishments in Boston and New York between 1825 and 1836 employed the best artists of the day and served as a training ground for younger lithographers such as John W. A. Scott (1815-1907), Benjamin F. Nutting (d. 1887), and Nathaniel Currier (1813-1888)—men who continued to develop the art and who were directly responsible for some of the finest prints of the century.

Not a great deal is known about the Pendletons' early years. William S. (1795-1879) and John B. (1798-1866) were born in New York City of English parents. Evidently their interests centered about the fine and mechanical arts, for as early as 1816 they were assisting the Peales to install gas lighting in the Philadelphia and Baltimore museums operated by that family. Later their names appear occasionally in Rembrandt Peale's correspondence, and in 1820 they were chosen by him to manage the traveling exhibition of his large allegorical painting *The Court of Death,* now in the Detroit Institute of Arts. There is a possibility that Peale made a print of this painting. If so, it would date from about 1827, and almost certainly would have been published by Pendleton of Boston. The well-known chromolithograph of *The Court of Death,* published by Sarony, Major & Knapp in 1859, may be based upon such a Pendleton print.

Sometime between 1824 and 1826 William Pendleton was associated with the engraver Abel Bowen, and about

No. 1. Lord Byron (first version), by Rembrandt Peale (1778-1860), 1825.

1824 John was working for the bookseller John Doggett. In late 1824 or early 1825 Doggett sent John to Europe as his agent. Details of that journey are obscure, but we know that John returned in 1825, bringing with him a quantity of lithographic stone, ink, crayons, and transfer paper; he also brought back two European printers schooled in lithography. Almost immediately thereafter the Pendletons established themselves as lithographers in Boston, and Rembrandt Peale produced his first lithograph.

Rembrandt Peale is an enigmatic figure in American art. He is known primarily for his "porthole" portraits of George Washington (see cover and No. 5) and recently for his much-publicized life portrait of Thomas Jefferson, which has entered the White House collection. His original portrait of Washington—the "Senatorial portrait"—was painted by Peale in 1823 and subsequently sold to the government. From 1823 until his death he produced nearly eighty smaller replicas of the painting, which are now scattered in public and private collections throughout the country.

Peale painted many finer things than the *Washington*. He was a highly talented, prolific artist who produced, over a working life span of some sixty-five years, upwards of a thousand portraits, plus landscapes, genre paintings, historical and allegorical pictures, copies of European masters, some drawings of high quality, and the lithographs with which this article is concerned.

Apart from his artistic endeavors, Peale was at one time or another a museum proprietor, a naturalist and mechanic, an amateur poet, a founder and promoter of the American gaslight industry, an officer and member of the American Academy of Fine Arts, and a founder of the National Academy of Design. He was also an ardent traveler who made five trips to Europe between 1802 and 1832, an author of some skill and perception—his *Notes on Italy* (Philadelphia, 1832) is a delightfully urbane, highly informative travel book—a teacher of drawing and penmanship in the Philadelphia public schools, and a lecturer who, in emphasizing the cult of Washington in order to sell paintings, probably did more than anyone else in the long run to damage his own artistic reputation.

Of his first experiments with lithography, Peale later wrote to William Dunlap:

I was among the first of the artists who employed this admirable method of multiplying original drawings. My first attempt in New York, was a head of Lord Byron, and a female head from a work of Titian. In 1826, I went to Boston, and devoted myself for some time to lithographic studies, and executed a number of portraits and other subjects, and finally, a large drawing from my portrait of Washington, for which I obtained the silver medal from the Franklin Institute at Philadelphia, in 1827.

On March 13, 1827, Rubens Peale, latter-day proprietor of the Baltimore museum founded by his brother Rembrandt in 1814, placed an advertisement in the *Baltimore American* announcing the closing of the live rhinoceros exhibition and offering for sale

LITHOGRAPHIC PRINTS—received from Pendleton's Lithographic Establishment, Boston, for sale, a collection of highly finished Lithographics, among which are characteristic portraits of Lord Byron, and Mrs. Hannah More, Picturesque Views of the Residences of Scott and Byron, No. 1 of Lithographic Sketches, and Jefferson's Rock of Harper's Ferry—all those from drawings by Rembrandt Peale, Esq., together with a choice collection of French prints, selected in Paris by a gentleman of Taste.

History has left no record of how successfully these prints sold in Baltimore or elsewhere. It is clear, however,

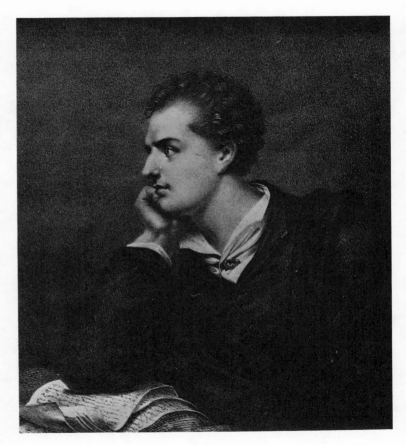

No. 2. *Lord Byron* (second version), 1825.

that Peale felt some encouragement as a result of his initial experiments, for he continued producing designs for Pendleton until 1828, when he undertook an extended tour of Europe.

In the early nineteenth century, before enactment of stringent copyright laws, American printers freely pirated and plagiarized to their own advantage. The Pendletons, and the artists who designed for them, were no exception. Indeed, among the Peale lithographs only three or four can be considered original designs. The 1827 *Washington* (No. 5) is clearly by Peale and has the added distinction of having been drawn directly on the stone by the artist. The same can be said of both the 1832-1833 *Washington* and those of 1856 (Nos. 22, 23, 24). The prototype for all these was the large oil Senatorial portrait of 1823. Peale's statement to Dunlap, remarking upon the advantages of

No. 3. *Residence of Lord Byron/ Newstead Abbey,* 1826.

No. 4. *Residence of Sir Walter Scott/ Abbotsford,* c. 1826.

lithography as a means of "multiplying original drawings," gives us the key to his attitude toward the technique. He looked upon lithography as a method of reproduction, only incidentally as a creative medium in its own right. The one Peale lithograph which may be considered a design created expressly as such is *Jeffersons' Rock* (No. 7). It is based upon an original drawing (now unlocated) which was possibly executed some years earlier and was not used by the artist for a work in any other medium.

The question of prototypes for some other prints is more difficult. Sometimes Peale tells us his source; just as often he does not. The portraits after Stuart and after his own works are clearly identified in the legends, but prints based upon European paintings, such as the portraits of Lord Byron and of Hannah More (Nos. 1, 2, 8), fail to mention the artists from whose originals or prints Peale derived his designs. Several artists represented in *No. 1 of Lithographic Sketches, Memoranda of Form and Character* (Nos. 9-16) are identified; others are not. Such a cavalier attitude toward pirating was normal in 1825, but it creates difficulties for the cataloguer today.

When Harry T. Peters published his monumental work *America on Stone* (Garden City, 1931), he wrote that the book probably would never have been undertaken had it not been for his appreciation and admiration of the Pendletons' contributions to American lithography. He defined their importance as pioneers in the field and held them up as exemplars against whose work that of other American

lithographers must be judged. His estimate of Rembrandt Peale was equally trenchant, and he considered the large vignette head of Washington (1832-1833) "Perhaps . . . the greatest American lithograph."

Unfortunately, the present-day collector of American prints will find it difficult to acquire Rembrandt Peale lithographs. Except for the two 1856 portraits of Washington (Nos. 23, 24), all are rare. I know of only two complete sets of the *No. 1 of Lithographic Sketches,* three copies of the vignette head of Washington, six copies of the 1827 *Washington,* two of *Jeffersons' Rock*—and only one copy each of *Newstead Abbey, Abbotsford,* and the first version of Lord Byron's portrait.

All but three of the known Peale lithographs were produced between 1825 and 1833 and published by the various Pendleton establishments in Boston and New York. These exceptions are the 1856 oval portraits of Washington and a vignette bust portrait of Gideon N. Judd with the legend: *R. Peale, del. N. Currier's Lith.* engraved below (Nos. 23, 24, 25). This is the only evidence I have found that Peale produced work in collaboration with Currier.

Inasmuch as Peale kept no record of his work in this or any other medium, it is possible that works in addition to those named in the following check list may be discovered. I suspect, however, that if such prints do exist they will prove to be small book illustrations, probably portraits.

No. 1. Untitled lithograph of Lord Byron (1788-1824), first version, 1825; 10½ by 8½ inches. Peale stated that his first attempts in lithography were a head of Lord Byron and a female head after a work by Titian. No impression of the latter is known, but the Byron head exists in two versions. The design, not original with Peale, is based upon an 1813 life portrait by Richard Westall (1765-1836) now in the National Portrait Gallery in London. Peale's direct source was probably an engraving of that portrait, at least two of which were published in England prior to 1825. Although it bears no signature, this first version is firmly attributed to Rembrandt Peale on stylistic grounds. The print is the reverse of the Westall portrait, and it probably served as a preparatory design for Peale's second version. *American Antiquarian Society.*

No. 2. *Lord Byron,* second version, 1825; *R. Peale del. Litho. of Pendleton;* 11¾ by 9 inches. This version was printed in quantity and offered in the Baltimore museum advertisement of 1827. The composition is the reverse of the first version and corresponds to the Westall life portrait. Peale eliminated some background details and added a sheaf of manuscript beneath the poet's right elbow. The artist may not have been the first American to base a print upon the Westall portrait: a stipple engraving by David Edwin (1776-1841) appeared as the frontispiece to the *Analectic Magazine* for July 1814. It is a vignette bust portrait in full left profile very similar to the Westall head, but the poet's hand does not support his chin and the costumes differ. *American Antiquarian Society.*

No. 3. *Residence of Lord Byron/ Newstead Abbey,* 1826; *R. Peale del. Boston 1826. Lith. of Pendleton;* 7⅝ by 9½ inches. Peale had visited England in 1802 and may have seen Newstead Abbey, the Byron ancestral estate in Nottinghamshire, but it is unlikely that this is his own design. He was too much the faithful recorder of nature to have been responsible for all the architectural inaccuracies evidenced here. Peale's work therefore must have been based upon an unidentified contemporary print, one of the numerous romanticized illustrations employed to sustain the wildly popular Byronic cult during the early years of the nineteenth century. The lithograph is listed as one of the prints for sale in the Baltimore Peale museum advertisement of 1827. *American Antiquarian Society.*

No. 4. *Residence of Sir Walter Scott/ Abbotsford,* c. 1826; *R. Peale del. Lith. of Pendleton;* 7¾ by 9⅝ inches. Since Scott did not take up residence at Abbotsford, his estate near Melrose, until 1812, Peale would have had no reason to sketch the site during his early trip to the British Isles in 1802. Like No. 3, this lithograph is probably based upon an English engraving. It, too, is mentioned in the 1827 advertisement of the Baltimore museum. *American Antiquarian Society.*

No. 5 (see cover). *Washington (1732-1799),* 1827; *Drawn on Stone by Rembrandt Peale. Copyright secured 1827. Pendleton's Lithography, Boston./ From the Original Portrait Painted by Rembrandt Peale;* 24 by 17¾ inches. *Patriae Pater* is incorporated in the design, on a simulated stone tablet. This is Peale's most ambitious work in lithography, and one of the most handsome published in America during the nineteenth century. The design is taken from Peale's 1823 Senatorial portrait of Washington, popularly but incorrectly called the porthole portrait. All Rembrandt Peale portraits of Washington after 1823, except those which are clearly copies of works by other artists, are based upon this likeness. It was this print which Peale described to Dunlap as one of his initial experiments in lithography. The artist confused the matter by stating in later life that the stone was ruined by workmen after only a few impressions were taken, but he failed to clarify what he meant by "few." In his *America on Stone* (p. 309) Peters confused it with the large vignette head of Washington (No. 22) published in 1832 or 1833 by the Pendleton establishment at 9 Wall Street, New York City. Both are extremely well printed and equally rare. In 1827 Peale was awarded a

No. 7. *Jeffersons' Rock,* c. 1827.

Mʳˢ HANNAH MORE

A GREEK? NO.

Rembrandt Peale, del. *Pendleton's Lithography.*

WHAT a look of self-sufficiency and love of ease!—A scrutinizing eye—a nose that would snub at Cupid—and, for a pulpy lip, cherry-ripe, behold the receptacle of a quid, the measure of a whiff! Such a portrait might have dropped from the pencil of Knickerbocker.

silver medal by the Franklin Institute "For the best specimen of lithography, to be executed in the United States . . ." (*Franklin Institute Exhibitions*, 1825-1845, p. 403), and on July 20 of the same year he presented a copy of it to the American Philosophical Society. *Peale Museum.*

No. 6. Landscape with woman on a stone bridge; signed, lower right, *Peale;* 10¼ by 8¼ inches. There is no evidence of date or publisher, but this lithograph was probably printed by Pendleton in Boston before 1829. It is attributed to Rembrandt Peale on the basis of its style; the rendering of foliage, especially, is nearly identical to that in a number of his drawings. The source of the composition is uncertain, but I believe it is based upon a European picture. *American Antiquarian Society.*

No. 7. *Jeffersons' Rock,* c. 1827; *From Nature & on Stone by R. Peale Lith. of Pendleton-Boston/ On this spot the Magnificent Scenery of the Potomac and Shenandoah near Harpers' Ferry was described in the/ "Notes on Virginia";* 10³⁄₁₆ by 8½ inches. Peale's earliest depictions of scenery in the vicinity of Harper's Ferry are found in a sketchbook in the American Philosophical Society. His best-known view is the large landscape *Harper's Ferry* (1811) in the Walker Art Center, Minneapolis, of which there is also a small water-color sketch in the Peale Museum. *Jeffersons' Rock,* however, is quite unlike any of the other Peale views. Here the figure is scaled down in a manner which emphasizes the insignificance of man in relation to nature. It is surprising to find this attitude in Peale's work at so early a date, though it was to be fully developed by Thomas Cole, Asher B. Durand, and other American landscape painters as the century progressed. Peale's attraction to landscape was only sporadically expressed throughout his career, yet he always insisted to young artists that nature was the best teacher. While *Jeffersons' Rock* may be based upon a much earlier sketch, it can be considered one of Peale's few original lithographic compositions. It is mentioned in the Peale museum advertisement of 1827. *New York Public Library.*

No. 8. *Mrs. Hannah More* (1745-1833), c. 1827; *R. Peale del. Lith. of Pendleton-Boston;* 11¾ by 9¾ inches. Miss Hannah More (the "Mrs." of the title is incorrect) was an English writer on religion and a philanthropist whose works were widely known during her lifetime. She was an intimate of Dr. Johnson, the Garricks, Edmund Burke, and Joshua Reynolds. Bishop Porteus urged her to write *Village Politics* (1792) to counteract the subversive doctrines of Thomas Paine's *Rights of Man,* and a poem by the bishop himself provided the allegorical basis for Rembrandt Peale's great painting *The Court of Death.* This lithograph is based upon a painting by H. W. Pickersgill (1782-1875) executed in 1821, and it, too, was mentioned in the Baltimore museum advertisement of 1827. *American Antiquarian Society.*

Nos. 9-16. *No. 1 of Lithographic Sketches, Memoranda of Form and Character.* This small pamphlet in brown paper covers contains eight lithographs, each tipped in on a separate page. Below each lithograph is a caption in letterpress. The series—if a series was actually contemplated—is not known to have continued beyond this first number. It is doubtful that any of these compositions are original; in keeping with the common practice of the day Peale took liberties in adapting

JOHN WARREN M.D.

compositions of other artists for his own purposes. These lithographs were also mentioned in the Baltimore museum advertisement of 1827. All the prints were made c. 1827 and all are inscribed *Rembrandt Peale, del. Pendleton's Lithography*. The titles are *A Brown Study; The Pier Head; The Little Corporal; The Soldier's Birth-Right; A Greek? No; Anylayes Cherries; Gerard's Cupid; Damon.* Each measures 8¼ by 5¼ inches. *Henry Francis du Pont Winterthur Museum Library.*

No. 17. *John Warren M.D.* (1735-1815), 1828; *R. Peale del. & pinxt Pendletons Lith.*; 8¾ by 8 inches. Warren was a noted Boston surgeon who organized the Boston Medical Society and was the first professor of anatomy at the Harvard Medical School. The print, published in James Thacher's *American Medical Biography* (Boston, 1828), is based upon a life portrait done by Peale c. 1812. *American Antiquarian Society.*

No. 18. *Rev. John E. Abbot* (1793-1819), c. 1828; *R. Peale del. Lith. of Pendleton*; 7¾ by 9 inches. The occasion for this print is unknown. The absence of *pinxt.* following Peale's name implies that the design was not original. *American Antiquarian Society.*

No. 19. *Rev. John T. Kirkland D.D.L.L.D.* (1770-1840), c. 1828; *G. Stuart Pinxt. R. Peale del. Pendleton's Lithography;/ Published by W. & J. Pendleton, No. 1 Graphic Court, Boston;* 13⅜ by 9⅞ inches. Kirkland was a man of diverse interests and accomplishments who is best remembered today for his enlightened direction of Harvard College, where he served as president from 1810 to 1828. Peale's lithograph is based upon a life portrait painted in 1810 by Gilbert Stuart (1755-1828). *American Antiquarian Society.*

No. 20. The Reverend Horace Holley, L.L.D. (1781-1827), c. 1828; *G. Stuart pinxt. Pendletons Lithography, Boston. R.*

Peale del.; 11½ by 9½ inches. A noted Boston clergyman and educator, Holley served for some years as minister of the Hollins Street Unitarian Church in that city. *Museum of Fine Arts, Boston.*

No. 21. *Saml. Danforth M.D.* (1740-1827), 1828; *G. Stuart pinxt. R. Peale del./ Pendleton's Lithography;* 12¾ by 9⅝ inches. Peale's lithograph of this Boston physician and president of the Massachusetts Medical Society is based upon a portrait painted c. 1809 by Gilbert Stuart. Published in *American Medical Biography* by Thacher. *American Antiquarian Society.*

No. 22. *Washington*, 1832-1833; *Drawn on Stone by Rembrandt Peale. Lith. of Pendleton, 9 Wall St./ From the Original Portrait Painted by Rembrandt Peale./ Copy Right secured;* 21⅝ by 15¾ inches. Owing to the rarity of this print Peters (*America on Stone*, p. 309) identifies it as the Washington lithograph for which Rembrandt Peale received a silver medal from the Franklin Institute in 1827. Peters is in error: the vignette head carries the Pendleton New York address for the years 1832-1833, and the Franklin Institute citation of 1827 clearly states that the award was given for the lithograph ". . . printed at the press of Messrs. Pendleton of Boston . . ." Like the 1827 print (No. 5), the vignette is taken from Peale's 1823 Senatorial portrait of Washington. Here the nearly life-size head is on a larger scale, somewhat more slickly drawn, and given a higher finish. In quality the vignette portrait ranks with the 1827 porthole *Washington* and with *Jeffersons' Rock*

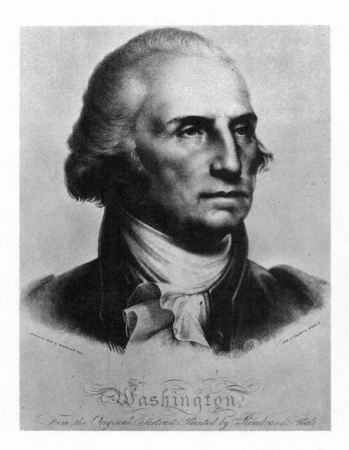

No. 23. *Washington* (first version), 1856.

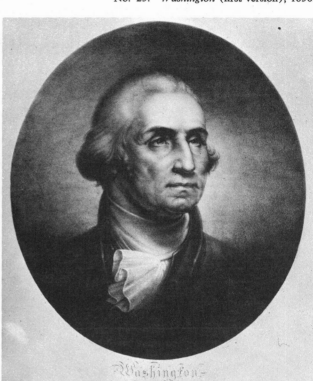

as among the finest of Peale's lithographic works. *Corcoran Gallery of Art.*

No. 23. *Washington, 1856; R. Peale. Duval & Co./ Drawn by Rembrandt Peale from his Original Portrait/ Copy Right secured, 1856;* 30 by 24½ inches. In 1856 Rembrandt Peale advertised in Philadelphia and elsewhere his last undertaking in lithography, an oval portrait of George Washington which, like his earlier versions, is based upon the 1823 Senatorial portrait. By the 1850's the artist had produced several score replicas in oil of this original portrait, and over the years certain details of Washington's head became altered and stylized. The arrangement of the hair grew more artful and complex, the ill-fitting false teeth had been made less conspicuous by the addition of a dimple beneath the lower lip. *Library of Congress.*

No. 24. George Washington, 1856; *Rembrandt Peale* [facsimile signature] *G. Washington* [facsimile signature] *P. J. Duval & Co. Phila.* etched on stone at bottom of oval; 30 by 24 inches. The details of Peale's relationship with Duval & Co. are not clear, but it appears that some difficulty arose over the publication or distribution of the first version of this lithograph (No. 23) and that, as a result, in the same year Peale produced another stone and registered the print in his own name. In the Philadelphia newspapers he placed the following notice: "The design for an Engraving from 'PEALE'S WASHINGTON'., as formerly announced by the author, not being realized according to his intention, all thought of it, for a time, was suspended. As the object could not be accomplished by confiding the task to another hand, he has been induced to undertake, to a limited extent, a more effective substitute—HEAD, FULL SIZE, finished in Crayon, on a Lithographic ground. These MONOCHROMES, by himself, from his original Portrait, he trusts will be favorably a-preciated."

It is not uncommon to find copies of this print with the *P. J. Duval & Co. Phila.* completely covered over with black crayon. Untrimmed copies carry the following inscription below the oval: *Entered according to Act of Congress in the year 1856 by Rembrandt Peale, in the Clerk's office of the District Court of The Eastern District of Pennsyla.* There is no reason to doubt that Peale drew the designs on the stones for both 1856 versions, and the first version was certainly printed by Duval. Inclusion of the Duval credit on both stones indicates, as well, that both were originally intended for or prepared for Duval by Peale. Peale's own copyright of the second stone implies, however, that he himself was the printer or that he had the printing done privately. If the printing was done by an unskilled hand, this would account for the fact that Peale felt it necessary to work over each copy with crayon. Peale continued to sell copies of the second version until his death in 1860, and a large number of unfinished copies were listed shortly thereafter in the inventory of his studio. *New York Public Library.*

No. 25. *Gideon N. Judd; R. Peale, del. N. Currier's Lith.;* 8 by 7 inches. *Your very sincere friend/ Gideon N. Judd* is written below in ink. This vignette bust portrait seems to be the only evidence of Peale's collaboration with Currier. *Smithsonian Institution, Harry T. Peters collection.*

Albert Gallatin Hoit (1809-1856)

BY PATRICIA L. HEARD

ALBERT GALLATIN HOIT painted many of the prosperous citizens of New England and the Maritime Provinces of Canada during his relatively short life, leaving a fascinating and well-executed record of his era.

He was born in Sandwich, New Hampshire, the son of Daniel and Sarah Flanders Hoit. Sandwich was an unlikely place to spawn an artist, for it was a New England frontier town, a stopping place on the way west. Little more than a crude settlement at the time of Hoit's birth in 1809, it had become one of the largest towns in the state by the time he died. Hoit's father was prominent in the town where, as storekeeper, he would have fulfilled the roles of banker, cattle trader, and developer. He was a thoroughly eighteenth-century character, always larger than his immediate surroundings; he held the title of general in the militia, represented his area in the statehouse in Concord, and held strong views about both politics and education. He saw to it that both his sons attended private academies and Dartmouth College, which Albert Gallatin Hoit entered in 1826 at the age of seventeen. It is clear from letters written by Hoit and members of his family that his enthusiasms at college did not extend to his studies, and that he got into a great deal of trouble, both through absences and neglect of his work. We do not know where Hoit received his initial training as an artist. By the time he reached Dartmouth, however, he was proficient enough to be able to give painting lessons at a nearby academy and to sell some prints he had made of the college. Until his graduation in 1829 he considered a teaching career and it was probably only his worsening relations with his father and his own mounting debts that drove him to make a career of what he could do most easily and most profitably. Shortly after his graduation he wrote to his sister that he had "an invincible repugnance to New Hampshire until I go independent of everyone."[1]

An example of Hoit's early work is his portrait of Susan Pierce Jarvis of Claremont, New Hampshire, painted in 1830 on the occasion of her marriage to Dr. Joseph Thornton Adams (Fig. 3). The inaccurate foreshortening of the arm and the concave torso betray Hoit's lack of experience in drawing from the nude—a deficiency that he never fully overcame. Despite its shortcomings it is a well-balanced portrait which more than hints at Hoit's ability to capture the personality of his sitters.

From 1833 to 1839 Hoit worked as an itinerant portrait painter in Maine and in the Maritime Provinces of Canada. His base was initially Portland, to which he returned at intervals throughout his six-year stay. In Maine he painted in Thomaston, Bangor, Belfast, and Howland, apparently receiving abundant orders wherever he went. At this period he practically never signed his work, so only a fraction of his output during these years has been identified. In 1835 he wrote to his mother from Bangor of his growing powers as a painter and of his satisfaction with his progress. He said that visiting artists from Boston (including Chester Harding) were much surprised to find such good work being done by one "without better means of study than I have had." He went on to say that his friends told him that if he were in Boston he would "rank next to the two first Portrait Painters in New England and first in miniatures."[2] His fine miniature of Pamelia Hill (Fig. 4), painted about 1838, bears out this claim. Its companion piece is a likeness of Hoit by Pamelia Hill.

By June 1836 Hoit had moved from Maine to Fredericton, New Brunswick, where he had his first real social and financial success. The region had been largely ignored by portrait painters, and it was in a period of growing prosperity and awakening identity. The shipbuilders on the Miramichi River and in St. John, and the leading people (or Family Compact as they were called) of both New Brunswick and Nova Scotia came to Hoit's studio. His many important commissions included all the judges of the supreme court of New Brunswick. The Honorable Ward Chipman (Fig. 5) was chief justice of the province when Hoit painted him in 1838. The portrait shows the artist's growing facility in the use of detail and a relatively ambitious pose.

Hoit, however, never cluttered his canvases with fussy details of dress or jewelry and his simplest portraits are often his best. A good example is his likeness of John Marston of Moultonborough, New Hampshire (Fig. 6). Because of the somber background and dark clothing, the eye is drawn to the face of the old man and is held there by its expression of strength and dignity. Although this is a sympathetic portrait of old age, Hoit has caught Marston's slightly quizzical expression, as though the sitter might have agreed with Chester Harding's grandfather that it was "very little better than swindling to charge forty dollars for one of those effigies."[3]

Despite his social and artistic success in Canada, Hoit's

Fig. 1. Self-portrait by Albert Gallatin Hoit (1809-1856). Oil on canvas, 30 by 25 inches. *Collection of Mrs. K. Dole; photograph by R. B. Hoit.*

Fig. 2. *Susan Hanson Hoit* (1814-1875), by Hoit, c. 1838. She was the artist's wife. Oil on canvas, 30 by 25 inches. *Dole collection; Hoit photograph.*

ultimate goals were to establish himself as an artist in Boston, and to take a trip to Europe. In October 1838 he married Susan Adams Hanson of North Conway, New Hampshire (Fig. 2), and in the fall of 1839 they moved to Boston.

In the spring of 1840 Hoit, armed with letters of recommendation from Daniel Webster (an old political friend of his father) set out for Cincinnati, Ohio, hoping to paint General William Henry Harrison, then Whig candidate for President. There he was fortunate enough to meet on the street another Dartmouth graduate, Salmon P. Chase, who was later secretary of the treasury under Lincoln. Chase was able to get Hoit an immediate introduction to Harrison. The resulting portrait (Fig. 7) is not only the most important but without doubt one of the best he ever did. It was the last portrait ever painted of Harrison, who died in office shortly thereafter.[4]

The spare austerity of the Harrison portrait contrasts markedly with those Hoit did on commission. The portrait of Amanda Fiske (Fig. 8), painted in October 1842, is a good example of this contrast. It is a painting of considerable charm and fine detail, and despite the faulty proportions (the head seems a little large for the body) Hoit has caught a genuinely childlike expression. He obviously found children a challenge because after 1848 when his

daughter Anna Maria was born, he painted his own children again and again. The portrait of his small son Albert Hanson Hoit (Fig. 9), done about 1855, shows how well he met this challenge.

In October 1842 Hoit sailed alone for Europe, where he remained until July 1844. This trip was the culmination of Hoit's ambitions, as it was for so many nineteenth-century American artists. In an era before great American private collections or museums these men must have had a great sense of artistic isolation.

Hoit arrived in England and traveled through France to Italy, where he spent two winters—the first in Florence, the second in Rome. In the spring of 1844 he returned to London by way of Switzerland, the Rhine, and Belgium. He took with him to Europe many commissions for copies of famous paintings to help defray his expenses, but few of these copies have been identified. We also have none of the landscapes he did on his travels, which is even more unfortunate. He was known to his contemporaries as a fine landscapist but evidently he signed practically none of those canvases, for very little of his landscape work is known.

Hoit's tour of Europe did not change his style to any marked extent, but it did improve the anatomical aspects of his work and perhaps added a dimension of richness to his use of color.

Fig. 3. *Susan Pierce Jarvis Adams* (1808-1878), by Hoit, 1830. In the background is Mt. Ascutney, Vermont, across the Connecticut River from Claremont, New Hampshire, where Mrs. Adams lived. The painting was made on the occasion of her wedding to Joseph Thornton Adams. Oil on canvas, 30 by 25 inches. *Fruitlands Museum.*

Fig. 4. *Pamelia Hill (1803-1860), by Hoit, c. 1838.* Oil on ivory, 3 by 2¾ inches. *Collection of Eleanor Hoit; Hoit photograph.*

Fig. 5. *The Honorable Ward Chipman, Chief Justice of New Brunswick,* by Hoit, 1838. Oil on canvas, 50 by 40 inches. *Photograph by courtesy of the government of the Province of New Brunswick.*

75

Fig. 6. *John Marston* (1757-1846), by Hoit, c. 1845.
Oil on canvas, 36 by 28 inches.
Collection of Mr. and Mrs. Marston Heard.

Fig. 7. *General William Henry Harrison* (1773-1841),
by Hoit, 1840.
This is the last known portrait of President Harrison.
Oil on canvas, 30 by 25 inches.
National Portrait Gallery.

Fig. 8. *Amanda Fiske,* by Hoit, 1842.
The subject was about five years old.
Oil on canvas, 38 by 31 inches.
Collection of Mrs. Otto E. Wolff.

On his return he and his wife settled in Boston, eventually building a house in Roxbury, and Hoit worked out of a studio on Summer Street. Despite the efforts he made to establish himself as an artist on the Boston scene, one has the feeling from letters written at this period that the competition was greater than he had imagined it would be. In 1848 he returned briefly to paint in the Maritimes, where presumably work was easier to find, but he fell seriously ill and was forced to return to Boston.

The same year he was commissioned to paint John Greenleaf Whittier (Fig. 10). An extremely fine example of his later work is the *Portrait of an Unknown Woman* (Fig. 11) of 1850. Here he has combined the growing skill of his later years with the facility he always had for depicting women's softer and more feminine qualities. Also in 1850 he traveled to Marshfield, Massachusetts, to paint Daniel Webster from life. He was later commissioned to paint a full-length portrait of Webster for the statehouse in Concord, New Hampshire, where that picture still hangs. During these Boston years Hoit exhibited annually at the Athenaeum, and in 1855 he received the hard-won permission to copy the Gilbert Stuart portrait of Washington there. This painting was first exhibited in 1856 at the Boston Mercantile Library Association.

Hoit was very much at home in the company of other artists and became the first president of the Boston Art Club. When he died on December 18, 1856, at his house in Roxbury his obituary in a New York monthly journal[5] called him "the best and truest of men . . . an artist who lived and died an honor to the profession." It can be added today that although he was seldom an innovator, he used his craftsmanship and skill to record his time with insight and understanding.

Fig. 9. *Albert Hanson Hoit* (1850-1902), by Hoit, c. 1855.
The artist's son.
Oil on canvas, 14 by 12 inches.
Hoit collection; Hoit photograph.

Fig. 10. *John Greenleaf Whittier* (1807-1892), by Hoit, 1848.
Oil on canvas, 30 by 25 inches.
Whittier Home Association, Amesbury, Massachusetts.

Fig. 11. *Portrait of an Unknown Woman.*
Signed and dated *A. G. Hoit 1850* on back.
Oil on canvas, 30 by 25 inches.
Private collection.

Fig. 12. *Still Life of Flowers.*
Signed twice: *A. G. Hoit. 1839* (bottom center)
and *A. G. Hoit. 1839 &. 1846* (lower left).
Oil on canvas, 17 by 13⅞ inches.
Collection of Mrs. Charles Goodrich Thompson.

[1] Albert Gallatin Hoit to his sister, Julia Maria Hoit,
 Rochester, October 17, 1830, from the collection of Hoit's letters
 in the Dartmouth College Library.

[2] Albert Gallatin Hoit to his mother, Sarah Flanders Hoit,
 Bangor, August 23, 1835, from the collection of Hoit's letters
 in the Dartmouth College Library.

[3] Chester Harding, *A Sketch of Chester Harding, Artist,
 Drawn By His Own Hand,* ed. Margaret White,
 annotations by W. P. G. Harding, New York, 1970, p. 31.

[4] For detailed information on the Harrison portrait
 see Monroe Fabian, ''A Portrait of William Henry Harrison,''
 Prologue: The Journal of the National Archives, winter 1969, p. 29.

[5] *The Crayon: A Journal Devoted to the Graphic Arts and the Literature
 Related to Them,* Vol. IV, p. 29.

Emanuel Leutze: portraitist

BY BARBARA S. GROSECLOSE

IN HIS DAY, Emanuel Gottlieb Leutze was one of America's best-known history painters, and he is still remembered as the artist of *Washington Crossing the Delaware*.[1] Portraiture, however, is another, less-publicized facet of Leutze's considerable talent. His early, awkward delineations of American ante-bellum society gave way to the later quiet, intimate, and assured depictions of family and friends in Düsseldorf. During the last decade of his life Leutze produced more portraits than at any other time during his career. His subjects then included the nation's leading legal, military, political, and literary figures. His development as a portrait painter offers an ironic counterpoint to the rise and fall of history painting in the United States. This increasing interest in portraiture is indicative not only of Leutze's popularity as a painter but of an accompanying decline of interest in commissioning historical subjects.

As an aspiring young painter in Philadelphia, Leutze obtained his first important commission in 1836. He was to take likenesses of famous people that would then be engraved and published in James Barton Longacre and James Herring's *The National Portrait Gallery of Distinguished Americans*. The project, however, collapsed the next year.[2] Leutze, who was a German immigrant, then followed in the footsteps of some of his American colleagues by becoming an itinerant portrait painter in Maryland and Virginia. In 1839 he was back in Philadelphia, where his former employer James Longacre hired him to paint a portrait of his wife, Eliza Stiles Longacre (Fig. 1).[3] The carefully modeled head and the thinly applied paint in tannish-pink tones are evidence of Leutze's early, rather cautious approach to figural representation. Although the treatment is stiff, the likeness suggests the artist's nascent talent for conveying warmth and elegance, traits which became the hallmarks of his mature portraiture. Longacre was not alone in his perception of Leutze's talent. In 1840 a group of Philadelphia merchants raised money to send Leutze abroad to study. His aim, inspired perhaps by his European heritage, was to become a history painter. Willingly he sacrificed a promising career as a portraitist to go to Düsseldorf.

Two pictures from Leutze's first years abroad reveal not only his increasing technical facility, but also that he did not forsake portraiture entirely. The first, a drawing of Juliane Lottner (Fig. 2), probably dates from the mid-1840's and clearly indicates the artist's new acquaintance with German art. The delicate line and meticulous detail suggest that Leutze originally was predisposed, in style at least, toward the painters of the Nazarene school within the Düsseldorf art community. In the other early picture, a painting done in 1846 of Juliane (whom he married in 1845), Leutze has created an integrated composition far removed from Nazarene simplicities (Fig. 3). The precise treatment of textures—the creamy pattern of the lace blouse, the nubby weave of the shawl—intensifies the elegant tilt of the head. Building his color scheme upon the bands of muted red, gold, and green in the shawl, Leutze used warm but subdued tones to evoke an over-all mood of intimacy.

His increased skill is not explicable solely in terms of formal training. Although he enrolled in the Düsseldorf Academy in 1841, Leutze established his own atelier a year later and thereafter worked independently of the academy's professors.[4] Moreover, the new dexterity apparent in the portrait of Leutze's wife was not immediately reflected in his history paintings. This fact, I think, indicates a particu-

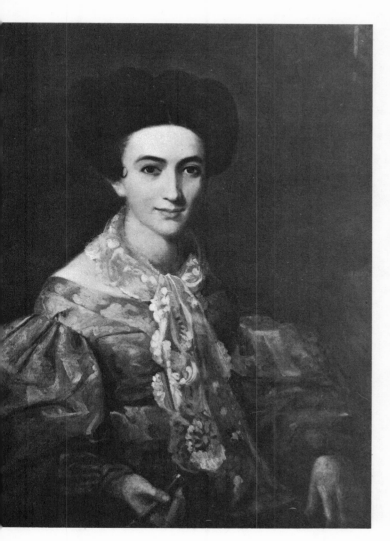

Fig. 1. *Eliza Stiles Longacre*, by Emanuel Leutze (1816-1868), c. 1839. Oil on canvas, 23 by 19 inches. *Collection of Andrew Longacre Jr.*

Fig. 2. *Juliane Lottner*, c. 1845.
Pencil. *Private collection.*

art market was also a weighty consideration, and it may explain the ensuing subordination of portraiture in Leutze's *oeuvre* to depictions of family and friends. With a peculiar but understandable inversion of logic, the American art public, in the organized form of the American Art Union and abetted by the popularity of the Düsseldorf Gallery in New York City,[8] was far more ready to confer recognition on history paintings by Americans living abroad than on similar works by resident artists. Without a focused cultural nationalism of its own in the visual arts, the American public in the first half of the nineteenth century longed to experience "high art" in the European tradition. Leutze's historical subjects appeared just as the enthusiasm for the Düsseldorf school crested, and the belief that art from abroad must be superior enhanced the reception of his paintings. The artist's success in America was, therefore, based upon his continued residence in Germany.

Fig. 3. *Juliane Lottner Leutze*, 1846.
Oil on canvas, 28 by 24 inches.
Staatsgalerie Stuttgart.

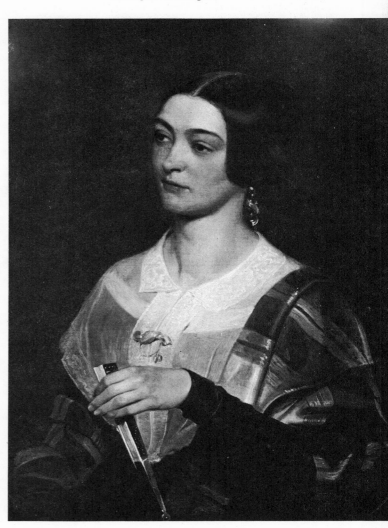

lar strength of Leutze's artistic personality: he painted best when his personal sympathies were closely engaged with the subject matter. In the nearly two decades Leutze spent in Düsseldorf, 1841 to 1859, his growing family, his in-laws, his political associates, and fellow artists such as Robert Schulze, Joseph Fay, and R. Ochs-Spenst, who shared his liberal political views, were enduring sources of inspiration.[5] Leutze also recorded on canvas or sketch pad the features of many of the American students who sought his assistance in Düsseldorf, among them Worthington Whittredge, Eastman Johnson, and William Morris Hunt. In his 1856 portrait of Whittredge (Fig. 4), perhaps his closest American colleague, Leutze combined a testimony of friendship with the Düsseldorf school's penchant for theatrics, harmoniously uniting the somewhat austere portrayal of Whittredge with the stark black and white costume.

Leutze apparently believed that he would be returning to the United States shortly, for he signed one of his earliest canvases from the Düsseldorf years *Emanuel Leutze/Philadelphia.*[6] Soon thereafter, however, he seems to have abandoned any thought of going home. "Here I am again in good, old Germany," he wrote a friend after a trip to Italy in 1845, "where I think I'll remain yet awhile."[7] Among his motivations for remaining abroad were his marriage to a German woman and his growing eminence within the Düsseldorf art community. But the American

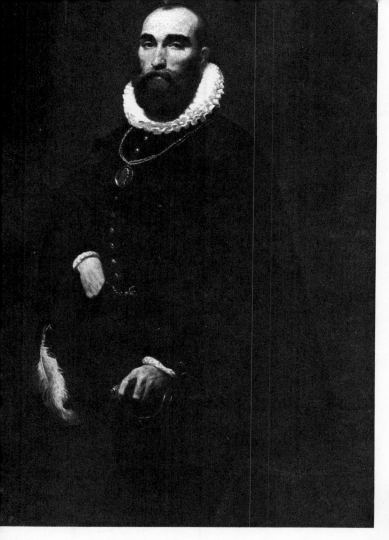

Fig. 4. *Worthington Whittredge*, 1856.
Oil on canvas, 57⅞ by 40½ inches.
Metropolitan Museum of Art.

Leutze's portraits attest to a happy and secure family situation. But as an ardent democrat and advocate of German unification, Leutze was disappointed by the failure of the 1848 revolution to accomplish that end. His disappointment deepened to near bitterness in the 1850's. Exasperated by the seemingly futile task of inspiring political activity in the face of Prussian restrictions, Leutze decided to leave Germany. "I am too much an American, a republican . . . to paint for the German grandees," he wrote.[10]

Embedded in Leutze's remark are the seeds of the irony that awaited him. He had given up a career as a portraitist in ante-bellum America for what he obviously considered to be the more glorified rank of history painter.[11] As Leutze matured artistically in Düsseldorf he gained insight and the ability to handle mood eloquently in portraiture, but he often subordinated this talent to the more flamboyant demands of historical subject matter. He emerged as one of the most successful history painters of his era. Leaving Germany in 1859, he renounced his place in the German painting hierarchy because he was "too American" to satisfy the taste of his German patrons in the post-1848 atmosphere.

Fig. 5. *Oberst Lottner*, 1853.
Oil on canvas, 55 by 39½ inches.
Hamburger Kunsthalle.

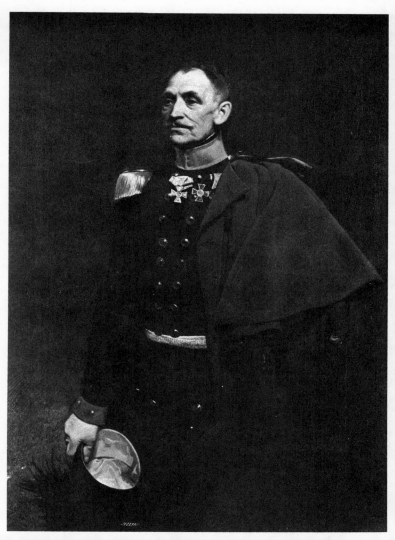

Despite Leutze's relegation of portraiture to a secondary role, he sometimes demonstrated his mature proficiency best in family likenesses, such as those of his in-laws, the Lottners. What had been, for the most part, intuitive handling of composition in the early portraits is here replaced by a strong sense of design. In *Oberst Lottner* (Fig. 5), the positioning of head and body on the same axis and the severe lines of the head suggest a sense of military rigidity. In contrast, Leutze captured a pensive mood in the painting of *Frau Oberst Lottner* (Fig. 6) through the static yet serene pose and withdrawn expression of the eyes. Dull tones in the dress and background are warmed by a soft light that barely catches the gleam of ring and brooch. The creamy laces of the collar and cap, both of which are painted freely with a pigment-laden brush, further soften the portrait. *Ferdinand Lottner* (Fig. 7) is an altogether more informal and ambitious treatment of the three-quarter-length figure, to which the graceful sweep of the fringed mantle imparts an almost Titianesque dignity.[9]

81

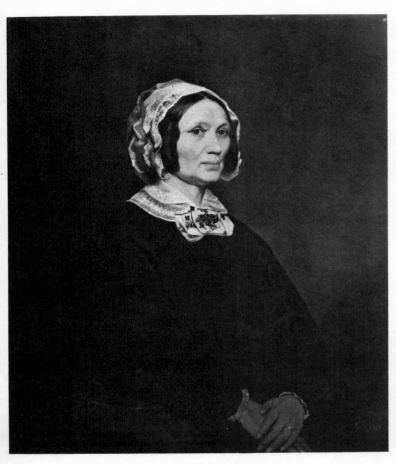

Fig. 6. *Frau Oberst Lottner*, 1848.
Oil on canvas, 37⅜ by 32¹¹/₁₆ inches.
Kunstmuseum der Stadt, Düsseldorf.

former president of the American Art Union; generals Ulysses S. Grant and Ambrose Burnside; John Sutter, the early colonist of California, and Abraham Lincoln. Leutze's unfailing good humor and confidence with his sitters always prompted admiration. When, for example, Nathaniel Hawthorne sat for Leutze, the author was not only satisfied with his portrait but delighted with the way the artist conducted the sittings.

I stay here [in Washington] only while Leutze finishes a portrait—which I think will be the best ever painted of the same worthy subject. . . . One charm it must needs have—an aspect of immortal jollity and well-to-doness; for Leutze, when the sitting begins, gives me a first-rate cigar, and when he sees me getting tired, he brings out a bottle of splendid champagne; and we quaffed and smoked yesterday, in a blessed state of mutual goodwill, for three hours and a half, during which the picture made a really miraculous progress. . . . Leutze . . . is the best of fellows.[13]

Fig. 7. *Ferdinand Lottner*, 1852.
Oil on canvas, 52⅜ by 40 inches.
Kunstmuseum, Düsseldorf.

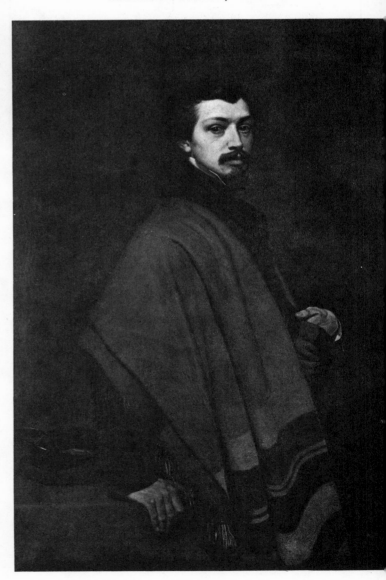

Leutze's willingness to leave hinged upon his negotiations for a single government commission with Captain Montgomery Cunningham Meigs, superintendent of a part of the United States Capitol construction. Leutze apparently thought it would be the first of numerous proposals of a similar nature from Congress. The commission from Meigs eventually resulted in *Westward the Course of Empire Takes its Way,* a fresco Leutze completed in the Capitol in 1862.[12] Thereafter, however, his opportunities to paint history in the grand manner were infrequent. Leutze returned to an unfamiliar United States on the eve of the Civil War when cultural nationalism exerted a greater influence and there was less demand for totally Europeanized art. The American "grandees" were beginning to control the art world in this country. Irresistibly they nudged Leutze away from the noble themes and past events that normally comprised the stuff of history painting to the making of official portraits. Leutze's homecoming had brought him full circle.

He unhesitatingly threw himself into active association with American dignitaries who were now the subjects of his paintings: William Seward, United States senator and secretary of state; Nathaniel Hawthorne; Chief Justice Roger B. Taney; Abraham Cozzens, patron of the arts and

The portrait (Fig. 8) is proof of the sense of well-being Leutze inspired. The oval bust stresses Hawthorne's blue eyes and high coloring, evoking in the smoothly contoured yet robust painted features a sense of the novelist's romantic nature and New England freshness.

Leutze was a remarkable man in many ways. Hawthorne found him to be "the best of fellows." A former associate, the painter William De Hartburn Washington, knew he could rely on Leutze's aid to support organizations beneficial to artists. He asked Leutze to lend both his name and his art to the establishment of the Washington Art Association.[14] But like most of his other acquaintances, neither Hawthorne nor Washington knew of Leutze's increasingly straitened circumstances in his later years. Strongly aware of political tensions, Leutze must have been distraught both by the war and its even more divisive aftermath. His health was poor and his finances were not in the best condition, but a natural reserve kept him from mentioning his declining fortunes to friends. Leutze did permit his friend and patron William Seward some knowledge of his situation, and it is not surprising that Seward's name figures promi-

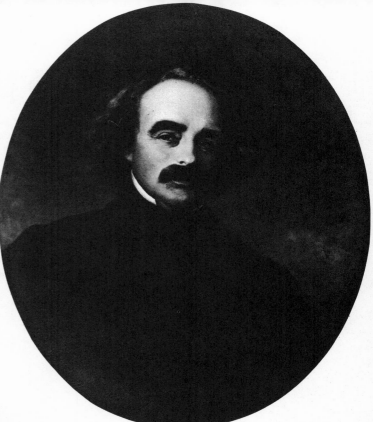

Fig. 8. *Nathaniel Hawthorne*, 1862.
Oil on canvas, 30 by 25 inches.
National Portrait Gallery.

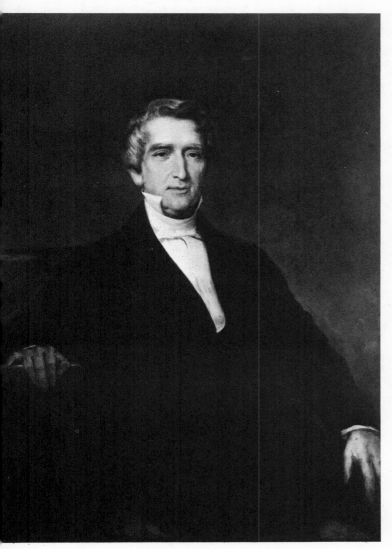

nently in the list of Leutze's final commissions.[15] Leutze painted two portraits of Seward, in 1859 and 1861. The earlier is a life-size canvas of Seward at work in his study;[16] the later (Fig. 9) was probably an official portrait, the purpose of which is now unknown. Seward's dignified bearing and grave mood are undiminished by the single exuberance Leutze allowed himself—the fluid stroke of white shirt front highlighting the matte black of the coat. One of his few large projects in the United States, *The Signing of the Alaska Treaty*[17] (1867), was a gesture of respect for the then secretary of state.

It is a measure of Leutze's boundless energy that his last decade in America was so filled with activity and a measure of his talent that his portraits were very little marred either by his unpropitious personal situation or by his unfulfilled hopes for history painting in the United States. While his later portraits are not always of the caliber of those executed during his Düsseldorf years, Leutze did possess an unerring ability to convey the personality of his sitter. In his portrait of the American jurist Roger B. Taney (Fig. 10), Leutze discerned not only a forceful character but a hawklike countenance that was in itself

Fig. 9. *William Seward*, 1861.
Oil on canvas, 45¼ by 34½ inches.
New-York Historical Society.

fascinating. Yet Leutze did more than just reproduce the old man's features, manipulating the horizontal accents of the bookshelves to encase the striking head and counter the rigid vertical of the spare, stiffly held body. Withered cheeks, ascetic mouth, and bushy eyebrows fairly loom toward the spectator. In the portrait of Taney, the vigor of the sitter is met and matched by the vitality of the artist.

Leutze remained a popular portrait painter in America until the very day of his death in 1868, when he collapsed following an early-morning painting session with a now unknown sitter. Unfortunately, his popularity was confined to his lifetime, and by the end of the century his name was rarely mentioned and thereafter forgotten. As a history painter, Leutze had few equals in this country. However, it is his portraiture, representing almost half of his total work, that shows Leutze to have been more dexterous a painter than has been generally acknowledged. The basic requisite of portraiture is simply the documentation of physiognomy in a pleasing composition. Leutze supplied us with much more: empathy as well as sympathy, sensitivity, and above all, the ability to create in paint the mood and character of his sitter.

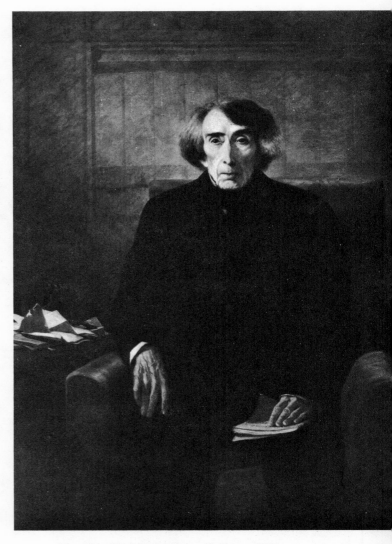

Fig. 10. *Chief Justice Roger B. Taney*, 1859.
Oil on canvas, 58 by 44½ inches.
Harvard Law School.

[1] Now in the Metropolitan Museum of Art.

[2] Leutze did complete the portraits of Senator Hugh Lawson White of Tennessee and Abraham Baldwin. The latter is a sepia-and-wash drawing after a painting by Robert Fulton, and is in the collection of the Pennsylvania Historical Society.

[3] There is a portrait of a very young girl, also entitled Eliza Longacre, in a private collection in Philadelphia. I assume the younger Eliza was a daughter of James and Eliza Stiles Longacre, and that the painting was probably undertaken in the same year, 1839.

[4] Leutze's official enrollment in the academy is documented in copies of the *Schülerlisten* in the Düsseldorf city archives. Leutze's break with the academy is noted by a number of his contemporaries. See, for example, M. Blanckarts, *Düsseldorfer Künstler: Nekrologie aus den letzten zehn Jahren* (Stuttgart, 1877), and Hermann Becker, "Emanuel Leutze," *Kölner Zeitung*, August 20, 21, 1868.

[5] A portrait of Leutze's wife and their first child, *The Amber Necklace*, 1847, is in the Museum Schwäbisch Gmünd; those of his fellow artists, all c. 1850, are in the Kunstlerverein Malkasten, Düsseldorf.

[6] The painting, now privately owned, is *The Return of Columbus in Chains to Cadiz*. It was exhibited in Brussels and then purchased by the American Apollo Association in 1843 directly from the artist in Düsseldorf. See the *Annual Report of the Apollo Association*, December 28, 1843.

[7] Emanuel Leutze to Julius Erhard, August 14, 1845, Erhard Stiftung, Museum Schwäbisch Gmünd. (My translation.)

[8] The Düsseldorf Gallery in New York City, which opened in 1849, was the creation of Johann Boker, a Prussian consul in New York and the honorary secretary of the "Art Union of Rhenish Prussia and Westphalia." In 1856 Henry Derby, founder of the Cosmopolitan Art Association, purchased the entire collection for $180,000, and maintained the exhibition as a free service to the public until 1862.

[9] The portrait of Ferdinand Lottner was recently seen in this country in the Yale University Art Gallery's exhibition *German Painting of the Nineteenth Century*. See the catalogue notes (New Haven, 1970) by Kermit Champa, pp. 111-112.

[10] Emanuel Leutze to Julius Erhard, October 1858, Erhard Stiftung. (My translation.)

[11] See Leutze's statement published in Henry Tuckerman, *Artist-Life, or Sketches of American Painters* (New York, 1847), p. 176. "The consistency and severity in the mechanical portion of the art taught at this school [the Düsseldorf Academy], are carried into the theory, and have led, by order and arrangement, to a classification of the subjects, which is of essential service; and soon confirmed me in the conviction that a thorough poetical treatment of a picture required . . . some one clear idea, which is to be the inspiration of the picture."

[12] A complete account of the commission may be found in Raymond Stehle, "Westward Ho! the History of Emanuel Leutze's Fresco in the Capitol," *Records of the Columbia Historical Society of Washington, D. C.* (1970-1972), pp. 306-322.

[13] Quoted in James Field, *Yesterdays with Authors* (Boston, 1885), p. 96.

[14] William De Hartburn Washington (1834-1870) founded the Washington Art Association in 1856 and was a vice-president and director of the union. Probably at his behest, Leutze was appointed an honorary member of the association and his name thus figured as a "backer" of the organization in the exhibition catalogues. See Josephine Cobb, *The Washington Art Association: An Exhibition Record, 1856-60*, reprinted from *Records of the Columbia Historical Society of Washington, D. C., 1963-1965* (Washington, D. C., 1966).

[15] The Leutze-Seward correspondence is in the William Seward collection of the Rochester University Library, Rochester, New York.

[16] The portrait is now in the Union League Club, New York City. Leutze also painted portraits of Seward's wife, Frances, in 1867, and his daughter Anna about 1865.

[17] Now in the Seward house, Auburn, New York.

Three Tennessee painters:

Samuel M. Shaver, Washington B. Cooper, and James Cameron

BY BUDD H. BISHOP, *Director, Chattanooga Art Association*

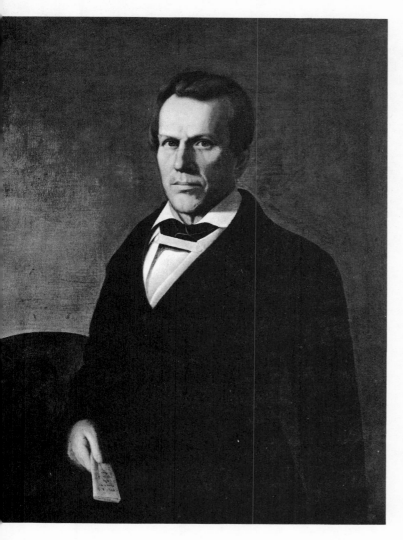

Fig. 1. *Thomas Amis Rogers Nelson* (1812-1873), by Samuel M. Shaver (c. 1816-1878), c. 1858. Nelson, born in Roane County, Tennessee, was a prominent Knoxville lawyer, congressman, Supreme Court judge, and antisecessionist. President Andrew Johnson's personal choice as defense counsel during Johnson's impeachment trial, Nelson was well-known as an orator, and wrote accomplished verse on the beauties of Tennessee. This portrait, with its combination of genuine likeness and fine modeling, represents Shaver at his best. This and a companion portrait of Mrs. Nelson and baby Elizabeth are in the possession of a direct descendant of the sitters. *Collection of Mrs. Joseph W. Johnson Jr.*

ART PRODUCED ALONG the American frontier in the early nineteenth century differs from that produced in the established culture centers on the east coast. In Boston, Philadelphia, Charleston—cities built on mercantile wealth and with strong ties to European tastes and traditions—artists found clients whose judgment and values demanded superior and stylish painting. Still life, genre, and landscape all had a place alongside portraiture. Not so in the provinces. Aspiring artists in newer settlements found their clients (usually second-generation pioneers indulging a newly acquired taste for luxuries) interested almost exclusively in portraits. In order to mine this vein, hardy traveling limners braved bad roads and uncertain destiny to reach their scattered market, and they left a trail across Tennessee as elsewhere in the young country.

Without their names and dates, however, and without stylistic comparisons, we are hard put to assess the impact of these itinerant artists on the taste of the countryside. Certainly the standard of their work does not equal that of accomplished Eastern artists. Many were self-taught artisans with limited skill, earning a living by meeting a market demand. But the work of these unknown men matches the character of their sitters—severe, serious, stoic. The directness and simplicity of these naïve portraits reflect the grass-roots American aversion to frills, the Puritan tradition that indeed dies hard in this country.

If traveling under difficult conditions to find clients seems arduous, development as an artist within the frontier communities must have been doubly difficult. There were few examples to study, fewer teachers to lead the way, and, of course, competition from itinerant artists who could trade on the glamour of coming from the East. In spite of all these handicaps, two native Tennesseans—Samuel M. Shaver and Washington B. Cooper—not only learned to paint well, but captured for themselves the lion's share of portrait commissions in East and Middle Tennessee during the middle decades of the nineteenth century; and transplanted Philadelphia artist James Cameron produced the major part of his *oeuvre* as a resident of Chattanooga from 1850 to 1860. Our discussion centers on the lives and works of these three men, whose careers reflect almost entirely their Tennessee background. Influential patrons, isolated stylistic development, and a provincial flavor were common to all three. Their work was a perfect barometer of a developing state, beautifully suited to the temper of the times.

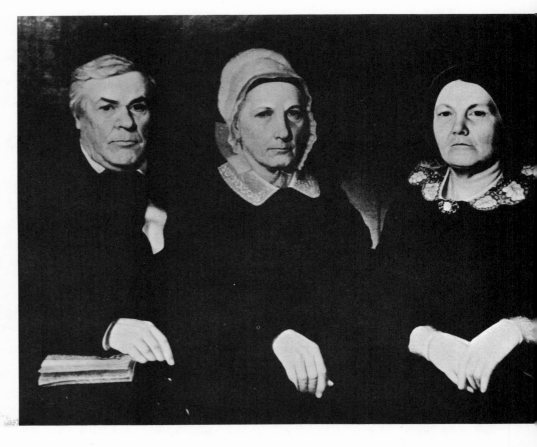

Fig. 2. *The Roper Family,* by Shaver, c. 1852. Shaver's mature, if austere, style is seen in this portrait of the Mossy Creek (now Jefferson City) family of John and Margaret Franklin Roper with their daughter, Mary Ann Roper. *Collection of Mrs. R. Eugene Volger; photograph by courtesy of Mrs. Clarence L. Carmichael.*

Samuel M. Shaver (c. 1816-1878) was born on Reedy Creek in Sullivan County, Tennessee (near present-day Kingsport), the fourth or fifth son of David and Catherine Barringer Shaver. His earliest works, from Sullivan County, could have been painted in the late 1830's, but his portrait of John McKinney of Rogersville in neighboring Hawkins County is the first to which even a rough date, 1844-1845, can be ascribed.

Shaver's first career break-through came in December 1845, with his marriage into a prominent Rogersville family. His own father had been a man of substance (justice of the peace in Sullivan County for many years), and Shaver's bride, Mary Hannah Elizabeth Powel, was the daughter of Samuel Powel, congressman and judge. The young couple lived with the bride's widowed mother, and Samuel painted a large number of the Powel clan. This led to other commissions, and a great deal of work can be ascribed to the years 1845 and 1846. One known miniature painted in Maury County (Columbia) in 1847 may indicate that Shaver took to the road occasionally, but records show that he lived in Rogersville from 1845 to 1852. He is listed in the 1850 census—with his name given erroneously as Powel—as "artist, age 34." In 1851, in the catalogue of the first year's curriculum of the Odd Fellows' Female Institute at Rogersville, he offers drawing and painting courses as "Professor Shaver." He drops from sight in 1852 (a painting trip to his parents' native North Carolina?) but reappears in 1856, when he returned to Hawkins County upon his wife's death. During the years from 1856 to 1860, he tended his four children and painted many more Hawkins

County portraits. He also traveled to nearby Washington and Carter Counties to paint prominent members of the pioneer Haynes and Taylor families.

From 1856 Shaver's work took a new direction, perhaps the result of travel and observation. He introduced ambitious background treatments—swags of drapery, classical columns, deep landscapes—that became a hallmark of his work. His meticulous attention to these backgrounds affords some valuable records of early Tennessee history. Railroad emplacements, views of towns, records of houses and estates all crop up in Shaver portraits after the late 1850's. His painting of Mrs. A. P. Hampton even attempts to presage the future: she is seen against a backdrop that includes an architect's projection of new buildings for the Female Institute. It was an interesting effort to keep the picture up to date, but the buildings were never erected. Mrs. Samuel Powel Jr., nee Armstrong, stands before the Armstrong estate, Stony Point, in Hawkins County. And Shaver's portrait of Joe Foard, prosperous businessman in Rogersville, includes a panoramic view of that town as it looked in 1860; many of the structures still stand.

The second boost in Shaver's career came in 1859, upon his removal to Knoxville. There he found a great demand for portraits and painted dozens of prominent citizens (Fig. 1). It was during this period that Shaver reached the peak of his powers. A fervent Confederate, he nonetheless showed great flexibility when Knoxville fell to Union troops. He continued to advertise in the daily paper, offering portraits, presumably to the new Yankee trade. He seems to have moved about freely

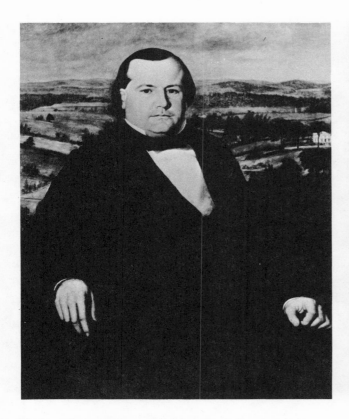

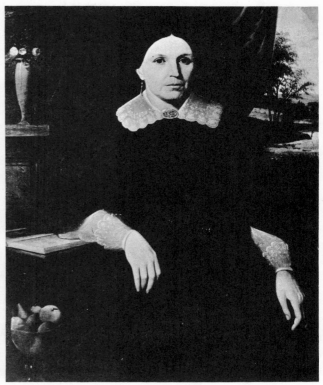

Fig. 3. *John Roper Branner* (1822-1869), by Shaver, c. 1866.
Branner, also of Mossy Creek, was president of the
East Tennessee & Virginia Rail Road from 1861 to 1869.
The Branner house, The Maples, can be seen in the
background view of the estate. *Collection of John R. Burnett;*
photograph by courtesy of Mrs. Carmichael.

Fig. 4. *Mrs. John R. Branner* (Deborah Massengill, 1822-1885),
by Shaver, c. 1866. In the background is Mossy Creek,
a typical example of Shaver's use of local detail.
Collection of Mrs. John Herndon;
photograph by courtesy of Mrs. Carmichael.

during the last years of the Civil War. Soon thereafter
(c. 1866) he painted the Branner family (Figs. 3, 4) of
Mossy Creek in Jefferson County.

In 1867 or 1868 Shaver joined his mother-in-law in
Jerseyville, Illinois (across the river from St. Louis),
where she had moved with his children. An 1868 St. Louis
directory lists an S. M. Shaver. Occasionally, he still
heard from his native state: William Rutledge, for
example, commissioned two portraits by mail and sent
photographs for him to work from. But eventually ill
health overtook him, and Shaver died in Illinois in 1878.
He left scores of portraits of Tennessee's earliest and most
prominent families. A check list of his work would include
names such as Roper, Branner, Rutledge, Sevier, Taylor,
Anderson, Kyle, Haynes, Netherland, and Powel.

Washington Bogart Cooper (1802-1889), the "man of
a thousand portraits," was born in Greene County near
Jonesboro, Tennessee. He grew up in Shelbyville, near
Nashville. His talent is said to have emerged at an early

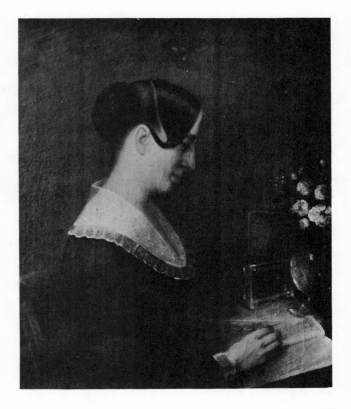

Fig. 5. *Anne Litton Cooper,*
by Washington B. Cooper (1802-1889), c. 1840.
Irish-born Anne and Cooper were married in Nashville in 1839.
The profile and the small still life give this unusual Cooper
portrait an intimate feeling. *Collection of Mrs. Norman Frost.*

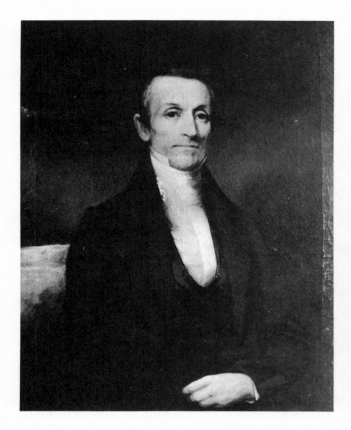

Fig. 6. *Judge James J. White* (d. 1865), by Cooper, 1838.
Judge White, who is thought to be buried in Gallatin Cemetery,
sat to Cooper first in October 1838.
The completion date of December 12, 1838, is recorded in
Cooper's account book, as is the price: $60.
Cooper also painted Mrs. White in 1839.
Collection of Mr. and Mrs. Will Wemyss.

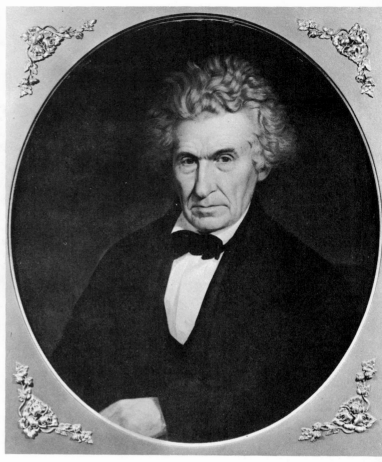

Fig. 7. *Anson Nelson* (1821-?), signed by Cooper, c. 1850.
Nelson, for many years (1853-1883) in public service in Knoxville,
was born in Washington County, Tennessee. *Tennessee Historical
Society.*

Fig. 8. *Dr. Felix Robertson* (1781-1865), by Cooper, c. 1850.
Robertson, who practiced medicine in Nashville for sixty years,
was the first child born in Nashville; he was the son of James
and Charlotte Robertson, founders of the city (see p. 380).
Graduated from the medical department of the University of
Pennsylvania in 1806, he married Lydia Waters in 1808. He
served as mayor of Nashville (1827-1828) and in 1830 became a
charter member of the Tennessee Medical Association, of which
he was president for nine terms. *Tennessee Historical Society;
this and Figs. 5, 6, 7, photographs by Helga Photo Studio.*

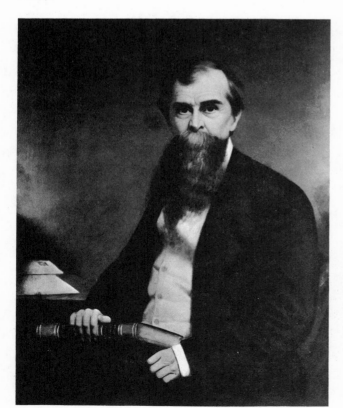

age, when he retrieved charcoal from the fireplace to
draw farm animals and the people around him . He was
studying in Murfreesboro in 1822, possibly with Ralph
E. W. Earl, and for a time he worked in Philadelphia
with Thomas Sully and Henry Inman.

In 1830 Cooper opened a studio in Nashville, where
he achieved immediate popularity. Considering the
immense demand for his services and the fact that he
showed in his account book an annual average of thirty-
five to forty portraits, it is strange that we can locate
with certainty fewer than sixty of his pictures. One rich
source is the collection of the Tennessee Historical
Society, housed at the Tennessee State Museum: the society com-
missioned Cooper to record for posterity many prominent
Tennesseans.

Cooper married Dublin-born Anne Litton, and his
tender profile portrait of her (Fig. 5) was an unusual
departure for an artist in Tennessee at this time. Cooper's
facility with likenesses and his softened realistic effects

88

soon brought an array of commissions: he was hired to paint a complete series of Tennessee governors and all the bishops of the Methodist Episcopal Church, South, to the time of his death. His highest fee was around $75 (half the price of a Sully at the time), but he apparently compensated for this by turning out a large volume of work. He was successful enough to send his younger brother, William Brown Cooper, to study at the National Academy of Design and, later, on a tour abroad.

William's entry into the art field has made research on Washington B. Cooper difficult, for the brothers had the same initials, overlapping dates, and similar signatures. However, since the younger Cooper enjoyed more study and travel, we may surmise that Cooper paintings with a softer, more diffuse light and a brighter palette are his work. Washington Cooper died in Nashville in 1889, William in Chattanooga in 1900. Their work, while technically accomplished, perfectly reflects the Tennessee of their day. Their sitters—judges, governors, men of achievement—wanted and got honest, direct likenesses suited to the sober Scotch-Presbyterian background of so many of them.

The major American landscape movement designated by the omnibus term Hudson River school was flourishing in the East in the 1840's and 1850's, but in Tennessee, landscape painting did not have a waiting throng of clients. A lone painter, James Cameron, has left us the few pictorial records extant of the still virgin Tennessee countryside before the Civil War.

Cameron (1817-1882), born in Greenock, Scotland, moved first to Philadelphia where he studied art and met and married Emma Alcock. He combined a wedding trip to Italy (1847) with painting, and sent back some Italian landscapes to the American Art-Union exhibition of 1848. Primarily interested in landscape, he nonetheless faced the economic necessity for obtaining portrait commissions. He apparently arrived in Nashville around 1850, but we know nothing of how Chattanooga businessman

and civic leader Colonel James A. Whiteside persuaded him to move to Chattanooga. Presumably Whiteside, in Nashville to watch his railroad interests, was trying to improve Chattanooga's cultural climate. He offered Cameron studio space and lodging on his ample estate and probably helped with portrait commissions. Cameron was enthralled by the spectacular Chattanooga scenery and, when time permitted, painted the mountains, valleys, and rivers of the region. At one point, he was financially able (through his wife's inheritance?) to buy property on a large hill in what is now downtown Chattanooga, called to this day Cameron Hill, and to build an impressive Italianate villa of stucco overlooking the Tennessee River.

Not many of Cameron's pictures survive, but the few we know are unique in their complexity. They are at once sophisticated and naïve, a combination of studied technique and faulty drawing. From the earliest Chattanooga portraits (the young Mrs. Whiteside, probably 1851), in which he displays a modest gift for likeness and a special sympathy for the personality of his sitter, to his monumental group portrait of the Whiteside family (Fig. 11), Cameron became increasingly ambitious in his compositions. His *Nolichucky River* (Fig. 9) and his view of *Moccasin Bend, Chattanooga* (Fig. 10) are dramatic attempts to capture a sense of grandeur. He throws almost everything in his experience into his baroque group portrait of the Whitesides, with mixed success.

Having fled the Civil War hostilities around Chattanooga, Cameron returned after the war to find the trees gone and his beloved landscape laid waste. Depressed, he gave up painting and went into business. After failing at that, he entered the Presbyterian ministry and moved to Oakland, California. He died there in 1882.

These three men lived and worked in Tennessee at the time of its greatest early expansion. Their *oeuvre* is a clear record of the taste, limitations, hopes, and pride of the makers of a new state.

Fig. 9. *Nolichucky River,* signed and dated by James Cameron (1817-1882), 1861. View of the river near present-day Greeneville, Tennessee. *Tennessee State Museum.*

Fig. 10. *Moccasin Bend, Chatta-nooga,* signed and dated by Cameron, 1857. One of several ambitious views of the countryside painted by Cameron during his ten-year (1850-1860) career in Chattanooga. This one, from the east brow of Lookout Mountain, shows the Tennessee River winding through Chattanooga Valley, its curves creating foot-shape Moccasin Bend. In the middle distance is Walden's Ridge, called Signal Mountain because of signal stations there during the Civil War. In the lower right is Chattanooga. The tree-covered knoll left of town is Cameron Hill, named for the artist. *Chattanooga Art Association.*

Fig. 11. *Colonel and Mrs. James A. Whiteside,* by Cameron, 1858-1859. An imaginary Italianate terrace is the setting for this view of the Chattanooga Valley, used as background for a family portrait. *Collection of Thomas B. Whiteside.*

Fig. 12. Detail of Fig. 11. Virginia, a slave, holds Charles, fifth child of Harriet Leonora Straw Whiteside and James A. Whiteside.

90

BY AGNES GILCHRIST

Daniel Huntington,
portrait painter over seven decades

THOUGH STANDARD reference works carry fairly full biographies of Daniel Huntington (1816-1906), very little has been published elsewhere on this outstanding American painter of the nineteenth century. This is the more surprising in view of Huntington's prominence in the cultural life of his day: he was president of the National Academy for twenty-one years, from 1862 to 1870 and again from 1877 to 1890; vice-president and trustee of the Metropolitan Museum of Art in its early days; a founder of the Century Club, and its president for sixteen years. He was also an extremely prolific painter, producing in the course of his seventy-one-year career some twelve hundred canvases, of which about a thousand were portraits.

After brief sojourns at Yale, Hamilton College, and New York University (he did not graduate from any of them), Huntington started painting with some of the leading artists of the time: Charles Loring Elliott (1812-1868), Samuel F. B. Morse (1791-1872), and Henry Inman (1801-1846). He was the son of a prosperous New York broker, and serious struggle had no part in his life. Even when his father lost most of his money in the panic of 1837 and Daniel had to turn to teaching painting, this led to a trip to Italy with one of his pupils in the course of

which he produced a number of post-Raphaelesque paintings of Latin beauties, variously labeled *Sibyl, Preciosa,* or just *Roman Maiden,* which were greatly admired and provided engravings for fashionable gift books in the years before the Civil War. In short, he was almost immediately successful. He first exhibited in the National Academy when he was only twenty; by the time he was thirty-three he had had a second sojourn in Europe and had reached the top of his profession, and he remained very near that peak until his death fifty-six years later.

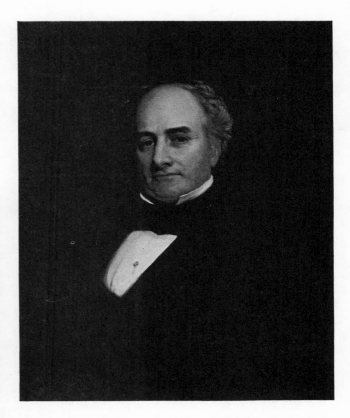

Fig. 1. Guy Richards (1788-1873). Signed and dated *D. Huntington 1846*; 30 by 25⅜ inches. The sitter, uncle of the artist's wife, was fifty-eight when this was painted. *Collection of Guy Huntington Richards.*

Fig. 2. Guy Richards, c. 1860; 36 by 29 inches. This painting of Mr. Richards in his later years has never been exhibited, and is published here for the first time. *Richards collection.*

Fig. 3. *Mercy's Dream.* Signed and dated *D. Huntington 1858*; 84 by 66¼ inches. Huntington painted this subject from Bunyan's *Pilgrim's Progress* three times; there are replicas in the Philadelphia Academy of Fine Arts and the Corcoran Gallery. An engraving published by A. H. Ritchie also proved very popular. *Metropolitan Museum of Art.*

In 1842 Huntington married Harriet Sophia Richards of Brooklyn. Their only child, Charles Richards, became a businessman.

Huntington's early patrons were the owners of the great Greek revival houses on Washington Square and the country houses on the upper part of Manhattan Island. The earlier portrait of his wife's uncle Guy Richards (Fig. 1) is an excellent example of his style at this time, in the eighteenth-century tradition of Reynolds but with tighter brushwork and drier, darker colors. In his second painting of this same subject (Fig. 2), done some fourteen years later, the painting is looser and the colors more brilliant.

Besides portraits, Huntington painted landscapes and scenes from history, which were much admired in the romantic period. His most popular painting, *Mrs. Washington's Reception* or *The Republican Court,* was exhibited at the Sanitation Fair in New York during the Civil War and in the Paris Exhibition of 1867 and was engraved by A. H. Ritchie in that year. He also painted large inspirational canvases like *Mercy's Dream* (Fig. 3), which was so successful that he painted it three times; it too was engraved by Ritchie.

But it is as a portraitist that Huntington is best known. He painted presidents and generals, writers and artists, as well as Astors and Vanderbilts. Most Huntington portraits are still privately owned by descendants of the sitters; however, there are three in the White House collection, and almost every public institution in New York City has one or more. The Chamber of Commerce of New York State has the greatest number, forty-three, in the great hall of its handsome building at 65 Liberty Street. (These and Huntington's famous painting of the *Atlantic Cable Projectors* may be seen by appointment.)

Huntington's portraits of women are most successful. According to a critic in the *Whig Review* for August 1846, "his women do not look like sylphs, angels nor goddesses, but like women, which is the grand reason that they are so beautiful." They may not have the chic of Madame X or the coquetry of Perdita, but they do mirror changing fashions in dress, coiffure, and accessories. His portraits of Mrs. Chrystie of about 1850 (Fig. 5) and Mrs. John Clarkson Jay painted in 1903 (Fig. 6), for example, show clearly the differences between the Victorian and the Edwardian matron.

In 1864 a group joined together to buy Huntington's portrait of his fellow artist and great friend Asher B. Durand (1796-1886; Fig. 7), painted in 1857, and presented it to the Century Association. A self-portrait by Huntington (Fig. 8) also hangs there—appropriately enough, in view of his early importance to the club.

Fig. 4. The Earl of Carlisle, George William Frederick Howard. Signed and dated *D. Huntington 1851*; 56 by 44 inches. Commissioned for the collection of the New-York Historical Society, for which the artist also did a portrait of Sir Charles Eastlake.

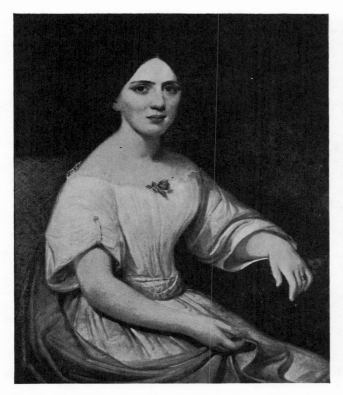

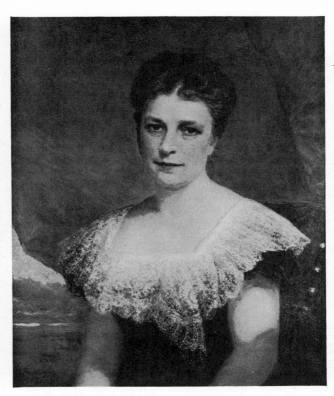

Fig. 5. Mrs. William Few Chrystie (Emily Harvey Thomas), c. 1850; 33½ by 27½ inches. *Photograph by courtesy of the Frick Art Reference Library.*

Fig. 6. Mrs. John Clarkson Jay (Harriette Arnold Vinto), signed and dated *D. Huntington 1903*; 30 by 25 inches. *Collection of Mrs. Arthur M. R. Hughes; Frick photograph.*

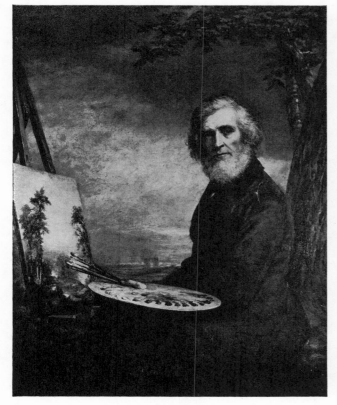

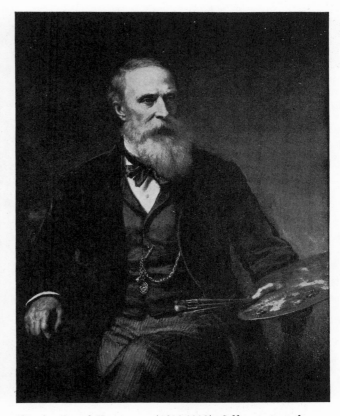

Fig. 7. Asher B. Durand (1796-1886). Signed and dated *D. Huntington 1857*; 55½ by 40 inches. The picture on the easel is Durand's famous *Franconia Notch*. Given by members of the Century Association in 1864, the portrait hangs on the stair wall in the present clubhouse in New York. *Frick photograph.*

Fig. 8. Daniel Huntington (1816-1906). Self-portrait at the age of seventy-four; signed and dated *D. Huntington 1890*; 46 by 36 inches. Huntington was a founder of the Century Association, and its president from 1879 to 1895. This picture now hangs in the association's library. *Frick photograph.*

III Folk Artists

The discovery of American folk art took place in the 1920's and was due to the insight of a group of New York artists, collectors, and dealers, including Edith Gregor Halpert, Elie Nadelman, Gertrude Vanderbilt Whitney, Charles Sheeler, and Juliana Force. Their first exhibition at the Whitney Studio Club in 1924, *Early American Art,* brought together forty-five objects. A second major exhibition on this subject was organized by Holger Cahill for the Museum of Modern Art in New York in 1932: *American Folk Art. The Art of the Common Man in America 1750–1900.* Alice Winchester and Jean Lipman, as editors of *The Magazine* ANTIQUES and *Art in America* during the decades of the 1940's, 1950's and 1960's, showed their continued enthusiasm for the subject by publishing the results of research into the work of individual artists or regional schools whose work was defined as folk art. Their most recent summation of this interest was in the catalogue for the 1974 Whitney Museum of American Art exhibition, *The Flowering of American Folk Art, 1776–1876.*

In this catalogue, Miss Winchester defined American folk art as "characterized by an artistic innocence," noting its inventiveness, vigor, and honesty. At the same time, she noted that it is not a true folk art; that is, an "ethnic expression which is not affected by the stylistic trends of academic art."

The articles in this section are only a few of those published in ANTIQUES, many during Miss Winchester's editorship. They have been chosen to represent the geographical range and technical variety characteristic of this genre. The articles also indicate the life-styles of these painters, as well as the pitfalls of enthusiastic attribution which has impeded research into their work. The first article is Jean Lipman's "American Primitive Portraiture, A Revaluation," published in 1941. (The cover illustration, *The York Family at Home* by Joseph H. Davis, referred to in her article has been omitted; there is a reproduction in the article on Davis by Frank Spinney, also included here.) In defending the artistic value of folk portraiture, Jean Lipman remarked on short-sighted critics whose yardstick of quality was "academic English or Continental standards." While enthusiastically endorsing the excellences of the genre, she erred in this early study by observing that it was "at first submerged by traditional European styles," while in fact folk art grew from European and American styles and compositions of the eighteenth century. She also observed that the itinerant portrait painter carried with him a stock of portraits complete except for the faces, which is no longer regarded as true.

All of the artists whose work is discussed in this section painted in New England and New York between 1800 and the Civil War. The articles on Zedekiah Belknap, William Matthew Prior, John Bradley, and Deborah Goldsmith present all of the information known about these artists. That on Elijah Canfield's portraits of Hiram and Sarah Upson publishes two of Canfield's three known works; the third, his copy of Edward Savage's *Liberty,* was published as the cover of ANTIQUES for February, 1971.

The articles on Joseph H. Davis, Asahel Powers, and Ammi Phillips present only part of the material available now on these artists. Frank Spinney's article on Davis was the first of two that he wrote for ANTIQUES in which he presented the work of this skilled watercolorist (the second article appeared in August, 1944). His research on Davis was recently incorporated by Norbert and Gail Savage and Esther Sparks in their catalogue, *Three New England Watercolor Painters* (Art Institute of Chicago, 1974), which also included the work of J. A. Davis and J. Evans. (*See* also two articles by Norbert and Gail Savage, "J. Evans, Painter," ANTIQUES, November, 1971, and "J. A. Davis," ANTIQUES, November, 1973; and Nina Fletcher Little's "New Light on Joseph H. Davis, Left-Hand Painter," ANTIQUES, November, 1970.) Nina Fletcher Little's article on Asahel Powers is part of the material more completely presented by her in the catalogue *Asahel Powers, Painter of Vermont Faces,* compiled for the exhibition at Colonial Williamsburg in 1973.

The third artist whose work is only partially presented here is Ammi Phillips. The identification of this artist as one of the most prolific portrait painters of this period has been the work of Barbara and Lawrence Holdridge, who first identified Phillips as the same artist as the anonymous painters known as the Border Limner and the Kent Limner. Their catalogue, *Ammi Phillips: Portrait Painter 1788–1865* (Museum of American Folk Art, New York, 1969) lists 309 portraits by Phillips, eleven of which are signed.

It seems likely that some of these portraits will be recognized as the work of other portrait painters, as was suggested by William Lamson Warren in his review of their earlier exhibition of Phillips' work at the Connecticut Historical Society in 1965–6. (*The Connecticut Historical Society Bulletin* 31 [January 1966]: 1–18). This was the case with some early attributions to John Bradley. The article on Bradley included here, "Drawn by I. Bradley from Great Britton," by Mary Black and Stuart Feld, corrected an earlier list and catalogued only the twenty-two works by Bradley which are signed. Some of the portraits once attributed to Bradley are now considered to be by Ammi Phillips.

While these articles, and others in ANTIQUES, immensely extend our knowledge of these "folk" artists, they suggest at the same time that there is still much research to be done. Books like *The Paintings and the Journal of Joseph Whiting Stock,* edited by Juliett Tomlinson (Wesleyan University Press: Middletown, Connecticut, 1976) are much needed.

The difference between the so-called "folk" artist's style and that of the academic painter was also alluded to in 1831 by William Matthew Prior, who advertised his "flat pictures," "a likeness without shade or shadow at one quarter price." One of these may be his portrait of Nat Todd, a simple head and shoulders portrait with no background detail. The label on the reverse of this portrait reads "PORTRAITS PAINTED IN THIS STYLE Done in about an hour's sitting." Prior, it seems, could paint in both styles.

Suggestions for further reading can be found in *The Flowering of American Folk Art, 1776–1876* (1974) by Jean Lipman and Alice Winchester.

AMERICAN PRIMITIVE PORTRAITURE
A Revaluation
By JEAN LIPMAN

MANY ART FORMS highly valued today — archaic Greek art, Italian primitive painting, African wood sculpture, American folk art—were a generation ago ignored or negatively criticized as childish and crude; and modern abstract art did not exist. The touchstone of value was then visual plausibility achieved through technical dexterity. To say that modern criticism has acknowledged the esthetic qualities of primitive and abstract art is an understatement. The key aspect of contemporary taste is the high value set on abstraction at the expense of the realistic approach to painting. There has been a complete reversal of standards. Academicism and verisimilitude have come to be judged negatively as diluting the intensity of perception, obscuring the personal viewpoint, preventing selectiveness and subordination — in other words, spoiling the major possibilities of abstraction.

In this esthetic revaluation there has, however, been a surprising critical lag in the field of early American painting. The native abstract tradition in American painting has heretofore been slighted by the critics to an extraordinary degree. Particularly in the field of portraiture, where the academic English tradition dominated the native style almost from the beginning, what is most distinctive and unique in American painting awaits clearer definition and more general appreciation. Most critics have consistently based their estimates on academic English or Continental standards, naming those American painters the greatest who were the least American and most imitative in their approach. The bold, abstract American style has been criticized as lacking in finesse of characterization and in subtlety of coloring and design. It is a strange blindness that has caused these critics to look for skilled academic refinement in the art of a sturdy pioneering people who had colonized a wilderness through fresh vigorous enterprise and robust vitality — qualities with which their native art was necessarily endowed. But, as Willard Huntington Wright commented in his *Misinforming a Nation*, "in our slavish imitation of England — the only country in Europe of which we have any intimate knowledge — we have de-Americanized ourselves to such an extent that there has grown up in us a typical British contempt for our own native achievements."

World affairs today, creating a conscious Americanism in this country, have paved the way for a timely artistic revaluation in which primitive painting, so purely of the American tradition, plays an increasingly important part. Its merits have been recognized for some years, and it would be foolish to hail it as a new discovery. But the time is ripe for considering American primitive painting, not as an isolated phenomenon, but as an essential and integral part of America's artistic development. The basic characteristics of the outstanding primitive portraits are those of the most typically American portraits. Certainly the time will come when an eighteenth-century portrait by a gifted unsophisticate like Richard Jennys or a fine nineteenth-century primitive will hold its own with any academic portrait.

The fact that primitive portraiture reached its height in the nineteenth rather than in the more "primitive" seventeenth and eighteenth centuries indicates that the native trend was at first submerged by traditional European styles and then eventually achieved independent development. A strong abstract quality is fundamental in this form of expression.

It cannot be sufficiently stressed that the style of the American primitive is essentially intellectual and abstract — not "quaint" — and that it represents the opposite of illusionistic realism, the essence of abstract design. The primitive artist, lacking the academic training which would have enabled him to approximate in paint the visible appearance of things, painted what he knew rather than what he saw. Being independent of the casual shifting appearance of reality, he instinctively organized and stabilized his composition from the point of view of design. His technical liabilities made way for a compensating emphasis on pure design. And so his portraits are stylistically characterized by firm outline, simplified mass, solid tone and color, stable pose and expression. As the primitive painter did not attempt to recreate any specific moment of visible reality, his vision was generalized and timeless. In his portraits he

FIG. 1 — PORTRAIT OF ELIZA SMITH, SCHOOLMISTRESS. Painted in 1832 by the pastor of Broad Street Christian Church in Johnson (now part of Providence), Rhode Island. Oil on canvas, 37 by 26 inches. Vividly discloses the attitude of a non-professional painter. Miss Smith is seated on a chair which rests in what appears to be a shallow box, but which on second glance is revealed to be an abstraction of a carpeted room. She and the telescoped section of room are set against a dusky scenic backdrop in which the pastor's church and a building which is probably Miss Smith's school are prominently placed as identifying attributes of painter and sitter. Another detail indicative of method is the clasped hands, which clearly show that the sprays of moss roses were painted as a decorative afterthought with no attempt at a functional rearrangement·of the hands. *From the author's collection.*

boldly recorded the fundamental and lasting characteristics of his sitter instead of trying to catch the transitory details of expression or gesture.

The anonymous primitive portrait — whether executed in oil, pastel, or water color, and whether on canvas, bed ticking, wood, paper, or glass — is first of all characterized by a strong sense of design which dominates the whole and controls every part. Each part of the portrait is conceived as a distinct unit, all of which add up to form a decorative and broadly descriptive composition. It was quite consistent with his general attitude for the itinerant limner to paint a number of attractively dressed bodies, then complete them with individual heads as customers were found, with

The style of the typical American primitive is at every point based upon the non-academic attitude of the artist. The degree of excellence in a primitive portrait depends upon the clarity and energy and coherence of the artist's personal mental picture rather than upon the beauty or interest actually inherent in the subject. The final result, as distinguished from academic portraiture, rests on the artist's instinctive sense of design when transferring his mental picture to a painted surface, rather than upon a technical facility for reconstructing in paint his observations of his sitter.

The outstanding characteristics of American primitive portraiture are well exemplified in the early nineteenth-century paintings reproduced with this article and on the Cover of this issue. The latter, *The York Family at Home*, dated *1837*, shows the manner in which single elements of design add up to create a decorative whole, bringing the art of portraiture close to that of still-life. In rigidly symmetrical arrangement selected attributes of the family and their home are displayed.

FIG. 2 — MEMORIAL FAMILY GROUP, NEW BEDFORD, MASSACHUSETTS (*c. 1840*). Oil on cardboard, 14 by 18 inches. Compare with the group portrait on the Cover. Here a decorative flower border is an integral and strikingly abstract element of the design, as are the nine yellow stars which symbolize the nine members of this family rigidly lined up among strange, gigantic flowering plants. *From the author's collection.*

FIG. 3 — BROTHER AND SISTER (*c. 1800*). Signed three times by J. N. Eaton of Greene, New York. Oil on wood, 23 by 24 inches. Pose and gesture interpret in the manner of the early illustrated children's books a prim text inscribed at the base. The sharp linear contour is an important stylistic element. It is a decorative and descriptive agent which firmly outlines shapes but puts the butterflies, birds, plants, a strange landscape cut by a stream, and the two Buddha-like children into a two dimensional world. *From the private collection of J. Stuart Halladay and Herrel George Thomas.*

no attempt to portray the sitter naturalistically. The painter, visualizing his sitters generically as well as individually, would usually include in each portrait distinguishing symbols, appropriate to his subject — binoculars for a sea captain, a shelf of apothecary bottles for a doctor, pet cat or dog, hobby horse or doll for a child, paintbox for a lady, half-open Bible for a clergyman. It is tempting at this point to quote Mark Twain's description in *Life on the Mississippi* of a typical portrait found in "The House Beautiful" in 1874:

In big gilt frame, slander of the family in oil: papa holding a book ("Constitution of the United States"); guitar leaning against mamma, blue ribbons fluttering from its neck; the young ladies, as children, in slippers and scalloped pantalettes, one embracing toy horse, the other beguiling kitten with ball of yarn, and both simpering up at mamma, who simpers back. These persons all fresh, raw, and red — apparently skinned.

And here is the first critical estimate of American primitive portraiture, written in 1842 by Charles Dickens as he described in his *American Notes* an Inn in the village of Lebanon, Ohio:

In the best room were two oil portraits of the kit-cat size, representing the landlord and his infant son; both looking as bold as lions, and staring out of the canvas with an intensity that would have been cheap at any price. They were painted, I think, by the artist who had touched up the Belleville doors with red and gold; for I seemed to recognize his style immediately.

FIG. 4 — UNIDENTIFIED GENTLEMAN AND HIS WIFE (*c. 1840*). By James Sanford Ellsworth. Both signed *Ellsworth. Painter.* Water color on thin paper; shown slightly less than actual size. These portraits show the characteristic manner in which a decorative formula was applied by an eccentric primitive miniaturist. The rigidly symmetrical poses, the incorporation of the signatures in the design, the odd clover-leaf foils for heads and bodies, are all elements of a highly stylized conception of portraiture. Ellsworth was primarily concerned with design; though well able to paint with verisimilitude, he limited himself to a realistic rendering of the faces so as not to interrupt the design of the whole. *From the author's collection.*

The symbols of this home include "Thomas York, aged 50, Hariet York, aged 26, Julia Ann F. York, 4 months," the Holy Bible, vase of flowers, cat, framed picture, morning paper, and high hat. The all-pervasive sense of design which animates each detail of table, chair, dress, and rug, overflows in the exuberant calligraphic flourishes of the title. This water color is in the collection of the Museum of Modern Art. Specific comment on the other illustrations is given in the accompanying captions.

FIG. 5 — PASTEL PORTRAITS (*c. 1830*). Found in Fairfield, Connecticut. Size, approximately 15 by 20 inches. The finely balanced decoration of a painted surface, rather than the penetration of character or real appearance, was the unconscious achievement of this able draftsman. The pose and expression of the heads is almost neutral. Our interest is held by the decorative accessories, the squirrel on a chain and bowl of nuts, in the gentleman's portrait, his gay figured waistcoat and nice bow tie, the paintbox and rose for the lady. *Formerly in the collection of Harry Stone.*

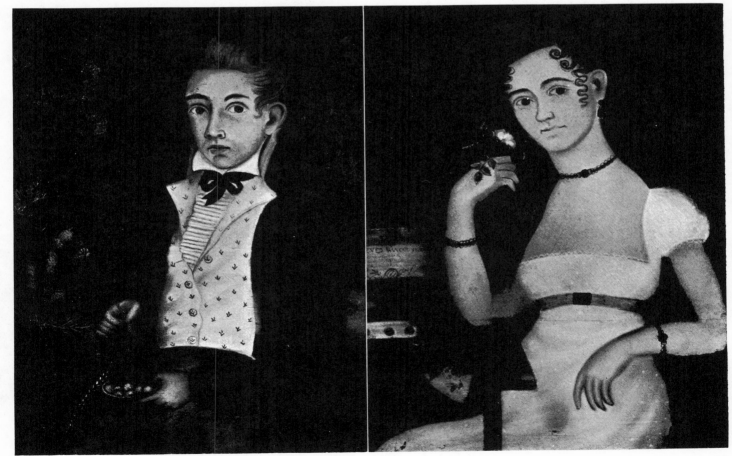

Zedekiah Belknap

BY ELIZABETH R. MANKIN,
Registrar, Smith College Museum of Art

PORTRAITS PAINTED BY the itinerant New England artist Zedekiah Belknap are found in nearly every major museum and private collection of American folk art.[1] He was born in Ward (now Auburn), Massachusetts, on March 8, 1781, the son of Elizabeth Wait and Zedekiah Belknap. Zedekiah Sr., a tailor, owned a two-acre lot in Ward.[2] According to family deeds dated 1794 and 1795, the family moved from Ward to Weathersfield, Vermont, in October 1794, where Zedekiah Sr. purchased twenty-five acres of land to be farmed by himself and his family. Zedekiah Sr.'s two elder brothers, Hezekiah and Joseph, were also farmers in Weathersfield.[3]

Unlike the other children in the Belknap family, Zedekiah Jr. was allowed to forego working on the farm in order to attend Dartmouth College in Hanover, New Hampshire. He graduated in 1807 and is listed in *Sketches of the Alumni of Dartmouth College* as having "studied divinity, and preached a few years, but was never ordained, his only employment known to us was that of portrait painting."[4] According to the Belknap family genealogy, Zedekiah Jr. served as a chaplain in the War of 1812. However, this is the only time he is known to have pursued a career other than portrait painting.

On April 30, 1812, he married Sophia Sherwin in Waterville, Maine.[5] Two conflicting stories about Belknap's marriage do, however, agree that it was short lived. According to family tradition Sophia died in 1815, leaving no children, and Belknap, overcome with sorrow, never remarried.[6] The other version of the story is contained in a letter found in Belknap's alumni records at Dartmouth College. In the letter a local Weathersfield historian wrote, "Belknap . . . married, but feared to bring his wife back home to Weathersfield where she would see all his limping relatives. Finally she insisted on coming, saw the sights and was horrified and insisted on parting from him. He staid around and did his painting with a broken heart. . . ."[7] Several members of the Belknap family were afflicted with a hereditary hip disease causing them to limp. Evidently the deformity was passed on in the family, whose members came to be known as the "Weathersfield Limpers."

Belknap undoubtedly came in contact with other painters while he was at Dartmouth College,[8] but it is difficult to determine exactly when he began his career as a professional portrait painter. His earliest known signed and dated work is inscribed in his own hand *Zedekiah Belknap/1810* (Fig. 1a). There is no evidence that Belknap ever had professional art training, but he was apparently quite a popular portrait painter in the small Vermont, New Hampshire, and Massachusetts towns through which he traveled during a career that spanned nearly forty years. About 150 signed or attributed likenesses have been discovered to date.

Belknap seems to have worked exclusively in oils and, as far as is known, painted only portraits. Most of his works

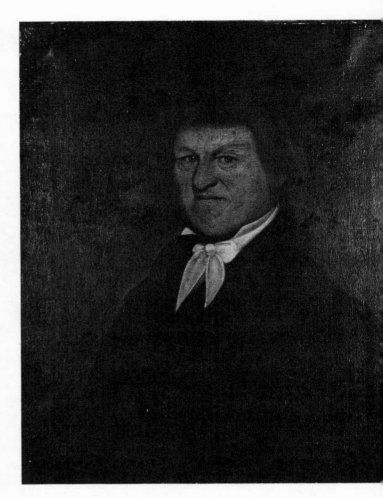

Fig. 1. *Joseph Stone* (1758-1837). Signed and dated at lower left, *Zedekiah Belknap/1810* (see Fig. 1a). Oil on canvas, 30 by 25 inches. The sitter lived in Ward (now Auburn), Massachusetts, and was known to have been a musician and a school teacher. According to his memoirs, which are owned by the Auburn Public Library, an institution that he helped to establish in 1830, he was an atheist who had a religious conversion in 1810 which changed his life and gave him a profound love of the Bible. *Private collection; photograph by Helen Marr-Parkin.*

Fig. 1a. Signature on the portrait shown in Fig. 1. This is the only known instance in which the artist spelled out his first name. There has been a great deal of confusion as to the proper spelling of Belknap's name. His gravestone in Weathersfield, Vermont, is inscribed *Zebakiah Belknap* (see Fig. 21). Town records there list his first name as both *Zedikiah* and *Zedekiah*.

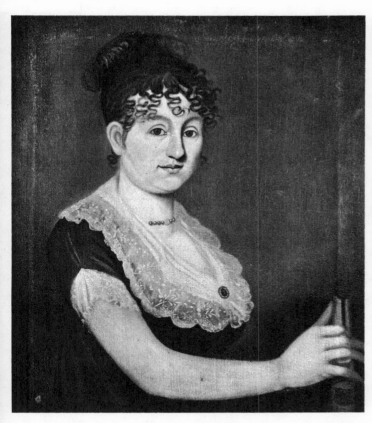

Fig. 2. *Mrs. Lenox,* c. 1810. Oil on canvas, 26½ by 22½ inches. This is one of six portraits of an unidentified family which has been called Lenox because the portraits were discovered in a house in Lenox, Massachusetts. Five of the portraits are in the Abby Aldrich Rockefeller Folk Art Collection. The sixth is in the Edward Duff Balkan collection at the Art Museum, Princeton University. *Abby Aldrich Rockefeller Folk Art Collection.*

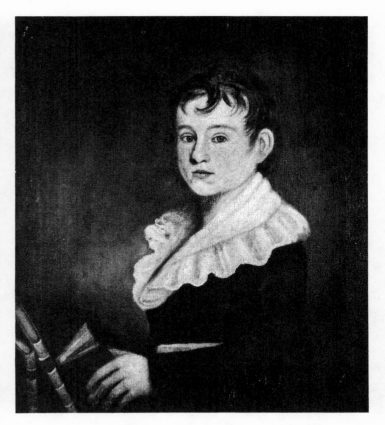

Fig. 3. *Master Lenox,* c. 1810. Oil on canvas, 26½ by 22½ inches. *Abby Aldrich Rockefeller Folk Art Collection.*

Fig. 4. *Young Man With Red Hair,* c. 1810. Oil on canvas, 26 by 21½ inches. *Collection of Mr. and Mrs. Peter H. Tillou.*

are on wood panel, although occasionally he used a coarsely woven canvas that has a distinct diagonal twill. His wood panels are usually scored with diagonal lines to simulate canvas twill. While characteristic of Belknap's portraits, scored wood panels were also used by other American portrait painters. The back of Belknap's panels are often covered with a gray-green wash.

Belknap's earliest likenesses, executed from about 1810 to about 1812, indicate his struggle to paint in an academic manner (Figs. 1-5). He painted on canvas during these years, and conscientiously attempted to model the faces of the sitters. He also frequently attempted difficult elements of anatomy, such as an outstretched arm or a hand holding a book (see Figs. 2, 3). Despite their academic overtones these early portraits contain most of the characteristics of Belknap's later formula style. Judging from the work that follows, such as the likenesses of Major and Mrs. Harrison (Pls. I, II) painted about 1815, and the Brown family portraits (Figs. 8-10) of 1819, the artist soon lapsed into a more comfortable style that enabled him to paint rapidly and was efficient for a traveling limner. He concentrated on the details of costume and used bright colors. Sitters are boldly outlined, but there is little modeling. Belknap consistently depicts only one side of the nose and outlines its profile with a heavy reddish shadow. Facial features are prominent: eyes are large and round, lips full,

(Text continued on page 1060)

Pl. I. *Major Thomas Harrison* c. 1815. Oil on basswood panel, 33½ by 25½ inches. See also Pl. II. A native of Boston, Massachusetts, Thomas Harrison joined the United States Army in May 1812 as an infantry captain and raised a company of men with whom he marched to the Canadian frontier. After losing a leg in the Battle of Chippawa, he was brevetted major for his distinguished service. In 1815, probably the year that this portrait was executed, he resigned his commission. He was an inspector in the Boston customhouse at the time of his death in 1855. *Abby Aldrich Rockefeller Folk Art Collection.*

Pl. II. *Mrs. Thomas Harrison* (first wife of Major Thomas Harrison), c. 1815. Oil on basswood panel, 33½ by 25½ inches. See also Pl. I. *Abby Aldrich Rockefeller Folk Art Collection.*

Fig. 5. *Young Woman With Lace Shawl,* c. 1810. Oil on canvas, 26 by 21½ inches. *Tillou collection.*

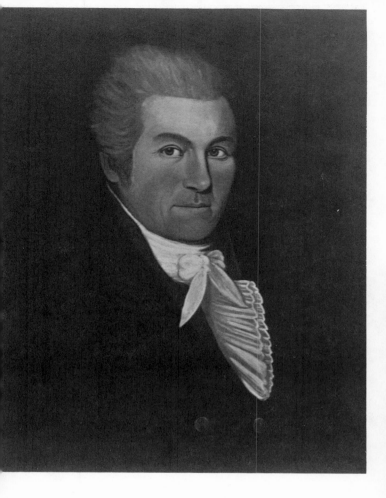

Pl. III. *Benjamin Pierce* (1757-1839), c. 1815. Oil on wood panel, 25 by 20 inches. See also Fig. 6. Born in Chelmsford, Massachusetts, Benjamin Pierce served heroically in the Revolutionary War and participated in the Battle of Bunker Hill. He settled in Hillsborough (now Hillsboro), New Hampshire, where his son, who became President Franklin Pierce, grew up. From 1789 to 1802 Benjamin Pierce was a member of the New Hampshire House of Representatives and from 1803 until 1809 he served on the governor's council. In 1805 he was appointed brigadier general of the Hillsborough County Regiment. He was elected governor of New Hampshire in 1827 and 1829. *Greenfield Village and Henry Ford Museum.*

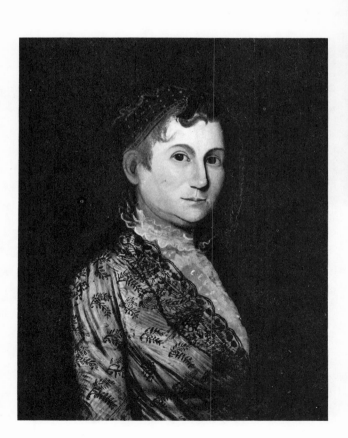

Pl. IV. *Mr. Jonathan Richardson.* Inscribed on the back, *The Portrait of Mr. Jonathan Richardson aged 47 yrs. weight. 237./ lb./ Z. Belknap pinxt./AD. 1829:* (see Fig. 15). Oil on wood panel, 27 by 22¾ inches. See also Pl. V. *Collection of Mrs. Kenneth Chorley.*

Fig. 6. *Anna Kendrick Pierce* (1768-1838) of Hillsborough, New Hampshire, c. 1815. Oil on wood panel, 25 by 20 inches. The second wife of Governor Benjamin Pierce (see Pl. III), Anna Pierce was the mother of President Franklin Pierce. *Greenfield Village and Henry Ford Museum.*

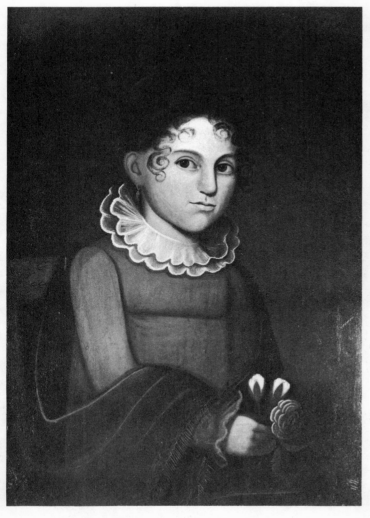

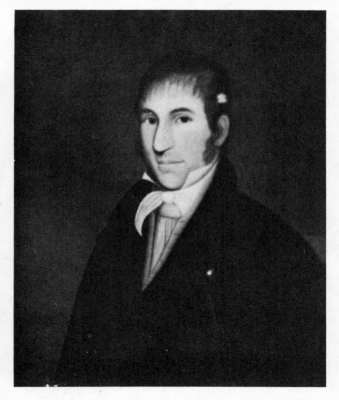

Fig. 8. *Philip Brown.* Signed and dated on the back, *Z. Belknap pinxt/May 7th 1819.* Oil on wood panel, 27 by 21½ inches. A resident of Hopkinton, New Hampshire, Philip Brown was a farmer, silversmith, and clockmaker. (A cherry tall-case clock with Brown's name on the dial was shown in ANTIQUES for July 1964, p. 61.) In 1820 he won a $25,000 New Hampshire lottery and became a very successful businessman. *New Hampshire Antiquarian Society.*

Fig. 9. *Mrs. Lavinia Brown* of Hopkinton, 1819. Oil on wood panel, 27 by 21½ inches. *New Hampshire Antiquarian Society.*

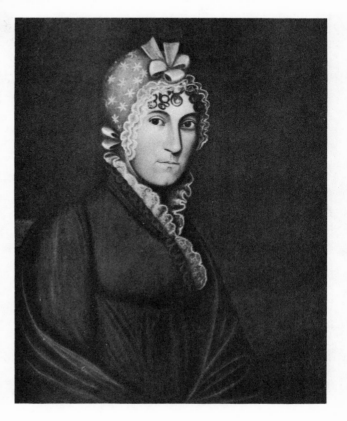

Fig. 7. *Mary Kirtland* (b. 1799) of Whitehall, New York, c. 1815. Oil on wood panel, 27 by 19½ inches. The sitter is one of the few known New York State residents painted by Belknap. She wears a bright red dress and a royal-blue shawl, and holds a rose, a flower that appears often in Belknap's portraits. *Collection of Sue and Ralph Katz.*

(Text continued from page 1057)
and ears flat and red. The artist disguised his shortcomings in the areas of perspective and anatomy by adding decorative elements such as a rose (Fig. 7), a music book (Fig. 17), or a basket of fruit (Pl. VIII). Green backgrounds, colorful shawls, and red curtains set off the stiffly seated subjects of Belknap's portraits. Because he paid great attention to costume and hair styles, Belknap's works document the fashions prevalent in small New England towns from about 1810 to 1850.

There are very few authentic Belknap signatures because the artist did not make it a practice to sign his works. The earliest known signature (Fig. 1a) is also the only one in which he spelled out his first name; his usual custom was to sign his name *Z. Belknap.* The latest signed portrait to have turned up is dated 1848 (Fig. 20).

The majority of Belknap's sitters were middle-class residents of small New England towns and villages. Their occupations include store and tavern keeping, clockmaking,

Fig. 10. *Sarah Lavinia Brown,* of Hopkinton, 1819. Oil on wood panel, 25 by 19¾ inches. *New Hampshire Antiquarian Society.*

and farming. Belknap painted several members of his own family as well as neighbors in Weathersfield and Springfield, Vermont. He also painted sitters who had been painted by one of his contemporaries, Asahel Powers (see Figs. 18, 19). Occasionally Belknap painted fairly important New Englanders such as Benjamin Pierce and his wife (Pl. III, Fig. 6). In a history of the town of Weathersfield, Zedekiah Belknap is noted as "a portrait painter of wide repute."[9]

Toward the end of Belknap's career he was affected by the introduction of the daguerreotype, as were most of the limners of the period. Although the artist's style changed little in four decades, the very few paintings of the 1840's that have survived are more realistic and lack some of the appealing decorative qualities of his earlier work. At some point during the late 1840's Belknap settled on the family farm in Weathersfield which his brother Samuel had purchased from their father in 1846 for $900. According to family tradition Belknap was not made very welcome on the family farm by his brothers and sisters. In 1857 he retired to the Chester Poor Farm, turning over to this institution his existing money to help compensate for his care. The town records note, "Town of Weathersfield in account with Charles Barrett, Overseer of the poor, Charge Boarding Z. Belknap from October 10, 1857; to June 8, 1858 $69.00/Town Farm."

Zedekiah Belknap died on June 8, 1858, at the age of seventy-seven. He is buried along with the rest of his family in Weathersfield (Fig. 21).

Fig. 11. *Unknown Woman,* c. 1820. Oil on wood panel, 25⅝ by 19¼ inches. *Private collection.*

Fig. 12. *Unknown Man,* c. 1820. Oil on wood panel, 24⅝ by 19¼ inches. *Private collection.*

Pl. V. *Mrs. Jonathan Richardson*, 1829. Oil on wood panel, 27 by 22¾ inches. See also Pl. IV. *Chorley collection.*

Fig. 13. *Luther Dana Brooks* (1795-1829) of Amherst, New Hampshire. Oil on wood panel, 27¼ by 22 inches. On the back of the panel, in what appears not to be the artist's hand, is the inscription *Portrait of/Luther Dana Brooks,/son of Isaac and Abigail Brooks, born in Amherst N.H./July 6th 1795./Drawn by Z. Belknap./Weathersfield Vt./May 1825.* Luther Dana Brooks died unmarried. *New Hampshire Historical Society.*

An exhibition of Belknap's works for which Miss Mankin is guest curator will be on view at the Abby Aldrich Rockefeller Folk Art Collection between May 8 and June 26, 1977; the New Hampshire Historical Society between July 1 and August 28; and at Old Sturbridge Village between September 1 and October 30.

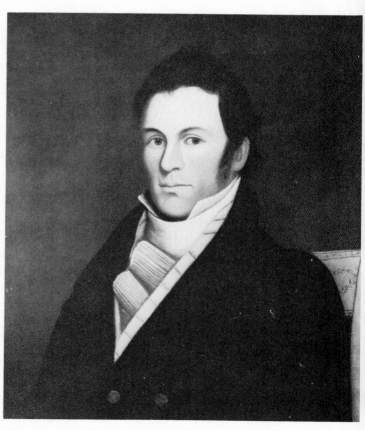

[1] I am grateful to Beatrix Rumford, director, and all the members of the staff of the Abby Aldrich Rockefeller Folk Art Collection for their guidance and help with the preparation of this article. I would also like to thank Nina Fletcher Little for making available to me her early research on Belknap, and Stephen Kornhauser, art conservator, for his generous assistance in the study of Belknap's paintings.

[2] Vital Records, 1781, Town Office, Auburn, Massachusetts.

[3] Probate Records, Town Office, Weathersfield, Vermont, vol. 3, p. 332.

[4] The Reverend George T. Chapman, *Sketches of the Alumni of Dartmouth College* (Cambridge, Massachusetts, 1867), p. 131.

[5] Carroll York Belknap, "Belknap Family Genealogy," private collection.

[6] All references to family history were provided by Helen Wheeler of Jamaica Plain, Massachusetts, the grandniece of Zedekiah Belknap.

[7] Letter from Raymond Beardslee, Springfield, Vermont, to Harold Rugg, September 22, 1936, in the alumni folder for Zedekiah Belknap, Dartmouth Rare Book Library, Hanover, New Hampshire.

[8] See ANTIQUES, July 1964, p. 63.

[9] E. W. Butterfield, *The Weathersfield Burying Ground* (Dover, New Hampshire, 1914), p. 1.

Pl. VI. *Kirk Pierce,* c. 1840. Oil on wood panel, 30 by 23 inches. Believed to represent Kirk Pierce, son of President Franklin Pierce's younger brother Henry Dearborn Pierce, the portrait was found in the Henry Dearborn/Kirk Pierce house in Hillsboro, New Hampshire. *Tillou collection.*

Pl. VII. *Frank H. Pierce,* c. 1840. Oil on wood panel, 30 by 23 inches. Believed to represent Frank H. Pierce, brother of Kirk Pierce (Pl. VI), this portrait was also found in the Henry Dearborn/Kirk Pierce house. *Tillou collection.*

Fig. 14. *Abigail Brooks Dodge* of Amherst. Oil on wood panel, 27¼ by 22 inches. On the back of the panel, in what appears not to be the artist's hand, is the inscription, *Portrait of /Abigail Brooks Dodge./Dau. of Isaac and Abigail Brooks./born in Amherst N.H./Sept. 25th 1806./Drawn by Z. Belknap./Weathersfield Vt./May 1825.* Abigail Brooks, sister of Luther, married Ninian C. Dodge in 1828. *New Hampshire Historical Society.*

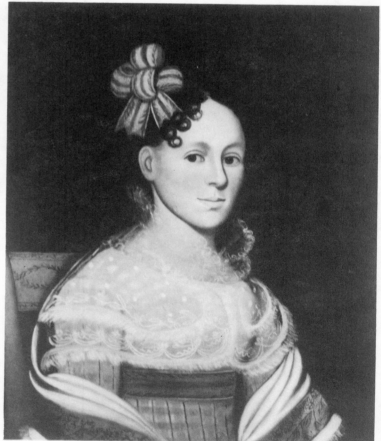

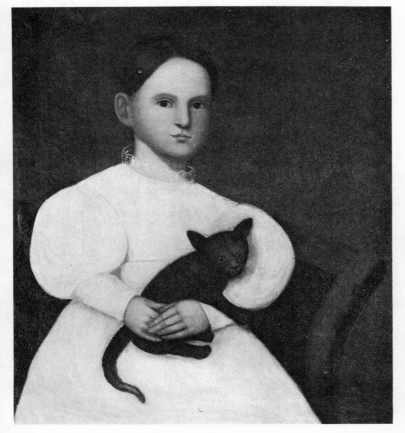

Fig. 16. *Girl in White Holding a Cat,* 1830-1835. Oil on canvas, 26¾ by 23 inches. Bernard Karfiol's (1886-1952) *Making Music* of 1938 portrayed the living room of Robert Laurent in Ogunquit, Maine. *Girl in White* is one of the paintings on the wall. *Collection of Paul and Marjorie Laurent.*

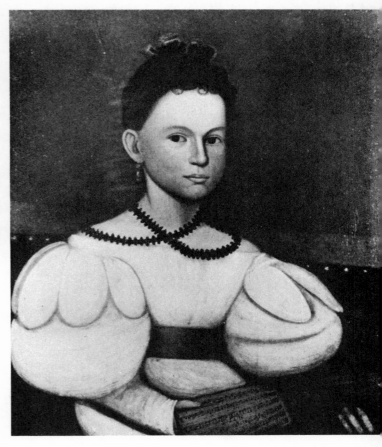

Fig. 17. *Young Girl Holding a Music Book,* c. 1835. Oil on canvas, 29 by 24 inches. *Private collection.*

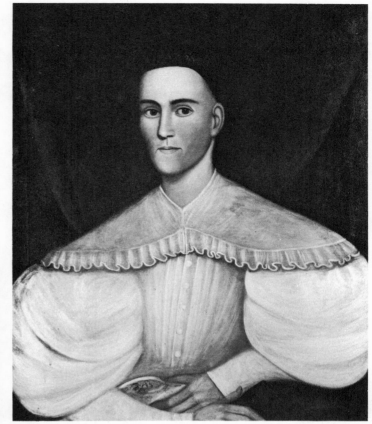

Fig. 18. *Hannah Fisher Stedman* of Chester, Vermont. Inscribed on the back, *Portrait of Miss Hannah F./Stedman Aged 27. yrs. Aug. 13th 1836./Painted in her last sickness. by Z. Belknap Augt. 13th. 1836.* The sitter died the following day. Oil on canvas, 28 by 24 inches. *Private collection.*

Fig. 18a. Inscription on the back of the portrait shown in Fig. 18.

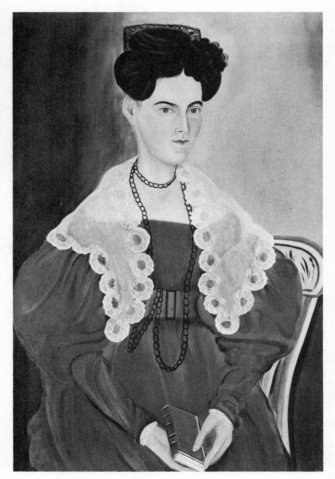

Fig. 19. *Hannah Fisher Stedman*, by Asahel Powers (1813-1843). Oil on wood panel, 26 by 25 inches. Inscribed on the back, *Hannah Fisher Stedman/AE 24 1833.* National Gallery of Art; gift of Edgar William and Bernice Chrysler Garbisch.

107

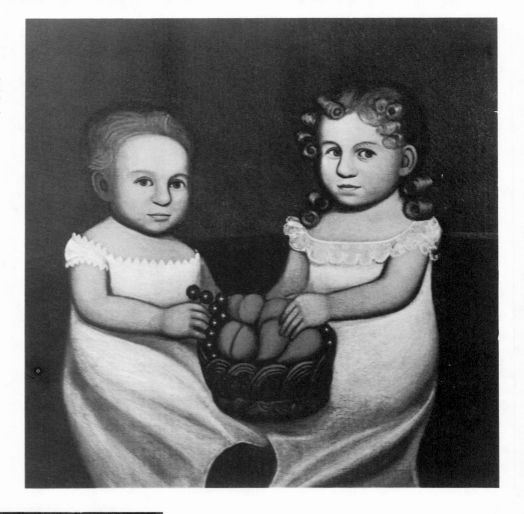

Pl. VIII. *Two Children Holding a Basket of Fruit*, 1825-1835. Oil on canvas, 27 by 27 inches. *New York State Historical Association.*

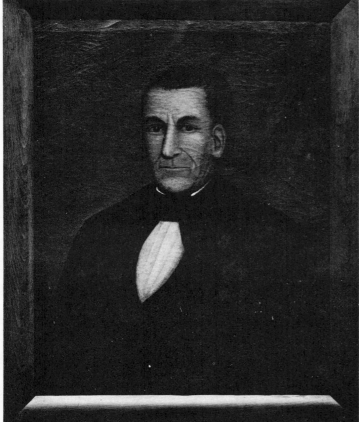

Fig. 20. *Rufus Holman.* Inscribed on the back *Portrait of Rufus Holman/at 71 yrs. Aug. 13th 1848/Z. Belknap pinxt/Nov. 1848.* Oil on canvas, 28 by 21½ inches. *Photograph by H. Peter Curran, by courtesy of Ona Curran.*

Fig. 21. Zedekiah Belknap's gravestone in the Aldrich Graveyard, Weathersfield, Vermont. The spelling of the artist's name is either a mistake on the part of the gravestone maker or another version of his first name. Other members of the Belknap family buried in the graveyard include the artist's father and mother, Zedekiah (d. April 19, 1846) and Elizabeth Wait Belknap (d. April 11, 1834); his brother Samuel (d. November 9, 1857); and his sisters Elizabeth and Polly (d. May 11, 1872).

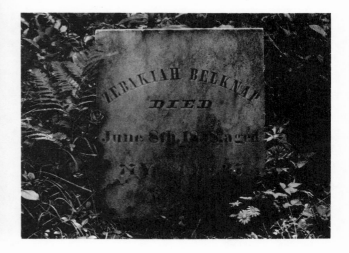

Chronological list of portraits by and attributed to Zedekiah Belknap

When a signature is not indicated, the portrait has been attributed to Belknap for stylistic or documentary reasons.

Joseph Stone (1758-1837); see Fig. 1

Young Man With Red Hair; see Fig. 4

Young Woman With Lace Shawl; see Fig. 5

Mr. Lenox, found in Lenox, Massachusetts, c. 1810
Oil on canvas, 26½ by 22½ inches
Abby Aldrich Rockefeller Folk Art Collection

Mrs. Lenox; see Fig. 2.

Master Lenox; see Fig. 3

Miss Lenox Holding Roses, found in Lenox, c. 1810
Oil on canvas, 26½ by 22½ inches
Abby Aldrich Rockefeller Folk Art Collection

Miss Lenox Holding Doll, found in Lenox, c. 1810
Oil on canvas 26½ by 22½ inches
Abby Aldrich Rockefeller Folk Art Collection

Girl in Mauve, found in Lenox, c. 1810
Oil on canvas, 26½ by 22½ inches
Art Museum, Princeton University, Edward Duff Balkan collection

Mr. Stewart, Middlebury, Vermont, c. 1810
Oil on canvas, 26¾ by 22½ inches
Private collection

Mrs. Stewart, Middlebury, Vermont, c. 1810
Oil on canvas, 26¾ by 22½ inches
Private collection

Hannah Harrison (1757-1812), Manchester, Vermont, 1810-1812
Oil on wood panel, 27½ by 23½ inches
Litchfield Historical Society

Nathaniel Wales (1778-1861), Newton Lower Falls, Massachusetts, 1813
25 by 19 inches
Whereabouts unknown
(According to *American Portraits Found in Massachusetts,* Boston, 1939, the portrait is signed and dated.)

Abigail Jackson Wales, Newton Lower Falls, 1813
25 by 19 inches
Whereabouts unknown
(According to *American Portraits Found in Massachusetts* the portrait is signed and dated.)

Woman in White, c. 1815
Oil on canvas, 27 by 21⅝ inches
Private collection

Mary Kirtland; see Fig. 7

Portrait of a Young Girl, c. 1815
Oil on wood panel, 27 by 21⅜ inches
New York State Historical Association

Benjamin Pierce; see Pl. III

Anna Kendrick Pierce; see Fig. 6

Major Thomas Harrison; see Pl. I

Mrs. Thomas Harrison; see Pl. II

Girl in a Red Dress, c. 1815
Oil on canvas
Private collection

Portrait of a Man, 1815-1820
Oil on wood panel, 27 by 22 inches
Private collection

Portrait of a Woman, 1815-1820
Oil on wood panel, 27 by 22 inches
Private collection

Rhoda True, 1815-1820
Oil on wood panel, 27¼ by 23 inches
Collection of Mr. and Mrs. Richard D. Keyes

Probably *Isaac Brooks* (1757-1840), Amherst, New Hampshire, 1815-1820
Oil on wood panel
Private collection

Probably *Abigail Kendrick Brooks,* Amherst, 1815-1820
Oil on wood panel
Private collection

Cambridge Man, found in Cambridge, Massachusetts, 1815-1820
Oil on canvas, 26 by 22 inches
Collection of Martin and Toby Landey

Cambridge Woman, found in Cambridge, 1815-1820
Oil on canvas, 26 by 22 inches
Landey collection

Daniel Clark Atkinson (1784-1842), Boscawen, New Hampshire, c. 1818
Oil on wood panel
New Hampshire Historical Society

Mahala Tilton Atkinson (1800-1820), Boscawen, c. 1818
Oil on wood panel
New Hampshire Historical Society

Philip Brown; see Fig. 8

Mrs. Lavinia Brown; see Fig. 9

Sarah Lavinia Brown; see Fig. 10

James Smith, Meriden, New Hampshire, 1819
Inscribed *Portrait of James Smith. Esq./Aged 52 yr. August AD 1819*
Oil on wood panel, 27 by 22½ inches
Society for the Preservation of New England Antiquities

Mrs. Mary Smith, Meriden, 1819
Inscribed *Portrait of Mrs. Mary Smith/Aged 47. AD 1819*
Oil on wood panel, 27 by 22½ inches
Society for the Preservation of New England Antiquities

Unknown Man; see Fig. 12

Unknown Woman; see Fig. 11

Portrait of a Man, c. 1820
Oil on wood panel, 27½ by 22½ inches
William M. Valentine House, Roslyn,
New York

Portrait of a Woman, c. 1820
Oil on wood panel, 27½ by 22½ inches
William M. Valentine House

Reverend Robinson Smiley, Springfield,
Vermont, c. 1820
Whereabouts unknown
(A daguerreotype of the portrait is
owned by the Congregational Church of
Springfield.)

Elizabeth Harkness Smiley, Springfield,
Vermont, c. 1820
Whereabouts unknown
(A daguerreotype of the portrait is
owned by the Congregational Church of
Springfield.)

Royal Wallace (1794-1829), Milford,
New Hampshire, c. 1820
Oil on wood panel, 27¼ by 21½ inches
Collection of T. R. Langdell

Hannah Wallace (1800-1879), Milford,
c. 1820
Oil on wood panel, 27¼ by 21½ inches
Langdell collection

James Wallace (1787-1831), Milford, c.
1820
Oil on wood panel, 27¼ by 21½ inches
Langdell collection

Sophia Tuttle Wallace (1780-1854),
Milford, c. 1820
Oil on wood panel, 27¼ by 21½ inches
Langdell collection

Elizabeth Bemis, Newton, Massachusetts, c. 1820
Whereabouts unknown

Girl With Gold Beads, c. 1820
Oil on wood panel, 26¾ by 22 inches
Abby Aldrich Rockefeller Folk Art Collection

Mrs. Powers, c. 1820
Oil on basswood panel, 27 by 22¾
inches
Abby Aldrich Rockefeller Folk Art Collection

Osgood True, Manchester, New Hampshire, c. 1820
Whereabouts unknown

Mrs. Osgood True, Manchester, c. 1820
Whereabouts unknown

D. Crane, Middleton, Massachusetts, c.
1820
Oil on wood panel
Private collection

Man With Side Burns, c. 1820
Oil on canvas, 27 by 22 inches
Whereabouts unknown
(Illustrated in *The Kennedy Quarterly,*
vol. 9, no. 3, December 1969, p. 182)

Woman With a Red Shawl, c. 1820
Oil on canvas, 27 by 22 inches
Whereabouts unknown
(Illustrated in *The Kennedy Quarterly,*
vol. 9, no. 3, December 1969, p. 182)

Mr. Gilson, Woodstock, Vermont,
1820-1825
Oil on wood panel, 27 by 22¾ inches
Whereabouts unknown
(Illustrated in *The Kennedy Quarterly,*
vol. 9, no. 3, December 1969, p. 182)

Mrs. Gilson, Woodstock, 1820-1825
Oil on wood panel, 27 by 22¾ inches
Whereabouts unknown
(Illustrated in *The Kennedy Quarterly,*
vol. 9, no. 3, December 1969, p. 182)

Deacon Daniel Emerson, 1820-1830
Oil on wood panel, 24 by 18 inches
Whereabouts unknown
(Illustrated in ANTIQUES, August 1971,
p. 210)

Hannah Moshier Emerson, 1820-1830
Oil on wood panel, 24 by 18 inches
Whereabouts unknown
(Illustrated in ANTIQUES, August 1971,
p. 210)

Jonas Minot Melville, Jaffrey, New
Hampshire, 1823
Oil on wood panel
Jaffrey Library

Betsy Lacey Melville, Jaffrey, 1823
Oil on wood panel
Jaffrey Library

Henry Melville, c. 1825
Oil on wood panel
Now destroyed

Mrs. Minor Giles Pratt (b. 1806 in
Ward, Massachusetts; d. 1860 in Honeoye, New York), c. 1825
Oil on canvas
Private collection

*Portrait of a Young Woman in White
Holding a Book,* c. 1825
Oil on canvas, 25 by 19 inches
Collection of Herbert W. Hemphill Jr.

Elizabeth Barber Smith (1804-1833),
South Hadley, Massachusetts, c. 1825
Oil on wood panel, 27 by 23 inches
Collection of Mr. and Mrs. Earl B. Osborn

Portrait of a Man, c. 1825
Oil on canvas, 26 by 22 inches
Collection of Sue and Ralph Katz

Portrait of a Woman, c. 1825
Oil on canvas, 26 by 22 inches
Katz collection

Luther Dana Brooks; see Fig. 13

Abigail Brooks Dodge; see Fig. 14

Isaac Brooks, Amherst, 1825
Inscribed (not in the artist's hand) *Portrait of/Isaac Brooks/born in Woburn,
Mass./August 16th, 1757./Drawn by Z.
Belknap./Weathersfield Vt./May 1825*
Oil on wood panel, 27 by 22⅜ inches
New Hampshire Historical Society

Abigail Kendrick Brooks, Amherst,
1825
Inscribed (not in the artist's hand) *Portrait of/Abigail Kendrick Brooks./wife
of Isaac Brooks./born in Amherst
(Monson) N.H./Aug. 8th 1764./Drawn
by Z. Belknap./Weathersfield Vt./May
1825*
Oil on wood panel, 27 by 22¾ inches
New Hampshire Historical Society

Unknown Man, 1825-1830
Oil on wood panel, 26¼ by 21¾ inches
Collection of Mary Allis

Unknown Woman, 1825-1830
Oil on wood panel, 26¼ by 21¾ inches
Allis collection

James Estabrook, Holden, Massachusetts, 1825-1830
Oil on wood panel, 26½ by 21½ inches
Private collection

Portrait of a Woman, 1825-1830
Oil on canvas, 27 by 22 inches
Hemphill collection

Man With Jabot, 1825-1830
Oil on basswood panel, 27¼ by 22½ inches
Abby Aldrich Rockefeller Folk Art Collection

Lady in White Shawl and Lace Cap, 1825-1830
Oil on basswood panel, 27¼ by 22½ inches
Abby Aldrich Rockefeller Folk Art Collection

Portrait of a Woman, 1825-1830
Oil on wood panel, 26 by 21 inches
Private collection

Marshall Newton, Fayetteville, New York, 1825-1830
Oil on canvas
Private collection

Gregory Stone, Weathersfield, Vermont, 1825-1830
Oil on wood panel, 30 by 26 inches
Whereabouts unknown
(Illustrated in *Garth's Auction,* October 8-9, 1971, catalogue, p. 228)

Prudence Leland Stone, Weathersfield, 1825-1830
Oil on wood panel, 30 by 26 inches
Whereabouts unknown
(Illustrated in *Garth's Auction,* October 8-9, 1971, catalogue, p. 228)

Prudence Leland Stone, Weathersfield, 1825-1830
Oil on canvas, 30 by 26 inches
Private collection

Portrait of a Child, 1825-1835
Oil on wood panel, 26 by 22 inches
Collection of Anne and Madison Grant

Two Children Holding a Basket of Fruit; see Pl. VIII

Mr. Taylor, Springfield, Massachusetts, 1825-1835
Oil on wood panel
Whereabouts unknown
(Illustrated in Antiques, October 1964, p. 486)

Mrs. Taylor, Springfield, Massachusetts, 1825-1835
Oil on wood panel
Whereabouts unknown
(Illustrated in Antiques, October 1964, p. 486)

Josiah Gilson, Esq., 1827
Inscribed *Portrait of Josiah Gilson, Esq. aged 34 yrs AD 1827*
Oil on wood panel
Private collection

Mrs. Vashti Gilson, 1827
Inscribed *Portrait of Mrs. Vashti Gilson aged 35 yrs. AD 1827*
Oil on wood panel
Private collection

Portrait of a Young Girl, 1829
Inscribed *Z. Belknap, A.D. 1829*
Oil on wood panel
Private collection

Ralph Warren, Esq., Townsend, Massachusetts, 1829
Inscribed (not in the artist's hand) *Ralph Warren, Esq/1829 Townsend, Mass*
Oil on wood panel
Private collection

Becky Sherwin Warren, Townsend, 1829
Inscribed (not in the artist's hand) *Becky Sherwin Warren/1829 Townsend, Mass.*
Oil on wood panel
Private collection

Dorman Theodore Warren, Townsend, 1829
Inscribed (not in the artist's hand) *Dorman Theodore Warren/born 1827, painted 1829./Townsend, Mass.*
Oil on wood panel
Private collection

Mr. Jonathan Richardson; see Pl. IV

Mrs. Jonathan Richardson; see Pl. V

Girl Holding Doll and Wearing Miniature, c. 1830
Oil on canvas
Collection of Edgar William and Bernice Chrysler Garbisch

Portrait of a Woman, c. 1830
Oil on wood panel
Whereabouts unknown
(Exhibited at the Miller Art Center, Springfield, Vermont, in 1958)

Portrait of a Woman, c. 1830
Oil on wood panel, 26 by 20 inches
Photograph by courtesy of Silver Spring Farm

Sarah Minot Melville (1818-1849), Nelson, New Hampshire, c. 1830
Oil on wood panel, 26 by 20 inches
Collection of Henry Melville Fuller

Portrait of Two Children, 1830-1835
Oil on canvas, 24½ by 29¼ inches
Collection of Mr. and Mrs. Albert B. Earl

Portrait of a Man, 1830-1835
Oil on canvas, 27¼ by 23¼ inches
Collection of Lilian and Don Glugover

Portrait of a Woman, 1830-1835
Oil on canvas, 27¼ by 23¼ inches
Glugover collection

Girl in White Holding a Cat; see Fig. 16
Portrait of a Woman, 1830-1835
Oil on canvas, 28⅛ by 24 inches
Private collection

Man in Black Jacket, 1830-1835
Oil on basswood panel, 28 by 23 inches
Abby Aldrich Rockefeller Folk Art Collection

Lady in White Shawl, 1830-1835
Oil on basswood panel, 28 by 23 inches
Abby Aldrich Rockefeller Folk Art Collection

Man in a Black Coat, 1830-1840
Oil on wood panel, 30 by 25 inches
Collection of Mr. and Mrs. Kenneth Hammitt

Asa Knight (1793-1851), Dummerston, Vermont, c. 1832
Oil on canvas, 29¾ by 25¼ inches
(Illustrated in Antiques, April 1975, p. 676)
Private collection

Mrs. Asa Knight (nee Susan Miller; 1796-1884) *and Asa Randolf Knight* (1831-1910), Dummerston, c. 1832
Oil on canvas, 30 by 25 inches
(Illustrated in ANTIQUES, April 1975, p. 676)
Private collection

Joel Knight, Dummerston, c. 1832
Whereabouts unknown
(Illustrated in *History of the Town of Dummerston,* Ludlow, Vermont, 1884, p.121)

Mrs. Esther Farr Knight, Dummerston, c. 1832
Whereabouts unknown
(Illustrated in *History of the Town of Dummerston,* p.143)

Mr. Chase, Springfield, Vermont, c. 1835
Oil on wood panel
(Nina Fletcher Little, *Asahel Powers Painter of Vermont Faces,* Colonial Williamsburg Foundation, 1973, Fig. 1, shows a portrait of Jonathan Chase of Springfield, Vermont, by Asahel Powers, 1832.)
Private collection

Mrs. Chase, Springfield, Vermont, c. 1835
Inscribed on leather strap attached to panel, *Chase*
Oil on wood panel
(Little, *Asahel Powers,* Fig. 2, shows a portrait of Mrs. Jonathan Chase of Springfield, Vermont, painted by Asahel Powers, 1832.)
Private collection

Master Chase, Springfield, Vermont, c. 1835
Oil on wood panel
(Little, *Asahel Powers,* Fig. 4, shows a portrait of Moses Fisher Chase of Springfield, Vermont, painted by Asahel Powers, 1832.)
Private collection

Martha Williams (1825-1875), Perkinsville and Springfield, Vermont, c. 1835
Oil on canvas
Private collection

Lucinda Williams, Springfield, Vermont, c. 1835
Oil on canvas
Private collection

Portrait of a Lady of Salem, Massachusetts, c. 1835
Oil on canvas
Fruitlands Museum, Harvard, Massachusetts

Portrait of a Lady From Salem, Massachusetts, c. 1835
Oil on canvas
Fruitlands Museums

Young Girl Holding a Music Book; see Fig. 17

Elderly Man, c. 1835
Oil on canvas
Collection of Robert Chase

Elderly Woman, c. 1835
Oil on canvas
Chase collection

Man with Glasses, 1835-1840
Oil on canvas
Private collection

Woman With Lace Cap, 1835-1840
Oil on canvas
Private collection

Lt. Governor Kidder, Vermont, 1835-1840
Oil on wood panel
Private collection

Mrs. Kidder, Vermont, 1835-1840
Oil on wood panel
Private collection

Mother and Child Holding Watch and Waterlilies, 1835-1840
Oil on canvas, 28 by 24 inches
Private collection

Portrait of a Woman, 1835-1845
Oil on ticking
Private collection

Hannah Fisher Stedman; see Fig. 18

Robert Bailey Thomas (1766-1846; founder of *The Farmer's Almanac),* Massachusetts, 1836
Inscribed *Portrait of Robert B. Thomas, Esq./Z. Belknap, Pinxt.* (now covered by a new canvas lining)
Oil on canvas
American Antiquarian Society

Mrs. Robert B. Thomas, Massachusetts, 1836
Oil on canvas
American Antiquarian Society

Elijah Dudley (1781-1858), Shrewsbury(?), Vermont, 1829 and 1838
Inscribed *Z. Belknap 1829/Shrewsbury/Finished over in 1838*
Inscribed (not in the artist's hand) *Portrait of Mr. Elijah Dudley*
Oil on canvas, 27¼ by 22⅞ inches
Old Sturbridge Village

Captain Randolph Sea Captain, Portsmouth, New Hampshire, 1839
Inscribed *Z. Belknap, 1839* (now covered by a new canvas lining)
Oil on canvas, 23½ by 18 inches
Fruitlands Museums

Frank H. Pierce; see Pl. VII

Kirk Pierce; see Pl. VI

George Emerson Lewis, Springfield, Vermont, c. 1840
Oil on wood panel, 25½ by 18½ inches
Old Sturbridge Village

Mary Redfield Lewis (1818-1900; niece of Zedekiah Belknap), Springfield, Vermont, c. 1840
Oil on wood panel, 26 by 18 inches
Old Sturbridge Village

Unknown Lady with Hymnal, c. 1840
Oil on wood panel, 26 by 19 inches
Collection of Mr. and Mrs. Samuel H. Blood

Roswell Lockwoort, c. 1840
28 by 24 inches
Whereabouts unknown; *ex coll.* Edith Gregor Halpert

Young Boy Holding Book, c. 1840
Oil on wood panel, 28 by 23 inches
Whereabouts unknown
(Illustrated in *Skinner Auction,* September 25, 1969, catalogue, lot 134)

Rufus Holman; see Fig. 20

Ammi Phillips, limner extraordinary

BY BARBARA AND LARRY HOLDRIDGE

THE BORDER LIMNER and the Kent Limner, those two mysterious names in the lore of American itinerant portrait painting, are no more. After thirty-seven years and dozens of separate inquiries into the identity of each, both have been replaced by one name alone: Ammi Phillips. Startling though the discovery is, it has driven no one to sorrow over the loss of the romantic anonyms. For this one man, whose style changes confused even experts, is more romantic, more intriguing, and greater by far than the cloaked figures who have represented him all these decades.

Two years of intensive research (recounted in detail in the Summer 1960 issue of *Art in America*) culminated in our resolution of the mystery. The work of the Border Limner, primitive but vigorously assured, was actually the early period of the sophisticated Kent Limner, whose

name we had found—signed by the artist as *Mr, Ammi, Phillips*—on the back of a typical Kent Limner oil portrait, of George C. Sunderland (Fig. 1).

The youthful Border portraits (c. 1812-1822), in contrast with those of the later Kent period, might be likened to the attempt of a gifted child to copy a portrait he has always seen in his home. His version is done boldly, with uncramped strokes, and the subject's pose is duplicated faithfully. But the viewpoint and the limitations of the child prevail. What emerges is a true primitive, in which everything is naïvely simplified. Outline holds the brightly colored forms, and subtleties are all but absent. If by comparison with the original the youngster's attempt seems crude, still it is—in its assurance, innocence, and simplification—completely fresh and disarming.

In Phillips' case, the youthful, primitive paintings were probably not copies of any pictures he had seen, but attempts to express an ideal toward which his untutored craftsmanship strove. For never during his entire development as an artist did he alter his basic conception of portrait painting. Rather, he endeavored continuously to make the painting on his easel resemble his *idée fixe*. The difference between *Philip Slade* (Fig. 3), say, and the later *Agriculturalist* (Fig. 5) is mostly a matter of technical skill. The fundamental design qualities, the characteristic stylized approach, remain the hall-

Fig. 1. *George C. Sunderland*, front and back. The Rosetta stone of the Kent-Border Limner mystery was this handsome portrait found in a Connecticut dealer's shop. To date, this is the only painting discovered which bears the artist's full signature, verified by comparison with his will. Note the trial run of the little-used first name on the stretcher, upper right. *Authors' collection.*

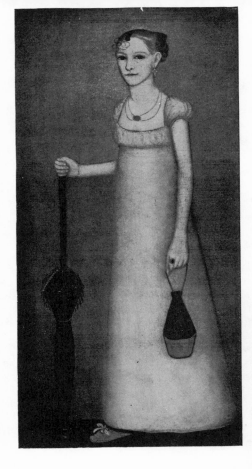

Fig. 2. *Harriet Leavens*. A Border period painting, c. 1815, and one of the only two full-length portraits by Phillips discovered so far. It is also by far the largest canvas: 57 by 28 inches as opposed to the average 33 by 28 inches. Like other Border portraits, this one is gaily colored in various soft hues, leading to the speculation that Phillips' earliest work may have been in pastels rather than oils. *Fogg Art Museum, Harvard University.*

Fig. 3. *Philip Slade*, 1818. Long attributed to the Border Limner, this early portrait already embodies Phillips' mature conception of portrait composition, while harking back to the earliest paintings yet found. This is one of the rare instances in which the name of the subject and the date, though not the artist's name, are lettered on the back of the canvas. *Collection of Edgar William and Bernice Chrysler Garbisch, National Gallery of Art.*

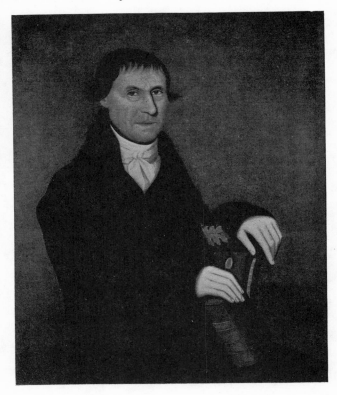

marks of any Phillips portrait, whatever its period.

To dismiss this single-mindedness as proof of a lack of artistic worth would be a mistake. For by sticking steadfastly to his preconceived ideal Ammi Phillips established his own classicism, unaided by the followers and imitators who usually, by perpetuating a master's style, constitute his school. In effect, Phillips was an entire school in himself, originating, refining, and proliferating his fixed style so successfully that today it seems to epitomize the limning art of America.

Phillips differed from the popular idea of the itinerant artist in that he did not live constantly on the road. It may be this erroneous but widely held notion of American country artists as little more than bums-with-paintbrushes which has prevented many people from considering their work seriously, as art. But in fact most of them were hard-working and earnest men, whose very lack of academic training resulted in America's most original contribution to world art. Cut off as these country people were from the usual sources of instruction, and forced to use their native resourcefulness, they ultimately developed a truly indigenous set of artistic conventions and values, no more to be ridiculed than those of the Egyptians or the Etruscans. But the isolation was soon broken, the tepid air of Victorianism swept into the remotest parlors of the land, and the still-young tradition was hurriedly shut up in attics. The wonder is that we have those magnificent fifty years of true native art as our heritage, and an artist of Phillips' stature to call our own.

Three years ago, when we first made the discovery that Ammi Phillips was the Kent Limner, we knew nothing about him apart from his name and, very roughly, the locality in which he worked. Slowly, with the help of genealogies, local histories, field trips, and an interested descendant of a sister of Phillips' first wife, we began to put together some facts about his long life.

Ammi Phillips was born on April 24, 1788, the fourth son of Samuel and Milla Phillips of Colebrook, Connecticut. Whether actually born in the village or not, the boy had close ancestral ties with it, since the Phillips clan had come there with the first settlers, and owned a substantial amount of its farmland. Even Ammi's first name was a local tradition—a tribute to the Reverend Ammi Ruhammah Robbins, beloved pastor in Litchfield County for more than fifty years.

Before he was twenty-six, Phillips had already painted portraits of the Dorr family of Hoosick (see color plate), young Harriet Leavens of Troy (Fig. 2), a certain Jerusha Rogers, said to be of Rensselaer County, and a few others still in existence. These known portraits indicate that the young artist had come to New York, and was fairly well established in the Albany area. In 1813,

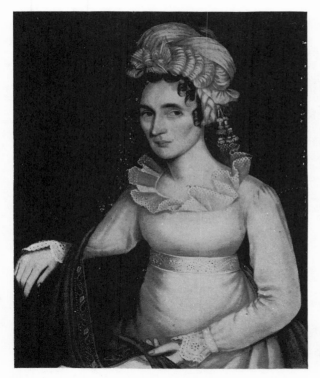

Fig. 4. *Lady in White*. Painted about 1825, the unknown lady is remarkable for her sultry sophistication, making this one of the most compelling portraits in American art. While the artist's mastery of his medium is complete, details such as the handling of the dress folds are highly reminiscent of the primitive Border period. *Collection of Edgar William and Bernice Chrysler Garbisch, National Gallery of Art.*

at the age of twenty-five, he married young Laura Brockway in Nassau, New York, and took her to live in Troy. Using that thriving town as his base, Phillips made long and short trips into the surrounding area to paint portraits. This was always to be the pattern of his career. Rather than wandering aimlessly, he mined an entire area for portrait commissions, and moved his home only when nearby prospects thinned out. Because he painted the people of his neighborhood, people whom he knew well, he was able to capture on canvas the inner as well as the outer character of his subjects.

In later years he left city life behind him, settling his growing family in Rhinebeck until after his young wife died. With his second wife, Jane Ann Caulkins, he made his home successively in Poughkeepsie, Amenia, and Northeast, all in Dutchess County. Finally, in his sixties and seventies, Phillips lived among the Berkshire hills of Massachusetts, in the village of Curtisville, now called Interlaken. There in 1865 he died.

Throughout this long span—some fifty-five years in all—Ammi Phillips painted portraits. But his years of greatest activity and inspiration—when he produced the portraits which were to earn him, a hundred years later, the name of Kent Limner—were those between the late 1820's and 1840. It was then that Phillips, leaving his farm, his children, and his wife, made many long trips down the west side of the Hudson, as far south as Phillipsburgh in Orange County. In other expeditions eastward, he persuaded scores of Dutchess County folk to sit for their portraits. Increasing skill and facility

Fig. 5. *The Agriculturalist*, c. 1829, incorporates the major elements which made Phillips so successful in his own time: highly decorative, posterlike stylization, and portraiture so sharply realized that it brings to mind one contemporary's comment about another Phillips painting: "It looks more natural than Nels does himself." *Authors' collection.*

Fig. 6. *Hannah Mills Raymond*, c. 1836. One of the original paintings discovered in Kent, Connecticut, in 1924, this is a fine example of the almost abstract quality of Phillips' Kent style. The circular design of the composition is carried down the slope of the shoulder, around the curve of the leg-of-mutton sleeve, and then gently in an upward curve from one hand to the other, and around again to the expressive face. While the pose differs only subtly from that of the *Lady in White* of 1825, there is a new leaning of the body which conveys great delicacy, and a gracious poise absent from other limners' portraits. *Authors' collection.*

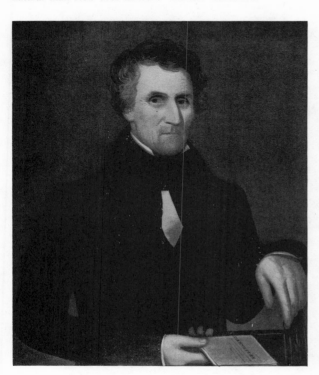

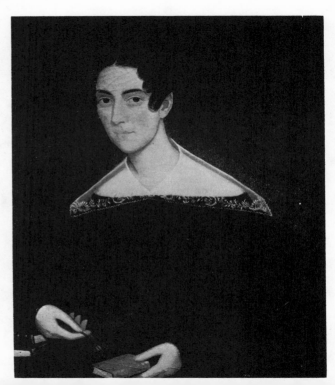

made him a prolific painter: for every portrait of the preceding years there exist a dozen or more Kent portraits.

It was in the 1830's also that Phillips painted most of the prosperous families in Kent, Connecticut. Because these were the first of his portraits to be rediscovered in the twentieth century, "Kent style" has become the accepted way of describing any Phillips painting in his manner of the 1830's.

All the Phillips women of the Kent period, whether farmer's wives or town sophisticates, wear the same mantle of aristocracy and of delicate breeding. All the men are cultivated and stalwart personages. They are individuals still, but Phillips has idealized them as a proud and truly impressive breed of Americans. These are ancestor portraits in the best sense of the term, for they transcend likenesses and maintain an air of timelessness.

Wherever Phillips painted them, in Kent, Rhinebeck, Pine Plains, Amenia, Schodack, and dozens of other places, these pictures have in common a quality of decorative stylization different from other portraits painted in America. With realism now subordinate to harmony of design, there is an almost abstract quality about these paintings, composed as they are of triangles, circles, rectangles, and ellipses (Fig. 6). Yet this pronounced stylization is not in the least dehumanizing. Each of the women conveys her own individuality, and each is, at the same time, the very essence of femininity, with her petal-like fingers and profusion of laces. In the

paintings of men there is greater angularity, in keeping with the virility of the subjects, and an even more dramatic posterlike quality. In all the Phillips portraits of this period, the dark plum or mulberry backgrounds add a sumptuous richness, against which the ivories, pinks, grays, crisp whites, and flat blacks glow warmly.

In the later years of Phillips' life, hack paintings outnumbered such triumphs as *Jane Kinney Fyler* (Fig. 7), and we can guess why. Age probably had a great deal to do with it, for he lived to be seventy-seven, and evidently painted until his death (Fig. 8). Then, with the change of times, saccharine Victorianism affected the demands of his customers. More dispiriting than anything else was the influence of the daguerreotype. Although Ammi Phillips kept painting after many limners had given up the struggle against this arch-competitor, the insensitive "realism" of the big black box began to be reflected in his own work, especially in the 1860's.

But even when the mediocre portraits have been noted, there remains a body of work remarkable for its enduring quality. Nearly one hundred years after the death of Ammi Phillips, and thirty-seven years after the first modern tribute to his work, the artist himself is emerging from obscurity. No longer simply the Border Limner or the Kent Limner, Phillips takes his place as a distinctly American master, who in his work spanned more than fifty years of our history, and who interpreted the men and women of his time with a vision of their splendor.

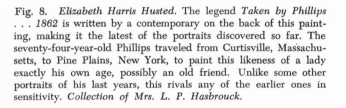

Fig. 8. *Elizabeth Harris Husted.* The legend *Taken by Phillips . . . 1862* is written by a contemporary on the back of this painting, making it the latest of the portraits discovered so far. The seventy-four-year-old Phillips traveled from Curtisville, Massachusetts, to Pine Plains, New York, to paint this likeness of a lady exactly his own age, possibly an old friend. Unlike some other portraits of his last years, this rivals any of the earlier ones in sensitivity. *Collection of Mrs. L. P. Hasbrouck.*

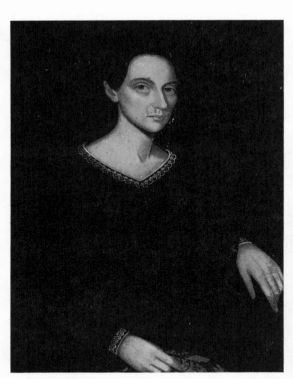

Fig. 7. *Jane Kinney Fyler*, 1848. A comparatively late masterpiece, this portrait has an enigmatic character, a quality both inviting and repelling, challenging yet unfathomable. Phillips remained uncompromising in this strong portrayal, notwithstanding the fact that the subject was his second cousin. *Authors' collection.*

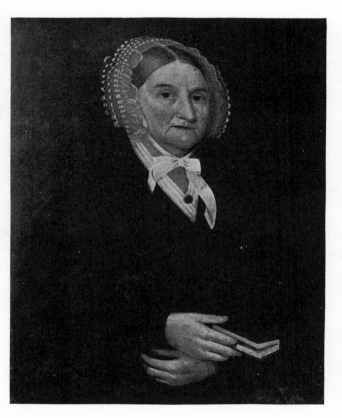

Portraits by Ammi Phillips
in museum collections

Abby Aldrich Rockefeller Folk Art Collection, Williamsburg, Virginia:
> MAN IN A BLACK JACKET, C. 1820
> WOMAN WITH JET AND GOLD NECKLACE, C. 1820
> MAN WITH A BOOK, C. 1848
> LADY ON A RED SOFA, C. 1848
> WOMAN IN A BLACK DRESS, C. 1850
> WOMAN IN A BLACK WRAP DRESS, C. 1850
> GERTRUDE HARDER, C. 1820
> WILLIAM G. HARDER, C. 1820
> DR. RUSSELL DORR, C. 1814
> MRS. RUSSELL DORR AND BABY ESTHER MARIA, C. 1814
> RUSSELL GRIFFIN DORR, C. 1814
> ROBERT LOTTRIDGE DORR, C. 1814

Albany Institute of History and Art, Albany, New York:
> PORTRAIT OF AN UNKNOWN WOMAN, C. 1824
> JUDGE VANDERPOEL VAN ALAN, C. 1820
> MRS. VANDERPOEL VAN ALAN, C. 1815

American Museum in Britain, Bath, England:
> MRS. GARRETT DU BOIS, C. 1812

Art Institute of Chicago, Chicago, Illinois:
> DR. CORNELIUS ALLERTON, C. 1821
> MRS. CORNELIUS ALLERTON, C. 1821

Berkshire Museum, Pittsfield, Massachusetts:
> MRS. GOODRICH AND CHILD OF HANCOCK, MASSACHU-
> SETTS, C. 1812

Fogg Art Museum, Harvard University, Cambridge, Massachusetts:
> HARRIET LEAVENS, C. 1815
> JERUSHA ROGERS, C. 1813

Henry Ford Museum and Greenfield Village, Dearborn, Michigan:
> MR. AND MRS. MORGAN HUNTING, C. 1830

National Gallery of Art, Washington, D. C., Edgar William and Bernice Chrysler Garbisch Collection:
> MR. BRADLEY, C. 1836
> MRS. BRADLEY, C. 1836
> LADY IN WHITE, C. 1825
> JOSEPH SLADE, 1816
> ALICE SLADE, 1816
> PHILIP SLADE, 1818

Princeton University Art Museum, Princeton, New Jersey:
> MRS. ZACHARIAH FLAGLER, C. 1820
> HANCOCK GOODRICH, C. 1812
> GIRL IN PINK, C. 1832
> GIRL IN RED, C. 1832
> MAN WITH THE "NEW-YORK ENQUIRER," 1832
> WIFE OF THE MAN, 1832
> PAULINA DORR, C. 1814

Senate House, Kingston, New York:
> DOCTOR DEWEY, C. 1820
> DOCTOR VAN DEUSEN, C. 1820
> REVEREND DE WITT, C. 1823
> REVEREND THOMAS DE WITT, C. 1830
> JAMES A. SLEIGHT, C. 1830
> MRS. JAMES A. SLEIGHT, C. 1830
> A LADY OF THE RADCLIFFE FAMILY, C. 1820

Shelburne Museum, Shelburne, Vermont:
> DR. ELMORE EVERITT, C. 1830

Published portraits
by Ammi Phillips

Holdridge, "Ammi Phillips," *Art in America*, Number Two, 1960; pp. 98 ff.:
> MRS. RUSSELL DORR AND BABY, C. 1814
> ALICE SLADE, 1816
> JOSEPH SLADE, 1816
> EBENEZER PUNDERSON, C. 1820
> MRS. BRADLEY, C. 1836
> UNIDENTIFIED LADY, C. 1855

Rediscovered Painters of Upstate New York, 1700-1875, New York State Historical Association, Cooperstown, 1958, p. 21:
> HARRIET LEAVENS, C. 1815

American Primitive Paintings from the Collection of Edgar William and Bernice Chrysler Garbisch, Part II, National Gallery of Art, 1957, pp. 36, 59:
> MR. BRADLEY
> PHILIP SLADE

Jean Lipman, *American Primitive Painting*, Oxford University Press, 1942, plate 20:
> UNIDENTIFIED LADY, C. 1836
> MRS. JULIA FULLER BARNUM, C. 1836
> MRS. ALMIRA PERRY, C. 1836

Elizabeth L. Gebhard, *The Parsonage between Two Manors*, Bryan Printing Co., 1909, frontispiece and opp. p. 220:
> REVEREND JOHN GABRIEL GEBHARD, 1820
> ANNA M. GEBHARD, 1820

Mrs. H. G. Nelson, "Early American Primitives," *International Studio*, March 1925, pp. 454 ff.:
> RUFUS FULLER, C. 1836
> ELIZABETH DRAKE FULLER, C. 1836
> JOHN MILTON RAYMOND, 1836
> PHOEBE PRESTON HAVILAND, C. 1836
> FLORILLA MILLS RAYMOND, 1836

Jean Lipman, "I. J. H. Bradley, Portrait Painter," *Art in America*, June 1945, pp. 160, 164:
> UNIDENTIFIED LADY, C. 1836
> UNIDENTIFIED GENTLEMAN, C. 1836
> JAMES A. SLEIGHT, C. 1836

New-Found Folk Art of the Young Republic, New York State Historical Association, Cooperstown, 1960, Number 11:
> MOTHER AND CHILD IN WHITE, C. 1816

Color plate, facing page. Russell Griffin Dorr, c. 1814. One of at least six little and big Dorrs of Hoosick painted by the Border Limner. Since Ammi Phillips in his youthful days intensively worked the so-called Border Country once claimed by both New York and Connecticut, this was a handy and appropriate label for the artist before his identity was known. Abby Aldrich Rockefeller Folk Art Collection.

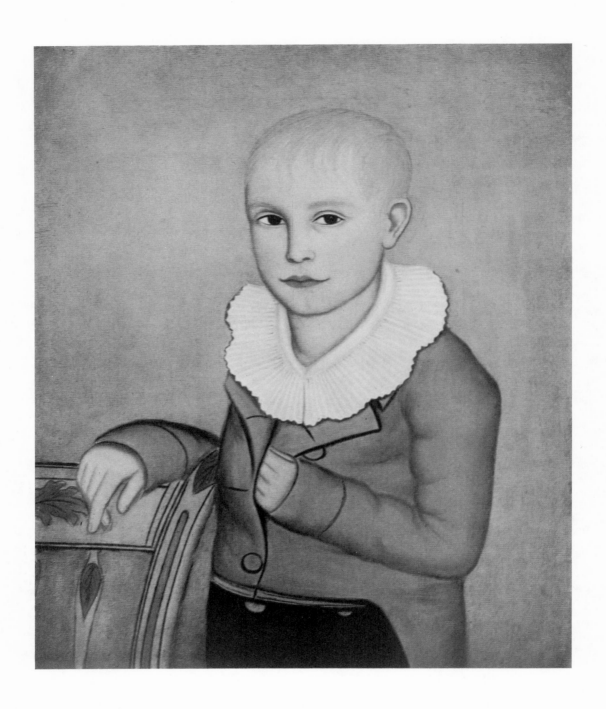

TWO AMERICAN PRIMITIVES

Abijah Canfield of Connecticut

IN ALL PROBABILITY, nothing would be known of Abijah Canfield's activities as a painter if he had not owed a debt to Hiram Upson which he found himself unable to pay. Abijah proposed to work out the obligation by painting Hiram's portrait and that of his wife. It is said that Hiram was somewhat loath to accept this proposal, but he acquiesced in the end. The finished products are illustrated here. A statement pasted on the back of each, written and signed by the Upsons' son-in-law, George W. Beach, declares that the portraits were executed in 1820 and presented on June 3, 1871, to the Upsons' second daughter, Martha, on the occasion of her forty-fourth birthday.

Abijah Canfield was born in Chusetown, part of Derby, Connecticut, on September 9, 1769, and died in the same town (though its name was changed in 1804 to Humphreysville) on August 14, 1830. Very little is known about him,

reluctantly—fell in with the suggestion would indicate that Abijah was no novice at portrait painting and that Hiram set some store by his skill. He must previously have seen some of his debtor's work. Probably Abijah Canfield enjoyed a local reputation as a painter. At any rate, the two portraits which have survived could scarcely be first attempts in the field.

It is said that the Upsons held the pictures in slight esteem, and that they would probably have been thrown away if their daughter Martha had not been fond of them and finally received them as a gift. Some of Sarah Upson's dissatisfaction with her portrait seems to have been due to the fact that the lace about her neck was an unauthorized addition. "I never wore a thing like that!" she is said to have remarked. Her dress, however, was painted correctly, and her little curls represented "quite as she wore them," she is reported to have told her children years later.

An inventory of Abijah Canfield's estate made after his death listed some 75 acres of land, two barns, three houses, a wood house, still house, shop, and cider mill, as well as cows, sheep, and all manner of tools, household effects, and grain. Among all these items, however, there is no mention of brushes, paints, canvas, palette, or paintings.

—KENNETH SCOTT

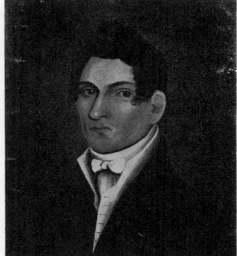

HIRAM AND SARAH UPSON by Abijah Canfield (1820). *Owned by Miss Grace Rogers of Newark, New Jersey.*

TINTYPES OF SARAH AND HIRAM UPSON in later life. A comparison of the features indicates that Abijah Canfield's portraits must have been quite good likenesses. *Now owned by Mrs. John L. Scott.*

beyond the fact that his father was a physician and he himself a farmer. Abijah inherited some land from his father, and on April 12, 1819, he purchased an additional plot for $100. Possibly this may have been the time when he incurred the debt to Hiram Upson. When he died in 1830, Canfield was still indebted to Upson, but only to the extent of $2.26. We have no way of knowing how much credit was allowed him for the portraits.

The fact that Abijah Canfield would have ventured to propose such a method of paying what he owed and that Hiram Upson—however

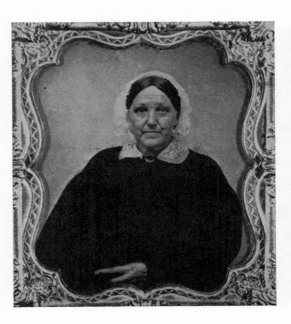
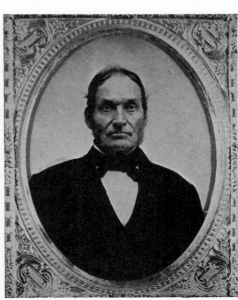

WILLIAM M. PRIOR, TRAVELING ARTIST

And His In-Laws, the Painting Hamblens

By NINA FLETCHER LITTLE

Nina Fletcher Little (Mrs. Bertram K.) has recently turned her attention from ceramics and New England architecture (see 1945, April through June) to early American painting. She was responsible for the first exhibition of paintings by Winthrop Chandler at the Worcester Art Museum last spring, and her monograph on that painter appeared in Art in America for April. This study of Prior is the first of a series on lesser nineteenth-century American painters, which will appear in ANTIQUES.

WILLIAM MATTHEW PRIOR was one of the most versatile artists of mid-nineteenth-century New England. His portraits on glass, and his "flat" likenesses done in tempera on artist's board, are well known to students and collectors of American primitive paintings. Less often found are his landscapes and his large portraits in oil. The latter show him to have been capable of producing results far superior to those usually credited to him by persons familiar only with his less accomplished work. The theory has been advanced that he changed his style abruptly, and inexplicably, some time during the 1840's while working in the vicinity of New Bedford, Fall River, and Sturbridge, Massachusetts. Therefore, these unshaded delineations, and many others which are not signed but follow a similar pattern, are sometimes grouped together under the generic name of the "Fall River-Sturbridge school of painting" (Clara Endicott Sears, *Some American Primitives*). The fact is that Prior could paint well when he wished to, or when it was financially profitable, but for his less affluent patrons he early adopted a style which provided a passable likeness with the least possible expenditure of his own time and effort. Such is the real explanation of the great dissimilarity which exists among various examples of his signed work. Proof of this has recently come to light, contained in a series of newspaper advertisements and in a rare label found on the back of one of his typical "flat" portraits.

From the family Bibles we learn that the first Benjamin Prior came from England to Duxbury, Massachusetts, in 1638. The second Benjamin was born there in 1699, and the third Benjamin in 1740. His son Matthew, shipmaster and father of the artist, was born in 1774. He married Sarah Bryant of Duxbury in 1797 and was lost at sea in 1816. Their second son was William Mat-

thew, born in Bath, Maine, on May 16, 1806. Of his childhood and early youth no details have survived, except the story that as a small boy he painted the portrait of a neighbor on a nearby barn door, causing quite a stir in the community. If he received any formal training there is no record of it, but a small portrait of a young man done on a white pine panel, signed and dated *Portland, Aug. 14, 1824*, indicates that he was already traveling and painting professionally at the modest age of eighteen years (*Fig. 1*).

On June 5, 1827, when he was twenty-one years old, Prior inserted the following notice in the *Maine Inquirer:* "Ornamental painting, old tea trays, waiters re-japanned and ornamented in a very tasty style. Bronzing, oil guilding and varnishing by Wm. M. Prior, Bath. No 1 Middle Street." The following summer he advertised again, once more proving a willingness to undertake any sort of decorative work. "Wm. Prior, fancy, sign, and ornamental painting. Also drawings of machineries of every description executed in good order and on shortest possible notice." (In this connection it is interesting to note that the first steam mill on Trufant's Point, Bath, was built in 1821, and that the Bath Furnace Company was casting machinery in pig iron at this same period.) In 1828 we find the first mention of himself as a limner. Under date of February 28, and continuing for some months thereafter, appears this notice: "Portrait painter, Wm. M. Prior, offers his services to the public. Those who wish for a likeness at a reasonable price are invited to call soon. Side views and profiles of children at reduced prices." Here is the first suggestion of a price scale based on type of work. In 1830 he was still carrying on as a general decorator: "Military, standard, sign and ornamental painting as usual." Coupled with this is an interesting statement of the values of his portraits, which ranged from $10 to $25 with gilt frames from $3 to $10. Therefore his most expensive likeness with the best frame would have cost the sitter $35, a not inconsiderable charge for a young man still in his twenties, at a time when other artists were doing large family portraits for as low as $10.

Several competent portraits are attributable to this period. One of an unknown young man is signed *By Wm. Prior, 1829 (Fig. 2)*. Here we find the figure set in an oval, quite unusual for Prior, and if the pose is slightly stiff the face is well drawn and modeled,

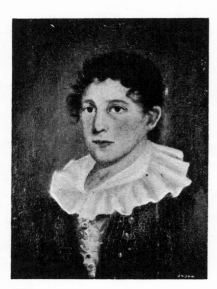

FIG. 1 — PORTRAIT of a young man. Oil on wood panel. Said to be a member of the Hall family of Tivoli, New York. Inscribed on back: *Painted by William Matthew Prior, Portland, Aug. 14, 1824.* The earliest dated portrait known to the author; done when Prior was 18. *Collection of Joseph Downs. Photograph courtesy Frick Art Reference Library.*

FIG. 2 — PORTRAIT of a young man. Oil on canvas, 26½ by 22½ inches. Signed on back: *By Wm. Prior, 1829. Courtesy Ginsburg & Levy Inc. Photograph courtesy Frick Art Reference Library.*

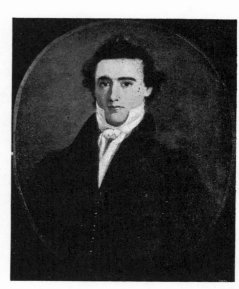

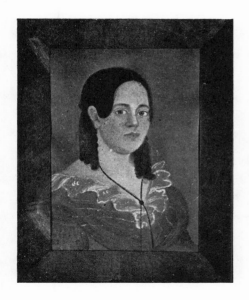

FIG. 3 — MR. AND MRS. NAT TODD, said to be of Paxton, Massachusetts. Tempera on academy board. His picture, 17 by 13; her picture, 14 by 10 inches. The backboard of his frame bears a printed label giving time and price of sitting. *From the author's collection.*

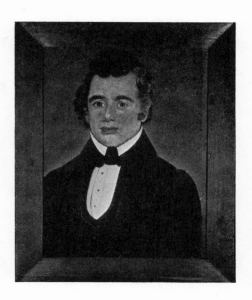

and the composition as a whole is dignified and pleasing. In 1831 he painted a comparable picture of H. B. Webb, Esq., of Bath which now hangs in the gallery at Fruitlands and the Wayside Museums Incorporated at Harvard, Massachusetts. In the same year he exhibited at the Boston Athenaeum his portrait of A. Hammett of Bath. Curiously enough this is his only appearance in the catalogues of the Athenaeum.

On April 5, 1831, appears the last advertisement in the *Inquirer:* "Fancy pieces painted, either designed or copied to suit the customer, enameling on glass tablets for looking glasses and time pieces . . ." Here can be discerned the beginnings of what later developed into his very successful line of glass portraiture. Although he came of seafaring ancestry and lived all his life on the New England coast no marine paintings are credited to him, and the following is his only reference to any work connected with ships: "Lettering of every description, imitation carved work for vessels, trail boards and stearn moldings painted in bold style." It is the closing sentence of this advertisement, however, which merits special attention, for here in his own words we find reference to the pictures which have come to typify Prior's work to the average collector: "*Persons wishing for a flat picture can have a likeness without shade or shadow at one quarter price.*"

Nat Todd and his wife, although painted at a somewhat later date, illustrate perfectly the "flat pictures" herein described, and are easily recognizable as typical examples of Prior's work (*Fig. 3*). On the back of his frame is a rare printed label which reads: "PORTRAITS / PAINTED IN THIS STYLE! / Done in about an hour's sitting. / Price $2,92, including Frame, Glass, &c. / Please call at Trenton Street / East Boston / WM. M. PRIOR"

Here we have corroboration of the fact that this type of painting resulted from the small amount of time and money to be expended by the sitter rather than from a potential lack of skill on the part of the artist.

It appears that Prior moved his family to Portland, Maine, sometime between 1831 and 1834. On April 28, 1828, he had been married to Rosamond Clark Hamblen by the Reverend Seneca White of the First Church in Bath. Their two eldest children, Rosamond Clark and Gilbert Stuart, were born in Bath in 1829 and 1831 respectively, while Rienzi Willey, William Matthew Jr., and Jane Willey were all born in Portland between 1836 and 1840. When Prior married Rosamond Hamblen, daughter of Almery and Sally (Clark) Hamblen of Portland, he became connected with a family of painters with traditions older than his own. Rosamond was a descendant of James and Hannah Hamblen, settlers in 1639 of Barnstable, Massachusetts, from where her great-grandmother, Mrs. Gershom Hamblen, moved to Gorham,

Maine, about 1763. Rosamond's grandfather George had been apprenticed in Barnstable to learn the trade of painter and glazier, which he continued to follow after his removal with his mother to Gorham. His son Almery eventually became a prominent "mechanic" in Portland, where he was associated in the painting business with his four sons, Joseph G., Nathaniel, Eli, and Sturtevant J. (brothers of Rosamond), whose names appear variously in the Portland directories from 1823 to 1841.

In 1834 "William Prior, portrait painter" first appears in Portland residing with his brother-in-law, Nathaniel Hamblen, painter, on Green Street. Before long, however, he established his own residence, and in 1837 his relatives Joseph G. and Sturtevant J., painters, list themselves as living "at Wm. M. Prior's." In 1838 three of the Hamblen brothers bought a large farm in Scarborough where Eli died suddenly in 1839, after which the Hamblens and Priors moved together to Boston.

Painted during the sojourn in Portland were the portraits of his brother and sister-in-law, "Captain" Eli and Maria Louisa (Hannaford) Hamblen (*Fig. 4*). These were done in 1838 shortly before the death of the former. He is shown with spyglass under arm, standing against the rigging of his ship, which appears in the background. It seems odd that his name is listed as "painter" in the directories and is not found in the shipping registers. These pictures are painted in Prior's better style and exhibit the qualities which are to be found in all the portraits of his own family, of which seven are still owned by descendants. (Two others are illustrated in ANTIQUES for November 1934, p. 180.)

It seems probable that the Prior family moved to Boston between May 8 and July 31, 1840, as these dates mark the birth of their daughter Jane in Portland, and the death of their second son, William Jr., in Boston. In any event Prior and all his Hamblen in-laws were definitely established there in 1841, living together in Nathaniel Hamblen's house at 12 Chambers Street. Three of the Hamblens called themselves "House, sign, and fancy painters," while Sturtevant J., probably a pupil of his successful brother-in-law, set himself up as a portrait painter and followed that profession for fifteen years. The two families remained at the Chambers Street address for only one year, moving in 1842 to Marion Street, East Boston, where they remained together until 1844.

During the next two years Prior's name does not appear in the city directories. Perhaps he was away on one of his long tours painting pictures wherever he could find sitters or families who would offer bed and board in return for his labors. It is said that at one time he owned a horse and wagon in which he took his wife and two elder children traveling through New England and adjoining states. In later years he used to pack forty canvases into

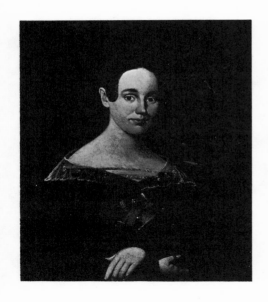

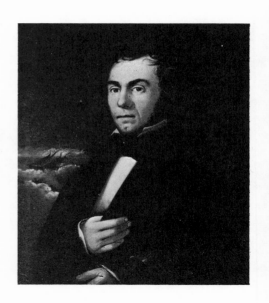

FIG. 4 — CAPTAIN AND MRS. ELI HAMBLEN of Portland, Maine. Oil on canvas. His picture is signed: *Portrait of Capt. Elie Hamblen, AE 34. Painted by William Mat. Prior, Portland, April 12, 1838.* Her picture is signed: *Prior, 1838. From the author's collection.*

a large wooden chest which measured 51 by 22 inches, put it on the train, and leave it stored in the depot when he came to the end of his journey. Then carrying as many canvases as he could, he would set off on foot into the nearby countryside, hoping to stay at the homes of prospective clients. In 1849 he painted seven children in one Newport, Rhode Island, family, ranging in ages from two to seventeen years, while remaining in their home for many weeks. His son Matthew traveled the New England coast with him, going as far south as Baltimore where pictures have been found signed with his name and bearing the address, *272 E. Monument St., Balto.* He peddled his pictures to workers in the East Boston shipyards as well as to patrons of an old hotel on Elm Street in Boston, and it is said that during Dickens' visit to Boston he painted his picture.

Prior lived at a time when painters' materials were not as easily come by as they are today. He prepared his own canvases, ground his own paint, and with the help of his sons Gilbert and Matthew made many of his own frames in the cellar of his Trenton Street house. A few of his signed pictures have been found on bed ticking, but according to his son he usually employed a type of cotton drilling which was stretched, primed, then scratched with a palette knife, and primed and scraped again, until a satisfactorily firm texture had been obtained. Another duty of the younger Priors was to turn the paint mill for the grinding of the colors, a tedious occupation. Prior made the frames on the portraits of himself and his first wife, now owned by his granddaughter, which are of wide mahogany veneer with an inner gold line. The type of frame supplied for the "flat pictures" was of plain beveled wood, two inches in width (*Fig. 3*), while his portraits on glass were given simple gilt moldings.

After considerable effort Prior succeeded in persuading

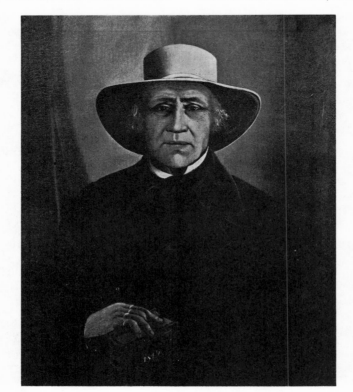

the Boston Athenaeum to allow him to make a copy of their portrait of Washington by Gilbert Stuart. He had long been an admirer of Stuart's work and had named his eldest son after him. Prior's picture is signed: *Copy from G. Stuart by Wm. M. Prior, 1850* (illustrated in ANTIQUES, November 1934, p. 180). From this model he made many copies on glass, using the technique of enameling with which he had decorated mirrors and clocks as a young man in Bath. These ranged in size from 18 by 22 to 22 by 25 inches. He did many other well-known personages in this medium, among whom were Mrs. Washington, Webster, Lincoln, Theodore Parker, and Napoleon. Signed *W. M. Prior,* they sold for $3 or $4 each (illustrated in ANTIQUES, February 1934, p. 78).

During the second quarter of the nineteenth century the Advent Movement was originated by a dynamic man named William Miller who came to believe, from a study of prophetic chronology, that the second coming of Christ and the end of the world would occur between March 21, 1843 and the same date in 1844. In 1831 he began to speak in support of his theories to many denominations throughout New England. He lectured with great success for thirteen days in the Casco Street Christian Church in Portland during March of 1840, and on October 13 of that year the Millerites held a large conference in Boston. It is probable that Prior attended both conclaves; in any event he and his brother-in-law, Joseph G. Hamblen, became ardent followers of the movement and Prior named one of his daughters Balona Miller after the chronologist.

Fig. 5 — PORTRAIT author believes possibly to be of William Miller, by Prior. Miller was the famous leader of the Millerite movement about whom Prior wrote *The King's Vesture* in 1862. This picture shows him holding a copy of *Voltaire,* whose teachings he followed before his conversion. Contemporary accounts note his shrewd blue eyes, his venerable white locks and wrinkles, and the white beaver hat which was part of his habitual costume. The date 1849 indicates the year of his death. *From the author's collection.*

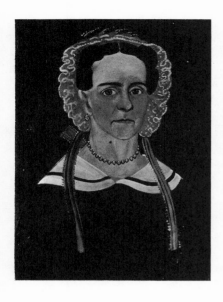

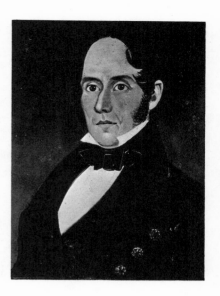

FIG. 6 — MR. AND MRS. AARON JEWETT of Longmeadow, Massachusetts. By Sturtevant J. Hamblen. Tempera on academy board, 14 by 10 inches. His picture is inscribed: *A. J., aged 44 years. Painted by L. J. Hamblin No 12 Chambers St., Boston 1841.* (The L. is an error for S.). *From Halladay-Thomas Collection.*

He attended as many of the gatherings as he could, often becoming greatly excited at the meetings. It would be surprising indeed if he had not painted the man for whom he held such admiration and respect, but it is only as this article is going to press that a hitherto unknown portrait of Miller has been discovered and attributed to Prior (*Fig. 5*). In 1862 he published a book entitled *The King's Vesture, Evidence from Scripture and History Comparatively Applied to William Miller, the Chronologist of 1843.* This complicated treatise is an attempt to prove by interpretation of scriptural prophecy that Miller was himself Christ in his second coming. On the same subject he wrote *The Empyrean Canopy* (1868) in which he tells of painting a chronological chart under the direction of Miller, and of being moved to paint his portrait.

By 1846 Prior had purchased a house at 36 Trenton Street, East Boston, which he called "The Painting Garret." Over the door he hung one of his large pictures as a combination sign and advertisement, and here he continued to live and work until his death in 1873. Sometimes he would have a great many pictures piled up waiting to be finished, and the last touches were often applied by his son Matthew. His wife died August 25, 1849, a year after the birth of her eighth child, and about a year later he married Hannah Frances Walworth of Andover, Massachusetts.

In the meantime the Hamblen brothers continued to pursue the painting business in Boston, and eventually a second generation grew up and carried on the family profession. During the 1840's and 1850's there are listed at times as many as six related painting Hamblens. Only Sturtevant, however, considered himself a portrait painter, from 1841 until 1856. After this, evidently becoming discouraged with his artistic career, he entered into a partnership in "Gent's Furnishings" with his brother Joseph. I have identified only four portraits, those of the Jewett family of Springfield, Massachusetts, as the work of Sturtevant Hamblen (*Fig. 6*). These are dated 1841 and were painted at 12 Chambers Street, during the first year that the Priors and Hamblens were living together in Boston. It seems obvious that he

FIG. 7 — LANDSCAPE. *View off Mattapoissett, Mass.* Detail shows Prior's signature on back. *From author's collection.*

did not customarily sign his pictures as those illustrated are inscribed by the owner and not by the artist. They are done on artist's board and have such a general similarity to the work of Prior that in all probability many of the unsigned likenesses attributed to Prior are in reality the work of Sturtevant J. Hamblen.

Prior also tried his hand at landscapes but apparently they were not in as great demand as portraits, and he seems to have confined himself mostly to adaptations of prints, or to stock subjects of which he made many copies. His view of *Mount Vernon and Washington's Tomb* (illustrated, ANTIQUES, November 1934) is not in any way distinguished from many others of its period. Another subject which he painted many times was called *Moonlight*, and he also did winter scenes. Two views bearing the Baltimore address, one dated 1855, appear to be purely imaginary, combining castles, cottages, and streams, populated with gaily dressed peasants and fishermen. One of his more unusual landscapes, intended to be definitely topographical, is entitled *View off Mattapoissett, Mass.* (*Fig. 7*). This may be one of the "fancy pieces" mentioned in his advertisements, as the scene is placed within an oval and a narrow gold line surrounding the entire composition serves as a frame. In addition to the title the reverse bears this inscription in Prior's 'easily recognized hand: *Warranted Oil Colours, by Wm. M. Prior. No. 1370. Price $2.50.* (see detail).

Mention should be made of a few of the other varied inscriptions found on his pictures which make a study of Prior's work both interesting and amusing. Many are carefully signed with the name of the artist, the place of origin, and the day, month, and year in which the work was presumably completed. Sometimes other valuable information is included, such as the price, or the age of the sitter. The portrait of Eli Hamblen (*Fig. 4*) is signed: *Portrait of Capt. Elie Hamblen, AE 34, painted by William Mat. Prior, Portland, April 12, 1838.* The likeness of one of his sons is inscribed: *Matthew Prior, painted by his Father, 1870, author of the King's Vesture and . . .* Here follow the titles of two of his other books, now unfor-

FIG. 8 — PORTRAIT of a lady and child. Oil on canvas. Inscribed on back: *By Wm. M. Prior. Mr. Turner paid $4.00. Mr. Sawin $4.00. May 1851. From the author's collection.*

tunately become illegible. On the back of his daughter's picture he wrote: *Rosamond C. Prior, Age 16, Painted by Wm. M. Prior, 1846. Retouched age 20, May 30, 1850.* Three portraits are known which are identified on the front in small block letters. Two dated *May 1843* (illustrated ANTIQUES, October 1938, p. 182) are of a colored man and his wife, and are unusual because of the landscape which appears through a window in the background. These and another signed picture dated *September 1854* of three little colored children indicate that Negroes were numbered among Prior's clientele; this fact recalls his connection with the Millerites, many of whose leaders supported the Abolitionist cause. Perhaps the most intriguing inscription is found on the reverse of one of his large "flat pictures" (*Fig. 8*). This reads: *By Wm. M. Prior. Mr. Turner paid $4.00, Mr. Sawin $4.00. May 1851.* The two figures are evenly disposed on the canvas, and the half of the picture paid for by each gentleman is clearly defined by an unmistakable line drawn down the background between the lady and the child. A printed label used by Prior has already been noted, and a stamp is sometimes found which reads: *Painting Garret / No. 36 Trenton Street / East Boston / W. M. Prior.*

In summing up the pictorial achievements of William Matthew

Prior it may fairly be said that he neither exhibited great artistic talent, nor excelled in imaginative composition. He could, however, execute portraits with a considerable degree of competence when occasion demanded. His flat likenesses are perhaps more interesting as examples of a conscious effort to give the public what it wanted at a price it was willing to pay, than for their inherent merit. Nevertheless he was an able and varied craftsman, combining a knowledge of general decorating with commercial, portrait, and landscape painting, all of which he pursued throughout an active and colorful career. His many signed pictures afford ample material for a study of the scope of his work, which deserves a recognized place among that of the other provincial artists of the 1800's.

NOTE: I wish especially to acknowledge the kindness of Mrs. Grace Lyman Stammers in allowing me to use her notes on Prior, including those obtained from the artist's son Matthew; also of the following members of the Prior and Hamblin families, with whom I have had interviews and correspondence: Miss Clara Roberts, Miss Marion G. Prior, Miss Alice H. Hamblin, and Mrs. Josephine Hamblin Day. Other sources of information include: *Some American Primitives* by Clara Endicott Sears; *William M. Prior* by Grace Adams Lyman, ANTIQUES, November 1934; *History of Gorham, Maine* by Hugh D. McClellan; newspapers, city directories, Prior family Bibles (Massachusetts Society of Mayflower Descendants), records of Bath and Portland in City Clerks' offices. — N. F. L.

DEBORAH GOLDSMITH
Itinerant Portrait Painter
By JEAN LIPMAN

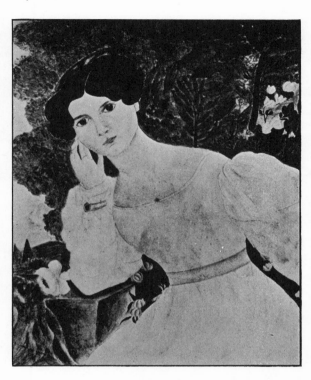

FIG. 2 — MISS CATHARINE NOBLE. Water-color portrait from Deborah Goldsmith's second album (*1829-1832*). Size, 5¾ by 6 inches. *This and Figures 1, 3, and 7 from the collection of Mrs. Olive Cole Smith.*

DEBORAH GOLDSMITH THROOP (*1808-1836*) is the first nineteenth-century lady itinerant painter to be presented to the twentieth-century public. The records of her life and work have been lovingly preserved by her granddaughter, Mrs. Olive Cole Smith, whose warm appreciation of the past has made this article possible. Deborah Goldsmith Throop died long before Mrs. Smith was born. But an old traveling bag, pushed back under attic eaves, was found full of letters from three generations. Its contents, including a series of letters which Deborah and her husband, George Throop, exchanged before their marriage, were arranged by Mrs. Smith and privately printed in 1934 as *The Old Traveling Bag*. Deborah's two albums were carefully preserved, with their rich contents of sentiments written by friends and her own poems and water colors dating from 1826 to 1832. Mrs. Smith has kept her grandmother's worktable and brushes, her oil paints, still soft, each color in a small bladder, and the powders for the water colors, wrapped in tiny newspaper packets. Photographs are still being assembled of all of Deborah's known portraits. And so we are privileged to examine the exemplary life and unique career of Deborah Goldsmith when with few exceptions the work done by the talented gentlewoman-painters of a hundred years ago has been scattered, and usually remains anonymous.

Deborah Goldsmith, who habitually signed her work *D. Goldsmith*, was born in North Brookfield, New York, in 1808, and died in 1836 in Hamilton, New York. Her parents, Ruth Miner and Richard Goldsmith, came there in ox-drawn covered wagons from Guilford, Connecticut, a few years before she, their youngest child, was born. The first water color in Deborah's second album is a portrait of Oliver Goldsmith copied from Reynolds' portrait, *via* a print, and there is a family tradition that Deborah Goldsmith's ancestors came from the same English family.

When Deborah was about twenty-one her older brothers and sisters were married and living in homes of their own, while poverty was threatening her aging parents. Quot-

ing Mrs. Smith's comments in *The Old Traveling Bag*: To Deborah, with her sensitive nature and her enjoyment of the refinements of life, poverty was a dread spectre. She had managed some way to improve her natural gift for painting. As a portrait painter she supported herself and helped her parents. It was the custom, then, to go to the homes of patrons and remain until the family portraits were painted. It was thus she went [to Hamilton] to the home of the Throops in 1831 to paint the family pictures. Probably while she painted his picture [*Fig. 1*], George made up his mind that he loved the sweet, quiet, serious young artist, that his future happiness depended on winning her to be his wife.

In the series of letters exchanged by Deborah and George during their courtship in 1832 we get a glimpse of the same charm, candor, and naïveté which distinguish Deborah's paintings. George, just twenty-one, had written his "declaration," enclosed with an essay on *Friendship and Spring*. Here it is:

That you may not mistake my meaning, I now declare unto you in words, my sole object in engaging your company. It is to obtain a friend, a friend to share with me the joys and sorrow of life; to cheer in the hour of gloom and be glad in the hour of joy; to gain heart and hand, and travel with me down the declivity of life, and, when fortune frowns and I am buffeted about on the stormy ocean of adversity, one who can look with a smile and console the tempest-beaten bosom with cheering conversation.

Yes, Deborah, this is all that urges me forward, and will it surprise thee when I declare that in thee my desires center, and all my hopes of earthly happiness have an end? After mature consideration and closely examining my own heart, I find that thy friendship and thy presence will ever be delightful. To know that thou art willing to comply with this request and impart thy virtue in increasing the happiness of one who respects virtue's innocence, is all that will make life delightful to me. I claim no perfection: such as I am, I offer myself and thus make manifest my desire.

Deborah, I wish not to draw from thee a hasty and inconsiderate answer. No, take your own time to consider. It is an important point; on it hangs all our future happiness. But this I claim: 'Tis truth I send, and truth I ask in return. Perhaps you may think I am asking too much, but please to inform me if I am on right ground, or not. So I add no more. Adieu.

Yours sincerely,
George A. Throop

P.S. — Friends in health. Write soon as convenient.

P.P.S.—Died on the 19th inst., of the billious fever, Mr. Hiram Niles, aged about 32. He left a wife and two little children. His sudden death is truly afflicting to the sorrowing friends, and to all rendered more so by the state of his mind. Lived about two miles south.

George

To this letter Deborah answered from Toddsville, where she had gone to execute some portrait commissions:

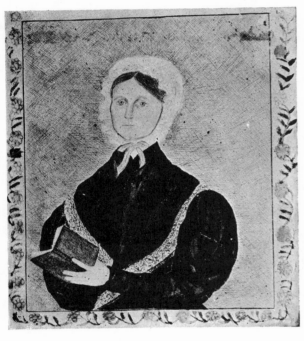

Do you think that this difference will ever be the cause of unpleasant feeling? Your age and mine differ. I do not know your age exactly, but I believe that I am nearly two years older than you. And now, permit me to ask, has this ever been an objection in your mind? And another thing which I expect you already know is, that my teeth are partly artificial. Nature gave me as many teeth as She usually gives her children, but not as durable ones as some are blessed with. Some people think it is wrong to have anything artificial, but I will let that subject go.

George and Deborah were happily married that same year, after a lengthy correspondence, with George's letters to Deborah addressed to a number of towns — for she evidently continued her career of itinerant portrait painting until her marriage. A letter from George addressed to her in June to Burlington Flats says, "to learn that you are in health and successful in your business or otherwise, would be a great satisfaction to my feelings." In July Deborah writes from

FIG. 3 (*left*) — SARAH STANTON MASON THROOP. Watercolor portrait from Deborah Goldsmith's second album, dated *1831*. Size, 5 by 6 inches.

FIG. 4 (*right*) — UNIDENTIFIED MAN. Miniature painted on ivory by Deborah Goldsmith Throop in 1834. Size, 2 by 3 inches. *From the collection of Mrs. Dan T. Smith.*

FIG. 5 (*below*) — THE TALCOTT FAMILY. Watercolor group portrait, inscribed on back, *Painted by D. Goldsmith, March 16th 1832. Mary Talcott, age 70, Sam'l Talcott 38. Betsy Talcott 30 Ch. Talcott 3 Emily Talcott 3 months. Size, 14 by 18 inches. From the collection of Mrs. John Law Robertson, on permanent loan at the Folk Arts Center, New York.*

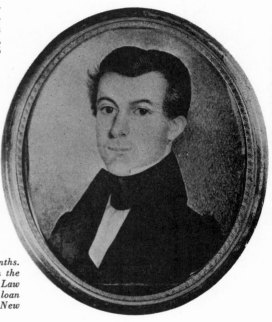

I do not know how long I shall stay in this place. I have business enough for the present, and for some reason or other, Mr. and Mrs. Lloyd seem to be over-anxious for me to remain here through the summer. A lady was here a few days since from Hartford. She thought I would do better there than here, and I may possibly go there, or to Cooperstown village, but I do not know yet, for I think I shall stay here as long as I can get portrait painting.

In this letter she concludes that if George will consult his mother and "obtain her approbation," she "will make no further objections" but comply with his request for her hand in marriage. Among the "objections" to which she refers are modest doubts as to whether her suitor will always remain steadfast through long years of prosperity and adversity, whether he will bear with all her weaknesses. And, answering his plea for candor, she prefaces her acceptance with this paragraph:

Some things I want to remind you of, that you may weigh them well (even now, before it is too late), I do not know but you have, but permit me to name them. Your religious sentiments and mine are different.

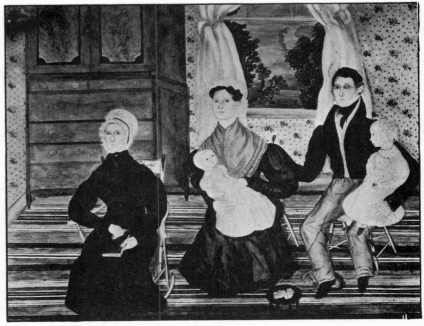

Brookfield, and ten days later George addresses her in East Hamilton. In a letter written in Brookfield in October Deborah mentions that she has been to Lebanon. Besides the dozen or so portraits owned by Deborah Goldsmith's descendants, there may be some still extant in the vicinity of Brookfield and Hamilton. In December 1832 George Addison Throop and Deborah Goldsmith were married, and settled in Hamilton. They had two children, Cordelia and James Addison, and in March 1836, Deborah died at the age of twenty-seven. Her mother's diary of Deborah's last sick-

Fig. 6 — Cordelia Throop (Cole). Daughter of Deborah and George A. Throop. Painted by Deborah Goldsmith Throop in oil on a poplar board in 1834 or 1835. Cropped. Size, 11 by 14 inches.

Fig. 7 — Sanford Boon. Deborah Goldsmith's brother-in-law — a silversmith. Painted by her in oil on a poplar panel in 1829. Size, 11 by 14 inches.

ness, also published by Mrs. Smith in *The Old Traveling Bag*, details day by day the young painter's uncomplaining suffering and her pious and peaceful end. This mournful diary highlights the attitude of an era which produced countless "sob pictures" and memorial verses.

The contents of Deborah's two albums likewise mirror the sentiments of her times. They contain a delightful assortment of quotations, original poems, drawings, and water colors. Keeping these diaries, albums, and painting portfolios was a genteel hobby much in vogue among young ladies a century ago, and a number of them have come down to us. Deborah Goldsmith's albums are notable for the variety and quality of their contents. As nineteenth-century "source material" they merit complete reproduction in color.

Verse was a favored mode of expression in those days. In Deborah's first album, whose contents date from 1826 to 1829, Deborah and her friends — and even her grandmother — wrote short rhymed sentiments, which Deborah decorated in water color with such motifs as little birds, flowers, Bacchus, cupids, pierced hearts, and miniature landscapes.

The second album, dating from 1829 to 1832, contains sentiments from relatives and friends up to and including

Deborah's wedding day, more of Deborah's poems, and a number of her finished drawings and water colors, including several fine small portraits. The titles of some of the water colors are *The Sisters, Childhood, Lady of Ruthven, The Young Spartan, The Silesian Girl*. Among the portraits are those of the artist's friend Catharine Noble (*Fig. 2*), Dan Throop IV, and Sarah Stanton Mason Throop (*Fig. 3*). The titles of the poems, which give some idea of their tenor, include *A Wish, I Think of Thee, Choice of Employment, Destiny, Thoughts of the Past, To the Moon*, and *Solitude*. In the album we also find scattered bits such as the following, dated 1829: "Innocently to amuse the imagination in this dream of life is wisdom." Deborah was then twenty-one years old!

It seems extraordinary that this serious young poetess and philosopher was also a professional itinerant, a portrait painter who traveled from town to town with her small wooden chest of painting equipment, executing on order ivory miniatures, oils, or water colors.

The illustrations of typical examples of Deborah's portraits speak for themselves. The delicate drawing, the sense of design and liking for pattern, and the naïve approach to the art of portraiture scarcely need comment. There is no record of any art lessons for Deborah, and while her itinerant career classifies her as a professional rather than an amateur painter, her work exemplifies the untutored early American art now variously termed "primitive," "provincial," and "pioneer." And, as a postscript, I ask: Why insist on the exclusive use of any one of these terms? Certainly Deborah Goldsmith's painting was provincial in origin and primitive in style; while she, a gentlewoman in her early twenties, keeping the wolf from the door by itinerant portrait painting, might typify the American pioneering spirit.

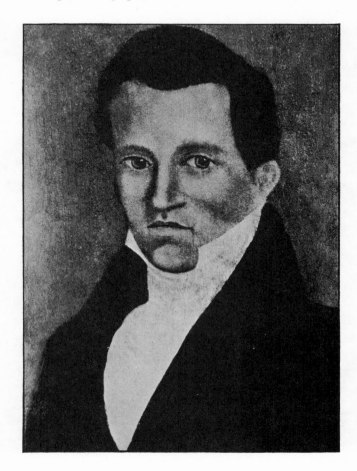

JOSEPH H. DAVIS

New Hampshire Artist of the 1830's

By FRANK O. SPINNEY

DISCOVERY IN AN ATTIC in Dover, New Hampshire, of the water-color portrait of Bartholomew Van Dame *(Fig. 1)* has provided the solution to a mystery in American primitive portraiture. Who was the unknown painter of the group of related pictures with characteristic profile portraits, painted furniture, and gaudy floor coverings, of which several examples are here illustrated? The answer appears on the Van Dame portrait, which carries this signature: *Joseph H. Davis Left Hand Painter.* Comparison of this portrait with the others of the group convinces one that here are works from the same hand, and that their painter may be rescued from anonymity, though he still remains a shadowy figure.

The fundamental basis for attribution of paintings is, of course, the internal evidence of the pictures themselves, revealing the artist's characteristic technique. Carried on parallel to critical examination, however, a documentary approach is often helpful, as exemplified by the selected instances cited below. Starting with the lucky Van Dame find and using this double approach, it has been possible to identify what seems one of the largest bodies of paintings attributable to an American primitive painter. Through the use of probate court records, registers of deeds, church and town records, local histories and genealogies, graveyard inscriptions, early newspapers, and other historical data, the works of Davis can be pinned down to a definite locale and period and related to each other.

The Van Dame portrait is inscribed *Painted At Bow Pond. June 27th 1836.* Bow Pond is a small village in the township of Strafford, New Hampshire, some ten miles from Lee and Dover. The portrait of this itinerant schoolmaster, preacher, and reformer, Van Dame, was discovered in company with a group of diaries which he kept over a period of some thirty years. As they do not begin until the 1840's, no mention is found of the writer's having his portrait painted. Some entries however, are of interest in connection with other portraits in this group.

While teaching in Lee, New Hampshire, in 1857, Van Dame wrote: "Sept. 23, 1857 . . . I then cut across the pasture & called at Mr. Tho. York's who is very low from consumption. I shaved myself here. I also sung & prayed at his request. I soon after left & went to his bro. David York's . . ." November 15 of the same year Van Dame recorded, "Mr. Thomas York was buried to-day."

A gravestone in the York burial lot in Lee is inscribed:
Thomas York . . . died . . . Nov. 11, 1857—Aged 70 yrs 7 mo.
Mary . . . wife of Thomas York . . .
died — June 19, 1815 Aged 36 yrs. 5 mo.
Deborah — wife of — Thomas York . . .
died July 21st 1827 Ae 34 yrs. 6 mos.
Harriett . . . wife of . . . Thomas York —
died Dec. 17th, 1840 Ae 29 yrs. 4 mo.

From the genealogical section of *The History of the Town of Durham, N. H.* we learn that Julia Ann York was the second child of Thomas York's third marriage. Van Dame's diary reveals that he (Van Dame) was a frequent contributor to a Freewill Baptist weekly newspaper, *The Morning Star,* published at the time in Dover. The York family *(Fig. 2)* shows Thomas York reading *The Morning Star.*

Two other portraits in the group under consideration are of James and Sarah Tuttle *(Fig. 3)* and of their daughter, Betsy Tuttle *(Fig. 4).* In Strafford, near Bow Pond, was the residence of James Tuttle and his large family. The town records for 1823 and 1824 report that a James Tuttle was voted Surveyor of Lumber for those years. A deed dated 1833 records that Joseph Huckins of Strafford granted to James Tuttle "one third part of a Sawmill erected on said Tuttle's land he now lives on together with the Iron work, tools, and saw . . .," and a deed of Ebenezer Foss of the same year granted to James Tuttle "4/18s of a Sawmill erected on said James Tuttle's land he now lives on also four twelfth parts of a Mill saw I own in partnership with Joseph Huckins . . ." Above the table in the Tuttle family portrait, painted in Strafford in 1836, is a framed picture of Tuttle's sawmill.

After a Tuttle family reunion in Dover in 1860, a list was made of James Tuttle's children present, with their ages. On this list, found in a Tuttle genealogy, is the name of Betsy (Dickey) Tuttle, aged 43 — the same Betsy who was

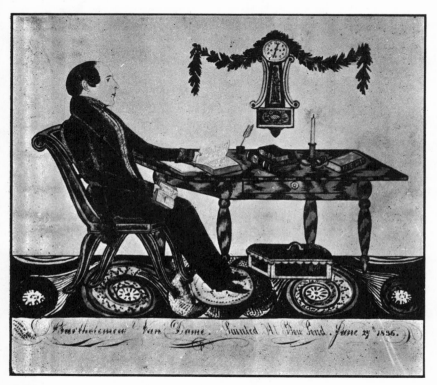

FIG. 1 — BARTHOLOMEW VAN DAME. Water-color portrait inscribed *Bartholomew Van Dame. Painted at Bow Pond, June 27th 1836,* and *Joseph H. Davis Left Hand Painter.* The artist's signature and the place of painting make this the key picture for tracing and identifying the other works of Davis. *From the collection of Mrs. Clifford O. Lomison and Mrs. Woodbury Hough.*

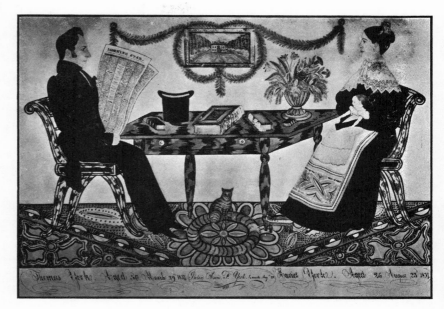

FIG. 2 — THE YORK FAMILY AT HOME *(1837)*. Water-color portrait attributed to Davis. The intricately designed carpet, the flowers, the tall hat, the cat, the garlanded overtable decoration, the chairs and table recur in most of the Davis family groups. This well-known painting was reproduced on the Cover of ANTIQUES for September 1941; Plate 30 of *American Primitive Painting*, by Jean Lipman (New York, 1942) ; Plate 40 of *American Folk Art — The Art of the Common Man in America 1750-1900*, The Museum of Modern Art (New York, 1932). *From the Museum of Modern Art.*

19 in 1836 when her portrait was painted.

Regarding Figure 5, genealogical records of Durham, New Hampshire, preserve the following item: *Hannah Monroe born May 6, 1761.* In the Sam Joy burial lot in Packer's Falls, a part of Durham, is a stone with the inscription *Hannah Munroe . . . died Feb. 8, 1851 . . . ae 90.*

Figure 6 shows the location of places where the subjects of the portraits are recorded as having lived at times compatible with the paintings, as discovered in the inscriptions or from documentary sources. The map shows clearly the relatively narrow confines within which the artist carried on his business, and suggests the area in which to look for evidence about him. While it is possible, as proposed in the catalogue of the American folk art in the Ludwell-Paradise House, Colonial Williamsburg, where two of the pictures are housed, that the painter "travelled throughout the East" and also that he may have lived in Berwick, Maine, I have found no pictures from outside the area shown on the map. Since the major work of the artist was performed in New Hampshire, it seems likely that he came from that section.

The search for information about "Joseph H. Davis Left Hand Painter" has as yet produced little satisfying information. The vital statistics for the state of New Hampshire, the town records of the state, the probate court records of Rockingham and Strafford Counties, New Hampshire, the register of deeds of the same two counties, and the directories, maps, early newspapers, genealogical and historical works pertaining to this region, have revealed only the few items listed below.

1. Vital Statistics (New Hampshire): Births: Joseph Hilliard Davis, January 24, 1820, Farmington. James and Rachel (Hilliard) Davis, parents.

2. Deeds of January 27, 1847: Strafford County, New Hampshire, Register of Deeds: *A*, Joseph H. Davis, grantee, from Ebenezer Ransom of Farmington, New Hampshire. *B*, Ebenezer Ransom of Farmington, grantor, to Joseph H. Davis of Farmington, Trader (a tract of land in Farmington for $30).

3. Strafford County map of 1856. An insert map of Dover shows the residence of a J. H. Davis on Pleasant Street.

4. *The Dover Directory for the Year Commencing July 1859* lists "Joseph H. Davis, confectionery, house Waldron."

The probate court records of York County, Maine, the southernmost part of the state in which are located Berwick, Lebanon, and other towns in the painter's work region, contain no mention of Joseph H. Davis. I have been unable to consult the vital statistics for the whole state.

With these too few facts, it is impossible to do more than speculate. The paucity of information is a kind of negative evidence, but untrustworthy in view of the incompleteness of many records. It is a plausible conjecture, supported by the chronology, that the Joseph H. Davises of the items above were all the same individual. It was not impossible for a talented youth in his teens (born in 1820, Davis would have been thirteen to seventeen in the period covered by the portraits) to have painted these pictures. It would not be difficult to spin out reasons for the successive steps in Davis' career.

The lack of any probate court record or death record forces one to move him finally from the state. Where did he go?

The art of the profile cutter, generally familiar in this period, shows its influence in the posing of his subjects. The use of accessories — Tuttle's sawmill, Van Dame's writing equipment, and so forth — to indicate the activity of the sitter is a traditional device. Nor was the family grouping with table, chairs, carpeting, and other furnishings an original concept of this provincial artist. An early family picture by Samuel F. B. Morse — at one time an itinerant portrait painter in this section of New Hampshire — shows a design similar enough to suggest that it was an arrangement in somewhat common use.

There is a small group of water-color portraits, similar in many respects to those that can be attributed, but undeniably cruder. Lacking the careful inscriptions, they offer no clue as to the identity of the subjects, the locale, or the time of painting. Are these examples of Davis' earlier work? Did Davis have imitators? Are they independent productions from another period and another place? Do they suggest a school of painters, some common inspiration, some lost model in a forgotten drawing text?

A search of this kind brings many tantalizing bits of incomplete information. A New Hampshire dealer was shown a photograph of one of the unsigned portraits. "Oh, yes," she volunteered, "I've had at least a dozen like that. They're by a man named Davis. I remember one of *Father reading the Dover paper.*" Could that have been *The York Family at Home?* And where are the other signed portraits? Another dealer of this section recalled buying one years ago from a house where an old man reminisced of his father telling him of the painter who came to the door and offered to paint and did paint a portrait for $1.50.

I would welcome information about these and other portraits, signed or unsigned, which appear to be from the hand of the artist of *Bartholomew Van Dame* and *The York Family at Home.*

The lists that follow do not claim to be complete. There are undoubtedly many portraits by the prolific Davis in public and private collections, in dealers' shops, and especially on the walls or in the attics of private homes.

LIST A
(These pictures I have personally examined, with exceptions noted, and believe can be definitely attributed to Davis.)

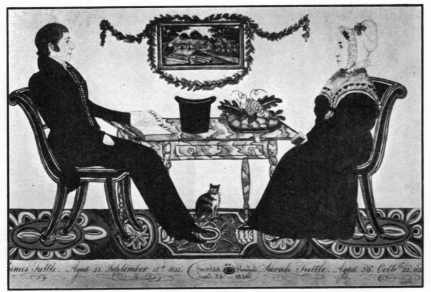

1. Subject: Bartholomew Van Dame, *b.* in Holland, 1807; an itinerant schoolmaster of Lee, Epping, Northwood, Strafford, and other towns of this section for many years; *d.* Nottingham, N. H., 1872. Date: June 27, 1836, Bow Pond, a part of Strafford, N. H. Description: water color on paper, 10 x 11⅛ inches. Inscribed *Bartholomew Van Dame. Painted at Bow Pond. June 27th 1836.* In lower left corner is the signature *Joseph H. Davis Left Hand Painter.* Owner: Mrs. Clifford O. Lomison and Mrs. Woodbury Hough.

2. Subject: The York family at home. Thomas York of Lee, N. H., *b.* March 29, 1787, *m.* 3d Harriett Bartlett of Brentwood, N. H., *d.* in Lee, Nov. 11, 1857. Julia Ann F. York, 2d. child of Thomas and Harriett York, *b.* Apr. 22, 1837. Harriett (Bartlett) York, *b.* Aug. 23, 1811 (1812?), *d.* Dec. 17, 1840. Date: Aug. 1837, probably Lee, N. H. Description: water color on paper, 10¾ x 14½ inches. Inscribed *Thomas York. Aged 50. March 29th 1837. Julia Ann F. York. 4 months. Aug^st 22 1837. Hariet York. Aged 26. August 23^d 1837.* Owner: The Museum of Modern Art, New York.

3. Subject: The Knowles family. David C. Knowles, son of Polly (Caverly) and Morris Knowles, of Northwood, N. H., *m.* Jan. 1, 1826, Mary Cate, *dau.* of Capt. Joseph Cate, formerly of Barrington, N. H. David Knowles owned a farm of 40 acres in Strafford, N. H., which he sold in 1838. At that time he was living in Kingston, N. H., from where he moved to Bradford, Mass., some time before 1842, where he ran an inn for many years. Date: 1836, probably Strafford, N. H. Description: water color on paper, 10 x 15½ inches. Inscribed: *David C. Knowles. Aged 31 Years. Sept. 12th 1836. Mary Knowles. Aged 31 Years. Nov. 5th 1836.* Owner: Holger Cahill.

4. Subject: The Tuttle family. James Tuttle, Strafford, N. H., *b.* 1777, *m.* Sarah Clark, 13 children (Esther and Betsy Tuttle were 10th and 11th); owned sawmill in Strafford, purchased in 1833. Date: Jan. 25, 1836, Strafford, N. H. Description: water color on paper, 9⅞ x 14⅞ inches. Inscribed: *James Tuttle. Aged 58. September 15th 1835. Sarah Tuttle. Aged 56. Octb 25 1835. Painted at Strafford Jany 25th 1836.* Owner: The New York Historical Society.

5. Subject: Esther Tuttle, *dau.* of James and Sarah Tuttle, *b.* May 20, 1815, never married, *d.* Jan. 5, 1892. Date: Jan. 18, 1836, probably Strafford, N. H. Description: water color on paper. Inscribed: *Esther Tuttle, Painted at the Age of 20 May 1835. Painted Jan 18 1836.* Owner: The New York Historical Society.

Comment: I have seen this picture only through the reproduction in Plate 34 of *American Primitive Painting,* by Jean Lipman, but the evidence that it is by Davis is, I believe, conclusive.

6. Subject: Betsy Tuttle, *dau.* of James and Sarah Tuttle, Strafford, N. H. Date: 1836 (probably Jan.), probably Strafford, N. H. Description: water color. Inscribed: *Betsy Tuttle. Painted at the Age 19, 1836.* Owner: The New York Historical Society.

7. Subject: Hannah Monroe, *b.* May 6, 1761, probably Durham, N. H., lived and died there Feb. 8, 1851. Date: 1837, probably Durham, N. H. Description: water color on paper, 8 x 9 inches. Inscribed: *Hannah Monroe. Aged 76 Years. May 6th 1837.* Owner: formerly The Downtown Gallery.

Comment: Attribution is made to Davis although the picture has been seen only in a photograph.

8. Subject: Samuel and Sarah Haley, Epping, N. H. Samuel, *b.* May 19, 1798, *d.* Feb. 24, 1884. Sarah, *b.* Jan. 25, 1798, *d.* Nov. 11, 1854. Date: 1837, probably Epping, N. H. Description: water color on paper. Inscribed: *Samuel Haley Aged 39 May 19th 1837. Sally Haley Aged 39 Jan. 25th 1837.* Owner: Miss Jane Burley.

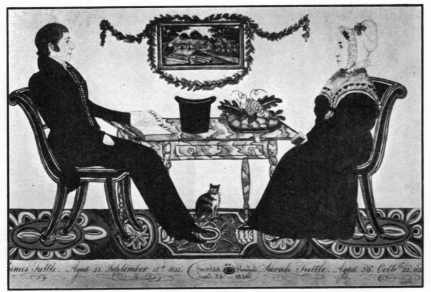

FIG. 3—JAMES AND SARAH TUTTLE *(1836).* Water color attributed to Davis. Showing, in comparison with Figures 1 and 2, how closely the artist followed his set pattern for this type of portrait. *From The New-York Historical Society.*

FIG. 4 — BETSY TUTTLE *(1836).* Water color attributed to Davis. Showing one of the artist's characteristic poses for single figures, again with his typical floor covering. The cracks and patches of the background are not a realistic rendering of an old plaster wall, but are cracks in the portrait itself. *From The New York Historical Society.*

9. Subject: Rebekah Cottle. Date: 1833, perhaps Lebanon, Me. Description: water color on paper, 6 x 9 inches. Inscribed: *Rebekah Cottle Aged 32 years. 1833.* Owner: Teina Baumstein.

10. Subject: Lucy Cottle. Date: 1833, perhaps Lebanon, Me. Description: water color on paper, 5 x 7 inches. Inscribed: *Lucy Cottle. Aged 8 years 1833.* Owner: Teina Baumstein.

11. Subject: Man at table (presumably one of the Cottle family). Date: probably 1833, Lebanon, Me. Description: water color on paper, 6½ x 8½ inches. No inscription. Owner: Teina Baumstein.

Comment: This and the two preceding portraits of Rebekah and Lucy Cottle were found pasted in the pages of a scrapbook. On the back of one of the pages to which the pictures were pasted is a handwritten reference to Lebanon. A map of York County, Me. (1856) shows the residence of a Cottle family in Lebanon.

12. Subject: John F. Demerit, *b.* Barrington, N. H., brother of Samuel Demerit (No. 13); school teacher. Date: 1836, probably Barrington. Description: water color. 11 x 13 inches. Inscribed: *John F. Demerit. Aged 32 Feb 26, 1836.* Owner: Durgin Farms.

13. Subject: Samuel Mitchell Demerit, *b.* Barrington. N. H., brother of John F. Demerit (No. 12); school teacher. Date: 1836,

probably Barrington. Description: water color on paper, 10 x 8 inches. Inscribed: *Samuel Mitchell Demerit Age 25 yrs. June 1836.* Owner: Durgin Farms.

14. Subject: The Hill family. Nicholas Hill was a store keeper and undertaker of Strafford, N. H. Date: May 19, 1836, Strafford. Description: water color on paper, 13 & 9½ inches. Inscribed: *Nicholas D. Hill. Aged 36 June 1836. Almira J. Hill. Aged 7 months May 24th. Eliza B. Hill. Aged 39. July. Painted at Bow Pond Strafford May 19th 1836.* Owner: E. E. Wiggin.

15. Subject: John and Mary Nealley. John Nealley was a farmer of Northwood, N. H. Date: 1836, Northwood. Description: water color on paper, 12 by 16 inches. Inscribed: *John Nealley 2nd. Aged 24 July 9th 1836. Mary Ann Nealley. Aged 22 Janry 12th 1836.* Owner: Mrs. Robert Low.

16. Subject: Samuel and Sarah Woodman. Date: 1836, Deerfield, N. H. Description: water color on paper, 14 x 11¾ inches. Inscribed: *Samuel Woodman Jr. Aged 30. Novembr 26, 1836. Sarah Woodman. Aged 29 Years. March 20th 1836.* Owner: Miss Josephine Haley.

Comment: Characteristic design except that figures are standing instead of being seated at either end of the table.

LIST B

(While attribution to Davis of the following pictures has a firm basis through the documentary approach and in the judgment of other observers, I have not had opportunity to examine them [with the exception of No. 1] either in the originals or through photographs.)

1. Subject: Mary Ann F. Hodgdon. Van Dame's journal mentions a "Mary Ann Hodgdon" of Lee and Newmarket, who may have been this subject. Date: 1833, Lee, N. H. Description: water color on paper 9⅞ x 12⅞ inches. Inscribed in free cursive hand unlike the formalized style of the usual legend: *Mary Ann F. Hodgdon Lee, N. H. 1833.* Owner: Teina Baumstein.

Comment: The different type of inscription, the crude representation of the carpet, one of Davis' striking characteristics, make it impossible to attribute this with the sureness of those in List A.

2. Subject: Sarah Elizabeth Haley, *dau.* Samuel and Sally Haley, Epping, N. H. (List A, 8). Owner: Mrs. Alice B. Curtis.

Comment: This portrait came down through the family of the

Comment: In the owner's opinion this portrait is by the artist of *The York Family at Home.*

4. Subject: The Libby family. Deacon Ira Libby, b. Dec. 9, 1788, Berwick, Me., *m.* April 26, 1813, Fanny Langdon, Lebanon, Me. (d. Feb. 12, 1871), d. Feb. 18, 1840; lived always on his father's farm on Beech Ridge, North Berwick. Date: Sept. 1, 1834, North Berwick, Me. Description: water color on paper, 11½ x 11½ inches. Inscribed: *Ira Libbey. Aged 45 years & 2 months 1834. Beach-Ridge Sept. 1st. 1834. Fanny Libbey Aged 47 & 9 months. 1834.* Owner: Jean Lipman.

5. Subject: John L. Pinkham, Farmington, N. H., d. 1887; records exist of his land transactions for the period 1840 to 1860. Date: 1835, probably Farmington, N. H. Description: water color on paper. Inscribed: *John L. Pinkham, Born August 16th 1813, painted at the Age of 22. 1835.* Owner: Mrs. Arthur M. Greenwood.

6. Subject: Thomas and Sally Demerit. Thomas was selectman and schoolmaster in Northwood, N. H., for many years. Date: Oct. 12, 1836, Northwood, N. H. Description: water color on paper. Inscribed: *Thomas Demeritt Aged 67 Years 6 months 1836, Sally Demeritt Aged 57 Years 5 months 1836. Painted October 12th 1836 Northwood, N. H.* Owner: Mrs. Albert Boni.

Comment: Jean Lipman in *American Primitive Painting* attributes this portrait to the painter of *The York Family at Home.*

7. Subject: The Tilton family. John T. Tilton, Deerfield, N. H., *m.* Hannah B. Barstow, East Kingston, N. H., Oct. 19, 1830. A map of Deerfield (1857) shows two houses under the name of J. T. Tilton. Date: June 1837, probably Deerfield, N. H. Description: water color on paper. Inscribed: *John T. Tilton Aged 33 Decembr 2nd 1836, Isabell A. Tilton Aged 1 year & 7 months June 13th 1837. Hannah B. Tilton Aged 32 March 8 1837.* Owner: The American Folk Art Collection, Colonial Williamsburg.

Comment: Attributed to the painter of *The York Family at Home* in the catalogue of the American Folk Art Collection.

8. Subject: Woman in an interior. Date: *c.* 1835. Owner: American Folk Art Collection Comment: see List B. 7.

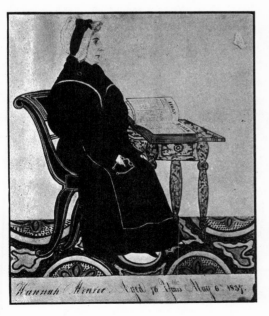

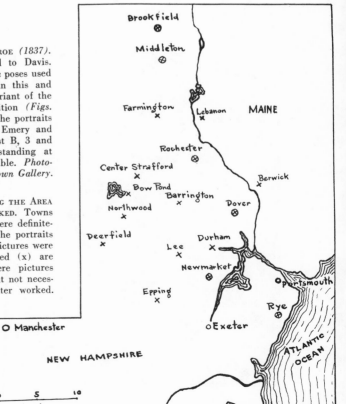

FIG. 5—HANNAH MONROE (1837). Water color attributed to Davis. The three characteristic poses used by Davis are shown in this and Figures 2 and 4. A variant of the seated family composition (Figs. 2, 3) can be found in the portraits of Joseph and Sarah Emery and the Libby Family (List B, 3 and 4) with the figures standing at either end of the table. *Photograph from the Downtown Gallery.*

FIG. 6—MAP INDICATING THE AREA IN WHICH DAVIS WORKED. Towns marked with *X* are where definitely traced subjects of the portraits lived at the time the pictures were painted. Towns marked (x) are shown as places where pictures have been reported, but not necessarily where the painter worked.

owner, sister of the owner of the Samuel and Sally Haley portrait (List A, 8). There is every reason to attribute it to Davis.

3. Subject: Joseph and Sarah Emery. Joseph, b, July 4, 1808, *m.* June 12, 1836, Sarah Ann Libby of Berwick, Me. Date: Sept. 1834, Berwick, Me. Description: water color on paper, 14 x 14 inches. Inscribed: *Joseph Emery Aged 25 & 2 months. 1834. Sarah Ann Emery. Aged 20 years. 1834.* Owner: Jean Lipman.

"Drawn by I. Bradley From Great Britton"

BY MARY CHILDS BLACK, *Director, Museum of Early American Folk Art,*
and STUART P. FELD, *Associate curator of American paintings and sculpture, Metropolitan Museum of Art*

THE FIRST ARTICLE on the nineteenth-century American folk painter John Bradley, written by Jean Lipman, appeared in *Art in America* more than twenty years ago. On the basis of four signed portraits forty-five other paintings, all portraits, were attributed to him. Now, after years of additional study, not a single one of these attributions can be accepted. Twenty-nine of the portraits, of residents of Connecticut and New York State, are now attributed on the basis of firm stylistic and genealogical evidence to Ammi Phillips (1787/88-1865), an artist who has only recently emerged from the anonymity of the Border Limner and the Kent Limner (see ANTIQUES, December 1961). Three of the original number, the portraits of Julius Norton and Mr. and Mrs. Franklin Pearce (so-called), are attributed to Erastus Salisbury Field (1805-1900) on like grounds. The remaining portraits appear to be by three or more artists who have yet to be identified.

The four signed portraits by Bradley were unquestionably close to some of the paintings now attributed to Phillips, but because Mrs. Lipman's article dealt so largely with works by other hands, it established a broad stylistic

1

base that permitted attribution to Bradley of such pictures as *Boy Holding Dog* and *Girl with Flower Basket,* both in the collection of the Abby Aldrich Rockefeller Folk Art Collection at Williamsburg. The early confusion of the work of Phillips and Bradley led to conclusions about Bradley's activity in western Connecticut and New York State that, in view of the available documented facts, can no longer be accepted. Listings in the New York City directories for the period 1836 through 1847 establish John Bradley as a "portrait and miniature painter" at three different locations: at 56 Hammersley Street, in 1836-1837; at 128 Spring Street, from 1837 to 1844; and at 134 Spring Street, from 1844 to 1847—all addresses in the general area of present-day Houston Street. Further, a pair of dated portraits of Mr. and Mrs. Simon Content (4, 5), who lived on neighboring Grand Street, push the date of his activity in the city back to 1833.

Since the Lipman article appeared little has been learned concerning Bradley himself, aside from a few evocative notices that seem to relate to him and the conclusions that can be drawn from the eighteen additional portraits by him that have come to light. All of these are signed and all are dated or bear addresses that establish their dates within a fixed span of years.

While Bradley does not appear in the New York directories until 1836, a dozen portraits by him can be dated between 1832 and 1834. The subject of only one, *The Cellist* (1), in the Phillips Collection, Washington, D. C., has not been identified. Of the rest, the Contents lived in Manhattan and the remaining nine were residents of Staten Island, suggesting that Bradley himself may have lived there or may have spent considerable time there. A search of church, genealogical, and historical records reveals the presence of only one John Bradley on Staten Island between 1830 and 1850, but that listing is worthy of note. A little more than three weeks before the date June 19 inscribed on one of Bradley's five portraits of members of the Totten family of Staten Island, the scribe of the Moravian Church there recorded that John Bradley from Sailors' Snug Harbor became "Deranged 27 May 1834" (the sailors' home was established by the will of Richard Randall in 1801 "for aged, decrepit and worn out Sailors"). Since John Bradley the painter had been associated with Staten Island as early as May 1833, the date of his first known portraits of Staten Islanders, it may be that the mad John Bradley, who finally died in 1838, was an older relative. It was possibly during visits to his namesake that John Bradley the portrait painter received the commissions that associate him with the island.

Bradley's earliest painting thus far discovered, and his most widely known work, is *The Cellist* (1), which is signed and dated *I. Bradley Delin. 1832*. Although it is considerably smaller than any of Bradley's other works, it is his only known full-length portrait of an adult. The subject, whose name and home are unknown, holds a cello as he sits on a bench before a pianoforte, on which is set a book of music opened to a piece called *Mildred Court. P. M.* A pitch pipe and a figured silk scarf lie at his side. The picture is a fully realized likeness, quickly painted but beautifully composed. It is a *portrait d'apparat* in the eighteenth-century sense in that Bradley has depicted the sitter with objects obviously meant to reveal his interests and preoccupations.

The style that Bradley used in the decade and a half that encompass all his known works is visible in his earliest: the portrait has a hard, sharp, "liney" quality, in which silhouette is used to great advantage. In contrast to other self-taught painters of the period, who often used heavy dark lines to outline their forms, Bradley enclosed heads, hands, and other elements within a line of white paint that gave an illusion of depth and volume to his rather flat forms. His favorite color scheme is already apparent in the brilliant dark green figured carpet, the rich red drapery with gold tassels, and the medium brown background.

The first of Bradley's Staten Island sitters were Captain John Cole and his wife, Catharine Rachel Winant Cole (2, 3), whose portraits are dated May 1, 1833; Cole was then twenty-six and his wife nineteen. The Coles had been married in December 1831 in Woodrow Methodist Church, Staten Island, at which time Cole was described

2a

as a "'waterman' of Westfield," a Staten Island community. Both portraits have been badly damaged and extensively repainted, especially in the heads, but details of Bradley's style are still apparent in the hands and in parts of the costumes. Bradley's favorite colors are repeated in the red drapery with gold tassels, the red book in Mrs. Cole's hand, and the green baize table cover upon which Cole rests his hand on a brown leather book with the title *History of the United States*.

As with Bradley's other subjects, it is difficult to tell whether he went to the Coles or they to him. One is tempted to think that the painter might have lived on Staten Island before establishing himself in New York City in 1836; but seven months after he painted the Coles, in December 1833, Bradley painted portraits of the New York merchant Simon Content and his wife, Angelina Pike Content (4, 5).

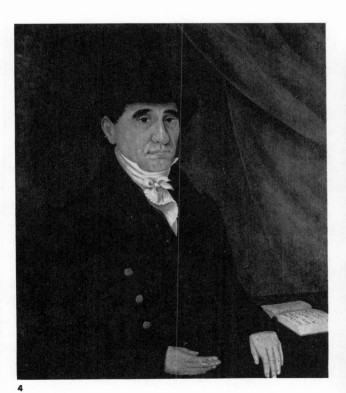

4

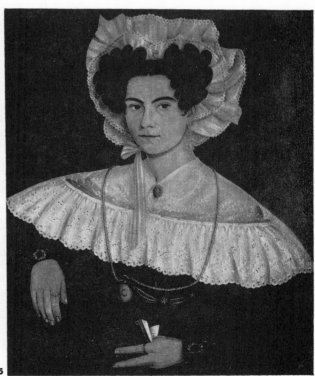

5

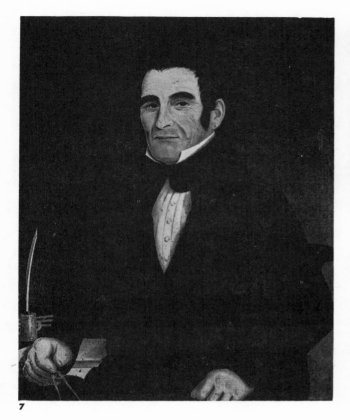

7

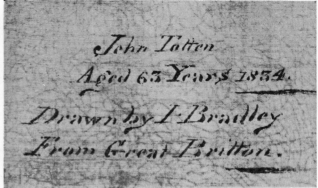

lengthy inscriptions on the back giving the names and ages of the subjects. Evidence that Bradley had indeed newly arrived here is firmly provided by a second signature on each, *Drawn by I. Bradley/ From Great Britton.*

Mrs. John Totten, in a somber black dress and white bonnet, holds a red book, while her husband rests his hand on a table covered with green baize. Brilliant red and green, with brown, are similarly introduced into the portraits of Abraham Cole Totten and his wife. The red of the latter's book is echoed in the curtain behind her husband, who, like his father, is seated next to a green-covered table. The portraits are further enriched with amusing bits of still-life detail. The elder Totten holds a pair of calipers, and on the table at his side is an inkstand with quill pen and a few other objects that defy identification. His son Abraham Cole holds what appears to be a syringe but is more likely a mechanical pen, while

According to the New York City directories of the period, Content was a dry-goods merchant who conducted his business at three different Grand Street locations between 1830 and 1840. Little more is known about the couple, but Bradley has effectively told us that they were of different faiths: Mrs. Content holds the Anglican Book of Common Prayer, while her husband sits at a table on which is an open copy of the Hebrew Old Testament. On the right-hand page is visible a passage in Hebrew and on the facing page its English translation: "Able sais/ ye obey the Command,/ ments of the Lord your/ God which I/ commend you this day."

The portraits of the Contents are striking, with the man shown in a high top hat and his wife in an elaborately embroidered and ruffled bertha and bonnet. The compositions are very closely related to those of the Cole portraits; Mrs. Content is shown in exactly the same pose as Mrs. Cole, but in reverse.

Bradley showed a marked propensity to sign, date, and inscribe his works. Both Content portraits are signed *I. Bradley* and dated on the front. In addition, an inscription on the back of the relined portrait of the man is apparently a careful copy of the legend on the original canvas: *Simon Content/ Taken in the year 1833 Dec./ A Native from Holland/ New York/ America . . .* [illegible]. The identification of New York as an American city is the first hint that the artist himself may have been a newcomer.

The following year, 1834, five members of the Totten family of Staten Island sat to Bradley: John Totten; his wife, Ann Cole Totten; two of their twelve children, John and Abraham Cole; and Abraham's wife, Mary Ann Brackett Totten (6-10). All but the portrait of the younger John are signed and dated on the front, and all bear

8

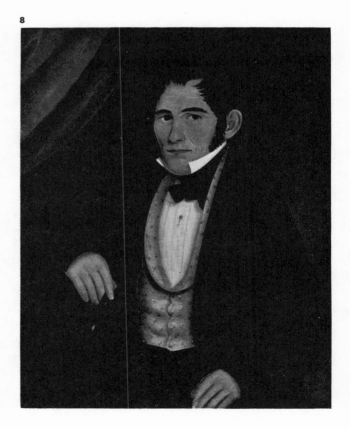

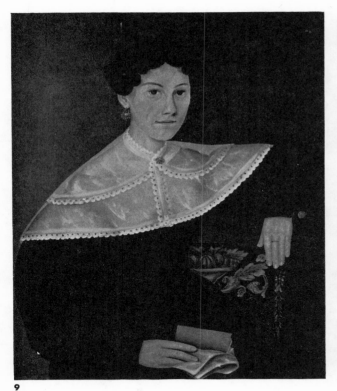

9

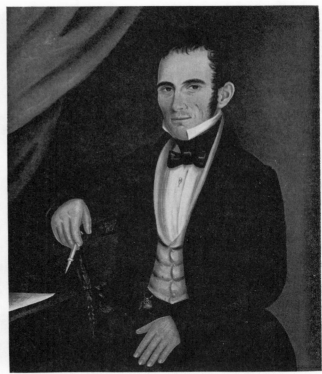

10

young John, who is posed in almost the same way, holds a lighted cigar. All five Tottens are seated in painted and stenciled Hitchcock-type chairs, which are most clearly visible in the portraits of Abraham Cole Totten and his wife. Bradley's peculiar mannerism of outlining faces and hands with white, giving them a strangely luminous quality, is particularly noticeable in the portraits in this group.

In 1834 Bradley painted two other Staten Island subjects, members of the Ellis family, probably Alice Murray Ellis and her husband, Abraham Ellis, who later became sheriff of Richmond County (11, 12). The paintings are in very poor condition and have been almost completely overpainted so that only traces of Bradley's work remain. Mrs. Ellis, who faces to the viewer's right, wears a black dress and a white collar and bonnet; she sits with her hand over the arm of what appears to be an Empire sofa upholstered in black horsehair with brass nails and a gilded rosette on the arm. Her husband wears a dark coat with brass buttons and a black stock; like the younger John Totten, who was painted in the same year, he holds a lighted cigar in one hand. In the background of each is a red curtain similar to those in a number of Bradley's portraits.

The year 1835 is a vacuum in Bradley's career, for no portraits from that year have come to light. By 1836 he was listed in the New York City directory as a portrait painter at 56 Hammersley Street. Three portraits are dated in that year. One of them is a powerful likeness of a man in a military uniform (13). The subject is believed to be a Mr. Newton of Newton Hook, New York, a small community in the township of Stuyvesant, one hundred miles north of New York City on the east bank of the Hudson. Because so little is known of Bradley's habits as a painter, it is impossible to tell whether he

traveled up the Hudson or whether his sitter came to New York. It was not unusual in the 1830's for a portrait painter to take to the road looking for commissions, but there is little evidence that Bradley ever went very far afield in search of subjects. Newton is shown seated in a typical Bradley pose with his left hand resting on the back of his chair. Behind him is a brilliant red curtain, partially covering a window through which is seen a vivid green landscape—a detail unique in Bradley's known work. The view shows a skirmish between Indians on a high cliff covered with palm trees and ranks of American troops on the shores of a body of water below. The scene may portray an incident in the Seminole Wars in Florida. The first Seminole War lasted from 1816 to 1819; after a period of peace, the war was revived in November 1835 and was in progress at the time the portrait was painted. Newton was a cavalry officer in the New York State militia; his uniform, with one epaulet and a single wing visible, is more in keeping with the period of the first of the Seminole Wars, but there is no reason why he could not have served in the second. The length of the fringe on the epaulet indicates that he had achieved field grade of major or above.

Another portrait signed *I. Bradley* and dated *1836* is *Girl with Doll* (14), the first of a group of four full-length portraits of children. The subject, a child of about four years, has not been identified. Flanked by a beautifully grained doll's cradle and a footstool with acorn feet, she stands on an elaborate woven carpet or painted floorcloth of a type popular in the 1830's. Above is the familiar red curtain.

Throughout the years 1832 to 1836 John Bradley had consistently signed his portraits with the archaic *I.* for John. In 1836 for the first time he signed himself *J. Bradley*. This appears on the portrait of a serenely beautiful

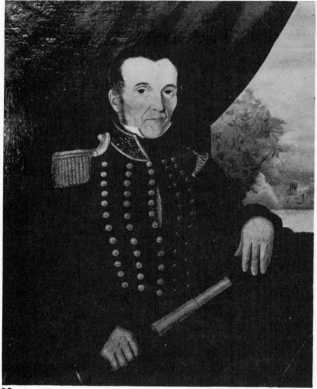

13

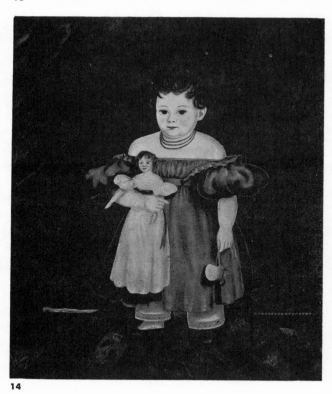

14

middle-aged woman in the collection of the National Gallery of Canada, at Ottawa (15). She is seated before a red-curtained window on a richly veneered pillar-and-scroll sofa similar to those advertised by Joseph Meeks and Sons of New York in 1833 (see ANTIQUES, May 1962, p. 504). In addition to earrings, a pin, a belt buckle, and four rings, she wears a gold cross on a chain, a most unusual detail in American paintings of this period.

Although none of Bradley's paintings bears a date later than 1836, the seven remaining pictures can be dated within a few years on the basis of his changing addresses, which the artist consistently inscribed on his portraits from 1837 on. Five portraits have come to light bearing the signature *J. Bradley* and the address 128 Spring Street, where he worked from 1837 until 1844. Two of these paintings, now separated, appear to have been executed as a pair (16, 17). They are inscribed identically, and the subjects wear matching fobs on their watch chains. There are interesting parallels in the histories of the two pictures. The man has been identified as Mr. Britton, a surveyor who laid out Bergen County in northeastern New Jersey (he holds a folding rule and a rolled plan, suggesting the profession of architect or surveyor). Although the name is known there, no Britton to suit this description has been located in Bergen County. The woman has been identified as Mrs. Stephens, which would seem to make the connection improbable. But a portrait signed by J. Bradley was once owned by a woman with the last name of Stephens in Closter, a town in Bergen County. Miss Stephens no longer owns it; but perhaps the Oberlin portrait (17) was once hers, and, as has so frequently happened, her name became associated with the sitter. Like the subject of the Ottawa portrait, the Oberlin lady wears an elaborately embroidered bertha and a quantity of jewelry, and she sits on a similar Empire sofa.

This piece appears once again in another of the portraits bearing the 128 Spring Street address. The subject of *Boy on Empire Sofa* (18) poses rather stiffly on Bradley's most exuberant version of the popular pillar-and-scroll sofa. The solemn child holds a book titled *The History of Robin Hood*, which may be a short title for *The noble birth and gallant achievements of the remarkable outlaw Robin Hood, from a manuscript in the British Museum*, published in London in 1827.

The two remaining portraits painted between 1837 and 1844 are very similar (19, 20). They are full-length portraits of children standing on brightly colored carpets. In each case the child shares the picture with a large potted rosebush and a cat. One of the subjects has not been identified, but the other was Emma Homan, who later became Emma Homan Thayer and, appropriately enough, made water-color sketches of flowers as illustrations for books on horticulture. In spite of Bradley's street address on the front of the canvas, there is a family tradition that the portrait of Emma Homan was painted at Wading Brook or Wading River, a small village near Riverhead in Suffolk County, Long Island.

The latest of Bradley's works now known are the portraits of James Patterson Crawford and his wife Margaretta Bowne Crawford of Freehold, New Jersey (21, 22). Both are signed *J. Bradley* and inscribed with Bradley's last New York address, 134 Spring Street, where he is listed in the New York City directories from 1844 to 1847. By this time the camera was in common use, and the portraits show the influence of the new device: colors

Check list of the works of John Bradley (w. 1832-1847)

Those illustrated here are starred.

*1. *The Cellist.* Signed and dated at lower right: *I. Bradley Delin. 1832.* Oil on canvas, 17¾ by 16¼ inches. *Phillips Collection, Washington, D. C.* Ill. ANTIQUES, February 1947, p. 102.

2. *Catharine Rachel Winant (Mrs. John) Cole (1813-1871).* Signed, dated, and inscribed on the back: *Mrs. Catharine R. Cole./ Aged 19 Years./ Drawn by I Bradley May 1th. 1833.* Oil on canvas, 30⅜ by 23⅜ inches. *Staten Island Historical Society.*

*2a. Detail of Catharine Cole portrait showing signature, date, and inscription on the back.

3. *Captain John Cole (1807-?).* Signed and dated at lower right: *I. Bradley Delin 1833.* Signed, dated, and inscribed on the back: *Capt; John Cole/ Aged 26 Years./ Drawn by I Bradley May 1th. 1833.* Oil on canvas, 30⅜ by 27¾ inches. *Staten Island Historical Society.*

*4. *Simon Content.* Signed and dated at lower right: *I. Bradley Del. 1833.* Dated and inscribed on the back: *Simon Content/ Taken in the Year 1833 Dec./ A Native from Holland/ New York/ America . . . [illegible].* Oil on canvas, 30½ by 26 inches. *Collection of Mrs. John Gordan.*

*5. *Angelina Pike (Mrs. Simon) Content.* Signed and dated at lower right: *I. Bradley Delin/ 1833.* Oil on canvas, 30½ by 26 inches. *Gordan collection.*

6. *Ann Cole (Mrs. John) Totten (1773-1840).* Signed and dated at lower left: *I. Bradley Fecit 1834.* Signed, dated, and inscribed on the back: *Ann Totten/ Aged 61 Years 1834/ Drawn by I. Bradley/ From Great Britton.* Oil on canvas, 32½ by 26⅜ inches. *Staten Island Historical Society.*

*7. *John Totten (1771-1846).* Signed and dated at lower right: *I. Bradley Fecit 1834.* Signed, dated, and inscribed on the back: *John Totten/ Aged 63 Years 1834./ Drawn by I. Bradley/ From Great Britton.* Oil on canvas, 32½ by 26⅜ inches. *Staten Island Historical Society.*

*7a. Detail of John Totten portrait showing signature, date, and inscription on the back.

*8. *John Totten* (the younger; 1801-?). Signed, dated, and inscribed on the back: *John Totten./ Aged 33 Years, 1834. June 19th/ Drawn by I. Bradley./ From Great Britton.* Oil on canvas, 32½ by 26⅜ inches. *Collection of Edgar William and Bernice Chrysler Garbisch.*

*9. *Mary Ann (Mrs. Abraham Cole) Totten (1812-?).* Signed and dated at lower left: *I. Bradley Delin. 1834.* Signed, dated, and inscribed on the back: *Mairy Ann Totten/ Aged 22 Years 1834./ Drawn by I. Bradley./ From Great Britton.* Oil on canvas, 33 by 27 inches. *Collection of Stuart P. Feld.*

*10. *Abraham Cole Totten (1804-?).* Signed and dated at lower right: *I. Bradley Delin,/ 1834.* Dated and inscribed on sheet of paper at lower left: *A. C. Totten/ 1834.* Signed, dated, and inscribed on the back: *Abraham Cole Totten/ Aged 30 Years 1834./ Drawn by I. Bradley/ From Great Britton.* Oil on canvas, 33 by 27 inches. *Feld collection.*

11. *Alice Murray (Mrs. Abraham) Ellis (?).* Oil on canvas, 32¼ by 25⅜ inches. There is at present no signature on this painting, but a note on the back of an old photograph in the Staten Island Historical Society records that the picture was originally signed at the lower right, *I. Bradley Del. 18—.* *Staten Island Historical Society.*

12. *Abraham Ellis (?) (1809-1873).* Signed and dated at lower right: *I. Bradley Delin. 1834.* Oil on canvas, 32¼ by 25⅜ inches. *Staten Island Historical Society.*

*13. *Mr. Newton (?) of Newton Hook, New York.* Signed and dated at lower left: *I. Bradley Pinxit 1836.* Oil on canvas, 34¼ by 28¼ inches. *Collection of Dr. and Mrs. Lysle Harrington.*

*14. *Girl with Doll.* Signed and dated at lower left: *I. Bradley Pinxit 1836.* Oil on canvas, 34¼ by 28¼ inches. *Abby Aldrich Rockefeller Folk Art Collection, Williamsburg.*

*15. *Portrait of a Lady.* Signed and dated at lower left: *J. Bradley Pinx/ 1836.* Oil on canvas, 34¼ by 27⅜ inches. *National Gallery of Canada, Ottawa.*

*16. *Portrait of a Surveyor, called Mr. Britton.* Signed and inscribed at lower right: *by J. Bradley 128 Spring St.* Oil on canvas, 34 by 26⅝ inches. *Collection of Mrs. Hobart McVicker Agnew.*

*17. *Portrait of a Lady, called Mrs. Stephens.* Signed and inscribed at lower right: *by J. Bradley/ 128 Spring St.* Oil on canvas, 33½ by 26½ inches. *Allen Memorial Art Museum, Oberlin College, Oberlin, Ohio.*

*18. *Boy on Empire Sofa.* Signed and inscribed at lower right: *by J. Bradley/ 128 Spring St.* Oil on canvas, 34½ by 27 inches. *Abby Aldrich Rockefeller Folk Art Collection.*

*19. *Little Girl in Lavender.* Signed and inscribed at lower right: *by J. Bradley 128 Spring St.* Oil on canvas, 33⅞ by 27⅞ inches. *National Gallery of Art, Washington, D. C.; gift of Edgar William and Bernice Chrysler Garbisch.* Ill., Garbisch collection catalogue, Part I, p. 65; 1954.

*20. *Emma Homan* (later Emma Homan Thayer). Signed and inscribed at lower right: *by J. Bradley 128 Spring St.* Oil on canvas, 34 by 27½ inches. *Collection of Edgar William and Bernice Chrysler Garbisch.* Ill. Garbisch collection catalogue, Part II, p. 62; 1957.

21. *James Patterson Crawford (1815-1874).* Signed and inscribed at lower left: *by J. Bradley 134 Spring St. N. Y.* Oil on canvas, 34 by 27 inches. *Monmouth County Historical Society, Freehold, New Jersey.*

22. *Margaretta Bowne (Mrs. James Patterson) Crawford (1817-1910).* Signed and inscribed at lower left: *by J. Bradley 134 Spring St. N. Y.* Oil on canvas, 34 by 27 inches. *Monmouth County Historical Society.*

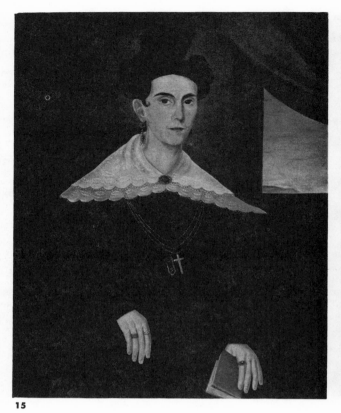

15

16

that were once clear, warm, and bright are darkened and subdued. Bradley has seated Mrs. Crawford next to the keyboard of a pianoforte, on which is set a clearly inscribed sheet of music: *The Angel's Whisper/ Sung by Mr. Wood,/ A popular ballad from the Songs of the Superstitions of Ireland/ Written and Composed by/ Samuel Lover/ N. York [?]/ published by E. Riley and Co./ 29 Chatham St.* (According to the New York City directories, Edward C. Riley was in business as a "prof. music" at 29 Chatham Street from 1833 through 1843.) The words and music that follow are nearly as legible as the title.

The only other work that may be by John Bradley is a pastel drawing of a vase of flowers on a marble slab, signed *Drawn by J. Bradley—N. Y. 1846.* Its present location is unknown, so it is impossible to determine whether it is by the same hand, but the form of the inscription and the relationship of the subject to the still-life elements in *Little Girl in Lavender* and *Emma Homan* suggest that the attribution is not unreasonable.

All the known paintings by Bradley date between 1832 and 1847; for the last eleven years of this period he was a resident of New York City and was the only painter of that surname to be listed in the New York City directories always as a portrait painter, and sometimes as a painter of miniatures as well. The year following his disappearance from the directory, a number of Bradleys are listed as painters—Israel, John, Perry, William H., Thomas, Patrick, Jeremiah, and Robert—but since they did not identify themselves as portrait painters, they were probably house or fancy painters and not artists.

John Bradley consistently signed his portraits, and no unsigned pictures can be convincingly attributed to him. At first he used the signature *I. Bradley,* later *J. Bradley,* but he never signed any portrait *I. J. H. Bradley,* although *The Cellist* has been erroneously published and exhibited as by I. J. H. Bradley for many years.

John Bradley left few clues to his identity, his origins, and his interests. Most of his known subjects lived in New York City, on Staten Island, and in New Jersey. He set down two pieces of music so accurately that they might still be played; one of them was a popular Irish ballad. He mentioned his British origin five times and recorded the name of one of his subjects, Mary Totten, as "Mairy"—a key to his pronunciation. Between 1820 and 1832, the date of Bradley's earliest known portrait, only two men listed as John or J. or I. Bradley arrived as immigrants in New York. One of them, John Bradley, a manufacturer from Liverpool, aged twenty-six, arrived with his wife, Sarah, on September 6, 1827. But the immigrant most likely to have been the portrait painter was the John Bradley who arrived a year earlier on August 7, 1826, aboard the *Carolina Ann.* He came from Ireland, but his age and occupation are not given.

This interim study of the work of John Bradley is the result of the labors of many people over a long period of time. The authors wish to express their appreciation to Mrs. Raymond M. Safford of the Staten Island Historical Society; Mrs. Hobart McVicker Agnew, Dorset, Vermont; William Campbell of the National Gallery of Art, Washington, D. C.; and the staff of the Frick Art Reference Library, New York. Also to Edward Dwight, director of the Munson-Williams-Proctor Institute, Utica, New York, who brought the fine portrait of Mr. Newton of Newton Hook to our attention.

17

18

19

20

Asahel Powers, painter of Vermont faces

BY NINA FLETCHER LITTLE

THE ITINERANT ARTIST Asahel Powers (1813-1843) is the subject of an exhibition which will be at the Abby Aldrich Rockefeller Folk Art Collection in Williamsburg, Virginia, until December 2. Powers first came to public notice in the spring of 1958 when the Miller Art Center (now the Springfield Art and Historical Society) in Springfield, Vermont, held an unusually interesting exhibition of local family portraits. Included were three groups of colorful, eye-catching pictures which, despite slight differences of style, appeared to be by the same artist. One of these groups consisted of four portraits of the Chase (or Chace) family, of which three were signed *Asahel Powers* (one less distinctly than the other two) and dated 1832.

An informative paragraph in the exhibition catalogue[1] provided biographical background on the Asahel Powers who was then believed to have been the artist. He was born in 1759 in Shirley, Massachusetts, and came to Springfield, Vermont, with his family in 1772, eventually becoming a sharp "justice lawyer." He died in 1841. Jean Lipman assumed[2] that this Asahel Powers painted the pictures signed with his name. Subsequent research, however, made it evident that not all the information about this branch of the Powers family had been published. A family history[3] traces their descent from Walter Powers (1639-1708), who settled in Concord, Massachusetts. It

Fig. 1. *Jonathan Chase*, by Asahel L. Powers (1813-1843), 1832, Springfield, Vermont. Inscribed on back *Jona Chace. AE 42'y-11m/ Springfield-sept 22d 1832/V.t/ Asahel Powers painter.* Jonathan Chase was born in Unity, New Hampshire, in 1789, but spent his life in Springfield, Vermont. Oil on wood, 38 by 25¼ inches. *Springfield Art and Historical Society, Springfield, Vermont.*

Fig. 2. *Mrs. Jonathan Chase* (nee Susan Fisher) of Springfield, 1832. Inscribed on back *S. Chace-AE 34.y.2m/ Springfield V.t Sept 22 1832/ Asahel Powers.* The sitter was born in 1798. Her parents came from Charlestown, New Hampshire, to Springfield in 1806. She wears a green gown and her double-bead earrings are picked out in gold paint. The open pages of her book are headed *Atlantick Souvner.* Oil on wood, 36⅞ by 25⅜ inches. *Springfield Art and Historical Society.*

Fig. 3. *Charles Mortimer French,* c. 1832. Inscribed on back *Charles Mortimer French/taken at 6 years old./ Asahel Powers./Painter.* This is one of Powers' most striking portraits because of the color, composition, and almost total absence of perspective. Heavy facial shadows and the curious clawlike hands suggest the work of a young and unskilled artist. Oil on wood, 36 by 21¾ inches. *New York State Historical Association.*

Fig. 3a. Inscription on back of portrait illustrated in Fig. 3. Powers' calligraphy varied, but this form is found on several portraits of the early 1830's. After 1835 he appears to have used the signature *A. L. Powers* and to have substituted canvas for wooden panels.

reveals that lawyer Asahel had a son and a grandson of the same name and that all three resided in and around Springfield until 1840.

Visits to Springfield and to registries of deeds and probate in various surrounding towns yielded the information that the lawyer Asahel was a prominent citizen who was considered a "shrewd pettifogger." In his estate papers, filed in 1841, there was nothing to connect him with the painting profession. His son, Asahel Jr., born in 1789, married and raised a large family in Springfield. He owned a good-size farm comprising land and "stock of neat cattle, horses, sheep, hogs etc., together with every article of farming tools and of household furniture,"[4] but there is no documentary evidence that he engaged in anything but farming. Only the grandson Asahel L., born in 1813, is designated "Portrait Painter" in the Powers genealogy. He began his career as a traveling artist early: the first portrait attributable to him is of a Rutland man dated 1831. But apparently Powers returned periodically to Springfield, for several pictures of the mid-1830's are inscribed *Springfield.* He died in Olney, Illinois, on August 20, 1843, as Richland County probate court records revealed. It appears, therefore, that all the portraits signed *Asahel Powers, A. Powers,* or *A.L. Powers* are the work of the lawyer's grandson, and that they illustrate the development of his artistic style during the brief decade of his painting career.

Only three portraits presently known are signed clearly *Asahel Powers* (Figs. 1, 2, 3). These pictures of Jonathan Chase, his wife Susan (Fisher) Chase, and Charles Mor-

Fig. 4. *Debrah Martin,* 1833. Inscribed on back *Debrah Martin/AE 31 1833/ A Powers.* This buxom lady has not been further identified, although hers is one of Powers' most compelling likenesses. The heavy black outlining of the chair is a repeated characteristic in Powers' portraits. Oil on wood, 33½ by 25 inches. *Collection of Mr. and Mrs. Don H. Ladd.*

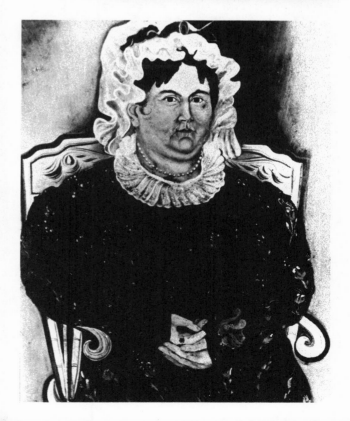

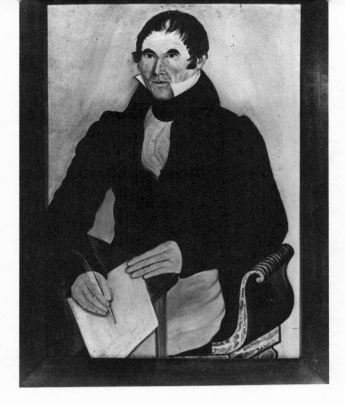

Fig. 5. *Jesse Stedman* of Chester and Springfield, Vermont, attributed to Powers, 1833. Inscribed on back *Jesse Stedman 52, 1833*. The son of a revolutionary veteran, the sitter came from Ashburnham, Massachusetts, to Vermont in 1794, where he became a prosperous businessman. The paper he holds is headed *Chester, Oct. 25 1833*. The Empire settee is in a style fashionable during the early 1830's. Oil on wood, 25¾ by 24¾ inches. *Abby Aldrich Rockefeller Folk Art Collection.*

timer French are arresting, not only for the richness of color and detail that always characterizes Powers' work, but for the boldness of facial delineation. The heavy gray shadowing of the features, the absence of modeling and highlights, and an obvious unfamiliarity with the elements of anatomy and perspective represent, to most observers, the key features of Powers' earliest and most powerful style.

A group of nine unsigned pictures of the Cobb and Harris families of Windham, Vermont, was probably painted by Powers around 1831 (see Pls. I, II). Gazing directly at the viewer, the sitters pose stiffly in yellow painted windsor chairs against most unusual curtain backdrops. These two-dimensional figures epitomize the artist's innate ability to

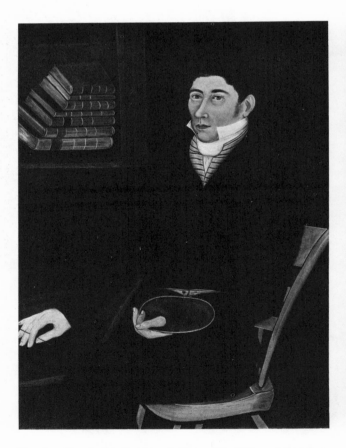

Fig. 6. *Mr. J. B. Sheldon* of Unionville, Ohio, attributed to Powers, c. 1833-1834. This and the portrait in Fig. 7 typify Powers' uncanny ability to project the personality of his sitters. The portrait was probably painted in Vermont before the Sheldons moved to Unionville. Another member of the Sheldon family was painted in Vermont. Unfortunately, no further information is available. Oil on wood, 41⅛ by 30¾ inches. *National Gallery of Art; gift of Edgar William and Bernice Chrysler Garbisch.*

Fig. 7. *Mrs. J. B. Sheldon* of Unionville, attributed to Powers, c. 1833-1834. Inscribed on back, but not in the artist's hand, *Mrs. J. B. Sheldon/Unionville, O.* The sitter's large ear trumpet is one of the many unusual accessories in Powers' portraits. The jewelry is executed in gold leaf, reinforced in places with yellow paint, and the eyelet embroidery is depicted by scratching through the white surface paint to reveal a gray paint beneath. Oil on wood, 41 by 30¾ inches. *National Gallery of Art; Garbisch Collection.*

Pl. I. *Lucy Miranda Cobb* of Windham, Vermont, attributed to Powers, c. 1831. Her portrait is almost a duplicate of that of her older sister Emeline. Presumably, this portrait was painted before Lucy Cobb died of consumption in 1831 at the age of eighteen. Oil on wood, 34 by 26¾ inches. *Private collection.*

Pl. II. *Judge William Harris* of Windham, attributed to Powers, c. 1831. The sitter came from Brattleboro to Windham in 1822 and subsequently filled many important town offices. He became president of the West River National Bank in Jamaica, Vermont, and is painted appropriately displaying a bank note in his wallet. Oil on wood, 35½ by 26 inches. *Private collection.*

Fig. 8. *Child with Moss Rose,* attributed to Powers, c. 1833-1834. The unidentified sitter is the only small child to have appeared among Powers' subjects. Oil on wood, 26½ by 14¾ inches. *Museum of Fine Arts, Springfield, Massachusetts.*

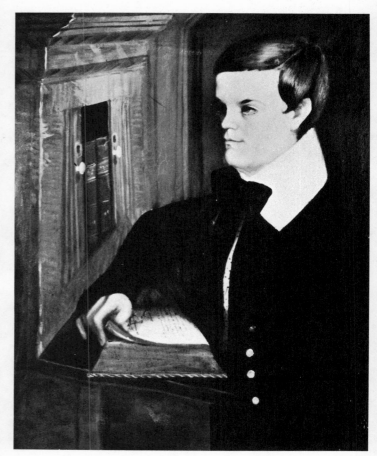

Fig. 9. *Boy Studying Geometry,* by Powers, 1839. Inscribed on back *A L Powers/ Painter/ Oct 1839.* Several sketches, apparently by the artist, appear on the back of the canvas, including two heads in profile and a rose. The impressive desk-and-bookcase in the background makes this one of Powers' more ambitious compositions. Oil on canvas, 30 by 25 inches. *Collection of Mrs. Milton K. Brandt Jr.*

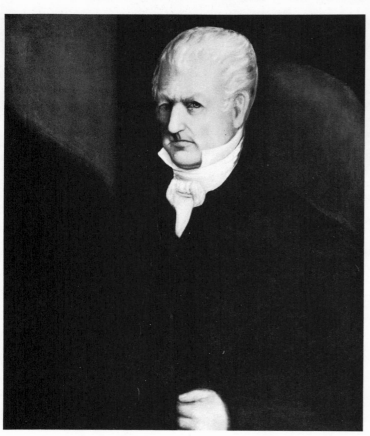

Fig. 10. *Elisha Arnold* of Peru, New York, 1840. Inscribed on back *A L Powers/ Painter/ 1840/ Fe [e] recd.* A country judge and state senator, Elisha Arnold was known as a shrewd Quaker businessman. The words *Fe [e] recd* are in lieu of a receipt. Oil on canvas, 30 by 25 inches. *Clinton County Historical Society.*

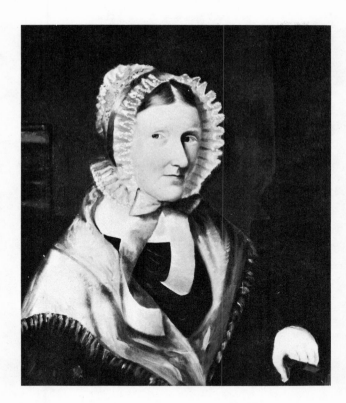

Fig. 11. *Mrs. Peter Weaver* (nee Susan Butler) of Plattsburgh, New York, 1840. Inscribed on back before relining, *A L Powers/ Painter/ 1840*. The column in the background of this well-posed and -lighted portrait indicates the artist's increasing awareness of academic conventions. Oil on canvas, 30 by 25 inches. *Private collection.*

convey personality by means of a strikingly linear pattern of color and design. In 1833 appear the signed and dated portraits of Debrah Martin (Fig. 4) and of four members of the Jesse Stedman family painted in Chester, Vermont (see Fig. 5).

Like most folk artists, Powers delighted in painting costumes and interior details. His portraits of Mr. and Mrs. J. B. Sheldon (Figs. 6, 7) and *Child with Moss Rose* (Fig. 8) are good examples. As years went by other types of brushwork appeared on caps, collars, and shawls. Powers was innovative, imaginative, and experimental. He tried various backgrounds and color effects and his compositions reveal a definite progression away from the extremely naïve manner exemplified in his earliest work toward the more accomplished style he achieved during the middle and late 1830's. Whether he gained new facility from apprenticeship to an established artist, experience, or observation of other artists' techniques remains obscure.

Following the custom of his Vermont contemporaries such as Horace Bundy (1814-1883) and Zedekiah Belknap (1781-1858), Powers apparently dropped his first name after the mid-1830's and adopted the signature *A. L. Powers.* He painted this and the date 1839 in a bold, angular script on the reverse of *Boy Studying Geometry* (Fig. 9). The sequence of Powers' pictures found in Vermont appears to end in 1839.

A request forwarded to the National Archives revealed that Sophia (Lynde) Powers, the painter's mother, applied for a land bounty in 1850 and a pension in 1871 based on her husband's voluntary military service in Springfield, Vermont, during the summer of 1812. She stated in her application that her husband had died in Olney, Richland County, Illinois, on February 20, 1845. During the first half of the nineteenth century, many Vermonters crossed Lake Champlain on the ice while traveling west to take up new land. Asahel Powers Jr. and his wife went to Illinois early in the 1840's. A brother of Asahel Jr. had settled in Olney some years before.

Asahel L. Powers traveled west via Clinton and Franklin counties in New York, where several Powers relations and a number of other former residents of Vermont were listed in the 1840 Federal census. In Plattsburgh and nearby towns Asahel painted at least seven likenesses signed and dated 1840, all but two of which are still owned by descendants of the original owners (see Figs. 10, 11). In Malone, some fifty miles northwest, he painted fine portraits of Mr. and Mrs. Benjamin Clark, who had close family connections in Springfield and whom Powers undoubtedly knew (Pls. III, IV).

This group of New York State portraits shows Powers' work at what he must have considered the peak of his career. Characterizations are penetrating, facial modeling and highlighting quite assured, color and composition extremely pleasing to the eye. The landscape and still-life painter Daniel Folger Bigelow, who was born in Peru, New York, in 1823, once wrote that he had received his first art instruction at age eighteen from Powers, to whose influence he owed his own "delicacy of coloring and treatment."[5]

In Plattsburgh, curiously enough, remains the only documentary evidence that Asahel L. Powers was ever married. On December 25, 1844, Elizabeth M. Powers, his widow, was named administratrix of his estate although his uncle, George Powers, had been appointed administrator only fifteen months before in Olney. The Olney estate was small and no painting equipment was listed, nor have any signed portraits yet been reported in Illinois. But 130 years after his death we may now evaluate Asahel L. Powers' work and credit him with having left to posterity a memorable pictorial record of more than fifty upcountry faces.

[1] The paragraph was based on C. Horace Hubbard and Justus Dartt, *History of the Town of Springfield, Vermont,* Boston, 1895, p. 418.

[2] ANTIQUES, June 1959, pp. 558-559.

[3] Amos H. Powers, *The Powers Family,* Chicago, 1884, pp. 9, 16, 28, 51.

[4] Deed from Asahel Powers Jr. to William Bragg, April 7, 1817, Windsor County Deeds, Springfield, Vermont, Book 5, p. 269.

[5] Scrapbook of Daniel Folger Bigelow in the collection of Mrs. Emmet O'Brien.

Following two pages.

Pl. III. *Benjamin Clark* of Malone, New York, by Powers, 1840. Inscribed on back before relining, *A L Powers/ Painter/ 1840*. The sitter was the editor of the *Fort Covington Gazette.* Oil on striped ticking, 35½ by 29½ inches. *Private collection.*

Pl. IV. *Mrs. Benjamin Clark* (nee Mary Smith) of Malone, 1840. Inscribed on back before relining, *A L Powers/ Painter/ 1840*. Oil on striped ticking, 35½ by 29½ inches. *Private collection.*

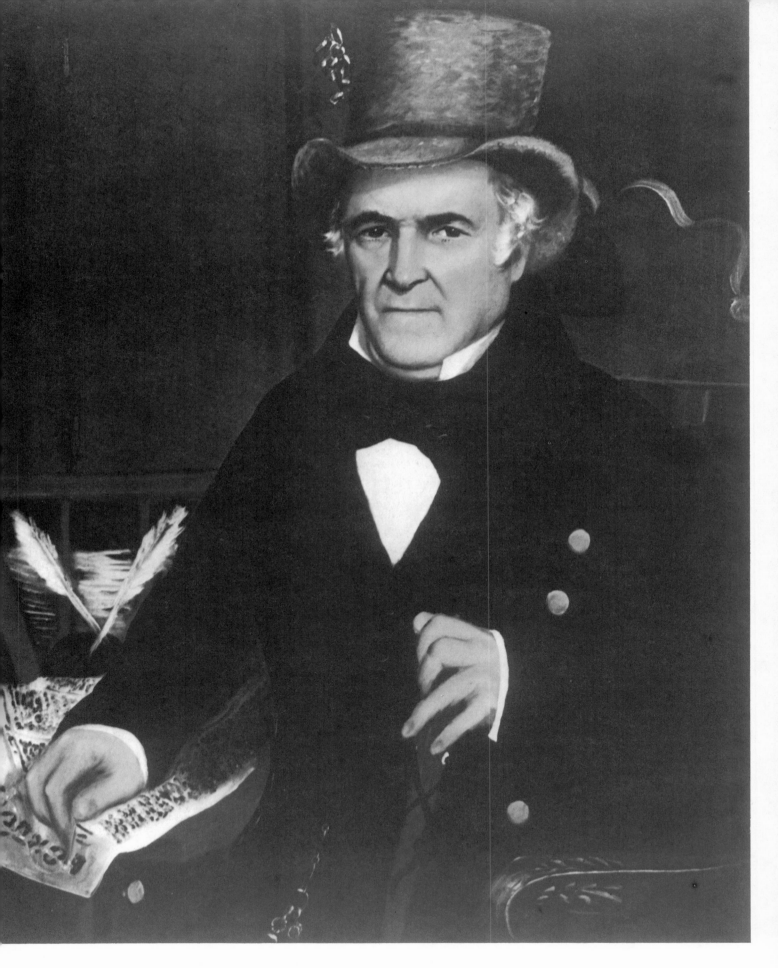

146

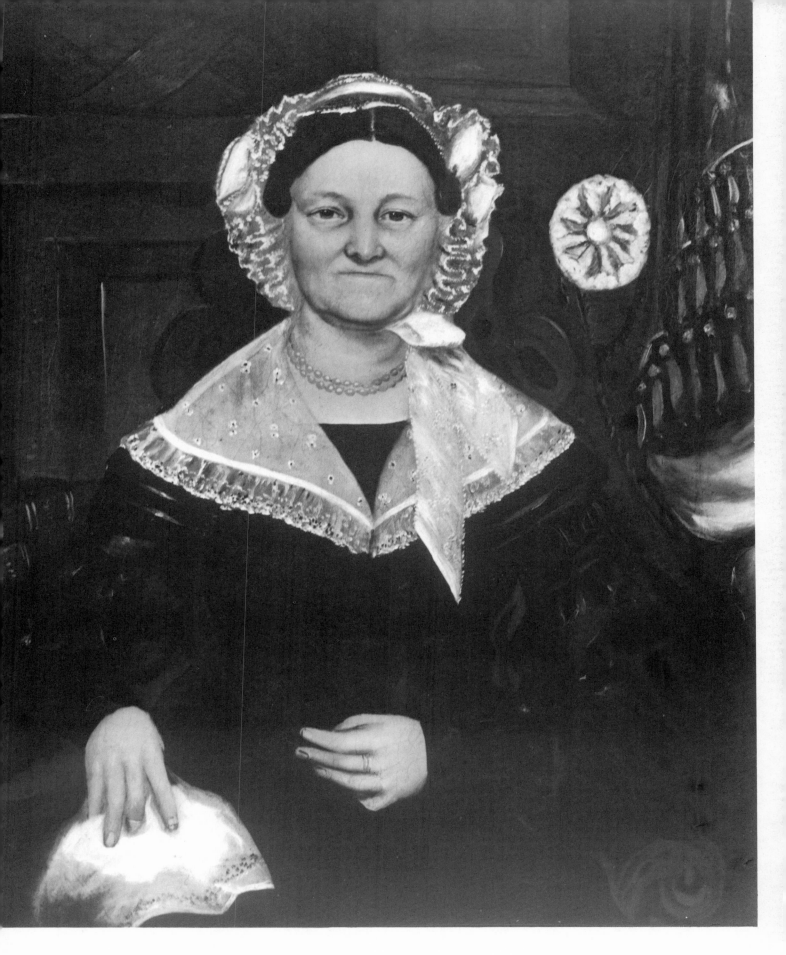

IV Sitters

One interesting way of approaching portraiture is to group together the portraits of one person, or a number of people painted in the same period and the same time. This method provides a means of comparing the perceptions of various artists or those of one artist over a period of time. Again, as is often the case with the history of American portraiture, the iconography of George Washington provides an early example of this approach. The earliest known historical lecture on American portraits was given frequently by Rembrandt Peale toward the end of his career, on the portraits of Washington. The first publication on this subject was Henry T. Tuckerman's *The Character and Portraits of Washington* (New York, 1859). Subsequent publications appeared in *The History of the Centennial Celebration of the Inauguration of George Washington,* edited by Clarence Bowen (New York, 1892), and in the more recent *The Life Portraits of Washington and their Replicas,* by John Hill Morgan and Mantle Fielding (Philadelphia, 1931), and *Portraits of Washington,* by Gustav Eisen (New York, 1932).

Similar studies have been made of the portraits of other presidents, including Andrew Oliver's two studies of *Portraits of John and Abigail Adams* (Harvard University Press, 1967) and *Portraits of John Quincy Adams and His Wife* (Harvard University Press, 1970), and Alfred L. Bush's *The Life Portraits of Thomas Jefferson* (University of Virginia Museum of Art, 1962). *The Magazine* ANTIQUES has published several studies of this type. In addition to the book previews of Andrew Oliver's studies, in April, 1967 and November, 1970, these include Harold Holzer's "Some Contemporary Paintings of Abraham Lincoln" (February, 1975) and Nicholas Wainwright's "Nicholas Biddle in Portraiture," reprinted in this anthology.

The study of Nicholas Biddle's portraits reveals as much about the artists and their styles of portraiture as it does about Nicholas Biddle. The twenty-two portraits of Biddle made between 1805 and 1843 include seven miniatures, one drawing, one silhouette, five marble busts, and eight oil paintings. Biddle was painted more than once by three artists, Thomas Sully, Jacob Eichholtz, and Henry Inman. As might be expected from a knowledge of their other works, Inman and Sully romanticized Biddle, giving him a dreamy look or a distant stare, while Eichholtz' portraits are more prosaic. Biddle commented on Eichholtz' style by writing:

> and yet if the portrait be dull & heavy the whole fault must not rest in him, for dullness is very contagious and I am willing to believe that like a man of the world I have accommodated my looks to the Lancaster standard.

Three other articles discuss various portraits of one sitter. Two, John Francis McDermott's "Another Coriolanus: Portraits of Keokuk, Chief of the Sac and Fox," and Mary M. Kenway's "Portraits of Red Jacket," deal with portraits of Indians. (The frontispiece accompanying Mr. McDermott's article, illustrating George Catlin's portrait of Keokuk on horseback, has not been included here). Among these portraits we find the work of two artists, Charles Bird King and George Catlin (Catlin's oil study of Red Jacket painted in 1826 and illustrated as figure 2 in Mary M. Kenway's article is now at the Gilcrease Institute, Tulsa). Both artists painted numerous portraits of Indians in the 1820's and 1830's. King's work has recently been discussed in Hermann J. Viola's *The Indian Legacy of Charles Bird King* (1976). King's portraits were reproduced in Thomas L. McKenney and James Hall's *History of the Indian Tribes of North America,* published between 1836 and 1844; a new edition of 1933, *The Indian Tribes of North America,* has a very useful introduction by Frederick Webb Hodge. Catlin's portraits and other paintings of Indians were published in his *Letters and Notes on the Manners, Customs and Condition of the North American Indians* (1841). More information about his Indian paintings appears in John C. Ewers' *George Catlin, Painter of Indians and the West,* Smithsonian Institution, 1956; Harold McCracken's *George Catlin and the Old Frontier,* New York, 1959; and Marjorie Catlin Roehm's *The Letters of George Catlin and His Family, a Chronicle of the American West,* Berkeley and Los Angeles, 1966.

Hannah London's article on Sully's portraits of Rebecca Gratz also presents several interpretations of one sitter and comes from the author's long interest in portraits of American Jews. In addition, she has published *Portraits of Jews by Gilbert Stuart and Other Early American Artists* (1927), *Shades of My Forefathers* (1941), and *Miniatures of Early American Jews* (1953); the latter two have recently been reprinted as *Miniatures and Silhouettes of Early American Jews* (1970).

Studies of portraiture of regional interest are represented here by William Barrow Floyd's "Portraits of Ante-Bellum Kentuckians." Mr. Floyd's *Jouett-Bush-Frazer: Early Kentucky Artists* (Lexington, 1968) made a major contribution to our knowledge of portrait painting in Kentucky before the Civil War. Other articles of this type which have appeared in ANTIQUES include "Some Philadelphia Miniatures," by Jeannette Stern Whitebook (October, 1962) and Ronna L. Reynolds' "Wethersfield People and Their Portraits" (March, 1976). The knowledge of regional portraiture has also been expanded by the publications of the State Societies of the National Society of the Colonial Dames, including Edna Talbott Whitley's *Kentucky Ante-Bellum Portraiture* (1956), *The North Carolina Portrait Index, 1700–1860* (1963), *Early Georgia Portraits, 1715–1870* (1975) and *Louisiana Portraits* (1975). This research has been augmented by the work of two departments in the Smithsonian, the Catalog of American Portraits at the National Portrait Gallery and the Bicentennial Inventory of American Paintings Executed before 1914 at the National Collection of Fine Arts. Both surveys are research files which contain references to thousands of American portraits, many of which are not otherwise recorded. These and similar unpublished resources are invaluable for studies of portraits of individuals or for studies of regional artists.

Nicholas Biddle in portraiture

BY NICHOLAS B. WAINWRIGHT, *Director emeritus, Historical Society of Pennsylvania*

THE LIFE of Nicholas Biddle, who was born in Philadelphia in 1786 and died in 1844 at Andalusia, his country seat on the Delaware River, was one of virtually unchecked success until the darkening of his final years by the collapse of the Bank of the United States, of which he was president. The bank's failure was largely attributed to him (an opinion which has moderated with the passage of time).

Biddle was a man of many parts. He was the first American to visit Greece solely as a tourist, on a trip which did much to atune his taste. He was a linguist and a scholar, the editor for a time of the nation's outstanding literary journal, *The Port Folio,* and the man selected by William Clark to edit the journals kept by members of the Lewis and Clark expedition. He served with distinction in both houses of the Pennsylvania legislature, became noted for

Fig. 1. Portrait of Nicholas Biddle (1786-1844) by an unknown French artist. Gray-blue wash drawing, 7½ by 6½ inches. Inscribed on the back in Biddle's hand *Paris Novr 1805.* The cardboard backing to the drawing bears the label of the framer: *Simon, Place du Musée Napoléon, No. 9, a Paris. Collection of General Nicholas Biddle.*

his public addresses, and was associated with more projects for the public good than any other Philadelphian of his day. An accomplished poet, wit, and writer, he was also a practical farmer and horse breeder as well as a collector of art and a person who influenced the architecture of his time.

Of his personal appearance a number of writers have left comments. In Philadelphia's *City Item* for June 30, 1866, a contributor observed: "Nicholas Biddle, of our days, I knew well. He was, in spite of everything said about him by the partizan papers at the time, not only a great financier, but a noble man in every sense—beautiful in person as Apollo; highly educated, polished in his manners, and gifted with all the grace that ever adorned the most refined court of Europe."

A writer in Philadelphia's *Sunday Dispatch* for February 6, 1859, had this to say:

Mr. Biddle was a handsome man, and he dressed in a style which some would consider foppish, but which became his commanding presence. He was well built and very erect, and he wore his hair—which was parted in the middle over the forehead—in a flowing mass on the back of his neck. We have frequently seen him striding along Chestnut Street, clad in a blue coat with gilt buttons and yellow Nankeen pants, and with hands covered with canary-colored kid gloves—a glossy beaver hat, placed on the back of his stately head, completed the picture.

Yet another comment, found in an unidentified newspaper clipping, records that he had "a smooth round face, exceedingly handsome; very luxuriant hair; a person neither tall nor short [he was five feet seven], slightly inclined to obesity, but graceful in the extreme; the whole appearance that of a *bon vivant*; in short, one who could not be mistaken for aught but a gentleman."[1]

On Biddle's death Sidney George Fisher filled pages of his diary with a summation of the banker's career. Included was the following:

How he was followed, praised, worshipped, can scarcely be conceived by those who did not witness the scenes in which he was an actor. I saw but little except that which was exhibited in society. Wherever he appeared there was a sensation and a crowd immediately formed around him. His manner was gracious, smiling, easy, gentlemanlike, a little condescending & exhibited supreme self-satisfaction & elation. His conversation was ready, fluent, elegant & witty. His language was always choice & happy, and without being raised above the conversational tone, without approaching the vile habit of haranguing, flowed in free, sparkling & harmonious periods. His figure was short, round & fat, yet his carriage was erect & not ungraceful and his head and face were stamped with the marks of character and intellect. His features were regular and chiselled, his mouth remarkable for beauty and expression, his eye grey, full and beaming. He wore his hair very long, hanging around his face in silken curls, and he was very neat and recherché in his dress.

That Biddle was vain seems to have been generally acknowledged, although not so vain as to arouse ridicule. It may account for the rather large number of portraits of himself which he commissioned. However, some weight should be given to other reasons for this amiable trait. For

Fig. 2. Portrait of Biddle by Jacob Eichholtz (1776-1842), 1811. Oil on canvas. *Private collection.*

Fig. 3. Portrait of Biddle by Eichholtz, 1811. Oil on canvas. *Private collection.*

Fig. 4. Miniature of Biddle, perhaps by Anna Claypoole Peale (1791-1878), c. 1814. Oil on ivory. *Private collection.*

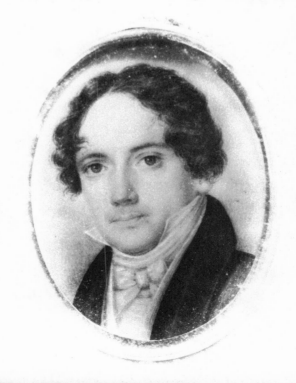

one, he was much interested in artists—an interest that went back to 1805 and his selection in Paris, with the help of the sculptor Jean Antoine Houdon, of the Pennsylvania Academy of the Fine Arts collection of casts from antique sculpture. Many artists found him willing to encourage their work. In securing for himself so ample a record of his appearance, Biddle may also have had in mind the fact that he had six children who were to inherit the portraits.

The earliest known portrait of him is the 1805 wash drawing by an unknown French artist shown in Figure 1. Since 1804 Biddle had served as secretary to the American minister to France, General John Armstrong, and was in 1805 on the verge of departing for his grand tour of Europe.

The next known likeness is a miniature by Benjamin Trott, who lived in Philadelphia from 1806 to 1819 (Pl. I). It was evidently done late in 1810, for early in 1811, when Biddle was at Lancaster attending the sessions of the legislature, he sent the miniature to his fiancée, Jane M. Craig, in Philadelphia. Among her surviving letters to him is one dated March 6, 1811, in which she writes: "I did not even get a look at the dear little picture yesterday, tho' to tell the truth it gives me little satisfaction for the painter has just taken your features without giving them any of your expression." Later, she must have relented, for on March 30 Biddle wrote to her: "I am glad to learn you are less dissatisfied with Trott's picture than you were at first."

Not content to depend entirely on Trott for his likeness, Biddle had meanwhile been sitting for the Lancaster artist Jacob Eichholtz, who was just beginning his painting career. On February 21, 1811, Eichholtz completed the painting shown in Figure 2, for he recorded its cost, frame included, as £11/5. Biddle sent the picture to Philadelphia, where Jane Craig saw it in mid-March and informed him of her reaction in a letter dated March 14: "I called at your mother's this morning to see a cousin of yours who

150

has lately come to town, and the first object that struck my eye on entering the room was the picture. All I can say of it is that I hope you do not suppose that you resemble it. Such thick lips, such dead eyes, so little of my Edwin's [a romantic name she applied to her fiancé] expression. Oh fy how could you extol the painter so much.'' Never highly regarded by the Biddles, this portrait was subsequently used as a mark at which to shoot by some of their cousins' children. When restored, it was necessary to cut it down to an oval.

Undeterred by the want of success of this first effort, Biddle sat once more for Eichholtz in 1811 (Fig. 3). He wrote Jane that he hoped the second portrait would ''perhaps be a good substitute for the unmeaning face I gave you.'' But later he informed her: ''It is a melancholy satisfaction to know that in making an ugly picture the worthy painter has not made a very strong likeness; and yet if the portrait be dull & heavy the whole fault must not rest on him, for dullness is very contagious and I am willing to believe that like a man of the world I have

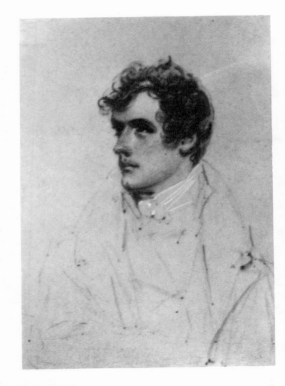

Pl. I. Miniature of Biddle by Benjamin Trott (c. 1770-1843), 1810. Oil on ivory. *Collection of General Nicholas Biddle.*

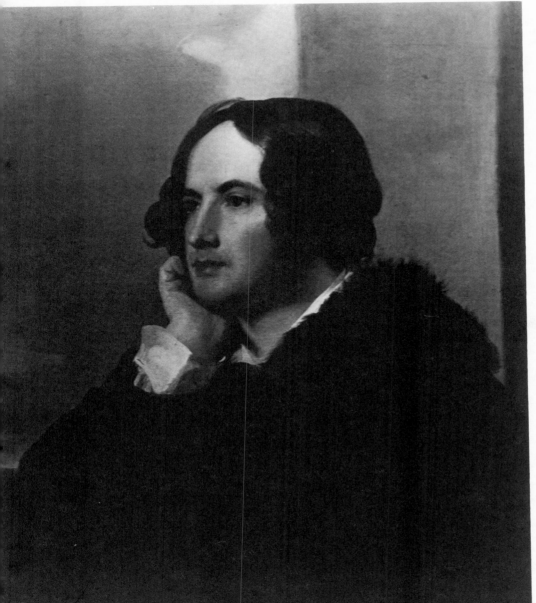

Pl. II. Portrait of Biddle by Thomas Sully (1783-1872), 1826-1828. Oil on canvas. *Collection of James Biddle.*

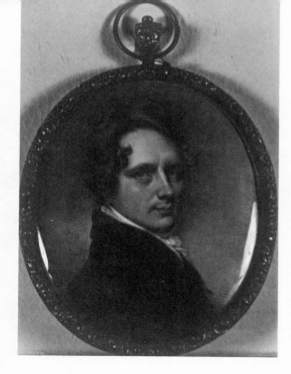

accommodated my looks to the Lancaster standard.'' Later still, he added: ''When you see it if you do not think it worth keeping we will put it into the fire without any mercy, and no harm will be done either to my own vanity or my charity to the painter.''

Whatever the Biddles thought of Eichholtz' second effort, which is owned by Biddle descendants, the artist was proud of it. In 1834 he recalled that he had shown it as a specimen of his work when, in 1811, he sought professional advice from Gilbert Stuart: ''Previous to visiting Boston, I had painted a portrait of Mr. Nicholas Biddle, President of the United States Bank, and as it required, in visiting Stuart, that I should have a specimen of skill with me, in order to know whether I was an impostor or not, Mr. Biddle very politely offered me the picture I had painted for him and which was well received by the great artist.''[2]

As if discouraged by portraits on canvas, Biddle did not sit for one for fifteen years, but he did have a number of miniatures taken during the interval. About 1814 he paid

Pl. III. Miniature of Biddle by Henry Inman (1801-1846), c. 1831. Oil on ivory. *Collection of General Nicholas Biddle.*

Pl. IV. Portrait of Biddle by Rembrandt Peale (1778-1860), c. 1836. Oil on canvas. *Collection of General Nicholas Biddle.*

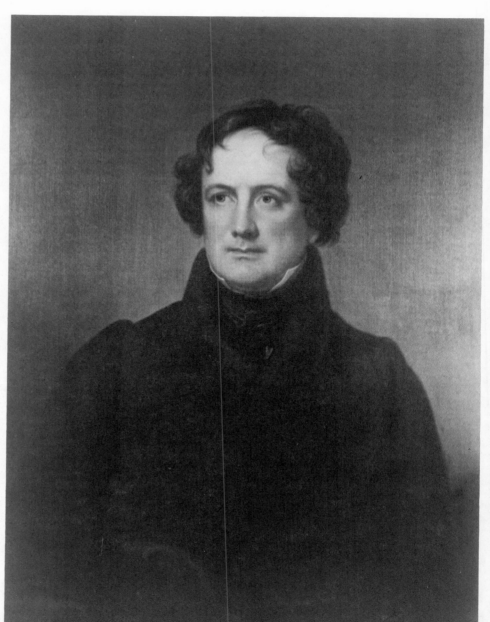

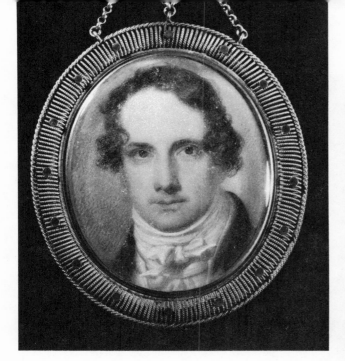

Fig. 5. Miniature of Biddle, probably by a W. Brown or John Robinson (d. c. 1829), c. 1818. Oil on ivory. *Private collection.*

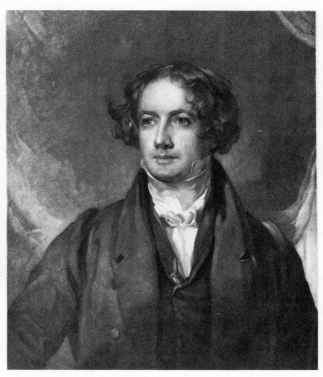

Fig. 6. Engraved portrait of Biddle by John Sartain (1808-1897), 1831, after the lost oil portrait of 1831 by Thomas Sully. *Author's collection.*

Fig. 7. Engraved portrait of Biddle by Sartain, 1837, after the lost oil portrait of 1837 by Jacob Eichholtz. *Author's collection.*

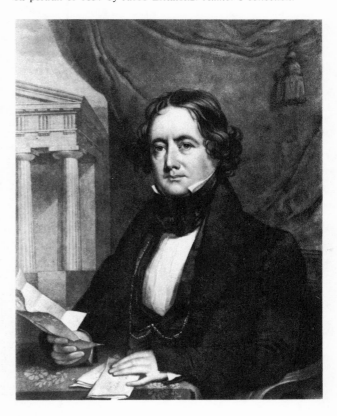

Anna Claypoole Peale $30 for one (see Fig. 4). Subsequently she painted another, evidently not from life, and tried unsuccessfully to sell it to Biddle for $20. In 1932 Charles J. Biddle, Biddle's great-grandson, purchased the latter portrait which has since hung at Andalusia. Other miniatures of this period include one by a W. Brown, who exhibited at the Pennsylvania Academy in 1819. On June 10, 1818, Biddle sent him $25 more than he had asked, writing: "You have taken so much trouble with my picture that you must permit me to add something to the moderate compensation you ask for the time & talents bestowed on it." The following year John Robinson exhibited a miniature of Biddle at the Academy. The miniature shown in Figure 5 is probably by either Brown or Robinson.

It is odd that Biddle was so slow to turn his attention to Philadelphia's most popular artist, Thomas Sully. In 1818 Sully had painted portraits of Biddle's brothers majors Thomas and John, both War of 1812 heroes, the first of whom was killed in a duel in 1831, while the second founded a military dynasty. Then, in 1821, Sully painted Biddle's studious brother Richard, and in 1826 he painted a small head of yet another brother, Commodore James. Among other Biddle portraits by Sully is one of Biddle's sister Ann, who married Francis Hopkinson.

It may have been the picture of Commodore James that aroused Nicholas Biddle's interest. At all events, the day after Sully completed that portrait he began painting Nicholas Biddle's wife and a few months later was commissioned to paint Biddle himself. The latter portrait was completed in October 1826, but evidently was in some way unsatisfactory, for in 1828 Sully extensively reworked it, charging a larger fee than he had asked for the original portrait (Pl. II). Engraved by Samuel Cousins of London, this painting, Byronic in mood, is probably the best-known likeness of Biddle. Since about 1840, when Biddle gave up his Philadelphia town house, it has hung in Andalusia together with Sully's lovely portrait of Mrs. Biddle, which Cephas G. Childs reproduced as a lithograph about 1829.

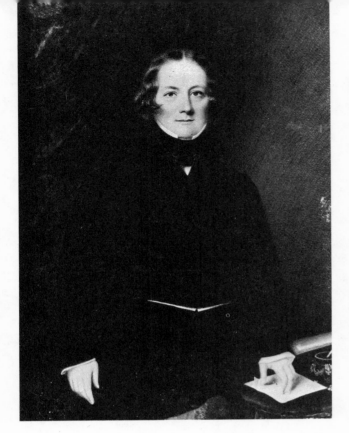

Fig. 8. Miniature of Biddle by George Freeman (1789-1868), 1838. Present whereabouts unknown. *Photograph by courtesy of the Frick Art Reference Library.*

Joseph Cowperthwaite, Biddle's Delaware River neighbor and cashier of the Bank of the United States, commissioned Sully to make a replica of his 1826-1828 portrait of Nicholas Biddle. Later this painting (which is smaller than the original and is oval) was acquired by Biddle descendants.

Biddle resorted to Sully a number of other times, commissioning him to paint a double portrait of his daughter Meta and her cousin Annie E. Biddle in 1836, a small portrait of his sixteen-year-old son Craig in 1839, and, also in 1839, a dramatic portrait of his favorite brother, the commodore. Not many Biddles escaped Sully.

In 1831, at the height of his powers, Biddle himself sat again for Sully. The painting was the only likeness that caught Biddle's well-known exuberance and dash, the "full and beaming" eyes recollected in his diary by Sidney George Fisher. What must have been the most pleasing of all the likenesses of Biddle; the painting was destroyed some time between 1872 and 1884 in a warehouse fire which also devoured what Fisher described as Sully's "exquisite picture" of the beautiful and exotic Jane Josephine Sarmiento, who married Biddle's son Edward. Fortunately, as soon as Sully had completed the 1831 portrait Biddle had it engraved by John Sartain at a cost of $60 plus $7 for the plate (the original painting had cost $75). Few of these engravings have survived (Fig. 6).

The appearance of the painting is also partially preserved in an oval replica made by Sully in 1837. The replica is probably smaller than the original, and is rather insipid compared with Sartain's engraving. It was commissioned by the Philadelphia Society for the Promotion of Agriculture, of which Biddle was president from 1831 until a month before his death. When that society celebrated its seventy-fifth anniversary in 1860, Sidney George Fisher attended in order to hear Craig Biddle speak. Of the

occasion he wrote, "The portrait of Craig's father, Nicholas Biddle, was hanging on the wall, who, with all his shortcomings, was a man of fine talents, of varied culture, of liberal mind & high spirit. . . . It was pleasant to see the son of a distinguished man also distinguishing himself." Today, the portrait hangs in the society's rooms at 325 Walnut Street.

Another likeness of Nicholas Biddle taken in 1831 or soon thereafter bears a considerable resemblance to Sully's 1831 portrait. This is a miniature painted by Henry Inman who, at the age of thirty, had just moved to Philadelphia (Pl. III). It was inherited by Biddle's son Edward and is now the property of Edward's grandson General Nicholas Biddle.

The next to record the banker for posterity was Rembrandt Peale. About 1836 he painted a serious, contemplative Biddle as he appeared at the conclusion of his struggle with President Andrew Jackson (Pl. IV). In 1839 this portrait was engraved by J. B. Longacre and T. B. Welsh to illustrate a sketch of Biddle's career in *The National Portrait Gallery of Distinguished Americans,* in which the reader is informed: "Many busts and paintings of Mr. Biddle have been taken of various degrees of merit. The portrait of Rembrandt Peale, from which is taken the engraving prefixed to this notice, is preferred."[3] Perhaps this reflected Biddle's opinion. At any rate, this painting too descended through Biddle's son Edward to General Biddle.

Biddle sat for Jacob Eichholtz once again in 1837 so

Fig. 9. Marble bust of Biddle by E. Luigi Persico (1791-1860), 1837. *Collection of James Biddle.*

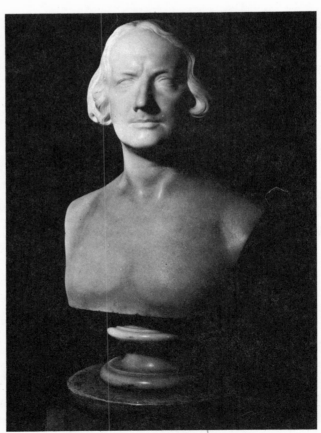

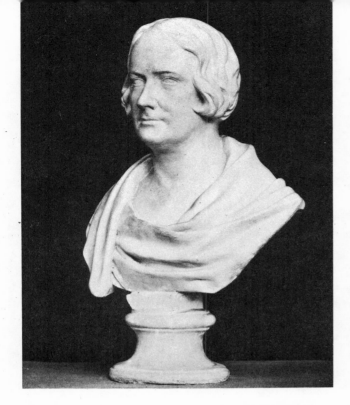

Fig. 10. Marble bust of Biddle by Robert Ball Hughes (1806-1868), c. 1840. The whereabouts of both the original marble and the plaster cast that Biddle kept is not known. The illustration reproduced here is from a photograph taken for Dr. Charles E. Cadwalader about 1895. It was reproduced in an article by Edward Biddle which appeared in the Philadelphia *Evening Bulletin* on February 15, 1913. At that time Edward Biddle knew where the original marble was.

in 1838 commissioned George Freeman to paint miniatures of both himself and his wife (see Fig. 8). These were painted in the Biddles' Spruce Street house and while the one of Mrs. Biddle is pleasing and rather touching, that of Biddle is unconvincing. The miniature of Biddle seems to have disappeared since a change of its ownership within the Biddle family in 1932.

As the writer for *The National Portrait Gallery of Distinguished Americans* observed, many busts were made of Biddle. The earliest recorded one is a marble (whereabouts unknown) by Raimondo Trentanova, who died in 1832. Its existence is known solely though its exhibition in 1865 at the Pennsylvania Academy of the Fine Arts. In 1837 E. Luigi Persico created a marble bust of Biddle which Biddle's children considered to be one of the best likenesses of him (Fig. 9). Persico had come from Naples and had made two statues for the Federal government as well as a bust of Dr. Nathaniel Chapman, Biddle's kinsman by marriage. In 1838 one of a number of casts of Persico's bust of Biddle was exhibited at the Pennsylvania Academy. Another cast was sent by Mrs. Biddle to her cousins in Ireland. "The bust," Jane Montgomery wrote her on October 4, 1839, "arrived safe and sound which gave great pleasure. . .we are also delighted to see it so much admired, some say what a fine forehead, others what a

that an engraving could be made from which the artist anticipated a large profit through public sales. Eichholtz created a workmanlike composition showing Biddle at his desk and a portion of the Bank's façade in the background. Of the engraving (Fig. 7) the *United States Gazette* reported on September 22, 1837: "Sartain has made a likeness of Nicholas Biddle in mezzotinto, in which he is unrivalled. We think the likeness is good, failing a little on close examination, but nearer we believe than any other that we have seen."

Biddle did not like the Eichholtz portrait. "I have not any very great ambition in the way of face," he informed a banking associate, "but I have been sadly traduced into the very lowest low Dutch by a well meaning friend, Mr. Eichholtz, and I hope to recover my equilibrium by Mr. Sully's means."[4] But there were to be no more Sully paintings of him. As for the Eichholtz portrait, the painter offered it for sale in 1838 at the Artists' Fund Society, and shortly thereafter all record of it vanishes. Only Sartain's engraved plate survives, given to Craig Biddle by Eichholtz' son-in-law, who had had an interest in the engraving scheme. Perhaps the painting went to England, since it was engraved there by H. Dowe and published by Charles Tilt of Fleet Street, London.

While Eichholtz was trying to sell the original oil, Biddle

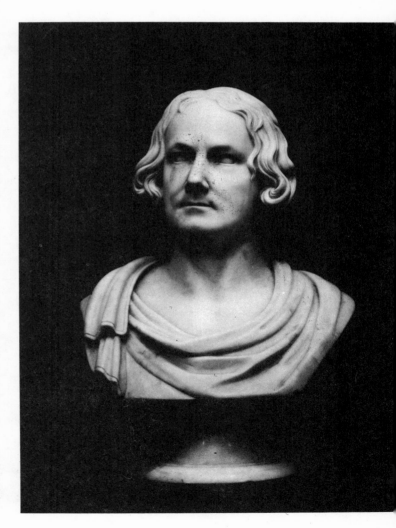

Fig. 11. Marble bust of Biddle by Hugh Cannon (c. 1814-after 1857), 1838. On September 4, 1838, an article in the *United States Gazette* said of Cannon: "He is a native Philadelphian and served his time under John Struthers. Last week he completed in fine Italian marble a bust of Nicholas Biddle." *Pennsylvania Academy of the Fine Arts.*

155

sweet countenance." Still another of the casts served as the model for a wood carving to adorn the brig *Nicholas Biddle,* which was launched at Williams and Mitchell's yard in Southwark on September 15, 1838.[5] Among Biddle's papers is a letter of September 27, 1838, from W. D. Lewis:

Capt. Dolby expects the bust in order that a proper mask may be made to place on the stern of your name sake in lieu of the 'poppinjay' that has usurped your place. Mr. Hughes, the bearer of this, has called upon me this moment and if you do not wish to lose *cast* I recommend you to send it to the carver & do the genteel thing yourself. Mr. Rush [John Rush, son of and successor to the famed carver William Rush] the carver's shop is in Kensington [a section of Philadelphia].

Subsequently, in December of that year, when the *Joseph Cowperthwaite* was launched, named for the cashier of the Bank of the United States, her stern was also ornamented with a carved head of the man whose name she bore, as well as representations of the bank, its charter, and Cowperthwaite's books and desk.

The Mr. Hughes mentioned by Lewis was the English-born sculptor Robert Ball Hughes. Evidently he was rather down on his luck to be reduced to serving as an assistant to Rush in somewhat mundane tasks. In an undated letter Hughes wrote to Biddle: "It having been suggested to me how much it would forward my views if I could prevail on you to do me the honor of sitting for a bust, I come to entreat that favour." Another undated letter from Hughes to Biddle reads: "I will have the pleasure of placing in your house your bust the week after next and sincerely trust it will meet the approbation of your family." This correspondence may have been written in 1840, the year Hughes exhibited at the Artists' Fund Society a model of the bust, "now being executed in marble" for Biddle. It seems likely that Biddle did not give Hughes many sittings, as his bust (see Fig. 10) appears to be basically a copy of Persico's. Although Biddle paid Hughes for the bust, he evidently gave it away, retaining only a cast which his children mistakenly believed to be a second effort by Persico.

A coarser, heavier bust by the Philadelphia sculptor Hugh Cannon was probably made for D. W. Coxe, a director of the Bank of the United States (Fig. 11). At any rate, it was Coxe who presented the bust to the Pennsylvania Academy in 1850.

In 1838 Biddle commissioned Shobal Vail Clevenger to do a bust of him for $300, half of which Biddle paid in advance. Clevenger made a model which was exhibited in 1839 at the Apollo Association in New York, but in 1840 he went to Europe where he died three years later. Shortly after Biddle's own death in the following year, his family learned with some dismay that Clevenger's widow intended to finish the bust in order to obtain the rest of the fee. Undeterred by Nicholas' son Charles J. Biddle's efforts to discourage her, she completed the bust in Florence under the direction of Hiram Powers and sent it on to Philadelphia (Fig. 12). The Andalusia Biddles did not want it, but it was acquired by their relatives the Hopkinsons, who gave it to the Historical Society of Pennsylvania in 1891.

At about the time Nicholas Biddle was negotiating with Clevenger, Richard M. Blatchford of New York persuaded Biddle to sit again for Henry Inman. Blatchford was New York counsel for both the Bank of the United States and the Bank of England, and later served as United States minister to Italy. In March 1839 Inman came to Phila-

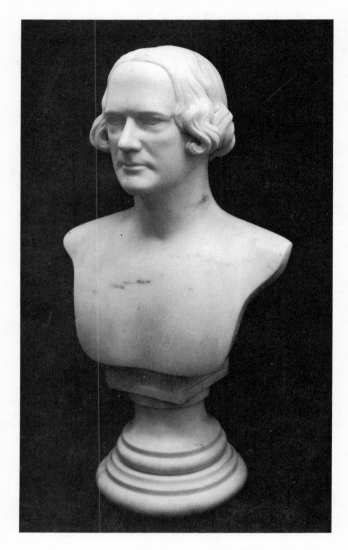

Fig. 12. Marble bust of Biddle by Shobal Vail Clevenger (1812-1843), completed by his wife, 1838-1845. *Historical Society of Pennsylvania.*

delphia to paint the picture, returning for more sittings in August and completing the picture in December (Fig. 13). Biddle is shown relaxed and smiling as he appeared in March 1839, the month he resigned as president of the bank. Among the reasons for retirement that he recorded in his private journal on March 28, the actual day of his resignation, was the condition of his health: "all the symptoms indicated that my great & increasing corpulence was leading me to a crisis not to be mistaken." On December 22, 1839, Blatchford wrote Biddle about the portrait: "All my hopes respecting it are fully realized, and it somewhat exceeds my expectations. I knew Mr. Inman was doing his best, and I was afraid he would try a little too hard and shoot over the mark. I do not know that there is a line, feature or expression that I would wish altered. . . . All who have seen it, and it has been seen by most of the artists here, declare it to be his best work—he is himself proud of it."

The last known likeness of Biddle is a silhouette cut by Auguste Edouart on January 12, 1843, presumably during one of Biddle's infrequent appearances in Phila-

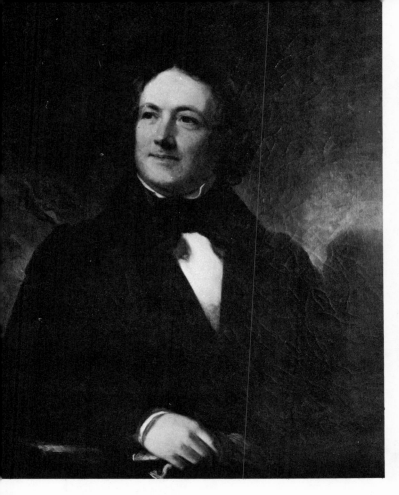

Fig. 13. Portrait of Biddle by Inman, 1839. Oil on canvas. *Collection of Mrs. T. Charlton Henry.*

[1] This clipping is in the files of the Historical Society of Pennsylvania. Except as noted, all quotations in this article are taken from manuscripts in the historical society.

[2] William Dunlap, *History of the Rise and Progress of the Arts of Design in the United States* (New York, 1834), Vol. 2, p. 229.

[3] R. T. Conrad, Biography of Nicholas Biddle, p. 18, in James B. Longacre and James Herring, *The National Portrait Gallery of Distinguished Americans* (Philadelphia and New York, 1839), Vol. 4.

[4] Letter to Samuel Jaudon, Philadelphia, March 31, 1838, in Nicholas Biddle Letter Books, Vol. 1, p. 387, Library of Congress.

[5] *United States Gazette*, September 17, 1838.

[6] In addition to many of the paintings mentioned in this article Andalusia contained more paintings and miniatures of members of the family and friends. Among notable paintings there which had adorned Biddle's Philadelphia house when Andalusia was occupied only from June to October was the *Wolf Hunt*, by Frans Snyders (1579-1657), a gift from Joseph Bonaparte, who had acquired it while king of Spain. Another large painting was a copy by Bass Otis (1784-1861) of Jacques Louis David's picture of a mounted Napoleon crossing the Alps. This was unquestionably taken by Otis from a replica in the collection of Joseph Bonaparte in Bordentown, New Jersey. Biddle was a great admirer of Napoleon, whose coronation he attended. He owned a statue of the emperor in his coronation robes which is still at Andalusia. Many objects of interest at Andalusia came from Mrs. Biddle's family, including her brothers James (d. 1832) and John C. (d. 1837). Among them were a Gilbert Stuart of Washington; a Charles Willson Peale of the Revolutionary general Charles Armand, marquis de la Rouërie, presented by the sitter to Mrs. Biddle's mother; and several Saint-Mémins.

delphia (Fig. 14). It is the only representation of him in full length. The "corpulence" which Biddle himself noted is evident, as are other characteristics noticed by observers earlier, notably the erect carriage and impressive head.

After two years of painful illness Biddle died at Andalusia in February 1844, by which time the big house must have been bulging with portraits, for it was then his only residence and no family distribution had been made.[6]

The usually caustic Sidney George Fisher, in contemplating Biddle's career at the time of his death, paid him the highest compliment of which he was capable: "Tho he did not deserve to be called a *great* man, yet he had more of the elements of greatness & the qualities allied to genius than any other prominent man in this city, or, Webster excepted, in this country, now living."

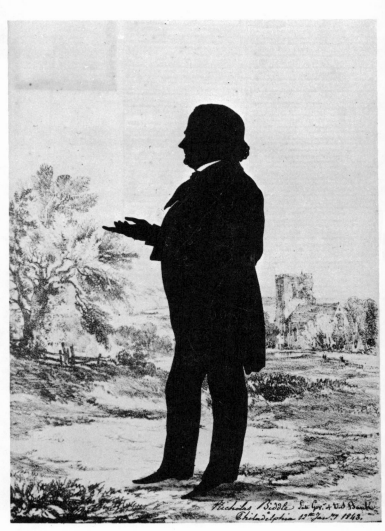

Fig. 14. Silhouette of Biddle by Auguste Edouart (1789-1861), 1843. Biddle autographed and dated this copy of the silhouette, which Edouart retained in an album of likenesses of many of the most notable Americans who posed for him, including Commodore James Biddle, whose silhouette he cut later in 1843. *Private collection.*

ANOTHER CORIOLANUS:

Portraits of Keokuk, Chief of the Sac and Fox

By JOHN FRANCIS McDERMOTT

In 1947 Mr. McDermott held a Newberry Library Fellowship in Midwestern studies. He spent the greater part of his time traveling and gathering material for a book on the middle-western frontier as artists saw it in the first half of the nineteenth century.

THE RICH CONTRIBUTION to our knowledge of the frontier made by the artists who ventured among the Indians during the first half of the nineteenth century is illustrated not merely by the variety of subjects painted but also by the successive impressions of the same subject reported by different artists. Particularly interesting in Indian biography are the many interpretations of principal figures among the tribes of the Middle West. The life story of the Sac and Fox chief Keokuk, who, for example, was repeatedly sketched during the second quarter of the nineteenth century, is rendered doubly vivid by these artists who painted him in his native surroundings.

Artistically he makes his first appearance at Prairie du Chien in 1825. There William Clark and Lewis Cass were negotiating a treaty with half a dozen great tribes of Indians controlling the Upper Mississippi Valley. Henry Rowe Schoolcraft, one of the most valuable of our Indian agents in the 1820's and '30's, had joined the Cass party when it arrived at his agency at Sault Ste. Marie. In his *Personal Memoirs* he described vividly the appearance of the Sac and Fox Indians when they came to the treaty ground armed and dressed as a war party; particularly was he impressed by Keokuk. He reported:

"Many of the warriors had a long tuft of red-horse hair tied at their elbows, and bore a necklace of grizzly bears' claws. Their head-dress consisted of red dyed horse-hair, tied in such manner to the scalp lock as to present the shape of the decoration of a Roman helmet. The rest of the head was completely shaved and painted. A long iron shod lance was carried in the hand. A species of baldric supported part of their arms. The azian, moccason and leggins constituted a part of their dress. They were, indeed, nearly nude, and painted. Often the print of a hand, in white clay, marked the back or shoulders. They bore flags of feathers. They beat drums. They uttered yells, at definite points. They landed in compact ranks. They looked the very spirit of defiance. Their leader [Keokuk] stood as a prince, majestic and frowning. The wild, native pride of man, in the savage state, flushed by success in war, and confident in the strength of his arm, was never so fully depicted to my eyes. And the forest tribes of the continent may be challenged to have ever presented a specimen of bold daring, and martial prowess, equal to their landing.

"Their martial bearing, their high tone, and whole behavior during their stay, in and out of council, was impressive, and demonstrated, in an eminent degree, to what a high pitch of physical and moral courage, bravery and success in war may lead a savage people. Keokuk, who led them, stood with his war lance, high crest of feathers, and daring eye, like another Coriolanus, and when he spoke in council, and at the same time shook his lance at his enemies, the Sioux, it was evident that he wanted but an opportunity to make their blood flow like water.

Wapelo, and other chiefs backed him, and the whole array, with their shaved heads and high crests of red horse-hair, told the spectators plainly, that each of these men held his life in his hand, and was ready to spring to the work of slaughter at the cry of their chief."

Could a painter resist such a sight, such a chief? Certainly James Otto Lewis, traveling with Cass, was as greatly excited as Schoolcraft by the approach of Keokuk at the head of a thousand warriors. The portrait that Lewis painted of this chief may be no great work of art, but it did record the sort of detail that Schoolcraft put in writing. The earliest picture shows Keokuk at the age of about forty or forty-five years. His father was half French, his mother a full-blooded Sac. Although not a hereditary chief, by his great gift of oratory and his skill as a war leader and negotiator he came early to be one of the most influential men of his tribe and was presently to become the head chief.

The full-length portrait Lewis painted either immediately on the spot or from a sketch made there has disappeared, but not without trace. It apparently was among those pictures by Lewis which Cass sent to Washington, for a copy by Charles B. King now hangs in the Newport Historical Society and a copy by Henry Inman is in the Peabody Museum at Harvard. Doubtless the original returned to Lewis' possession; a lithograph from it figures as No. 9 in his *Aboriginal Port Folio* published ten years after this Prairie du Chien meeting (*Fig. 1*). There was possibly another version of the Lewis work: on July 5, 1826, Charles B. King wrote to the Office of Indian Affairs asking for the loan of the "Head of Keokuk." Was this the bust portrait (copy) by Inman which is also in the Peabody Museum?

In 1829 Keokuk again sat for his portrait. Caleb Atwater, one of the treaty commissioners who went to Prairie du Chien that summer, found Keokuk "a shrewd politic man, as well as a brave one, [who] possesses great weight of character in their national councils. He is a high-minded, honorable man, and never begs of the whites." So much taken was Atwater that he had made "correct likenesses as I ever saw drawn" of Keokuk, Morgan, Tiama, Quasquawma, Tom, and several others of the principals belonging to "these brave and generous allies," the Sacs and Foxes. "Gratitude towards them," he tells us, "was my motive for being at the expense of these beautiful paintings." What became of his pictures remains unknown; he merely added that they had "gone to London a year since" (*i.e.*, 1830). The artist's name he nowhere mentioned in his *Remarks on a Tour to Prairie du Chien*.

More than twenty years later, however, in a letter to Lyman C. Draper about these drawings, Atwater spoke of "my Swiss artist, Rhindesberger," but it is certain that he had remembered badly the name of the long-dead artist. Undoubtedly it was Peter Rindisbacher who had painted his *War Dance of the Sauks and Foxes*, with its thirteen dancers and four musicians, among whom

FIG. 1 — LITHOGRAPH from J. O. Lewis' *Aboriginal Port Folio* (1835), after his painting of 1825. *Courtesy of the St. Louis Mercantile Library.*

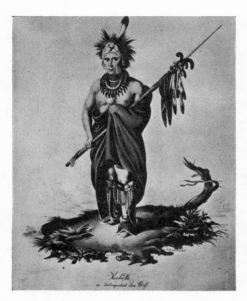

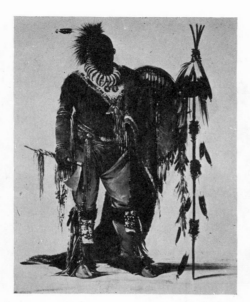

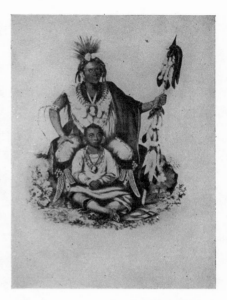

FIG. 2 — WATER COLOR by Peter Rindisbacher (c. 1829). *Courtesy of the United States Military Academy Museum.*

FIG. 3 — OIL PAINTING by George Catlin (*1834*). *Published by permission of the Smithsonian Institution.*

FIG. 4 — LITHOGRAPH in McKenney and Hall, *Indian Tribes of North America*, after the painting by Charles B. King (*1837*).

Keokuk is a principal figure. (This picture was reproduced a few years later by McKenney and Hall as frontispiece to the first volume of their *Indian Tribes of North America*, and was borrowed from that source three years after that by Charles Augustus Murray for the frontispiece of one of the volumes of his *Travels in North America*.) It must have been on the same treaty-making occasion that Rindisbacher did the full-length portrait of Keokuk reproduced here (*Fig. 2*). Both the *War Dance* and the *KeoKoKe* are among the Rindisbacher water colors in the United States Military Academy Museum. Whether these are the actual pictures done for Atwater cannot be determined.

Catlin was a great admirer of Keokuk and apparently met him on a number of occasions. He first saw the chief at his village about sixty miles up the Des Moines River in September 1834. After the Black Hawk War he had been elevated by General Scott to the position of high chief of the tribe in place of the deposed Black Hawk. At this time Catlin wrote, "I found Ke-o-kuck to be a chief of fine and portly figure, with a good countenance, and great dignity and grace in his manners." He was "a man with a good share of talent, and vanity enough to force into action all the wit and judgment he possesses, in order to command the attention and respect of the world." When the time came to be painted, the chief "brought in all his costly wardrobe, that I might select for his portrait such as suited me best; but at once named (of his own accord) the one that was purely Indian . . . and in it I painted him at full length . . . I have represented him in the costume, precisely, in which he was dressed when he stood for it, with his shield on his arm, and his staff (insignia of office) in his left hand" (*Fig. 3*).

But one picture was not enough for this great chief. "He is a man of a great deal of pride, and makes truly a splendid appearance on his black horse . . . and is excessively vain of his appearance when mounted, and arrayed, himself and horse, in all their gear and trappings." After the full-length portrait was done, he told Catlin that he "made a fine appearance on horseback" and wished to be painted so. "I prepared my canvass in the door of the hospital which I occupied, in the dragoon cantonment," Catlin continued, "and he flourished about for a considerable part of the day in front of me, until the picture was completed. The horse he rode on was the best animal on the frontier; a fine blooded horse, for which he gave the price of 300 dollars . . . He made a great display on this day, and hundreds of the dragoons

and officers were about him, and looking on during the operation. His horse was beautifully caparisoned, and his scalps were carried attached to the bridle-bits." Later (1837) when Catlin was lecturing in New York, Keokuk, his wife and son, and twenty others of his tribe on their way to Washington sat in the audience. Presently the artist placed this equestrian portrait of Keokuk before the audience, and the Indians "all sprung up and hailed it with a piercing yell." After the noise had subsided, the artist tells us, "Kee-o-kuk arose and addressed the audience in these words: 'My friends, I hope you will pardon my men for making so much noise, as they were very much excited by seeing me on my favorite war-horse, which they all recognized in a moment'" (*Frontispiece*).

When the second picture of the chief was finished, Catlin painted the oldest of his seven wives, who was apparently his favorite because she was the mother of his favorite son. The dress of Nah-wee-re-co "which was of civilized stuffs, was fashioned and ornamented by herself," he reported, "and was truly a most splendid affair, the upper part of it being almost literally covered with silver broaches." The family representations were completed with a picture of her boy, Me-sou-wahk or The Deer's Hair, then about twelve years old, later to be known as the Reverend Moses Keokuk and to succeed his father as tribal chief.

Like a practical man Catlin made as much capital as possible of his subjects. The illustrations used here are from the oils in the Smithsonian. The University of Pennsylvania Museum has another oil of Keokuk on horseback, like the first except that it is in outline. All four subjects of course were reproduced in the *Letters and Notes* (Plates 280, 281, 282, 290 of the seventh edition). The New York Historical Society has a collection of two hundred and twenty-one drawings by Catlin: Plate No. 15 shows Keokuk, his wife, and Pash-e-pa-ho; Plate No. 16 is Keokuk on horseback. Mention should be made of still another Catlin *Keokuk*. In the Ayer Collection of the Newberry Library are two manuscript volumes by the artist entitled *Souvenir of the North American Indians as they were, in the middle of the 19th century*. . . . According to a prefatory note Catlin in London in 1852 "reduced and copied" with his own hands the two hundred and seventeen portraits of his collection. The picture of Keokuk (Plate 79) is similar to but not identical with that reproduced in his *Letters and Notes* and strongly suggests that another oil once existed.

In September 1836 Catlin paid his last visit to the Sac and Fox

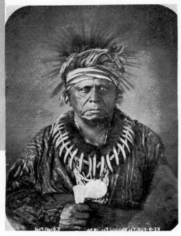

FIG. 5 — DRAWING from Ferdinand Pettrick's Sketch Book (1842). *Courtesy of the Ayer Collection, Newberry Library, Chicago.*

FIG. 6 — PHOTOGRAPH (1850) of the daguerreotype made in 1847. *Courtesy of the Missouri Historical Society, St. Louis.*

his right hand a war banner, the symbol of his nation as ruling chief. His person was erect, and his eyes fixed calmly but steadily upon the enemies of his people. On the floor, and leaning upon the knee of the chief, sat his son, a child of nine or ten years old, whose fragile figure and innocent countenance afforded a beautiful contrast to the athletic and warlike form, and intellectual though weather-beaten features of Keokuk." When it came Keokuk's turn to speak, we are told, "he stood erect in an easy but martial posture, with his robe thrown over his left shoulder and arm, leaving the right arm bare, to be used in action. His voice was fine, his enunciation remarkably clear, distinct, and rapid. . . . He spoke with dignity, but with great animation, and some of his retorts were excellent." (Catlin and McKenney and Hall were mistaken about the age of the child, for it is the same one in both these paintings; according to his own statement the boy was born in 1824.) The reproduction here is from the lithograph; the location of the oil is unknown.

An interesting (and unrecognizable) variation in this gallery of *Keokuks* was sketched at Washington in 1842 (*Fig. 5*). A German sculptor named Ferdinand Pettrich had come to Washington in 1835 commissioned to model North American Indians for Pius IX. Among other drawings in the manuscript sketchbook now owned by the Newberry Library is one of the Sac chief wrapped nobly in a toga. Possibly somewhere in Vatican City today there is a Keokuk waiting for some American to greet him!

The last portrait of Keokuk in his lifetime was painted by John Mix Stanley in May 1846, on the Kansas River when the Sac and Fox were removing from Iowa to the reservation in Kansas. This picture apparently was burned in the Smithsonian fire of 1865 when the great collection was almost entirely destroyed.

Three other oil portraits can be located: one signed *F. E. Arnoux* belongs to the Keokuk Public Library; another signed *G. H. Nollen* is the property of Miss Mary Wells Irwin of Keokuk; a third hangs in the Missouri Historical Society (St. Louis). All of these, it seems certain, were painted after Keokuk's death and were probably done from the daguerreotype made in 1847, now in the Missouri Historical Society collections. In spite of minor differences they are all copies of the same original and there is great likeness to the daguerreotype. The picture here reproduced is a photograph done in St. Louis in 1850 from the 1847 daguerreotype (*Fig. 6*).

For a man who lived beyond the frontier in the days before photography Keokuk had his likeness taken often enough. However the artists varied in their delineation of the chief, their work has given tone and vitality to the biography of that great Indian.

tribe when he was present at the treaty at Rock Island in which the Indians ceded their reserve on the Iowa River. Again he noted that "Kee-o-kuk . . . is a very subtle and dignified man, and well fitted to wield the destinies of his nation." Whether the artist painted any picture of the chief at this time is not known.

Next in the sequence of portraits is the very interesting picture of Keokuk and his son done in October 1837 by Charles B. King when the great Sac was on a visit to Washington, D. C. McKenney and Hall chose this to accompany the account of Keokuk in the *Indian Tribes of North America* (*Fig. 4*). The writer of the biography was much impressed by the contrast between the Sioux who appeared at the treaty sessions "tricked out in blue coats, epaulettes, fur hats, and various other articles of finery which had been presented to them, and which were now incongruously worn in conjunction with portions of their own proper costume — while the Sauks and Foxes, with a commendable pride and good taste, wore their national dress without any admixture, and were studiously painted according to their own notions of propriety." As usual, the most striking person in the whole assembly was "Keokuk, who sat at the head of his delegation, on their extreme left, facing his mortal enemies, the Sioux. . . . He sat as he is represented in the picture . . . grasping in

PORTRAITS OF RED JACKET

By MARY M. KENWAY

Miss Kenway, now research librarian for French & Co., studied at the University of London and at Johns Hopkins University, and was formerly connected with the library at Yale.

AFTER A HUNDRED AND TWENTY-FIVE YEARS in the limbo of forgotten paintings, the sketch in oils which George Catlin made of the great Seneca chief, Red Jacket, has reappeared. It is important both for the light it throws on the work of Catlin and for the touching picture it presents of decaying Indian greatness.

The Senecas in their days of pride boasted two great chiefs, Corn Planter, their leader in war, and Red Jacket, the orator,

inspirer of and spokesman for his people. Both these men were still living in the 1820's, when Catlin came to Buffalo. Corn Planter, perhaps because of his admixture of white blood, had by now accepted the tide of white settlement and made terms with the new way of life. Quite the reverse was true, however, of Red Jacket. He refused to acknowledge any change in the old roaming, hunting economy, and spent all his considerable powers in a useless endeavor to stem the forces shaping the future. He blamed the missionaries for his loss of authority, and clung the more closely to the old religion, drowning his rancor and frustration in drink, the frontier rotgut which went so far toward demoralizing the Indian. A greater contrast cannot be imagined than that between the two chiefs, once joint leaders of their tribe.

The year 1825 was probably the lowest ebb in Red Jacket's life. His much-beloved second wife had been converted to Christianity, and had influenced Red Jacket's children to that decision. This was the last straw for the aging chief. He removed from his village to the wildest parts of the reservation and severed all connection with his family and his people — at what cost of suffering Catlin's portrait makes clear.

Many artists had tried to paint Red Jacket, but up to that time none of any note had succeeded. No record remains, therefore, of the man in his prime. To all requests the chief had replied that when he died all trace of him should perish. Catlin, however, with the gift for winning the friendship of the Indian which was to smooth his path all his life, somehow made the conquest. Perhaps the secret lies in a powder horn decorated with scenes from Indian life, now in the Wyoming Historical Society, which Catlin made and presented to the old chief. It is the sort of gift which would have appealed to him. At any rate, Catlin won and held Red Jacket's interest long enough to paint this preliminary sketch (*Fig. 2*).

The life-size, full-length portrait painted in 1828 and taken to Europe has been lost, but surviving sketches give a fairly clear idea what it must have been like. One reproduced here (*Fig. 3*) from Catlin's sketchbook in the New York Public Library shows the changes which the artist made so that his portrait would conform to the taste of the time.

As Catlin explains in his book *Illustrations of the Manners, Customs and Conditions of the North American Indians*, he chose Niagara Falls as a background for the painting at Red Jacket's own request. The chief had confided to him that he believed his spirit would hover around Table

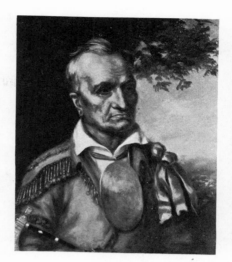

FIG. 1 — OIL PORTRAIT by Charles Bird King (*1785–1862*). *Yale Univ. Art Gallery.*

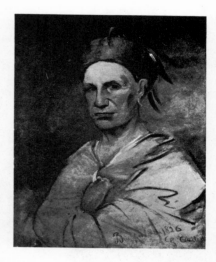

FIG. 2 — SKETCH IN OILS by George Catlin (*1796–1872*). *Courtesy of French & Co.*

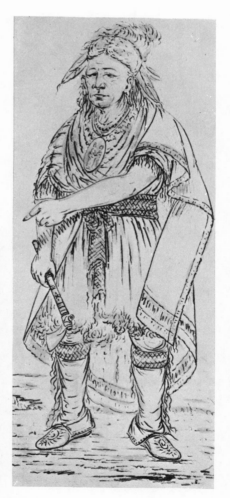

FIG. 3 — DRAWING from George Catlin's sketchbook. *Reserve Division of the New York Public Library.*

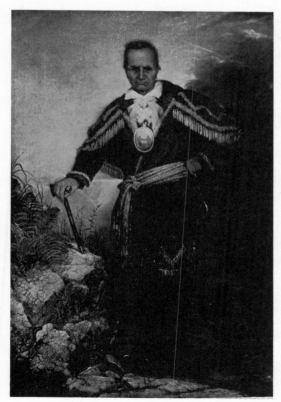

FIG. 4 — OIL PORTRAIT by Robert W. Weir (*1803–1889*). *New York Historical Society.*

Rock after death. The same background appears in a portrait of Red Jacket by Robert W. Weir (*Fig. 4*). By 1828 the old chief seems to have made terms with life, for in that year he visited New York and sat to Weir in his studio. The resulting portrait is small but shows the subject full length, in much the pose used by Catlin. Red Jacket was then seventy-seven or seventy-eight, with only two more years left to him. This is the portrait of an old man, a little resigned, or at least acquiescent. Two years earlier, when Catlin painted him, the will to fight and dominate was there.

Much the same may be said of the portrait by Charles Bird King, shown in Figure 1. Though it cannot be more than a year later at most than the Catlin portrait, the sitter has already aged perceptibly. The power and the will to resist which were present even a year before are gone, the fires are banked. Tragedy is there, not only the personal tragedy of a lonely old age but the general tragedy of the Indian.

Red Jacket, the great orator, saw and grasped even at an early date the ultimate fate of his people. In 1797 he said: "We stand, a small island in the bosom of the great waters. We are encircled — we are encompassed. The evil spirit rides upon the blast, and the waters are disturbed. They rise, they press upon us, and the waves once settled over us, we disappear forever. Who then lives to mourn us? None. What marks our extermination? Nothing. We are mingled with the common elements."

Portraits of Rebecca Gratz by Thomas Sully

BY HANNAH R. LONDON

THE THREE DISTINGUISHED PORTRAITS illustrated here are of the beautiful Jewess Rebecca Gratz, who was born in Philadelphia March 4, 1781, and died there August 29, 1869. They were all painted by Thomas Sully (1783-1872) and are listed in what is known as his Register. This *Account of Pictures,* as the artist termed it, is a record of his work giving the name of the sitter, the size of canvas, the dates when each painting was begun and finished, and the purchase price. Occasionally he added remarks pertaining to the social status of the sitter and the person by whom the portrait was commissioned.

The original manuscript of the Register is in the possession of the Pennsylvania Historical Society; a transcript of it is printed in the book *The Life and Works of Thomas Sully* by Edward Biddle and Mantle Fielding (Philadelphia, 1921). These two authors say that Sully signed his monogram, *TS,* and the date on the face of each of his paintings or on the back of the canvas. Not all his works are recorded in his Register; however, he did list over two thousand portraits in addition to miniatures and several hundred subject pictures.

Born in England, Sully was brought as a boy by his parents to Charleston, South Carolina, in 1792. He did not meet with success in business and was advised to become a painter. His instructors were a French artist known only by his surname, Belzons; Charles Fraser, the miniaturist; and Sully's elder brother, Lawrence. The brothers worked together in Richmond and Norfolk until Lawrence's death in 1803. Thomas Sully later married his widowed sister-in-law. In 1806 he moved to New York City. The following year he was in Boston, where he met Gilbert Stuart and was forever grateful for the opportunity to stand by the famed artist's chair as he painted. In 1808 Sully finally settled in Philadelphia. From there he made frequent trips to coastal cities to ply his brush.

In 1809 Sully went to London and there he met Benjamin West, who advised him to study the painting of the most renowned portrait artists. The work of Sir Thomas Lawrence particularly impressed Sully, who emulated his great English contemporary in his charming and delicate portrayal of women. Sully was back in Philadelphia in 1810. In 1837, he paid another visit to London and painted a portrait of the young Queen Victoria which became celebrated. The following year he returned to Philadelphia. There he died in 1872 after a greatly respected life of eighty-nine years.

Rebecca Gratz was the daughter of Michael Gratz (1740-1811), a Silesian who immigrated to America in 1759 and became a Philadelphia merchant with substantial interests in the West, as far as Illinois and Kentucky. In 1769 he married, at Lancaster, Pennsylvania, Miriam Simon (1749-1808), daughter of Joseph and Rosa (Bunn) Simon. Rebecca was the seventh of their twelve children.

Rebecca Gratz devoted her long life to raising the nine children left by the death of her sister Rachel Gratz Moses, and to philanthropic works. She was secretary of the Female Association for the Relief of Women and Children in Reduced Circumstances in Philadelphia, and was one of the founders and for many years secretary of the Philadelphia Orphan Society, both of which were nonsectarian organizations. She founded the Jewish Foster Home for orphan children, and under her guidance the first Hebrew Sunday school in the United States was established in 1838.

As early in Sully's career as 1807, Washington Irving wrote the following letter (now at the Historical Society of Pennsylvania), dated November 4 of that year, to Rebecca Gratz:

I hardly need introduce the bearer, Mr. Sully to you, as I trust you recollect him perfectly. He purposes passing the winter in your city, and as he will be 'a mere stranger and sojourner in the land,' I would solicit for him your good graces. He is a gentleman for whom I have a great regard, not merely on account of his professional abilities, which are highly promising, but for his amiable character and engaging manner. I think I cannot render him a favor for which he ought to be more grateful than in introducing him to the notice of yourself and your connections . . . Excuse the liberty I have taken and believe me with the warmest friendship./Ever yours,/Washington Irving Mr. Hoffman's family are all well, and you are often the subject

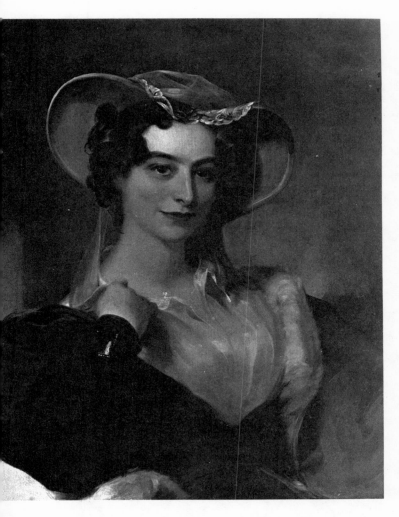

Fig. 1. *Rebecca Gratz* (1781-1869), by Thomas Sully
(1783-1872). Oil on canvas, 30 by 25 inches.
Painted, according to Sully's Register,
between October 25, 1830, and June 8, 1831.
Illustrated, Hannah R. London, *Portraits of Jews . . .*, p. 177.
Collection of H. Gratz Joseph.

of their conversation. Remember me affectionately to all the family.

Rebecca had met Washington Irving at the home of Judge and Mrs. Josiah Ogden Hoffman of New York. Mrs. Hoffman (nee Maria Fenno) was the stepmother of the young Matilda Hoffman who was engaged to Washington Irving, then a struggling young writer. Irving was inconsolable when Matilda Hoffman met her untimely death in 1809, and Rebecca won his everlasting friendship by her affection for Matilda. On his visit to Sir Walter Scott in 1817, Irving described Rebecca's loveliness of character to the author, who, greatly impressed, immortalized her in his conception of Rebecca in *Ivanhoe*. Rebecca Gratz never denied that she was the prototype of the novel's heroine. The claim has been disputed, but it has also been well defended in an article by Gratz Van Rensselaer entitled "The Original of Rebecca in Ivanhoe" which appeared in the *Century Monthly Magazine* for September 1882.

From the Hoffman family Edward Greene Malbone, the well-known miniaturist, brought letters of introduction to

Rebecca Gratz. She assisted him in obtaining commissions and he painted a miniature of her in 1804 (illustrated in my book *Portraits of Jews*, p. 155). The first mention of a portrait of Rebecca by Sully is an entry in his Register indicating that in 1807 he made a copy of Malbone's miniature of her, priced at $30.00, for Thomas Abthorpe Cooper, the distinguished English actor. I have been unable to locate this Sully miniature.

After Rebecca received Irving's letter introducing Sully, she apparently lost no time in recommending the young artist, for among the numerous portraits of Jews listed in his Register we find the names of members of her immediate family and of collateral relatives. In 1808, when Sully settled in Philadelphia, Rebecca's father, Michael Gratz, sat for a portrait. A Miss Etting and a Miss Sally Etting, both relatives of hers, are listed in the Register for the same year, as well as Solomon Moses, the husband of her sister Rachel.

It was not until the early 1830's that other members of the family came under Sully's brush. The portrait of Rebecca's brother Benjamin Gratz is recorded in 1831, together with that of his first wife, Maria Cecil Gist. Listed in 1835 is the portrait of her cousin, another Rachel Gratz, daughter of Barnard Gratz and second wife of Solomon Etting. In 1836 the name of Major Alfred Mordecai appears; a graduate of the United States Military Academy at West Point, he was the husband of a niece of Rebecca's. Another relative painted by Sully, in 1833, was Sarah Anna Minis, wife of Dr. Isaac Hays of Philadelphia.

On October 25, 1830, Sully began the bust portrait of Rebecca Gratz (Fig. 1), now owned by H. Gratz Joseph of St. Catharines, Ontario. She is depicted wearing a hat with a wide brim, her head turned a little to her left, her hand resting lightly at the neck. Sully recorded it as in oil on canvas, twenty-five by thirty inches. He lingered over this portrait, for according to his Register it was not finished until June 8, 1831, when it was priced at $75.00.

When I saw the portrait over forty years ago it was hanging in the spacious dining room of Henry Joseph's home in Montreal. He was Rebecca's grandnephew and had inherited the largest collection of family ancestral portraits, chiefly by Stuart and Sully, that I had ever looked upon. I noted Rebecca's soft, dark brown eyes, her olive complexion and brown curly hair. She wore a claret-color dress and over the bodice was a pale yellow mantle bordered with white fur. Years after the portrait was painted, it was referred to by John Sartain in *The Reminiscences of a Very Old Man, 1807-1897* (New York, 1899). Telling of a visit to Rebecca Gratz in her later life, he wrote, "Her eyes struck me as piercingly dark, yet of mild expression, in a face tenderly pale. The portrait Sully painted of her must have been a remarkable likeness, that so many years after I should recognize her instantly by remembrance of it."

After this portrait was illustrated in my book *Portraits of Jews by Gilbert Stuart and Other Early American Artists* in 1927, I received a photograph of another portrait, in profile, of Rebecca Gratz (Fig. 2) from John Gribbel of Philadelphia, with the following letter, dated April 28, 1928:

The portrait of Rebecca Gratz wearing the Turkish turban, is still in my possession. To me it is one of the most beautiful things that Sully ever did.

You are probably acquainted with the tradition in the Gratz family, that when Sully was painting this portrait Rebecca insisted on wearing the Turkish turban. The family being un-

able to swerve her from her decision, disowned the portrait, and Sully's fee book shows the entry of this portrait scratched out.

Though Rebecca's profile portrait is noted in Sully's Register as "erased," this charming portrayal in which she is shown with a cluster of curls at the nape of the neck was obviously finished. In the Register it is listed as a second portrait, begun November 15, 1830, painted for the subject's brother Hyman Gratz. The bust portrait measuring sixteen by nineteen inches was priced at $75.00. Biddle and Fielding comment on the turban, which they say emphasizes "the oriental beauty of her features." The portrait is listed in the catalogue of the *Memorial Exhibition of Portraits by Thomas Sully* held in 1922 at the Pennsylvania Academy of the Fine Arts in Philadelphia.

I have been unable to trace this portrait to its present location. An inquiry about it published in ANTIQUES for November 1969 (p. 736) brought the information that after the death of John Gribbel it was sold at auction by William D. Morley, Inc., in Philadelphia, on November 8, 1941. Unfortunately the auctioneer's sales records for that period were all destroyed by a flash flood, so he has no record of the purchaser's name.

The Register lists one more portrait of Rebecca, painted on a wood panel, seventeen by twenty inches. It is a head picture which shows her wearing a tulle ruff (Fig. 3). Painted for Mrs. Benjamin Gratz (Maria Gist), Rebecca's sister-in-law, it was started May 16, completed June 11, 1831, and priced at $50.00.

Maria Gist Gratz was the daughter of Colonel Nathaniel Gist of the Revolutionary Army and a granddaughter of Sir Christopher Gist, an intimate friend of George Washington. She was extremely fond of Rebecca, who returned her affection and wrote to her frequently (see *Letters of Rebecca Gratz,* edited by Dr. David Philipson, Philadelphia, 1929). After Maria's death, Benjamin Gratz married her widowed niece, Mrs. Ann (Boswell) Shelby. Their daughter, Anna, married Thomas Hart Clay Jr., grandson of the great statesman Henry Clay. The portrait of Rebecca painted for Maria Gratz is owned by Henrietta Clay of Lexington, Kentucky, daughter of Mr. and Mrs. Thomas Hart Clay Jr.

Several portraits of Rebecca Gratz supposedly by Sully though not listed in his Register have come to my attention, but as yet I do not have conclusive evidence of their authenticity. The three illustrated here, which show her as younger looking by far than the age of forty-nine or fifty that she had attained when they were painted, are fully documented as the work of the illustrious Thomas Sully.

The author's book *Portraits of Jews by Gilbert Stuart and Other Early American Artists,* published in New York in 1927, was reprinted in 1969 by Charles E. Tuttle Co., Inc., Rutland, Vermont.

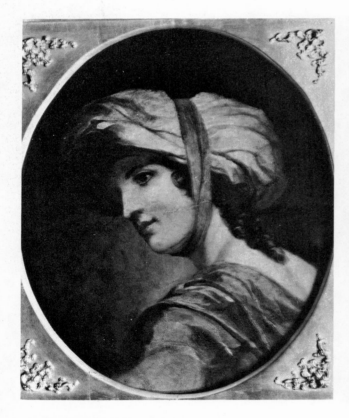

Fig. 2. *Rebecca Gratz* by Sully. Oil on canvas, 19 by 16 inches. Begun in November 1830 for the subject's brother Hyman Gratz. Ex coll. *John Gribbel; sold at auction in Philadelphia in 1941; present whereabouts unknown.*

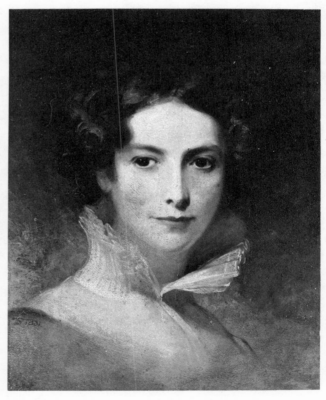

Fig. 3. *Rebecca Gratz* by Sully. Oil on panel, 20 by 17 inches; signed, lower left, *TS 1831.* Painted between May 16 and June 11, 1831, for Maria Gist Gratz, the subject's sister-in-law. *Collection of Henrietta Clay; photograph by courtesy of the Frick Art Reference Library.*

Portraits of ante-bellum Kentuckians

BY WILLIAM BARROW FLOYD, *Curator, Old State Capitol Restoration*

PORTRAITURE WAS THE major means of artistic expression in ante-bellum Kentucky. Not long after the first settlements were established, resident and itinerant painters appeared on the frontier. Although many artists would have welcomed commissions for history pictures, landscapes, or animal paintings, they were invariably asked for portraits, for that was the only means of recording individual likenesses prior to the widespread use of the daguerreotype in the 1840's.

During the late eighteenth and the nineteenth century, Kentucky seems to have produced and patronized a wider variety of competent artists than any other state outside the thirteen original colonies. Indeed, three painters born in the state before the beginning of the nineteenth century, Matthew H. Jouett, William Edward West, and Joseph H. Bush, eventually established national reputations.

Matthew Harris Jouett, the pre-eminent early Kentucky artist, was born in Mercer County in 1788. He was educated at Transylvania University and read law before turning to painting as a career. He studied under Gilbert Stuart in Boston for four months during 1816, after which his style developed a sophistication that caused him to be called Stuart's favorite pupil. His portrait of Justice Thomas Todd bears the unquestionable mark of Stuart in its composition, modeling, and coloring, although the hands and background lack the finish of the master (Fig. 1). Thomas Todd held a number of important positions in Kentucky government before he was appointed an associate justice of the United States Supreme Court by President Jefferson in 1807 (See p. 919).

Jouett's portrait of Isaac Shelby, Kentucky's first governor, is entirely representative of his work (Pl. II). The absence of background details puts the emphasis on the sitter, whose strong character and determination are caught in this forthright likeness.

Near the end of his life Jouett began to soften and somewhat romanticize his portraits, perhaps as a result of corresponding with and visiting Thomas Sully in Philadelphia. In this vein is his painting of Mrs. Benjamin Gratz which he must have painted not more than two years before his death (Pl. IV). Benjamin Gratz was a member of a prominent and philanthropic Philadelphia family who carried on the tradition of social and financial leadership when he settled in Lexington, Kentucky. Gratz Park still bears his name and his handsome house remains a show place of the city (see p. 844). He was painted in Philadelphia by Thomas Sully (Fig. 2). Sully's influence upon the fine arts in Kentucky was great, for the best native-born painters of the commonwealth studied under him, including William Edward West, Joseph H. Bush, Oliver Frazer, and Aaron Houghton Corwine.

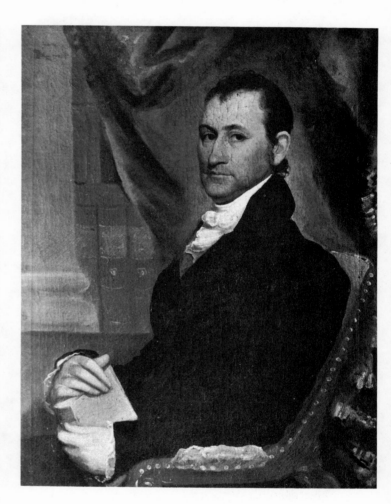

Fig. 1. *Thomas Todd* (1765-1826), by Matthew Harris Jouett (1788-1827), c. 1818-1826. Oil on canvas, 36 by 28¼ inches. *Kentucky Historical Society; photograph by Helga Photo Studio.*

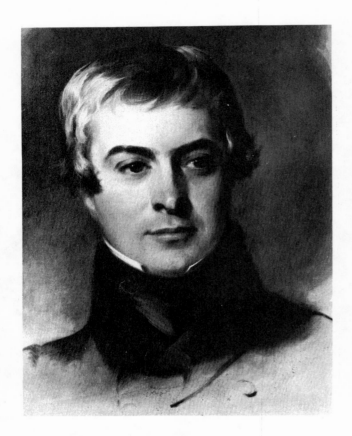

Fig. 2. *Benjamin Gratz* (1792-1884), by Thomas Sully (1783-1872), signed and dated *TS 1831*. Oil on canvas, 19½ by 15 inches. *Private collection; Helga photograph.*

While his renown is based upon his bird and animal paintings, John James Audubon also executed a small number of charming portraits (see p. 853).[1] He wrote: "So high did my reputation suddenly rise, as the best delineator of heads in that vicinity, that a clergyman residing in Louisville had his dead child disinterred to produce a facsimile of his face."[2]

Chester Harding, a native of New England, had his first success as a portraitist during a trip to Paris, Kentucky, in 1819, when he is said to have completed one hundred portraits of Kentuckians at $25 each. One of the first Kentucky group portraits was undoubtedly painted by him at this time (Fig. 5). Colonel John Speed Smith, his wife, who was a sister of Cassius M. Clay (see Fig. 11), and their barefoot daughter pose in the parlor of their handsome Madison County house. Colonel Smith was an aide-de-camp to General William Henry Harrison in the War of 1812 and later served in the Kentucky and United States legislatures. He was appointed United States district attorney for Kentucky by President Andrew Jackson.

Chester Harding painted the only life portrait of Daniel Boone several months before the pioneer's death in 1820 (see Fig. 6). The artist wrote of his visit to Boone:

I found the object of my search engaged in cooking his dinner. He was lying in his bunk, near the fire, and had a long strip of venison wound around his ramrod, and was busy turning it before a brisk blaze, and using salt and pepper to season his meat. I at once told him the object of my visit. I found that

Fig. 3. Portrait of a man, believed to be a self-portrait by William Edward West (1788-1857), c. 1819. Oil on canvas, 30 by 24 inches. *Private collection; Helga photograph.*

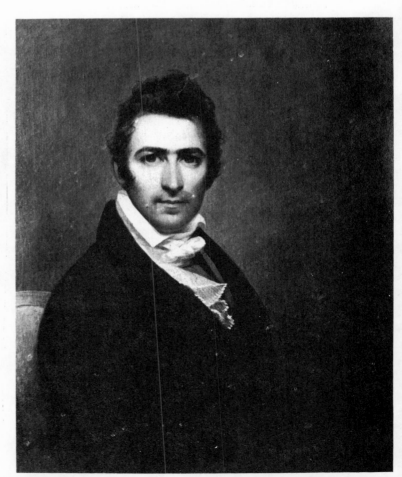

Among the important Kentucky artists who have yet to receive their just acclaim is William Edward West, who was born in Lexington in 1788, the same year as Jouett. After studying with Sully in Philadelphia he painted in Natchez, Mississippi, and then established an enviable reputation in Europe. He exhibited at the Royal Academy in London and became famous for a portrait of Lord Byron. A recently discovered portrait, illustrated in Figure 3, descended in a family with a Natchez background. It is a warmly colored painting typical of West's work before his departure for Europe in 1819. For these reasons and because of several historical clues, I believe this to be a self-portrait by West.

Watercolor sketches and crayon, pencil, or chalk portrait drawings, as well as oil paintings, were frequently produced in Kentucky. The itinerant artist Samuel H. Dearborn advertised in Lexington's *Kentucky Gazette* of May 1, 1809, that he planned to be in the city for several weeks: "As portraits require time to execute, those ladies and gentlemen who wish theirs painted, must apply soon. The low price which he has for his small likenesses on paper it is expected will induce many to substitute them for blank profiles." Dearborn seems to have been commissioned to do a number of watercolor profiles of which the companion pictures of Major and Mrs. William S. Dallam (Fig. 4) are typical. These rather primitive, straightforward likenesses are representative of a type of portrait that found a ready market in Kentucky during the early decades of the nineteenth century.

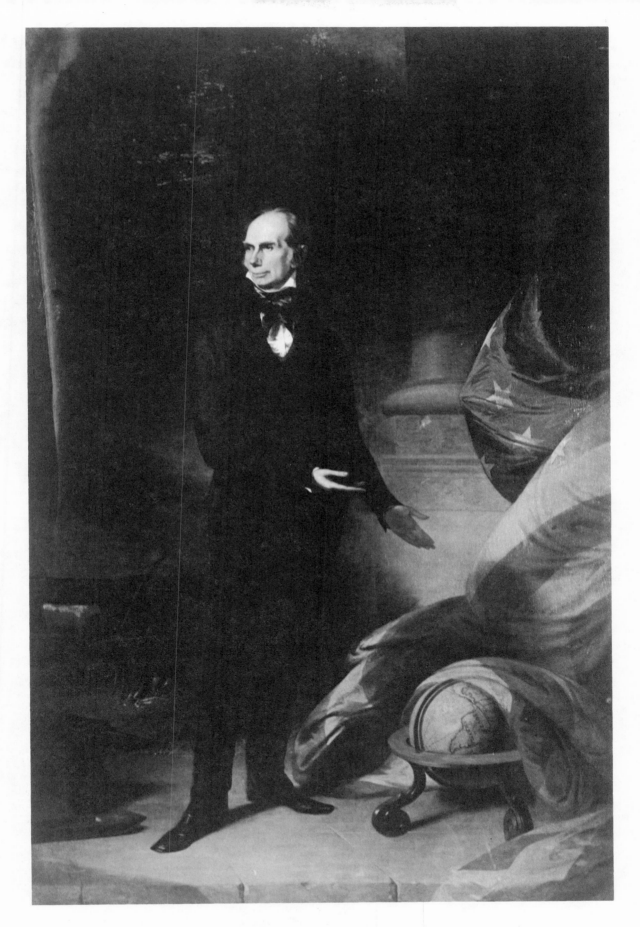

Pl. I. *Henry Clay* (1777-1852), by John Neagle (1796-1865), signed and dated *John Neagle 1843*. Oil on canvas, 111¼ by 72½ inches. *Union League of Philadelphia; gift of Henry Pratt McKean; color photographs are by Helga Photo Studio.*

167

Pl. II. *Isaac Shelby* (1750-1826), by Matthew Harris Jouett (1788-1827), c. 1818-1826. Oil on canvas, 29 by 24 inches. *Kentucky Historical Society.*

Pl. III. *Mrs. Isaac Shelby* (nee Susannah Hart; 1764-1833), by Patrick Henry Davenport (1803-1890). Signed and dated *Painted by P. Henry Davenport/ Danville/Ky/1827.* Oil on wood, 25½ by 21¼ inches. *Kentucky Historical Society.*

Fig. 4. Portraits of Major and Mrs. William S. Dallam (nee Letitia Preston Meredith) by Samuel H. Dearborn (w. c. 1804-1823), c. 1811. Watercolor on paper, 9 by 12 inches (by sight). Both pictures are signed *Dearborn delin. Private collection; photograph by courtesy of the Frick Art Reference Library.*

he hardly knew what I meant. I explained the matter to him and he agreed to sit. He was . . . rather infirm.[3]

Tradition has it that a fever had so weakened Boone that a friend had to stand behind him and steady his head while Harding worked on the portrait. Harding made a number of subsequent painting trips to Kentucky before the Civil War, always finding ready patronage.

Joseph H. Bush, often considered second only to Jouett among native-born Kentucky artists,[4] was probably born in Mercer County. He spent much of his early life in Frankfort, where his father was proprietor of the Washington Inn. His talents came to the attention of Henry Clay (see Pl. I), who not only lent him money to study under Thomas Sully but is reported to have personally escorted him to Sully's Philadelphia atelier.

Bush's early linear style had none of the softness and sophistication of Sully's painting, but he did obtain striking likenesses. One of his first portraits was a stark representation of the infirm and neglected frontiersman General George Rogers Clark, taken not long before his death (Fig. 7). A great-niece of the general remarked: "Years after the portrait was painted Mr. Bush told me . . . that whilst he had painted many finer he had never painted one which was a truer likeness."[5] A later portrait of his nephew Thomas James Bush (Fig. 8) shows the artist's progression into romanticism.

About 1853 Bush visited Oak Hill, the Woodford County estate of Colonel Joseph Harris Woolfolk. He remained for some months and painted at least six members of the Woolfolk family. His portrait of Mrs. Joseph Harris Woolfolk (Pl. VI) is an especially fine character study.

A native of Mason County, Aaron Houghton Corwine was one of the most promising artists born in Kentucky. His talent was discovered early and he went to study under Sully when he was only sixteen. Two years later, Corwine settled in Cincinnati, where he became that city's most renowned artist. He later traveled to England to study the

Fig. 5. *The John Speed Smith Family*, attributed to Chester Harding (1792-1866), c. 1819. The subjects are Mrs. John Speed Smith (nee Eliza Lewis Clay; 1798-1887), Sally Ann Lewis Clay Smith (Mrs. David Short Goodloe; 1818-1875); and Colonel John Speed Smith (1792-1854). Oil on canvas, 100 by 78 inches. *J. B. Speed Art Museum; Helga photograph.*

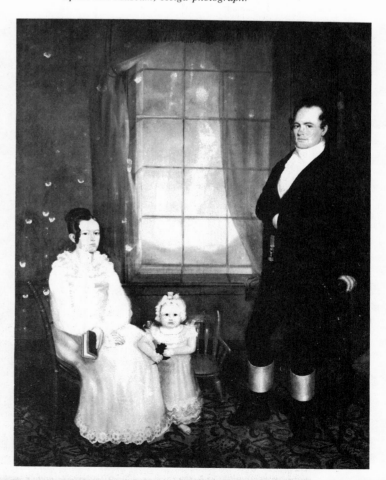

169

works of the great British portraitists, and while there, painted the self-portrait shown in Figure 9. Edward H. Dwight has described this likeness as "strongly influenced by Reynolds and Lawrence, in which his handsome youthful face bears a strange, pensive and quizzical expression."[6] Suffering from consumption, Corwine returned to America where his promising career was cut short by his untimely death at the age of twenty-eight.

Patrick Henry Davenport was born at his parents' Indian Queen Tavern in Danville. Apparently self-taught, he developed one of the most individualistic painting styles in early Kentucky. A particularly forceful likeness of Mrs. Isaac Shelby (Pl. III) reveals the intrepid character of that pioneer lady who reared a large family at Traveler's Rest in Lincoln County and served as mistress of the governor's mansion during the two terms her husband held the highest office of the commonwealth.

Dr. Ephraim McDowell (Fig. 10) was posed in front of his medical library by Davenport, who took pains to delineate the titles on some of the volumes that had been written by the physician's instructor in Scotland. Dr. McDowell had studied medicine at the University of Edinburgh before returning to Danville, Kentucky, his birthplace, where he established an international reputation for performing the world's first successful ovariotomy in 1809.

Oliver Frazer was the youngest of the important painters born in Kentucky before the Civil War. He was also the best trained and traveled of them all. Born in Fayette County, he studied under Jouett and Sully, and later spent nearly four years visiting the art centers of Europe. While abroad, he copied many noted paintings and made a great number of sketches. One of his most handsome portraits is of Cassius Marcellus Clay, taken about the time Clay graduated from Yale (Fig. 11). It captures the youthful enthusiasm and vitality of the man who was destined to become a noted abolitionist and United States minister to Russia during the Lincoln administration. Frazer's pictures of children were always charming, as his wistful group portrait of Edward, John, and Benjamin Anderson demonstrates (Pl. VII).

Tradition has it that the *Ormsby Family* (Pl. V) was painted by an Irishman who spent five years at Maghera Glass, the Jefferson County home of Colonel and Mrs. Stephen Ormsby Jr. This picture gives evidence of considerable talent and training, and reveals the high quality of portraiture which was available to Kentuckians during the decade before the Civil War, even by artists whose names have long been forgotten.

Henry Clay, the great statesman of Kentucky for over forty years, was painted by more noted artists and more frequently than any other citizen of the commonwealth. One of the most dramatic of these portraits was executed by John Neagle, a distinguished Philadelphia artist, at Ashland, Clay's country house in Lexington (Pl. I). When the portrait was completed, Clay wrote to Neagle:

I know that you took the greatest pains to produce a perfect likeness, studying thoroughly your subject, and carefully examining all previous pictures of it, which were acceptable to you. And it is the judgment of my family and friends that you have sketched the most perfect likeness of me that has hitherto been made. My opinion coincides with theirs. I think you have happily delineated the character, as well as the physical appearance, of your subject.[7]

Neagle painted portraits in Kentucky on at least two other occasions but was deterred from settling there as a young man by the competition provided by Jouett, who had a

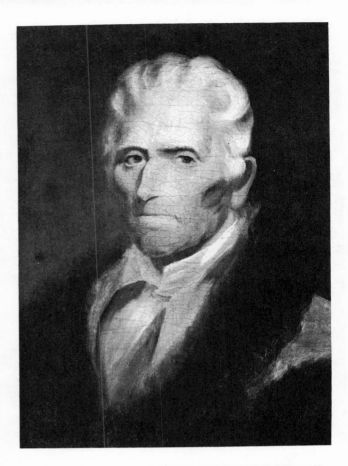

Fig. 6. *Daniel Boone* (1734-1820), by Harding, 1820. This replica of Harding's life portrait was given by the artist to Matthew Harris Jouett. Oil on canvas, 20 by 14 inches. *J. B. Speed Art Museum; Helga photograph.*

Fig. 7. *George Rogers Clark* (1752-1818), by Joseph Henry Bush (1794-1865), c. 1817. Oil on canvas, 31 by 25½ inches. *Locust Grove, Louisville; Helga photograph.*

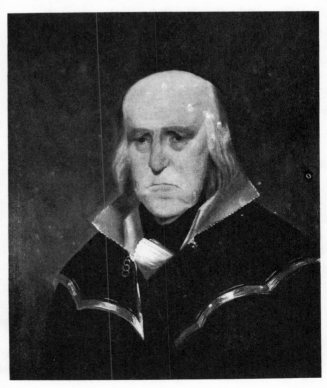

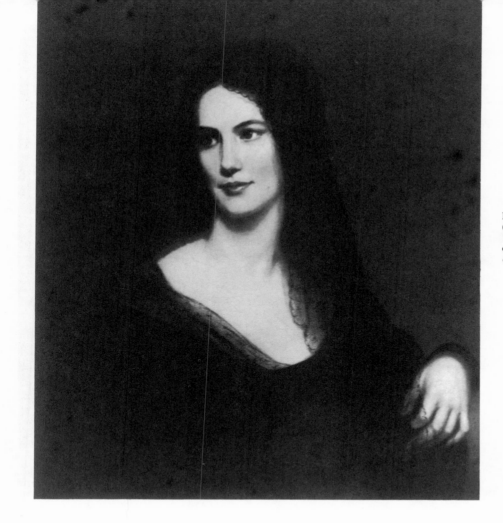

Pl. IV. *Mrs. Benjamin Gratz* (nee Maria Cecil Gist; 1797-1841), by Jouett, c. 1825. Oil on canvas, 30 by 25 inches. *Private collection.*

Pl. V. *The Ormsby Family,* by an unknown Irish artist, c. 1851. *Standing, left to right:* Hamilton Ormsby (1832-1905); Mary Ormsby (1841-1895), Peter Benson Ormsby (1835-1894), Harriet Ormsby (b. c. 1847), Jane Ormsby (1837-1860), Stephen Ormsby (1849-1879); *seated, left to right:* Edmonia Haynes Taylor (1833-1903) and Henrietta Ormsby (1839-1908). Sam is the barefoot servant and Zeke, the dog. Oil on canvas, 29 by 36 inches. *Private collection.*

Pl. VI. *Mrs. Joseph Harris Woolfolk* (nee Martha Mitchum; 1797-1888), by Joseph H. Bush (1794-1865), c. 1853. Oil on canvas, 29½ by 24½ inches. *Private collection.*

Pl. VII. *The Anderson Boys,* by Oliver Frazer (1808-1864), 1839. *Left to right:* Edward Riley Anderson (b. c. 1837), John Foster Anderson (1833-1871), and Benjamin Milam Anderson (1836-1865). Oil on canvas, 29 by 24 inches. *J.B. Speed Art Museum.*

Fig. 8. *Thomas James Bush* (1840-1920), by Bush, c. 1843. Now destroyed, the portrait was formerly in the collection of the Lexington Public Library. Oil on canvas, 35 by 25 inches. *Photograph by courtesy of the Frick Art Reference Library.*

virtual monopoly of the important portrait commissions.

The two presidents of the United States associated with Kentucky are Zachary Taylor and Abraham Lincoln. Taylor lived most of his life in Jefferson County and sat for his portrait frequently. James Henry Beard's painting of him in the uniform of a Mexican War general (Fig. 12) was "said by his friends and those familiar with his personal appearance, to be the most correct likeness extant."[8] Beard traveled about the commonwealth, painting at Louisville, Frankfort, Lexington, and Covington at various times before the Civil War.

A rare, beardless likeness of Abraham Lincoln was painted by George Peter Alexander Healy at Springfield, Illinois, in 1860, shortly before Lincoln's first inauguration (Fig. 13). Healy was one of America's most successful portraitists and was patronized by the royal families of England and France as well as by socially prominent

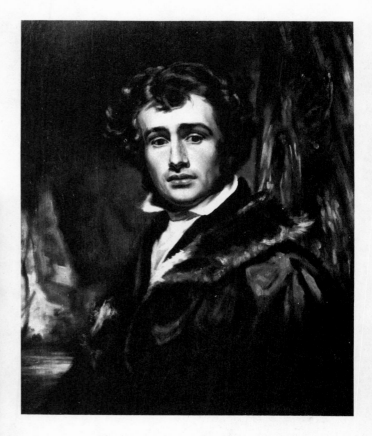

Fig. 9. Self-portrait by Aaron Houghton Corwine (1802-1830), c. 1829. Oil on canvas, 30 by 25 inches. *Maysville Kentucky Public Library; Helga photograph.*

Fig. 10. *Dr. Ephraim McDowell* (1771-1830), by Davenport, c. 1820-1829. Oil on canvas, 27¼ by 21⅛ inches. *McDowell House and Apothecary Shop; Helga photograph.*

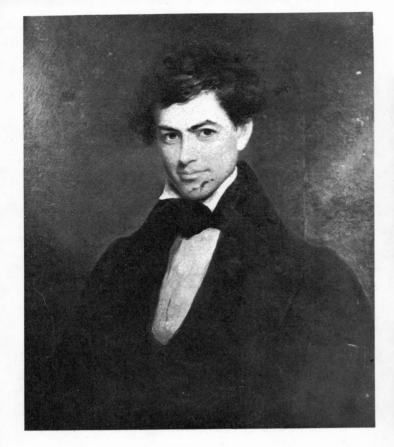

Fig. 11. *Cassius Marcellus Clay* (1810-1903), by Frazer, 1833. Oil on canvas, 29 by 24 inches. *Madison County Courthouse; photograph by courtesy of Jack K. Hodgkin.*

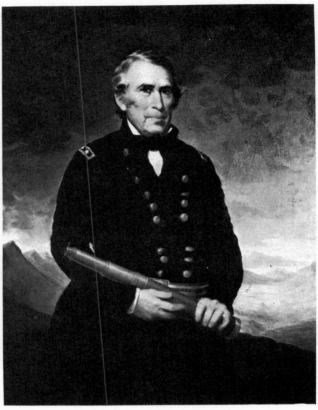

Fig. 12. *Zachary Taylor* (1784-1850), by James Henry Beard (1812-1893), c. 1848. Oil on canvas, 51 by 33¾ inches. *Charleston, South Carolina City Hall; photograph by Louis Schwartz.*

Fig. 13. *Abraham Lincoln* (1809-1865), by George Peter Alexander Healy (1813-1894), signed and dated *G.P.A. Healy./1860.* Oil on canvas, 30⅜ by 25⅜ inches. *Corcoran Gallery of Art.*

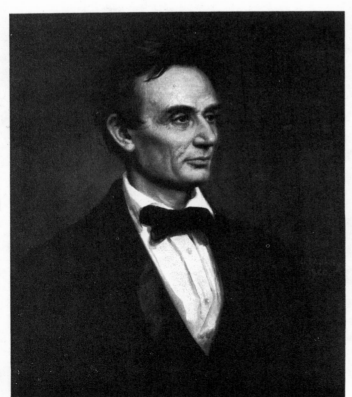

Americans. He painted portraits in Kentucky on a number of occasions, including likenesses of his fellow artists Bush and Frazer.

Portrait painting as a profession suffered severely from the growing popularity of photography and was nearly eliminated in Kentucky by the reduced fortunes and changed social order resulting from the Civil War.

[1] See also ANTIQUES, June 1955, pp. 499-501.

[2] Mrs. Wade Hampton Whitley, *Kentucky Ante-Bellum Portraiture*, Richmond, 1956, p. 621.

[3] Paul S. Harris, "Frontiersman Daniel Boone by Chester Harding," *J. B. Speed Art Museum Bulletin*, No. 19 (February, 1958), n. f.

[4] Richard H. Collins, *History of Kentucky*, Covington, 1874, Vol. 1, p. 624.

[5] William Barrow Floyd, *Jouett-Bush-Frazer: Early Kentucky Artists*, Lexington, 1968, p. 89.

[6] Edward H. Dwight, "A Cincinnati Artist: Aaron H. Corwine," *The Bulletin, Historical and Philosophical Society of Ohio*, No. 17 (April, 1959), p. 107.

[7] Excerpt from a letter from Henry Clay to John Neagle, May 29, 1843, in Ainsworth R. Spofford Papers, Library of Congress.

[8] *Charleston Courier*, October 21, 1848.

Index